DATE DUE

AP 2 '02			
FE 13 '03			
DE 8 '05			
DE 17 '07			

DEMCO 38-296

Andy Warhol, Poetry, and Gossip in the 1960s

Andy Warhol,

Poetry, and Gossip in

Reva Wolf

the 1960s

THE UNIVERSITY OF CHICAGO PRESS · CHICAGO AND LONDON

ory, State University of New York, New Paltz, and

in England and on the Continent, 1730 to 1850.

The University of Chicago Press, Chicago 60637

The University of Chicago Press, Ltd., London

06 05 04 03 02 01 00 99 98 97 1 2 3 4 5

ISBN: 0-226-90491-1 (cloth)

ISBN: 0-226-90493-8 (paper)

An earlier version of chapter 1 appeared in the *Harvard Library Bulletin* 5, no. 2 (1994). It is used here with permission.

All excerpts from "The Skaters" and "The Recent Past" from John Ashbery, *Rivers and Mountains* (New York: Ecco Press, 1977), © 1967 John Ashbery, are reprinted by permission of Georges Borchardt, Inc., for the author.

All excerpts from Jack Kerouac, *Visions of Cody* (New York: Penguin Books, 1993), © 1972 by the Estate of Jack Kerouac, are reprinted by permission of Sterling Lord Literistic, Inc.

Library of Congress Cataloging-in-Publication Data

Wolf, Reva, 1956–

 Andy Warhol, poetry, and gossip in the 1960s / Reva Wolf.

 p. cm.

 Includes bibliographical references and index.

 ISBN 0-226-90491-1 (cloth : alk. paper). — ISBN 0-226-90493-8

(paper : alk. paper)

 1. Warhol, Andy, 1928– —Criticism and interpretation.

 2. Popular culture—United States—History—20th century.

 I. Title.

NX512.W37W66 1997

700′.92—dc21 96-46791

 CIP

To the memory of

my mother, Ruth Smith Wolf

and

to my father, Abraham Wolf

and to my mentors,

Jonathan Brown and

Robert Rosenblum

CONTENTS

ILLUSTRATIONS

A gallery of color plates follows page 48.

ACKNOWLEDGMENTS

I relied on the generosity of many individuals to produce this volume, and I am grateful to all those who assisted me as I researched, wrote, and acquired permissions for it.

Vincent Fremont and Fred Hughes at the Andy Warhol Foundation for the Visual Arts facilitated the early stages of my research. Also at the Foundation, Martin Cribbs cheerfully delivered my legion of messages, Heloise Goodman and later Beth Savage helped me track down photographs, and Neil Printz assisted with questions about specific paintings. I would like to extend a special thank you to Tim Hunt, a curator at the Foundation, who was uncommonly magnanimous with his time, knowledge, and human understanding (the latter two of which he possesses in considerable abundance). Three individuals at the Andy Warhol Museum—Margery King, John Smith, and Mathew Wrbican—helped in a number of ways, and warm thanks go to them, too.

This book would surely have taken a rather different shape had I not benefited from the willingness of several of the subjects of my study to share aspects of their past with me. Gerard Malanga gave freely of his time and resources over a period of six years. Also of tremendous assistance were Daisy Aldan, John Ashbery, Bill Berkson, Diane di Prima, Charles Henri Ford, Allen Ginsberg, John Giorno, Fred W. McDarrah, Taylor Mead, Jonas Mekas, Billy Name, Ron Padgett, and Ed Sanders. I was aided too by John D. Brainard for the estate of Joe Brainard, Alice Notley for the estate of Ted Berrigan, Maureen O'Hara for the estate of Frank O'Hara, Jim Strong for the estate of Eric Pollitzer, and John Wallowitch for the estate of Edward Wallowitch.

Many scholars, librarians, museum and gallery staff members, students, acquaintances, collectors, and members of the publishing community helped me with research and permissions, and I am grateful to each of them: John Abbott, Diane Agee, Callie Angell, Jean Ashton, Debra Balken, Marcella Beccaria, Carl Belz, Adeane Bregman, Annie Brose, Diana Bulman, Kenneth E. Carpenter, Mikki Carpenter, Jim Condon, Betty Cunningham, Dorothy David, Darla Decker, Caroline Demaree, Sarah DeMott, Donna De Salvo, Anita Duquette, Kenward Elmslie, Carmen Fernandez, Jeffrey Figley, May Flower,

Paul B. Franklin, Thomas Frick, Eleanor M. Garvey, Robert Haller, Cathy Henderson, Richard F. Holmes, Antonio Homem, Paige Kennedy-Piehl, Barbara Kratchman, Arunas Kulikauskas, Daniel Kunitz, Robin Lydenberg, Russell Maylone, Gillian McCain, Marguerite J. McDonough, Leslie A. Morris, Tibor de Nagy, Jeanne Newlin, Rieko Omura, Kristin A. Peterson, John Rexine, Stephanie Rosenfeld, Ann Sass, Linda Shearer, Elliott Shore, Marvin Taylor, Barbara Tucker, Marcia Tucker, Stephen E. Vedder, Frank Walker, Faith Ward, Shizuko Watari, and John Yau.

Jane Palatini Bowers and Joanna E. Fink read and commented on the entire manuscript and provided support in myriad other ways. An anonymous reviewer gave me additional extremely useful advice for reshaping the introduction and conclusion. My manuscript benefited further from the fine editorial work of Jenni L. Fry at the University of Chicago Press.

I was fortunate to have received grants from various institutions; these afforded me time, library resources, and intellectual exchanges that were invaluable to my work. I accomplished much of my research in 1990–91 while Andrew W. Mellon Faculty Fellow in the Humanities at Harvard University. The members of the Department of Fine Arts at Harvard, and in particular John Shearman, who was then chair of that department, gave me the opportunity to test some of my ideas in a course I taught there as well as in a program at the Harvard Film Archive and in other, less structured settings. I also thank the students who participated in the course for their feedback and energy, and the staff of the Harvard Film Archive for its help with the film program. I later taught variations of the course at Boston College, and the same thank you goes to the students in those classes.

I formulated the first chapter of this book as a participant in a National Endowment for the Humanities Summer Seminar for College Teachers directed by Richard Wendorf at Harvard in the summer of 1992, entitled "Portraiture: Biography, Portrait Painting, and the Representation of Historical Character." The stimulating seminar readings and discussions, along with individual conversations with members of the group, contributed in important ways to my work. In more tangible terms, the seminar led to the publication of an earlier version of chapter 1 in the *Harvard Library Bulletin,* for which I am grateful to Dr. Wendorf.

Financial support for studying the photographic work of Fred W. McDarrah was provided by a Research Expense Grant from Boston College.

I tended to the final detail work of acquiring photographs and permissions while launching a new project as a member and National Endowment

for the Humanities Fellow at the Institute for Advanced Study in Princeton, N.J., in 1995–96. I feel confident in saying that it would be difficult to encounter an environment more conducive to scholarly happiness, so supportive were the staff, faculty, and fellow members. I thank them all, and especially Irving Lavin for making my stay at the Institute possible.

For their ongoing support, special thanks also go to my editor Kiki Wilson and to Jonathan and Sandra Brown, Jason Drucker, María Fernández, Lia Gangitano, Carol Hurd Green, Joanne Lukitsh, Robert Rosenblum, and, above all, to my family.

Acknowledgments

A long-held and early established commonplace about Andy Warhol is that he and his art lack personal, emotional significance. Warhol himself contributed to this viewpoint through what he said—or did not say—about his work. Yet only a bit of probing beyond the accepted viewpoint shows that such a viewpoint, while not entirely false, is rather incomplete. The present study of the artist's relations with poets brings to light the personal facet of his art by showing that he used his art to communicate with people he knew. This is a facet of Warhol that his detractors may well prefer not to see, as it removes a key piece of evidence in their criticisms of him as well as of his creations.

In a recent instance of this kind of attack, the label "depersonalization" is afixed to the activities of Warhol, who, it is claimed, "took perverse pleasure in feeling nothing for others."[1] However, the work that Warhol made both for and in response to his friends and acquaintances—several examples of which are contained in the chapters that follow—reveals that he actually had strong feelings for the people around him. He expressed these feelings through his art, as the particular social contexts of its production and initial reception that I detail in this study demonstrate.

It is likely that many—and certain that some—of my readers will be puzzled at first by my focus on Warhol and poets. What could the connections possibly be? they will undoubtedly be asking themselves, and with good reason. For contained within the conception of Warhol as impersonal is another, equally skewed one, which is that he did not read. This conception, too, emerged fairly early in the artist's career as a fine artist. It is, for example, one reason for his exclusion from certain kinds of projects dating to the 1960s.

One such project was the fall 1965 *Art in America* magazine special feature entitled "Painters and Poets." For this feature, the writer Francine du Plessix had asked each of twenty-two American painters to produce a visual interpretation of one of his or her favorite poems. Each work was then published in the magazine alongside the chosen poem.[2] The existence of this project illustrates the prevalence of linking up the two arts at the time. In addition, who was included and who was omitted from the project reveals a great deal about

the social structure then in place among poets and visual artists. Warhol was not perceived as fitting into this structure and therefore was not invited to participate in "Painters and Poets."

The perception, however, was false. By 1965, Warhol had in fact collaborated with poets on a wide range of projects. Many of these collaborations, a selection of which I discuss in the chapters that follow, were published in the underground press or were connected to Warhol's filmmaking activities. But since they did not fall within the parameters of the mainstream art institutions, they went unnoticed.

Still, the out-of-the-way venues of these collaborations do not adequately explain the situation, since on occasion Warhol did contribute to collaborative projects that fell comfortably into the mainstream of art-making activities. For instance, he designed a print (fig. 1) for a 1964 portfolio of litho-

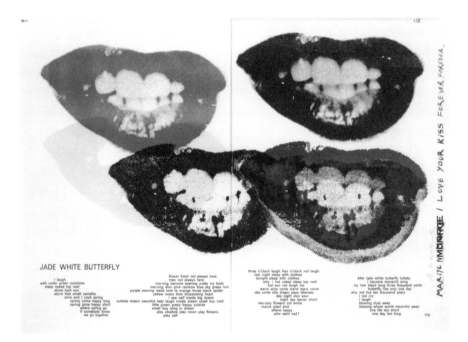

Fig. 1. Andy Warhol, *Marilyn Monroe I Love Your Kiss Forever Forever* (double page headpiece, pages 112 and 113) from the portfolio *1¢ Life* by Walasse Ting (Bern, Switzerland: E. W. Kornfeld, 1964). Lithograph, printed in color, composition: 11⅝ × 21¼" (29.5 × 54 cm). The Museum of Modern Art, New York. Gift of the author, Walasse Ting, the editor, Sam Francis, and the publisher, E. W. Kornfeld. © 1997 Andy Warhol Foundation for the Visual Arts / Artists Rights Society (ARS), NY. Photograph © 1997 The Museum of Modern Art, New York.

graphs entitled *1¢ Life*, which included imagery by twenty-eight visual artists and was produced expressly to accompany poems by the painter and writer Walasse Ting. Warhol's print accompanied those of artists such as Joan Mitchell and Alfred Leslie, who, unlike Warhol, were known for their collaborations with poets.

To understand why this and other of Warhol's literary-related activities have been all but invisible we need to turn to his image, as I have already suggested. To be sure, Warhol's own behavior contributed to this image. His seemingly unserious and anti-intellectual demeanor and his avoidance during the 1960s of talking about subjects like poetry, either in interviews or with friends and collaborators, made him seem singularly unliterary. Even poets whom he knew well recalled a Warhol who was "monosyllabic" or who "hated poetry and had no connection to it whatsoever."[3]

The view of Warhol as lacking an interest in and knowledge of the verbal arts remains strong today despite all the evidence to the contrary. For example, Warhol owned hundreds of books. Ted Carey, with whom Warhol was close in the late 1950s, recalled that Warhol "used to spend a lot of money buying books."[4] Ample proof of this statement is found in the catalog accompanying the auction of his belongings that was held shortly after his death.[5]

Only a few critics of Warhol's work have acknowledged his interest in books. One of them is Stephen Koch, who in his 1973 study of Warhol's films observed parenthetically that "contrary to the myth he propagates, Warhol is quite widely read."[6] Koch did not, however, bring this observation to bear on his analysis of Warhol's work.

More recently, the writer Phyllis Rose has proposed that Warhol should be taken seriously as a writer himself. She has argued that his books—*The Philosophy of Andy Warhol* (1975), *POPism* (1980), and *The Andy Warhol Diaries* (1989)—should be considered substantial contributions to literature, that they reveal a literary sensibility in the tradition of Walt Whitman and Gertrude Stein and in this regard form a counterpart to Warhol's paintings, which Rose likewise views as being fundamentally literary.[7] Rose accurately saw that Warhol, as she put it, "understood the literary imagination."[8] One of my aims in this study is to show the extensive presence of that imagination in his paintings, prints, and films.

If the omission of Warhol from the 1965 *Art in America* "Painters and Poets" feature reflected the widely held view that Warhol lacked a literary sensibility, it also revealed that he was not a member of the prevailing painter-poet artistic circle, even though, as will become evident in chapter 1, he cer-

3

tainly aspired to be one. In an editorial statement that served to introduce "Painters and Poets," Francine du Plessix observed that in almost every case the artist chose to illustrate a poem that was by someone with whom he or she was connected through either friendship or family bonds.[9]

Three artists had wanted to illustrate poems by Frank O'Hara, du Plessix noted, adding that this was because O'Hara was more a part of the painting world than other poets of his generation.[10] O'Hara disliked Warhol—a sentiment I discuss in chapter 1—and it is likely that this animosity in large part explains why Warhol did not figure in the painter-poet world represented in the *Art in America* project.

Du Plessix's point that the artists almost invariably chose to illustrate poetry written by people they knew is extremely important. For the history of painter-poet relationships in post–World War II New York, like the history of those relationships in both Europe and the United States before the War— notably among the cubists, dadaists, and surrealists—was a history of groups in which personal affiliations were central. The formation of interartistic groups in New York during the early 1960s has been foregrounded by Sally Banes in a recent study in which she characterizes these groups as "communities."[11] In the present volume, I outline Warhol's affiliations with some of the communities Banes has covered and some additional ones. Unlike Banes, I am interested in direct, personal interactions between members of communities, as those interactions manifested themselves artistically. Thus my study is neither about social relations solely nor about art solely, but about the points at which the two converge. It is my belief that often we can obtain the fullest understanding of artistic creation precisely by looking at such intersection points.

Artists and writers have been portrayed in groups at least since the second half of the nineteenth century. Two famous photographs of such groups were published in *Life* magazine around 1950, just prior to the beginning of my story: one is of writers and was taken at the Gotham Book Mart when the British poet Edith Sitwell visited New York in 1948 (fig. 2); the other is of the abstract expressionist painters and was taken two years later (fig. 3).[12] An underlying message of both photographs is that art is something which occurs within communities rather than in isolation. This message resounded in the lively social networks of artists that emerged in the 1960s.

A significant difference between the two *Life* photographs is that the one of the abstract expressionists represents a world almost exclusively of hetero-

4

THE POETS GATHER

For many years the Sitwells' writing was looked on as brilliant but not profound. But in the past few years critics and other poets, many of whom gathered around the Sitwells in New York (*below*), have come to believe that Edith is now a major poet. This change of opinion came with a change in Edith's own writing. During and since the war her work has taken on depth, soberness and an intense, almost grieving understanding of the conflicts and sufferings of mankind. *Heart and Mind* (*below*), possibly her most popular poem, bespeaks the irreconcilable conflict between the golden lionlike heart and the cold moonlike mind.

HEART AND MIND

Said the Lion to the Lioness—'When you are amber dust,—
No more a raging fire like the heat of the Sun
(No liking but all lust)—
Remember still the flowering of the amber blood and bone
The rippling of bright muscles like a sea,
Remember the rose-prickles of bright paws
Though we shall mate no more
Till the fire of that sun the heart and the moon-cold bone are one.'

Said the Skeleton lying upon the sands of Time—
The great gold planet that is the mourning heat of the Sun
Is greater than all gold, more powerful
Than the tawny body of a Lion that fire consumes
Like all that grows or leaps. . . . so is the heart
More powerful than all dust. Once I was Hercules
Or Samson, strong as the pillars of the seas:
But the flames of the heart consumed me, and the mind
Is but a foolish wind.'

Said the Sun to the Moon—'When you are but a lonely white crone,
And I, a dead King in my golden armour somewhere in a dark wood,
Remember only this of our hopeless love
That never till Time is done
Will the fire of the heart and the fire of the mind be one.'

COPYRIGHT, VIEW MAGAZINE

WEARING TIBETAN BRACELETS AND CAPE, EDITH RECITES IN TOWN HALL

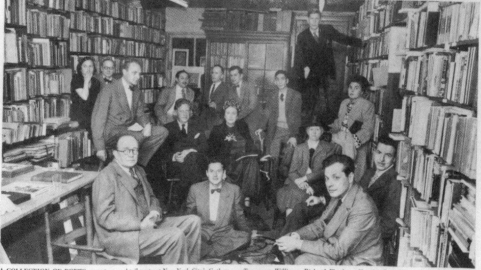

A COLLECTION OF POETS came to a cocktail party at New York City's Gotham Book Mart to pay homage to the visiting Sitwells. Left foreground: William Rose Benét. Behind him: Stephen Spender. Behind him: Horace Gregory and his wife, Marya Zaturenska. Behind the seated Sitwells are (*left to right*) Playwright-Poet Tennessee Williams, Richard Eberhart, Novelist-Poet Gore Vidal and José Garcia Villa. On the ladder is W. H. Auden. Standing against the bookcase (*right*): Elizabeth Bishop. Seated in front of her is Marianne Moore. Seated at the right: Randall Jarrell (with mustache), Delmore Schwartz. On the floor (*center*): Charles Henri Ford.

CONTINUED ON NEXT PAGE

Fig. 2. Page from the article "The Poets Gather," *Life,* 6 December 1948. Photographs by Lisa Larsen. © Time Inc.

Introduction

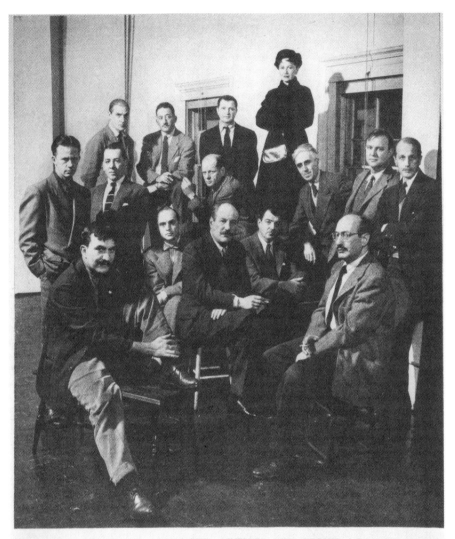

IRASCIBLE GROUP OF ADVANCED ARTISTS LED FIGHT AGAINST SHOW

The solemn people above, along with three others, made up the group of "irascible" artists who raised the biggest fuss about the Metropolitan's competition (*following pages*). All representatives of advanced art, they paint in styles which vary from the dribblings of Pollock (LIFE, Aug. 8, 1949) to the Cyclopean phantoms of Baziotes, and all have distrusted the museum since its director likened them to "flat-chested" pelicans "strutting upon the intellectual wastelands."

From left, rear, they are: Willem de Kooning, Adolph Gottlieb, Ad Reinhardt, Hedda Sterne; (next row) Richard Pousette-Dart, William Baziotes, Jimmy Ernst (with bow tie), Jackson Pollock (in striped jacket), James Brooks, Clyfford Still (leaning on knee), Robert Motherwell, Bradley Walker Tomlin; (in foreground) Theodoros Stamos (on bench), Barnett Newman (on stool), Mark Rothko (with glasses). Their revolt and subsequent boycott of the

show was in keeping with an old tradition among avant-garde artists. French painters in 1874 rebelled against their official juries and held the first impressionist exhibition. U.S. artists in 1908 broke with the National Academy jury to launch the famous Ashcan School. The effect of the revolt of the "irascibles" remains to be seen, but it did appear to have needled the Metropolitan's juries into turning more than half the show into a free-for-all of modern art.

Fig. 3. "Irascible Group of Advanced Artists Led Fight against Show," *Life,* 15 January 1951. Photograph by Nina Leen. © Time Inc.

Introduction

sexual men who by and large believed that the media and fame were detrimental to the cause of art, while the photo of the writers represents a largely homosexual world in which a woman was the star and also was someone who basked in the media limelight. It was the latter group with which Warhol identified. In the literary world, it was somewhat more acceptable during the late 1940s and the 1950s to be either homosexual or a woman (among one's peers, at least) than it was in the visual art world.[13] Indeed, Warhol saved the page of *Life* with the Sitwell entourage photograph. He seems to have been a great fan of Sitwell, for he liked to listen to a recording of the poet reading her book *Facade* accompanied by the music of William Walton.[14]

It will become evident in the course of this study that the writings that appealed to Warhol and to the many poets with whom he interacted were largely by homosexual writers, with a lineage that can be traced from Walt Whitman, Oscar Wilde, and Marcel Proust to Gertrude Stein, Jean Cocteau, and Jean Genet.[15] However, it would be wrong to conclude that Warhol's interactions with poets were based on sexual affiliation alone. Even when the focus of the interactions was on identity itself—particularly identity as connected to the use of appropriation, which I discuss at length in chapter 4—the poets involved were of every possible sexual orientation. By the same token, it is important to keep in mind that specifically homoerotic themes—as found in Warhol's work and generally—carry numerous meanings that are accessible not only to homosexuals. As Gregory Woods put it in his study of male homoeroticism and modern poetry, these themes "exist within a context of others, and their meanings are open to the common reader, straight or gay or neither."[16]

Warhol's artistic interactions with poets do tend to have one thing in common: they function as pieces of conversations. The filmmaker Paul Morrissey hit on a key aspect of Warhol's work in all media when he described Warhol's early movies as traceable to the epistolary novel: "Basically, Andy's always felt his films are an extension of home movies, you know, a record of friends, either a record of your family or a record of your friends or a record of your travels. It goes back to the epistolatory [*sic*] novel which was the first novel, letters back and forth between friends."[17] As I show in the chapters that follow, Warhol's work often served as a means by which he not only recorded the people around him but communicated with them, and they in turn communicated with him in their own work.

*

Warhol's creation of artistic dialogues with poets during the 1960s was a continuation of his practices of the previous decade when he was a highly successful commercial artist. Among the collaborative books and portfolios that he made at the time as gifts for his friends and clients was *A la recherche du shoe perdu* of 1955, for which the poet Ralph Pomeroy wrote captions to accompany Warhol's shoe drawings (figs. 4 and 5). To judge from a portrait that Warhol drew of Pomeroy around the same time, which is ornamented with a heart, the collaboration had a romantic dimension to it (fig. 6).

A personal reference was, moreover, embedded in the title of the portfolio, which is an obvious play on Marcel Proust's famous work *Remembrance of Things Past*. We learn that Pomeroy had linked himself to Proust (certainly in part because Proust, like Pomeroy, was homosexual) in the biographical sketch appearing on the back cover of Pomeroy's 1961 book of poems entitled *Stills and Movies*, where it is explained that "his name derives from the apple

Fig. 4. Andy Warhol, cover, *A la recherche du shoe perdu*, 1955. © 1997 Andy Warhol Foundation for the Visual Arts / Artists Rights Society (ARS), NY.

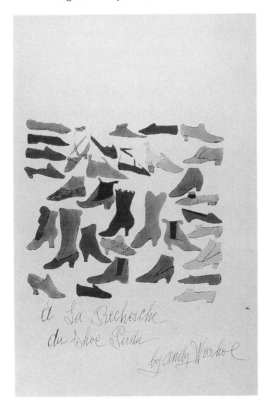

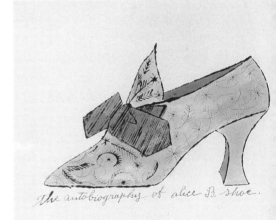

Fig. 5. Andy Warhol, *The Autobiography of Alice B. Shoe*, from the portfolio *A la recherche du shoe perdu*, 1955. © 1997 Andy Warhol Foundation for the Visual Arts / Artists Rights Society (ARS), NY. (Poetry by Ralph Pomeroy.)

Introduction

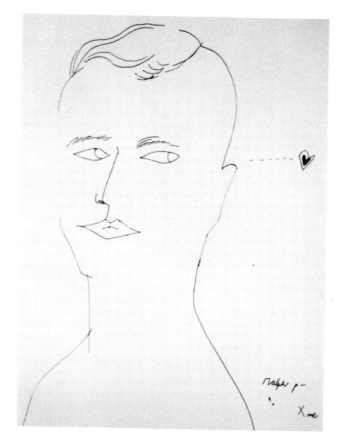

Fig. 6. Andy Warhol, *Ralph Pomeroy*, ca. 1955. Collection of Richard F. Holmes, Cape Town, South Africa. © 1997 Andy Warhol Foundation for the Visual Arts / Artists Rights Society (ARS), NY.

country of Normandy and appears—in its original spelling (de la Pomme-raie)—in the discussion of place names carried on by M. Brichot in 'Remembrance of Things Past.'"[18] Personal associations like the one embedded in the title *A la recherche du shoe perdu* would remain a central component of Warhol's interactions with poets in the following decade, as we shall soon see.

The relationship between image and word in Warhol's collaboration with Pomeroy and, later, in many of his collaborations with poets during the 1960s had its roots in his college training in commercial art. In courses taught by Robert Lepper at the Carnegie Institute, students were assigned to illustrate passages from novels and other kinds of books.[19] Warhol also designed, in 1948, a cover for the institute's student literary journal, *Cano;* it was the forerunner of his mimeograph journal covers discussed in the following chapters.

Relationships between image and text were, in addition, a fundamental component of the commercial art that he began to practice in 1949 when he graduated and moved to New York. A good example of this aspect of Warhol's

9

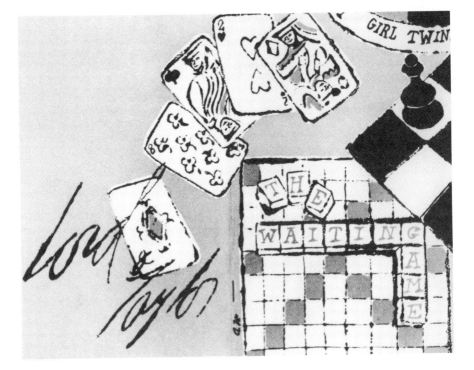

Fig. 7. Andy Warhol, *The Waiting Game,* promotional booklet for Lord & Taylor's maternity shop, ca. 1956. © 1997 Andy Warhol Foundation for the Visual Arts / Artists Rights Society (ARS), NY.

commercial work is a promotional piece for Lord & Taylor's maternity shop showing a game board in combination with the words "the waiting game" (fig. 7).

Warhol's first one-person exhibition, held in 1952 at the Hugo Gallery in midtown Manhattan, consisted of drawings based on the writings of Truman Capote. The drawings are thus an extension of the assignments he was given in Lepper's course.[20] Warhol's romantic obsession with Capote is a story that has been told many times. What I want to emphasize about the story is that, as with Pomeroy, Warhol used his art to make a personal connection with a writer.

Warhol was obsessed with Capote because Capote was a star and because he was a homosexual star. But another reason for his attraction to Capote was his sheer admiration for people who could write. He sought out people he believed had this gift, probably in large part because he felt he lacked it himself.[21] In his early years in New York, Warhol tried his hand at poetry, although

10

without much success. It is possible that he was the author of the poem "Blue Butterfly Day," which accompanies one of his 1950s designs and, like them, has a childlike sweetness (fig. 8, see also pl. 1). In any case, drawing and painting came much easier to him than writing poetry.

Warhol definitely did compose some poetry. Samples of it appear in an evidently amorous correspondence that he conducted in 1951 with Tommy Jackson, a printer at Black Mountain College in North Carolina (an important center for interartistic exchange during the late 1940s and early 1950s). Postcards that Jackson and Warhol wrote to each other at times took the form of little poems. On one postcard Jackson wrote simply (and in the manner of Gertrude Stein), "its snowing; its snowing."[22] On another postcard Warhol wrote to Jackson, "he brings me one rose and i bring him three."[23] Years later,

Fig. 8. Andy Warhol, *Blue Butterfly Day*, ca. 1955. Collection of WATARI-UM, The Watari Museum of Contemporary Art, Tokyo. © 1997 Andy Warhol Foundation for the Visual Arts / Artists Rights Society (ARS), NY. Photograph courtesy of WATARI-UM.

Warhol still wrote poetry on occasion. A passage of his book *The Philosophy of Andy Warhol* is written as a poem entitled "About Time"; it has the same self-consciously childlike sweetness as does his poetry of the 1950s.[24]

Some of the communications between Warhol and the poets with whom he interacted in the 1960s took the form of poetry that was meant to be a verbal counterpart to Warhol's art. In the field of literary studies this kind of poetry goes by the Greek term *ekphrasis*.[25] Although I will look at *ekphrastic* poems, especially in chapters 3 and 4, my aim is to show that these poems were produced not solely to create verbal representations of the content and/or formal devices of Warhol's art, but also as a means of engaging in a conversation. Therefore, a semiotic or formalist approach to the relations between the art and poetry in question, such as the approach employed by Wendy Steiner in her study of relations between visual art and literature,[26] would be unsuitable to my topic because, with such an approach, the human element that was so central to the making of the work in question would be entirely lost. Among all the recent studies to consider relations between images and words, W. J. T. Mitchell's books *Iconology* and *Picture Theory* have more to offer if one wants to take into account how images and words connect among living beings who exist within particular kinds of social worlds.[27]

Just how fascinatingly elaborate Warhol's artistic dialogues with poets were is especially evident in chapter 4, which concerns verbal and visual appropriation. These particular dialogues of the early to mid-1960s were extraordinarily intellectually sophisticated. In them, Warhol together with Ted Berrigan, Gerard Malanga, and a few other poets raised all the questions regarding authorship that would soon be posed in now-famous and often-cited essays by Roland Barthes ("The Death of the Author," 1968) and Michel Foucault ("What Is an Author?," 1969), which were both published in English translation only in the late 1970s.[28]

Because my focus is on dialogue, and dialogue perforce means that there are at least two people speaking, I will discuss the work of the participants on all the sides of a given communication. Therefore, this study concerns not only Warhol but several other figures as well and, more broadly, the groups within which they interacted. I hope that this approach will make clear why Warhol's work, even when it is a form of gossip, is a serious human matter.

*

While Warhol was drawn to such highly associative images that there seems to exist an endless number of ways to interpret them, thereby effectively rendering a definitive interpretation impossible, my contextual approach to Warhol's production of art will show that he quite often emphasized certain meanings on the basis of such factors as who the work was made for or where it was going to be placed and when. In other words, he generated his own interpretations of his art as he moved it from one context to another.

Of course, an approach that relies on this kind of contextual consideration, like any approach, has limitations. In some instances the circumstances that led Warhol to focus on, say, a particular subject or technique, or that led a poet to compose in a certain way, are clear and easy to establish; in other instances, these circumstances of production are less clear, and the resulting analysis therefore involves a degree of speculation. I believe, however, that prudent speculation, even if it proves to be controversial, can open doors to ways of thinking about objects and events and people that otherwise might remain closed.

13

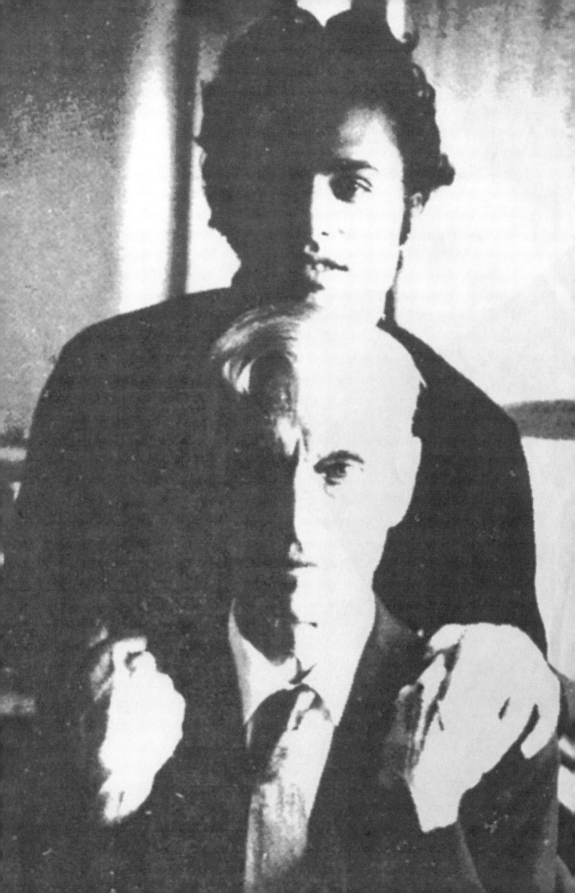

Portraiture, Poetry, and Gossip

Gossip," the literary critic Hugh Kenner observed, "thrives in all small communities, academic, cultural, professional, it thrives in neighborhoods, thrives wherever people subsist on each other's company, make do with each other's mysteries." [1] Gossip plays a large role in most of our lives. As anthropologists, psychologists, sociologists, literary critics, and fiction writers have pointed out in recent decades, gossip, though it tends to be denounced as "idle chatter," is often a powerful means of communication and of achieving specific aims. [2] The role gossip has played in shaping how art criticism and art history have come to be written, or even how some works of art come to look the way they do, remains largely unacknowledged, at least in print. And by being blind to the force of gossip in history, we often fail to see the fullness of relations between people that makes art a vital, human thing. It is this blindspot that I want to remove by looking first at the relationship between Andy Warhol and another figure of recent art history who, like Warhol, openly acknowledged the significance of gossip in his life and work: the poet, art critic, and curator Frank O'Hara.

John Giorno, a poet who by his own account had been involved personally with such artists as Jasper Johns, Robert Rauschenberg, and Andy Warhol during the 1960s—he was the "star" of Warhol's 1963 film *Sleep*—wrote a gossip column at the end of that decade entitled "Vitamin G." As he later explained:

The idea was that the poetry and art world incessantly talks about itself. . . .
Ordinarily it just seems like boring gossip, but it actually is the dynamic re-
lationships between artists, between artists and poets, the hardcore of art
history. . . . You have all these art critics, like Clement Greenberg and Barbara
Rose and David Bourdon and Peter Schjeldhal [sic], and they write this fic-
tion. Their art criticism creates the art or artist, which then becomes a com-
modity. . . . It's all so righteous. They only show you one side of the coin.
Whereas I think who's fucking who is where it's at. . . . And all the neurotic
pain between people, which has some effect on their work.[3]

The final line of Giorno's passage raises an important point: the social dynam-
ics of the art world is a potential subtext of art and art criticism; artists gossip,
and so does their work.

Giorno undoubtedly inherited his conception of gossip from a circle of
poets and painters of the previous generation. This group revolved around
the charismatic figure of Frank O'Hara. O'Hara collaborated with his friends
who were painters on some fascinating satirical writings in which art and
judgments about art were conceived of as rumor, hearsay, or gossip.

In an amusing dialogue published in 1959, "5 Participants in a Hearsay
Panel," O'Hara and the painters Norman Bluhm, Mike Goldberg, Elaine de
Kooning, and Joan Mitchell discussed the question, "Is style hearsay?" Each
participant responded to this question by offering not her or his own opin-
ion but the purported opinion of someone else—or hearsay. Here are a few
examples:

NORMAN: Frank says: Style at its lowest ebb is method. Style at its highest ebb is
personality.
ELAINE: Betsy says, In matters of art, it's Vanity and Vexation not virtue that
triumphs.[4]

In each of these replies, style is mockingly (but also seriously) associated with
human conduct—with the artist rather than the art.

The possibility that art itself might contain gossip was considered in a
collaborative essay written two years later by O'Hara and his close friend, the
painter Larry Rivers. This piece, "How to Proceed in the Arts," is a parodic set
of instructions for would-be artists. "When involved with abstractions," the
authors suggested, "refrain, as much as possible, from personal symbolism,
unless your point is gossip."[5]

O'Hara not only wrote satires about the role of gossip in artistic commu-

16

nities; gossip was central to his very conception of art criticism (as well as of poetry). It is clear that he saw an analogy—even a deep connection—between gossip (what he thought of someone) and aesthetic judgment (what he thought of someone's work). A good example of how O'Hara articulated this analogy in his poetry is found in "Personal Poem." Composed in 1959 and first published the following year, the poem records a discussion of the relative merits of two living and two dead American writers in which O'Hara was engaged with his friend, the poet Leroi Jones (aka Amiri Baraka), over lunch:

> we don't like Lionel Trilling
> we decide, we like Don Allen we don't like
> Henry James so much we like Herman Melville[6]

It is easy enough to read between the lines here that the two "like Don Allen," for instance, because Allen was a supporter of their work (which he included in his highly successful 1960 anthology, *The New American Poetry*).

O'Hara's poetry is filled with references to his relationships with his friends and to their relationships with each other. The poem "Adieu to Norman, Bon Jour to Joan and Jean-Paul" (1959) refers to aesthetic decisions in the first stanza—"wondering whether you are any good or not"—and to decisions regarding relationships with people in the next stanza:

> and Joe has a cold and is not coming to Kenneth's
> although he is coming to lunch with Norman
> I suspect he is making a distinction
> well, who isn't[7]

By juxtaposing distinctions of an aesthetic order with ones concerning people, O'Hara again equated the two.

The gossip in O'Hara's poetry has been pointed out in both negative and positive assessments of his work. The negative criticisms invariably focus on what is perceived to be the lack of seriousness of language such as gossip. Pearl K. Bell, in a review of O'Hara's *Collected Poems*, wrote that "one must endure huge trash-heaps of what he called his 'I do this, I do that' poems, full of campy gossip, silly jokes, travel notes, subway rides, newspaper headlines, movie stars, sentimentalized shadows of anxiety. Mainly, he drew upon his vast collection of celebrated friends, in an extended family album. . . . The names may glitter, but O'Hara's poems to and about them do not."[8]

On the other end of the spectrum are the writers who have recognized that O'Hara's gossip is serious. One of the earliest instances of this viewpoint

17

is found in a poem written by Allen Ginsberg for O'Hara shortly after his death, entitled "City Midnight Junk Strains" (1966), in which O'Hara is referred to as a "chatty prophet" with "a common ear / for our deep gossip."[9] Perhaps O'Hara's gossip is "deep" principally for the simple reason that he used it often and boldly in his poetry, and thereby acknowledged—even took for granted—that gossip *is* deep.

Aesthetic and personal likes and dislikes were intertwined in O'Hara's art criticism just as they were in his poetry. He felt a particular aversion to Andy Warhol, and to pop art generally, which in his mind went against the painterly, expressive work that he had supported for many years and that typified the stylistic inclinations of many of his painter friends. In a 1963 Art Chronicle, O'Hara's regular column at the time for the journal *Kulchur*, he came to the defense of a few abstract expressionists (Arshile Gorky, Robert Motherwell) and artists influenced by abstract expressionism (Al Held, Larry Rivers), who "are each involved in contemporary High Art which, gossip to the contrary, has never stopped being more exciting than pop art." Here, in as serious a piece of art criticism as O'Hara would write, he quite directly associated matters of taste with gossip. Later in this same Art Chronicle, he launched an exceedingly nasty (if diverting) attack on pop art that alluded above all to Warhol: "Some preconceptions in imagery stand still at their freshest (soup cans, newspaper pages, road signs), like a high school performance of *The Petrified Forest*."[10]

This acerbic judgment was not only a defense of abstract expressionism. O'Hara did have positive things to say about other pop artists.[11] His dislike of Warhol, then, cannot be attributed solely to Warhol's seemingly anti-expressionist painting methods, but operated on a personal level and apparently dated to the late 1950s, prior to the advent of pop art. John Giorno recalls that in the early 1960s Warhol had recounted to him a visit that Frank O'Hara made to Warhol's home around 1958 or 1959, where he "pointed a finger and started laughing at Andy. . . . The pain that I think Andy felt for Frank's ridicule started even back in whatever year that was . . . and carried through."[12] This story is similar to the better-known anecdotes regarding Jasper Johns's and Robert Rauschenberg's supposed rudeness to Warhol.[13] (It is possible that O'Hara's remarks were especially painful because Warhol had been attracted to the poet; many years later Warhol published a rather carefully delineated character sketch of O'Hara, comparing him to another writer to whom he had been attracted, Truman Capote.)[14]

One of the peculiarities of O'Hara's negative view of Warhol's work is that

it existed despite the numerous similarities between the content of his poetry and of Warhol's pop paintings. An extensive analysis could be made of the thematic connections that link O'Hara's glorification of the American vernacular in such poems as "The Day Lady Died" (1959) or "Having a Coke with You" (1960), to name but a few examples, to Warhol's celebration of the vernacular in such paintings as *Marilyn Diptych* and *Green Coca-Cola Bottles* (see figs. 48 and 74).[15]

Until recently, literary critics who have written about O'Hara's relationships with visual artists have for the most part viewed the connections between O'Hara's poetry and pop art as superficial and the connections between it and abstract expressionism as substantial. This opinion is based on a comparison of O'Hara's spontaneous writing process to abstract expressionist painting methods.[16] To concur with such an opinion, however, is to say that the content of O'Hara's poetry is insignificant. Yet nothing could be more inaccurate. It is as if the literary critics unknowingly perpetuated the personal biases and contradictions that O'Hara had expressed in, for one, the aforementioned 1963 Art Chronicle column.

Warhol was not only aware of O'Hara's disdain for him, but was apparently also familiar with O'Hara's conception of art criticism as rumor or gossip (gossip being one of Warhol's own favorite activities, as he liked to point out).[17] He seems to have deliberately mimicked the gossipy language of writings such as "5 Participants in a Hearsay Panel" in a few lines of his well-known 1963 interview for *ARTnews:* "I just heard a rumor that G. quit working, that she's given up art altogether. And everyone is saying how awful it is that A. gave up his style and is doing it in a different way."[18] Later in the same interview, Warhol stated that style itself was not terribly important; the sheer force of content, such as the eroticism of Jean Genet's writing, seemed more potent than style.[19] And it is exactly this power of the image—the product of an effective combination of subject matter *and* style—that Warhol would use to get back at O'Hara for his cruel treatment of Warhol. Moreover, when Warhol took O'Hara on, he did so in the poet's own terms: through the use of gossip.

Warhol's piece of visual gossip took the form of two double portraits of the poets Edwin Denby and Gerard Malanga in which a relationship between them is implied by their poses. In the first portrait, Malanga stands behind the seated Denby and holds Denby's hands (fig. 9); in the second portrait, he leans over to kiss Denby (fig. 10). These two images, in effect, served to spread a rumor that Denby was in some way intimately involved with Malanga. Why

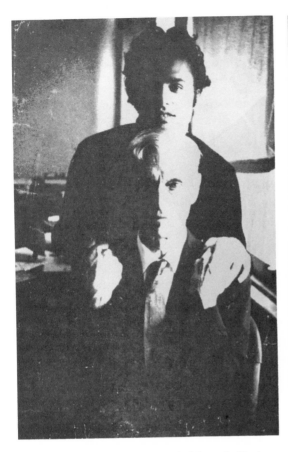 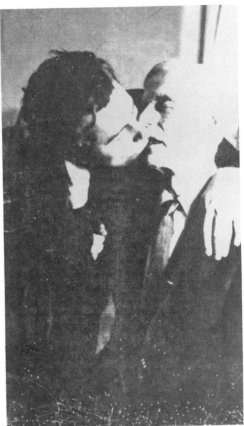

Fig. 9. Andy Warhol, front cover, *C: A Journal of Poetry* 1 (September 1963). Private collection. © 1997 Andy Warhol Foundation for the Visual Arts / Artists Rights Society (ARS), NY. Photograph © Archives Malanga.

Fig. 10. Andy Warhol, back cover, *C: A Journal of Poetry* 1 (September 1963). Private collection. © 1997 Andy Warhol Foundation for the Visual Arts / Artists Rights Society (ARS), NY. Photograph © Archives Malanga.

such a rumor might have been meant, among other things, to provoke Frank O'Hara will become clear with the knowledge, first, of what Denby and Malanga each meant to O'Hara, and then, of the circumstances surrounding the production of Warhol's two portraits.

As a poet, dance critic, and friend of the abstract expressionist painter Willem de Kooning, Edwin Denby—a soft-spoken man with a cultivated demeanor and striking physical presence—was a living legend to a circle of young poets, commonly known as The New York School, that developed into a tight-knit artistic and social community during the early 1950s. The writer and composer John Gruen, an active participant in this group, has reminisced: "Edwin Denby was our private celebrity and intellectual leader. Frank

O'Hara, John Ashbery, Jimmy Schuyler, and the rest of the young poets we knew clustered about him to discuss Balanchine's latest ballets, Bill de Kooning's latest show, or a John Cage concert."[20] Denby himself recalled that, among his younger poet friends, he became especially close to Frank O'Hara.[21]

Whereas Denby was around a generation older than O'Hara, Gerard Malanga was a generation younger than O'Hara. Malanga, like Denby, was physically striking; however, if Denby represented a model of gentility and urbanity, Malanga represented one of crudity and sexual indiscretion.[22] And Malanga's association with Warhol—who had hired him as his silkscreening assistant in late spring of 1963—would have served to confirm O'Hara's low opinion of the young poet. It is easy to see why an image of Malanga kissing Denby would have displeased O'Hara.[23]

Warhol's two pictures of Denby and Malanga were specially made as the cover design for an issue of *C: A Journal of Poetry* devoted to the poetry of Denby. The circumstances of their production, which can be documented in some detail, reveal that Warhol made an associative link between this journal and O'Hara. The editor of *C*, a mimeographed publication, was the poet Ted Berrigan, who, shortly after moving to New York in the winter of 1960–61, became an enthusiastic follower of the New York School poets and a supporter of young poets whose work interested him. He was a zealous fan of both O'Hara's and Warhol's work.[24]

Berrigan met Warhol at a poetry reading given by O'Hara in late July 1963.[25] At either this reading or one of the following year, Warhol made a film of O'Hara. The footage, two or three 100-foot reels of silent black-and-white film, was never screened (and according to Malanga, it "disappeared into Andy's apartment. . . . Frank didn't take Andy seriously, so this was Andy's way of getting back at Frank").[26] In any event, it was Warhol's introduction to Berrigan at the O'Hara reading that led Warhol to design his cover for *C*. A few days later, on 1 August, Berrigan sent the artist a couple of issues of *C* along with a letter, the content of which reveals Berrigan's desire to interest Warhol in his publication:

> Dear Andy
> Gerry Malanga asked me to send you a copy of my
> magazine, so here's a copy of issues # 1 and 2. Number 3
> with Gerry's poem will be out next week, and I'll send you a
> copy then.[27]

21

Joe Brainard, whose writing appears in 1 and 2 is

a painter, and is doing a cover for # 3.

Hope you like the

magazine.

Sincerely,

Ted Berrigan[28]

According to a few entries in Berrigan's diary of the following days, "Andy Warhol said he liked the magazine," and "Andy Warhol said he'd like to do a cover for *C* 4."[29]

Warhol knew that this issue of *C* was to consist of writings by and about Edwin Denby. Apparently he was provided with a handwritten draft of the table of contents, which listed two pieces by Frank O'Hara: an essay on Denby's poetry, and the poem "Edwin's Hand."[30] In other words, Warhol was keenly aware of the artistic and social world into which he had inserted himself by having agreed to design a cover for the Denby issue of *C*.

To produce this design, Warhol went to Denby's apartment, accompanied by Malanga, and he spontaneously but strategically shot a series of double portraits of Denby and Malanga, using a Polaroid camera and black-and-white film. From these photographs, he selected—again, strategically—two pictures for the *C* cover, which were then transferred to silkscreen in order to be printed onto the cover stock.

Regarding technique, these portraits occupy a significant position in Warhol's oeuvre. Therefore, I shall digress briefly to locate their place in Warhol's development as an artist. This is the first-known instance in which Warhol used Polaroids for silkscreen portraits, a practice he did not pursue at the time but one to which he would return and which would become his standard procedure for making portraits, beginning in 1970. Even his editorial approach to the *C* portraits—thoughtfully selecting a few photographs out of several he had shot—would become a customary step in his production of the later Polaroid portraits.[31]

A comparison of five rejected Polaroids from the Denby and Malanga sitting to the two images he chose to use for the *C* cover reveals that Warhol selected for the cover those images that were most legible, most centered compositionally, and that would set up a clear narrative which moved from a formal portrait on the front cover—a witty homosexual parody of conventional portrayals of husbands and wives[32]—to an intimate exchange on the back cover.[33]

22

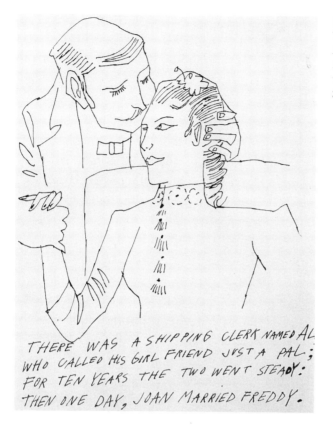

THERE WAS A SHIPPING CLERK NAMED AL
WHO CALLED HIS GIRL FRIEND JUST A PAL;
FOR TEN YEARS THE TWO WENT STEADY:
THEN ONE DAY, JOAN MARRIED FREDDY.

Warhol's deployment of the kiss scene on the back cover of *C* carries a few intriguing connotations. On the one hand, Warhol playfully associated the necrophilia evoked by this image—Denby's wan complexion was exaggerated to the point of being ghostlike due to the high contrasts of the Polaroid, and was still further pronounced when the image was transferred to silkscreen—with its placement at the end of the volume.[34]

The positioning of this scene on the back cover, on the other hand, served to signal that the act pictured here of two men kissing was, in terms of the social codes of the time, a secretive encounter, which Warhol then exposed; it is hidden, and we discover it only upon reaching the end of the volume.[35] But this "secret" was constructed by Warhol rather than simply having been an encounter he happened to record. Malanga has recalled unhesitatingly that for this photograph Warhol specifically instructed him to bend over and kiss Denby,[36] a pose curiously resembling that of a man and a woman in one of Warhol's collaborative litho-offset compendiums of the 1950s, *Love Is a Pink Cake* (fig. 11), in which the text beneath the image in at least one impres-

23

sion transforms it into a whimsical reference to homosexuality, as "Joan" is crossed out and replaced with "Al."[37] In his more visually blatant homosexual design for the cover of *C*, Warhol deliberately set out to produce a rumor about Denby's relationship with Malanga.[38]

It can be said that through the creation of this rumor Warhol played up the stereotype of the homosexual as a gossip, just as O'Hara had done in his poetry, as various critics, and most cogently Bruce Boone, have observed.[39] O'Hara would not have recognized the parallel, but nonetheless both his and Warhol's transpositions of gossip from the private realm of an exchange between two people to the public realm of art provoked the audience to confront the stereotype, and so created a good deal of discomfort among its members.[40]

Ted Berrigan noted in his diary during the first few weeks of December 1963, nearly two months after the Denby issue of *C* was published, that "*C* is a big success, although everyone (except me) hated Andy's cover for the E. D. issue. Hmmmm!"[41] Berrigan did not explain why "everyone"—undoubtedly a reference to the poets whose opinions mattered to him, and probably to O'Hara, who had just returned from a trip to Europe[42]—disliked this cover. Gerard Malanga's oral account provides more detail: "That picture caused a scandal . . . amongst the New York School literati. . . . There were people in the circle that felt that Andy was taking advantage of an old man." The one poet Malanga named as having felt this way was Frank O'Hara.[43] It is conceivable that Malanga himself was also accused of having "taken advantage of an old man," but in any case, what is interesting here is that Malanga's story concerns the reception of the scene pictured, rather than how it looked in aesthetic terms. Warhol used the portrait's potential to affect viewers because of *what* it depicted.

Warhol's construction of an amorous relationship between Denby and Malanga was in all likelihood his way of getting back at O'Hara for having been so unfriendly to him. Warhol's awareness of the structure of O'Hara's social world meant that he knew of O'Hara's affection for Denby and lack of affection for Malanga, and also that O'Hara would see his cover for *C*. As the social anthropologist Max Gluckman put it in his often-cited essay "Gossip and Scandal," "a most important part of gaining membership of any group is to learn its scandals."[44] This, Warhol did. His aim seems to have been rather directed. (His behavior was similar to that of a painter named Ctesicles, who, in a story told by Pliny the Elder in the *Natural History*, took revenge on Queen Stratonice by painting her in the arms of a fisherman and then exhibiting this

picture in public. In Warhol's portraits, Malanga operated somewhat like the fisherman in Ctesicles' painting.)[45]

Meanwhile, Malanga had his own motivations for wanting to be included on the cover of the Denby issue of *C*. He had submitted a poem to Berrigan expressly for this issue of the journal and was disappointed when Berrigan rejected it.[46] By being pictured on the cover, Malanga was able to have a place—indeed, an extremely prominent one—in the Denby issue of *C*.

For Warhol, the *C* cover served multiple purposes. Aside from provoking O'Hara, it was a way for Warhol to insinuate himself into O'Hara's circle of poets when O'Hara himself would not allow the artist in. The *C* portraits intimated that Warhol had the "inside scoop" on Edwin Denby's personal relations. The fact that Warhol took the Polaroids for these portraits at Denby's apartment—Denby's personal space, that is—rather than, say, Warhol's studio (this was a few months before he moved into the space known as the Factory), can be understood as Warhol's way of providing visual evidence that he had gained a certain degree of intimacy with a venerated member of O'Hara's group. Scholars of gossip have pointed out that one motivation for gossip is "a desire to be one of the in-group," or to demonstrate membership in such a group.[47] The *C* portraits of Denby and Malanga functioned like such verbal gossip.

By associating himself with Denby, Warhol was also casting himself, art historically, as a descendant of one of the heroes of abstract expressionism, the painter Willem de Kooning: Denby now posed for Warhol, just as he had for de Kooning in the 1930s.[48]

Warhol had used a portrait of two men for the purpose of appearing to belong to O'Hara's social circle on a previous occasion. In 1960, Fairfield Porter, a member of this circle, painted a portrait of Warhol and his companion at the time, Ted Carey (fig. 12). Warhol would have been aware of Porter's numerous portraits, made during the 1950s, of friends, among which figured a depiction of O'Hara (1957; Toledo Museum of Art) and a double portrait of the poets John Ashbery and Jimmy Schuyler (fig. 13). While Porter had painted these earlier portraits because the sitters were his friends, he painted the portrait of Warhol and Carey as a commission from Warhol.[49] Nevertheless, for Warhol, this picture—like his own portrait of Denby and Malanga of a few years later—allowed him to become, if only symbolically, a member of the "in" social group.[50]

Both of these works figure in an intriguing typology of portraits of male couples. In a remarkable subset of this typology, to which Warhol's pictures

25

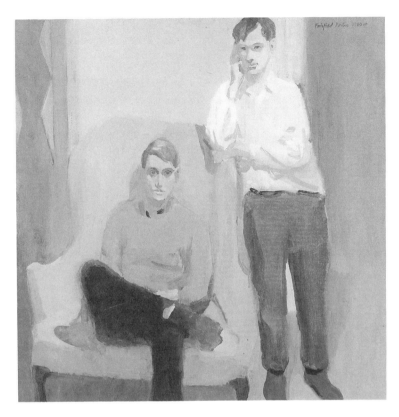

Fig. 12. Fairfield Porter, *Portrait of Ted Carey and Andy Warhol,* 1960. Oil on canvas, 40 × 40″ (101.6 × 101.6 cm). Collection of the Whitney Museum of American Art, New York. Gift of Andy Warhol, 74.117. Reproduced by permission of the Fairfield Porter Estate. Photograph © 1996 Whitney Museum of American Art.

Fig. 13. Fairfield Porter, *Jimmy and John,* 1957–58. Collection of Barbara and Michael Kratchman. Reproduced by permission of the Fairfield Porter Estate.

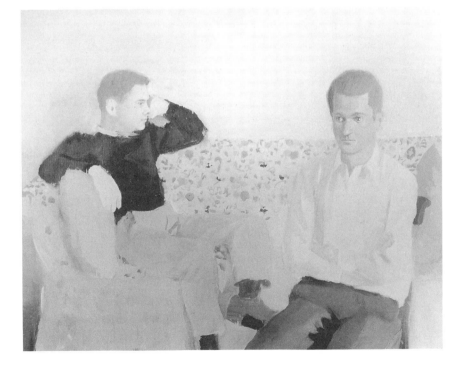

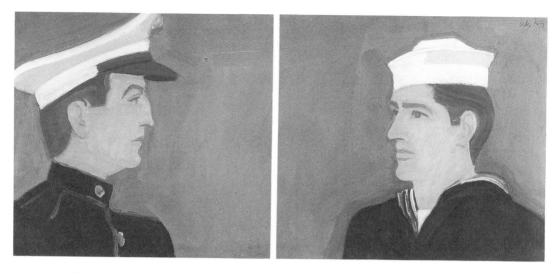

Fig. 14. Alex Katz, *Marine and Sailor*, 1961. Photograph courtesy
of Robert Miller Gallery, New York.

of Denby and Malanga belong, one man is considerably older than the other. These portraits record a social convention among homosexual men of the 1950s and early 1960s (which the "sexual revolution" of the mid-1960s eroded) whereby older men would at least appear to "keep" younger men. This kind of structured relationship is embedded in, for instance, a 1961 portrait by Alex Katz of Frank O'Hara at age thirty-five and the poet Bill Berkson at age twenty-two (fig. 14). The title of this painting, *Marine and Sailor*, humorously alludes to the conventional role of the younger man as protégé. This is not to say that O'Hara and Berkson were in actuality a couple, and according to Berkson they were not; the point rather is that the nature of their relationship was the subject of speculation, to which Katz's painting would potentially have contributed.[51]

During the early 1960s, Malanga often played the role of lover-protégé. Numerous photographic portraits picturing Malanga accompanied by an older man did not simply document but were an integral part of playing the role. Malanga posed with his poetry instructor from Wagner College, Willard Maas, and, at age twenty, with Andy Warhol, who was then around age thirty-five (fig. 15). The historically and socially particular type of relationship that such portraits encoded is well characterized in the following comments of Billy Name, who befriended Warhol in late 1963 and lived at the Factory from 1964 to 1969: "This was before the gay revolution. And it was the tail end of that Euro-culture where, in the arts world, older men would keep younger

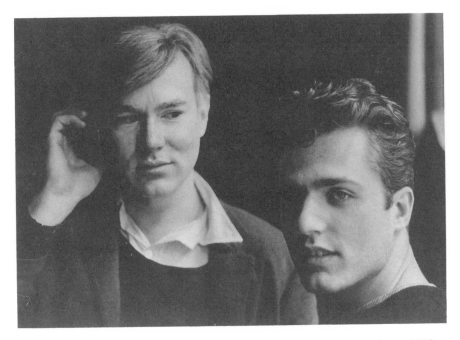

Fig. 15. Gerard Malanga with Andy Warhol the first day on the job at the Firehouse, NYC, June, 1963. Photo by Edward Wallowitch / Copyright the Estate of Edward Wallowitch / Courtesy of Gerard Malanga Collection.

boys and older women would keep younger girls. And they would sort of be like protégés. Well, Gerard was actually working for Andy when I came into the scene. . . . But he was also playing the role, when need be, of Andy's kept boy, which he wasn't, really." [52]

Speculation about the nature of Warhol's relationship with Malanga was commonplace at the time (and still is). [53] Photographs that showed the two side by side were undoubtedly important contributors to such speculation.

The double portrait format—whether used to depict two individuals of the same sex, or a woman and a man—lends itself to such social discourse. Various cases can be found, at diverse moments in history, of double portraits that provoked gossip. For example, on two separate occasions in the mid-1860s, the actress Adah Isaacs Menken posed with famous men for *carte de visite* photographs in ways that elicited public gossip about what precisely her relationship with each of the two men was (figs. 16 and 17). [54]

Warhol's cover design for *C* had a much smaller audience than did these *carte de visite* portraits, which were displayed in shop windows in Paris and London. The reception of Warhol's portraits of Denby and Malanga was virtually nonexistent within the mainstream art-publishing establishment. There are a few obvious explanations for the omission of these portraits from

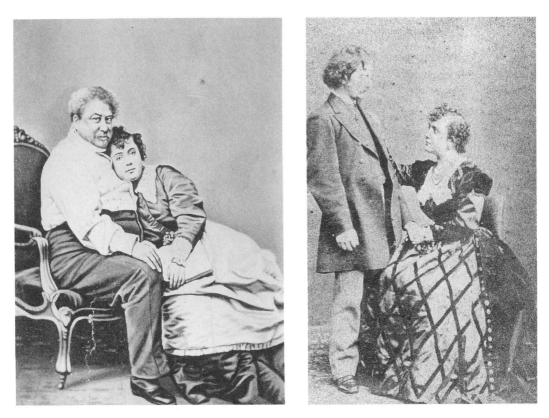

Fig. 16. (*above, left*) Alphonse Liébert, *Adah Isaacs Menken and Alexandre Dumas, père,* 1867. Harvard Theatre Collection, The Houghton Library.

Fig. 17. (*above, right*) *Adah Isaacs Menken and Algernon Swinburne* (photographer unidentified), late 1867 or early 1868. Harvard Theatre Collection, The Houghton Library.

the critical writing on Warhol that appeared during the 1960s: they dealt openly with the homosexuality of Denby, then a fairly well-known art world figure; and they were a journal cover rather than a work on canvas, thus having a rather low status in the hierarchy of what might be termed artistic venues.

The "unofficial" reception of the Denby and Malanga portraits among the young writers and artists who were involved in the production of the poetry journal *C,* by contrast, was lively and inventive. Like O'Hara's purported negative response to these images, the focus of this reception was on the sexual involvement that the portraits imply. (Put in the now-familiar terms of Walter Benjamin, this is an instance whereby the "cult value" of the photographic portrait was not replaced by its "exhibition value.")[55]

One fascinating form this reception took occurred during the very pro-

duction of Warhol's *C* cover. The portraits were silkscreened onto a few pillowcases, and the resulting witty association of these images with the bedroom takes the sexual intimation of the kiss scene a few steps further.[56] According to Malanga, Ted Berrigan produced these pillowcases. His recollection is that Warhol had given Berrigan the silkscreen for the *C* cover along with a can of paint, a squeegee, and instructions on how to print it; Warhol was unable to produce the cover himself, as he was at the time (September 1963) departing for Los Angeles to attend the opening of his second one-person exhibition there. Berrigan then took the liberty of using the silkscreen to print a few pillowcases[57] (a liberty in line with his own sensibility, as will become clear in chapter 4).

In another curious interpretation of Warhol's portraits, Berrigan's close friend Joe Brainard—who himself designed covers for some issues of *C*—drew and wrote on top of Warhol's cover on one copy of the journal (figs. 18 and 19). The poor quality of the silkscreening job on this particular cover, in which much detail has been lost, functioned for Brainard as a kind of blank upon which he could artistically project his own amusing and poignant narrative.

This narrative, like other responses to Warhol's pictures, concerned the relationship implied by Denby's and Malanga's poses. Brainard used arrows, for example, to call attention, on the front cover, to the fact that the two men are holding hands, and on the back cover, to the fact that they are kissing. Brainard's prose seems to be a kind of longing for romance: "BLUE MOON WITHOUT A LOVE OF MY OWN," taken from the lyrics of a well-known popular song, is printed neatly across Denby's lapel, and in a paragraph of script written sideways at the lower right he expresses his desire for love— with a man, as the concluding words, "he. he," playfully indicate. (The script on the back cover is Berrigan's handwriting and is his message to a woman friend named Chris; it belongs to a group of poems by Berrigan that include the words "dear Chris.")[58] Brainard's transformation of Warhol's images is an interesting mode of visual communication, a form of sign language that may have contained messages for a particular individual. In this regard, it functioned in a way similar to the Warhol images themselves, through which Warhol "spoke" to O'Hara.

In 1964, Warhol again responded to O'Hara's obloquy. In a cover design for the literary journal *Kulchur* (which, like the *C* cover, came about through his connection with Malanga),[59] Warhol put a still photograph made from his film *Kiss* (1963). The photograph featured French art critic Pierre Restany, an

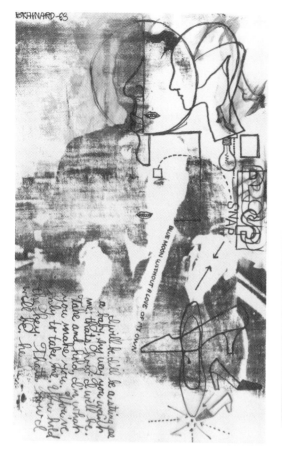
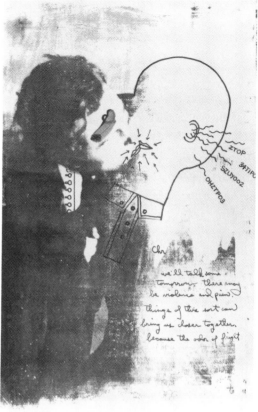

Fig. 18. (*above, left*) Ted Berrigan, Joe Brainard, and Andy Warhol, front cover, *C: A Journal of Poetry* 1 (September 1963). Ted Berrigan Papers, Rare Book and Manuscript Library, Columbia University. Reproduced by permission of the Estate of Ted Berrigan, Alice Notley, executor, and by the Estate of Joe Brainard.

Fig. 19. (*above, right*) Ted Berrigan, Joe Brainard, and Andy Warhol, back cover, *C: A Journal of Poetry* 1 (September 1963). Ted Berrigan Papers, Rare Book and Manuscript Library, Columbia University. Reproduced by permission of the Estate of Ted Berrigan, Alice Notley, executor, and by the Estate of Joe Brainard.

early supporter of pop art, kissing the experimental filmmaker and actress Naomi Levine (fig. 20). *Kulchur* was the very journal in which O'Hara's 1963 Art Chronicle article condemning Warhol's work had appeared. In fact, one of O'Hara's responsibilities as the art editor of *Kulchur* was to select the art for the cover of each issue. For the spring 1964 issue, however, Lita Hornick, the publisher of *Kulchur*, recalled that "Frank O'Hara had not come through with the cover he had promised, and I didn't dream that Frank and Andy were mortal enemies! The poets never told me any gossip. Alex Katz enlightened me when I was sitting for my portrait by him that spring."[60] As Hornick's words make clear, once again Warhol's image served to provoke O'Hara.

31

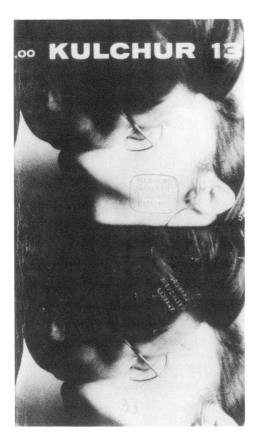

Fig. 20. Andy Warhol, *Kiss,* cover image of *Kulchur* 4 (spring 1964). © 1997 Andy Warhol Foundation for the Visual Arts / Artists Rights Society (ARS), NY. Photograph courtesy of the Harvard College Library.

In films such as *Kiss,* gossip is perhaps a more obvious component of the work than it is in silkscreen portraits such as the cover for *C.* One critic concluded an essay of 1966 on Warhol's work in film by asserting that "the places where Warhol's 'art' speaks its own voice—which is consequently a voice worth listening to—are the places where film and gossip, which for so long have bolstered and helped sustain each other in secret, mingle openly for the first time."[61]

This statement is also applicable to Warhol's silkscreen portraits. In his pictures of Denby and Malanga, art, poetry, and gossip—which similarly sustained each other—now "mingle openly." Warhol apparently even considered making a film of art-world gossip, which was listed among possible future Warhol films in an early 1965 issue of *The Nation: "An Open Letter to Barbara Rose* will show gossipy John Bernard Myers (Tibor de Nagy Gallery) gossiping for an hour and a half, by implication, to gossipy art critic Barbara Rose. (This would have to be a sound film.)"[62] But as the reception of Warhol's portraits of Denby and Malanga demonstrates, gossip need not include

32

sound. In the right context, visual imagery in itself can be a powerful agent of gossip.[63]

In addition, an awareness of the gossip embedded in the portraits of Denby and Malanga sharpens our sense of how highly personal Warhol's work in silkscreen could be. Some recent scholarship on Warhol has revealed autobiographical elements in his work from the 1960s that was formerly characterized as impersonal and emotionally detached.[64] Warhol's portraits for the cover of *C* show that his imagery was in some instances engaged in a direct and emotional dialogue with the artistic and literary worlds in which he operated. Other examples of visual gossip motivated by personal sentiments in Warhol's art are considered in the chapters that follow. But this analysis of the *C* portraits opens the way to other paths of inquiry, too, such as a reconsideration of the significance Warhol's output as a portrait painter, or a social history of the double portrait, to suggest but a few possibilities.

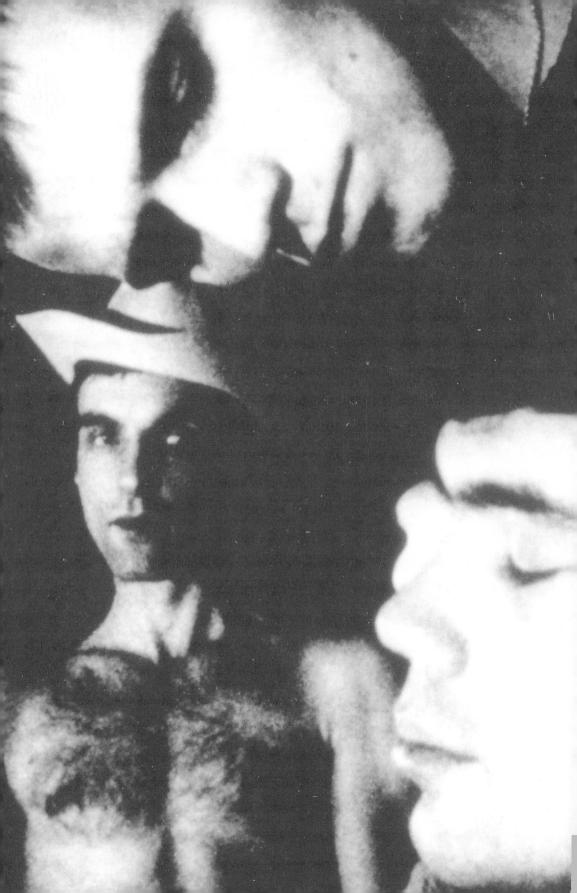

Andy Warhol at the Crossroads of Poetry and Visual Art: The Mimeograph Revolution

2

During the early to mid 1960s, a handful of mimeograph periodicals, including *C: A Journal of Poetry,* were circulating among interconnected groups of writers, visual artists, and filmmakers. Ted Berrigan, editor of *C,* later commented on the links between these publications and social relationships: "I like to know all the groups, because that way is the most fun, and the most interesting—I mean, that's how I know Jerry Rothenberg, for example; he had his own people . . . and that's how I knew Ed Sanders . . . and then there was myself and my friends. But then, after myself and my friends, there got to be groups, because there were a lot of people . . . because we had a magazine—that's how you get a group, I think, you start a magazine."[1]

The members of these loosely constructed groups knew each other's publications well. Often, an artistic dialogue that emerged in one publication—Warhol's *C* cover design, for instance—was picked up and developed in another. Even the advertisements these writers swapped to run in each other's publications occasionally figured in their dialogues. An announcement of the Edwin Denby issue of *C* that appeared in the mimeograph journal *The Floating Bear* highlighted what were thought to be the main selling points of the issue:

C: A Journal of Poetry. 4th issue - the poems of Edwin Denby, intro by Wieners, Edwin's Hand by Frank O'Hara. Each issue contains a different painting on the cover by Andy Warhol. 25¢ & 5¢ postage to Ted Berrigan, C, 360 East 9th St., NYC.²

In stating that the cover of each issue featured a painting by Warhol, Berrigan likely meant each copy of the Denby issue, since only the Denby issue contained a Warhol silkscreen on the cover. Berrigan's description foregrounded—and also replicated—the built-in paradox of Warhol's use of repetition in the silkscreen paintings; namely, that although each painting was of the same image and composition, the silkscreening process ensured that no two paintings were the same.³ Moreover, Berrigan probably had in mind the version of the Warhol cover that he and Brainard had altered (see figs. 18 and 19).

Another, related advertisement was for one of the pillowcases that Berrigan evidently made from the silkscreen for the Warhol *C* cover. The advertisement appeared in the 1964 underground mail-order catalog that the poet Ed Sanders produced. Sanders was the publisher of another mimeograph serial of the period, *Fuck You / A Magazine of the Arts,* and his mail-order catalogs served the readership of *Fuck You.* A clever example of his offbeat local entrepreneurship, Sanders's advertisement is amusingly lavish in its praise of Warhol and plays up the scandalous kiss scene and the uniqueness of its presence on a pillowcase, thereby providing a justification for the relatively high price of $100.00.⁴

Sanders's advertisement and the one in *Floating Bear* aimed to sell, but also to interpret, Warhol's portraits of Denby and Malanga. These interpretations expanded the dialogue Warhol had initiated upon producing the portraits so that it now encompassed a broader spectrum of the downtown New York visual art and poetry world.

Warhol reached out to this broader world through his own work in silkscreen and film, some of which seems to have been produced expressly in response to specific texts or themes found in *Floating Bear* and *Fuck You,* among other publications. The downtown mimeograph publication community operated in ways that facilitated the kinds of interartistic dialogues in which Warhol participated.

This community was a little world in which littler worlds, each repre-

sented by the magazine it produced, continually intersected. Everyone knew everyone else. Ted Berrigan recalled, "Ed Sanders and I spent a lot of time together. Like his bookstore was on the next street to the street I lived on in New York. I used to go over there every night. He was publishing *Fuck You* and I was publishing *C Magazine*. Between us we were publishing everybody in those magazines and we published each other and we published some of each other's heroes."[5]

Mimeograph publications were important conduits for the artistic and personal exchanges that occurred within and between literary cliques. The medium of the mimeograph was uniquely appropriate to such exchanges, because it served to get information out fast. As the writer Ron Loewinsohn has perceptively explained, "Of course there was a lot of cliquishness & schlock in these journals, but there was also a good deal of exciting writing. . . . But more important than the quality of their contents was the fact of these magazines' abundance & speed. Having them, we could see what we were doing, as it came, hot off the griddle. We could get instant response to what we'd written last week, & we could respond instantly to what the guy across town or across the country had written last month."[6] Indeed, if a writer submitted a poem to one of these publications, it would appear within weeks, not several months later as was typical of more established, typeset periodicals, such as *Paris Review* or even the avant-garde *Evergreen Review*, which relied on conventional networks for distribution.[7]

In the distribution of his early films, Warhol, like the mimeograph journal editors, released works to a selected public upon production. He eliminated much of the time lapse that usually occurs between filming and distribution because he was unencumbered by the extended editing and packaging that commercial film involves.[8]

Warhol's early films and the mimeograph journals often revealed details, at times exaggerated, of the personal lives of the people who either acted in the films or wrote for the journals. Often, in fact, the actors and the writers were one and the same. Moreover, these performers and authors, and their friends, constituted the principal audience of both the movies and the journals. To such an audience, the works contained levels of meaning that would not have been apparent to the general public.[9]

In addition, the viewing audience of Warhol's movies regularly overlapped with the readership of the mimeograph journals. The venues where the movies were commonly shown—Gramercy Arts Theater, New Bowery Theater, Washington Square Art Gallery, Film-Makers' Cinematheque, Ameri-

can Theatre for Poets—were frequented by this readership. Given such a setup, it makes perfect sense that some of Warhol's movies contributed to certain of the private dialogues that circulated in the mimeograph journals.

With this knowledge of the social structure of the mimeograph journal communities, we can now turn to specific instances in which Warhol participated in their artistic dialogues. An early example of this participation, Warhol's series of *Haircut* movies of late 1963 and early 1964[10] seems to relate directly to a prankish text about a haircut party which was published in the November 1963 issue of *Floating Bear* and entitled "Billy Linich's Party" (see appendix). Within the year, Linich (whom I will hereafter refer to by the surname Name, which he assumed in the mid-1960s) became a denizen of Warhol's Factory[11] after a falling out with *Floating Bear*'s editor, Diane di Prima. But in late 1963 and early 1964, he still worked regularly on the typing and miscellaneous other tasks connected with the publication of *Floating Bear*.[12] On the masthead of the November 1963 issue, Name is described as "maneuvateur."

Floating Bear was free (as was *Fuck You*). It was called a newsletter, and the only way to receive a copy was by knowing a person who worked on its production and thereby could add names to the mailing list. This selective distribution in itself ordained *Floating Bear* as an agent of communication within a circumscribed community.[13] Warhol's entry into this community enabled him to receive a copy of the *Floating Bear* issue containing the piece on Name's haircut party.[14]

Within the next month or so, Warhol began making his *Haircut* movies. Each of the three known movies with this title stars Billy Name, and together they contribute, as does the *Floating Bear* text, to a mythology of Name's actual haircut parties.[15] These parties were famous among Name's circle of friends—artists, dancers, choreographers, lighting designers, and writers who all published in or lent their services to *Floating Bear,* or both. It was reportedly a member of this group, the visual artist Ray Johnson, who first brought Warhol to one of Name's haircut parties in 1963.[16]

In this context it should be noted that Ray Johnson had his own special method of creating dialogues with people through his art. He regularly made art for particular individuals and sent it to them by mail. This work usually consisted of a letter accompanied by some drawing and collage that contained messages and symbols concerning his relationship with the recipient. The recipient was to respond to Johnson's missal, and sometimes Johnson

requested that he or she add something to it and then send it on to a specified third party. Johnson called his enterprise the New York School of Correspondence Art, and central to it was his belief that art is a medium through which to communicate with people.[17]

Johnson also transmitted his communications by way of the journal *The Sinking Bear,* the title of which is a spoof of *The Floating Bear;* like *Floating Bear* (as well as Johnson's correspondence art), it was sent through the mail. *Sinking Bear* featured sayings attributed to various members of the intersecting downtown art worlds and employed openly homosexual language. The quotations in it seem to have been largely invented as jokes, although it is often difficult to determine whether a given saying is or is not by the person to whom it is attributed. For example, the following quotation is attributed to Warhol (and is in his manner of speaking): "Write H O M O S E X U A L 8 times . . . because homosexual is such a beautiful word . . . it's beautiful when it's written out!"[18] There are also references in *Sinking Bear* to Name's haircutting activities, including, in the January 1964 issue, a parody of "Billy Linich's Party."[19]

Warhol's *Haircut* (no. 1), which was made in November or December of 1963, features Billy Name cutting the hair of his friend John Daley, who in fact was the author of "Billy Linich's Party" (and who then lived in the same building as Ray Johnson).[20] A third actor in *Haircut* (no. 1) is the choreographer and dancer Fred Herko, a close friend and neighbor of Diane di Prima who often assisted in the production of *Floating Bear.*[21] In some sequences of the movie, Herko dons a cowboy hat: the homoerotic associations that the cowboy image had taken on within this community are underscored in scenes where his chest is bare (fig. 21) or he is entirely unclothed.[22] The cowboy hat may, in addition, allude to a passage in "Billy Linich's Party" that obviously contains inside jokes comprehensible to only those who were very familiar with the social milieu of *Floating Bear:* "Ralph Di Padova made declarative sentences without alluding to Ouspensky. He said, 'I want a cowboy haircut.'"

There was one additional actor in *Haircut* (no. 1), the choreographer and collage artist James Waring, who is likewise a character in "Billy Linich's Party." Waring, like the other actors in the movie, for a time lent his services to the preparation of *Floating Bear,* where his dance productions were on occasion reviewed.[23] Name regularly worked on the lighting for Waring's productions, and Fred Herko often performed in them.[24] *Haircut* (no. 1), then, brought together on screen one particular artistic clique within the *Floating Bear* circle.

39

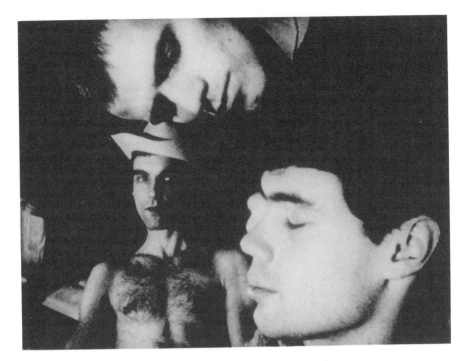

Fig. 21. Andy Warhol, *Haircut* (no. 1), 1963. © 1994 Andy Warhol
Foundation for the Visual Arts, Inc. All rights reserved.

The reader of "Billy Linich's Party" needed, as usual, to know information about this clique not provided in the text itself in order to grasp the significance of the single line that Waring is made to say. Waring's line is simply an assessment of the haircut party. He calls it "timeless and sexy." This line plays off the previous one, in which Michael Katz—a photographer who was another member of the *Floating Bear* circle—declares that the party is "very sexy." Waring's annexation of the word "timeless" onto Katz's "sexy" is undoubtedly a reference to Waring's interest in Zen.[25]

Warhol captured both the "timeless" and "sexy" features of Name's haircut parties in his movie, the former through the slow speed of the film (Warhol's early silent movies were filmed at 24 frames per second but screened at 16 frames per second) and the apparent extenuation of the haircutting act— the two together producing the feeling that the haircutting activity was endless—and the latter through the inherent physical proximity of two men during a haircutting. This intimacy was stressed through myriad details of the interactions of the men, and particulars such as Herko's cowboy hat and bare body.

Waring's description of Name's haircut party as "timeless" can be linked

with at least two other artistic references as well. The first of these is a poem by Waring on the subject of haircutting, in which time and repetition are the central motifs. Waring had included this little poem, entitled "Haircut," in a letter of 1960 to the composer La Monte Young. Young was an active member of the art movement called Fluxus, and Name had sung in Young's Theatre of Eternal Music in 1962 and 1963.[26] The epistolary mode of disseminating art was a customary Fluxus practice (Ray Johnson participated in various Fluxus enterprises), and because of the perforce select audience for such correspondence, it functioned a lot like the mail-dispatched *Floating Bear* and *Sinking Bear.*

Waring's haircut poem belongs, moreover, to a dominant genus of Fluxus writings, in which the format is a set of instructions for enacting an activity intended for anyone to perform. It reads: "Use a stop watch. Watch and time three minutes. During that time say 'haircut' as least, or as many times as you like."[27] Here, Waring transforms the physical act of haircutting into a verbal act of repetition bracketed within a fixed duration of time. He also builds a subtle sequence of puns around the words "watch" and "time" about time itself.

The second reference embedded in Waring's characterization of Name's party as "timeless" in the *Floating Bear* text concerns amphetamine. Name's haircut parties, aside from their practical objective of providing free haircuts to friends, were rituals that served to funnel the obsessive, focused activity resulting from habitual amphetamine consumption by Name and his coterie.[28] Amphetamine, like many drugs, distorts one's sense of time. As a stimulant, it at once speeds up the body's sense of time and elongates time—making time seem, so to speak, "timeless"—by adding many waking hours onto the day. Warhol, as has often been pointed out, was fascinated by the energetic behavior and stretching out of time produced by amphetamine, which he frequently recorded on film and audiotape during the mid-1960s (a practice that is further discussed in chapter 5).

The fact that a haircut is by definition a recurring activity is suggested in the very structure of "Billy Linich's Party." The text is divided up into nine segments, beginning with "First Haircut" and concluding with "Ninth Haircut." Thus, each of the nine segments represents one haircut (according to its subtitle if not the overall content, which consists of seemingly unrelated lines, quotations, and poems pieced together in a decidedly neo-dadaesque cut-and-paste manner).[29]

This serial format is akin to the structure of Warhol's movie *Kiss,* a collection of 100-foot reels of couples kissing that he started to make around Sep-

41

tember 1963, when the earliest of them was screened singly as *Andy Warhol Serial* (see fig. 20 above). Warhol continued filming reels of the *Kiss* serial in November and December, simultaneous with the production of *Haircut*. The existence of at least three distinct Warhol movies with the title *Haircut* suggests that he may have also originally envisioned them as a serial work, thereby associating his own aesthetic with the serial structure of "Billy Linich's Party."[30]

The movie designated *Haircut* (no. 3) consists of twelve 100-foot reels showing Billy Name cutting the hair of his friend Johnny Dodd, who worked with Name on lighting for various downtown dance and theater productions. The intimate, erotic—even romantic—relations between the two men are articulated in this haircut film by various subtle gestures and compositional devices: Name gently blowing on Dodd's face after cutting the front of his hair (reel 4); the two sharing a cigarette (reel 8); Name combing and running his fingers through Dodd's hair (reel 10); and (in a visually breathtaking sequence) a frontal view of Name's face aligning with the profile of Dodd's at one moment, the two smiling simultaneously at another moment, and Name's studious gaze into the face of Dodd leading to a poetic overlaying of their noses a bit later—all these images implying a unity between the two men (reel 11).[31]

This implied relationship between Name and Dodd provides clues to the inner workings of their artistic clique, as did the implied relationship between Denby and Malanga in Warhol's *C* cover, that would have been fully evident only to members of the clique. An idea of the intricacy of these inner workings is suggested if *Haircut* (no. 1) and *Haircut* (no. 3) are compared. In each film, Name is paired with a different man. This criss-crossing of personal relations within a small social group was also jokingly hinted at on the pages of *Floating Bear* and probably had some basis in reality. Appearing in the October 1963 issue of the newsletter, which was guest-edited by Name, a "letter" attributed by di Prima to John Daley and addressed to Name included this passage about Daley, Dodd, and Herko: "Johnny Dodd was getting despondent about being forsaken by Freddie, so I forwarded the all-time favorite information to him. I wouldn't say he was my all-time favorite, so far, but he's certainly among the top ten. Or fifteen. Not only is he a superior lay (as I'd been led to believe he wasn't) who comes back for more in the morning, and an all-around sweetie-pie; he also has fits at parties."[32] The 1 April date of this letter indicates that its off-color, revelatory content probably should not be taken at face value. Nonetheless, the inside jokes embedded here do suggest

that the actual personal connections between Daley, Dodd, Herko, and Name were somewhat elaborate.[33]

Warhol at once recorded and contributed to the intricacy of these relationships through his portrayals of distinct couplings—Name with Dodd; Name with Daley, accompanied by the nude or bare-chested Herko—in his different haircut movies. Warhol depicted a further criss-crossing of pairs within this group in one of the segments of his film *Kiss,* in which Dodd and Herko, seated on a couch in the Factory, are engaged in a romantic embrace. This segment of *Kiss* was made around the time of the haircut movies, and it likewise served as an instrument through which Warhol participated in the private dialogues of a particular microcosm.[34]

The haircut movies were among those Warhol screened publicly very shortly after they were filmed—that is, while the relationships recorded in them still had currency. One haircut movie, evidently *Haircut* (no. 3), premiered on 10 January 1964 at the Gramercy Arts Theater.[35] In the following few months, two distinct *Haircut* movies were screened at the American Theatre for Poets (also known as the New York Poets Theatre), which was run by Diane di Prima and her husband, theater director Alan Marlowe.[36] In other words, these screenings were held at the same locale at which both Herko's and Waring's company regularly danced. Warhol's films thus reached the very *Floating Bear* audience that they were about.

In sum, the haircut as a motif functioned like a secret password that identified members of a particular social world. By tracing the lineage of the haircut motif from Waring's poem to Name's haircut parties to John Daley's text about these parties to Warhol's films of them to *The Sinking Bear,* we are provided with a vivid illustration of how the evolution of a given motif was one way in which the *Floating Bear* artistic community identified itself; the haircut had special meanings that only members of the community understood. Textual and visual art, then, played as much a role in shaping this community as did conversation and physical interaction. Warhol, in both the production and screening of the haircut films, found a place for himself within this community, inserting into it his unique aesthetic vision of eroticism and romance.

Another film that Warhol screened at the American Theatre for Poets in order to reach its regular audience features Diane di Prima and Alan Marlowe. The fact that di Prima and Marlowe ran this multipurpose theater would not have been lost on viewers of the movie. Warhol filmed the short episode-like

43

movie of di Prima and Marlowe (the title of which is at present uncertain) soon after 29 January 1964, when di Prima sent a letter to the artist that alluded to his interest in making a film of the couple: "come see us & shoot a Day in Our House like you said & show the Alan & me pornography—."[37] Warhol ended up filming di Prima and Marlowe for around three minutes, the duration of a 100-foot reel of film, rather than for the originally planned length of one day. Di Prima recalled, "He came and shot a movie. It was a very short movie. A three or five minute movie of me and Alan. Alan is in bed, and he's covered by a tiger skin, which he's stroking the tail of in a very obviously suggestive manner. I get on the bed in a black leotard and tights and kind of trample him. It was a tiny room."[38]

Like the haircut movies, this film can be associated with aspects of both the art and the personal lives of its actors. In terms of art, the tiger skin on the bed in the movie, for instance, brings to mind a passage from di Prima's libretto for a dance-opera called *Poets' Vaudeville,* which was performed by James Waring in late August 1963 (fig. 22).[39] *Poets' Vaudeville* is divided into five parts—"People," "Animals," "The Seasons," "Love," and "Death"—of which the fourth part, "Love," contains a reference to the marriage bed and animal skin imagery that appears in Warhol's film: "I'll make a sheet of your skin / To lie on w/ my husband."[40]

The scene of Warhol's movie in which di Prima pounces on Marlowe contains similar references to art and life. It alludes to the tensions in the couple's marriage (and perhaps to the connection of these tensions to Marlowe's sexual attraction to men). The other members of the *Floating Bear* community were familiar with these tensions, which in fact were satirized in the following lines of "Billy Linich's Party": "Alan Marlowe had a new gleam in his eye and a new gash above / it. Diane Di Prima wore black and blue velvet. Who should / be angry?"

These and several other lines of "Billy Linich's Party" are, in addition, parodies of di Prima's *Poets' Vaudeville* lyrics. For example, the words "who should be angry" of the above quotation occur repeatedly in *Poets' Vaudeville* (functioning there as a kind of unifying motif),[41] while the references to di Prima's and Marlowe's physical lashing out at each other serve as a gossip-laden postscript to the "Love" section of *Poets' Vaudeville.*

The first section of *Poets' Vaudeville,* "People," is in itself made up of gossip about di Prima's circle of artists, writers, and performers. The gossip element was derived from the work of Frank O'Hara, whose poetry had been published in *Floating Bear,* and with whom di Prima was close at the time.[42]

Fig. 22. Billy Name, photograph of *Poets' Vaudeville* performance with Deborah Hay and James Waring. Judson Dance Theatre, 25 August 1963. Photograph courtesy of Billy Name.

In making the films of di Prima and Marlowe, and of Name as a haircutter, Warhol was responding to elements of the *Floating Bear* group's aesthetic that paralleled his own artistic concerns. Openly employing gossip as an integral component of art is one of these elements. Another is a fascination with the bestial dimension of human behavior and, by extension, relations between human beings and animals. An interest in human-animal correspondences is evident throughout *Poets' Vaudeville* and most overtly in its second part, entitled "Animals." Marlowe's activity of stroking the tiger skin in Warhol's film is an example of how Warhol and the actors collaborated to bring this shared fascination together in one work of art.[43]

The correlation of animals and humans was central to the work of Michael McClure, another poet connected to the *Floating Bear* community whose work caught Warhol's attention. McClure, like di Prima and many other poets active at the time, was drawn to the idea that theater was an art form with great potential for the poet, and he wrote several plays. His play *The Feast,* composed largely in an invented beast language to be performed by humans, was published in an early issue of *Floating Bear.*[44] McClure's play *The Blossom, or Billy the Kid,* in which humans and animals are again associated, premiered at the American Theatre for Poets in 1964 and was directed by Alan Marlowe (who also played the lead role of Billy the Kid) with lighting by Johnny Dodd. It is

45

highly likely that Warhol saw this production; he possessed a copy of the mimeograph program for it.[45] Further, he was probably aware that McClure's glorification of and identification with the historical figure Billy the Kid in *The Blossom* had entered into the dialogue of the *Floating Bear* group, for it was mocked in the issue of *Floating Bear* guest-edited by Name.[46]

Warhol had also seen another play by McClure, *The Beard,* which was first performed in 1965.[47] *The Beard* has much in common with *The Blossom:* it is set in eternity, the animal and human are conflated, and Billy the Kid is a central character (Jean Harlow being the only other character in *The Beard*). In a published interview of 1977, Warhol acknowledged his admiration for *The Beard.*[48] It is easy to see why this play appealed to him. The androgyny of its two characters (who both wear white beards to indicate that they exist in eternity), the ample use of repetition in the text (such as of the line "You want to be as beautiful as I am"), the obsession with beauty (as in the just-quoted passage), the intersection of the public and private (most striking in the ironic line "no one is watching," which is perforce false given the fact of an audience), the celebration of heroes of American popular culture (Billy the Kid and Jean Harlow), the notoriety (in several cities, performances of *The Beard* were closed down on obscenity or other charges)—all these features of McClure's play had parallels in Warhol's own work.[49]

Indeed, at the end of 1964 Warhol had already produced a film in which the protagonist was Jean Harlow—acted by a man in drag. In addition to a convolution of sexual identity, this film, entitled *Harlot* (Warhol's first to include sound), shared with *The Beard* allusions to the bestial side of humans, a generous deployment of repetition, a centrality of poetry and the poet as motifs, and an interest in Harlow that echoed the popular fascination with the actress at that moment (a biography of Harlow was published in 1964).[50]

Thus, it makes perfect sense that Warhol actually transformed *The Beard* into one of his works by creating a film version of it. Warhol's movie of *The Beard,* which he apparently filmed in 1966, starred Gerard Malanga as Billy the Kid and Mary Woronov—an actress and painter who was Malanga's girlfriend at the time—as Jean Harlow. The casting was typically nuanced so that the actual lives of the performers are reflected in the characters they played. Like Billy the Kid and Jean Harlow in McClure's play, Malanga and Woronov were somewhat androgynous, and their coupling therefore invited interpretation as embodying the kind of male-female mirror imagery that is central to McClure's two characters.

More subtly, Malanga's role was in all likelihood tied, in the mind of War-

hol, to Malanga's calling as a poet. The result is an extension of McClure's identification of himself with the historical figure of Billy the Kid, so that the identification also applies to Malanga. This identification was, on one level, generic: McClure "the poet" is equated with Malanga "the poet." But on another level the equation was more specific, for Malanga shared with McClure a highly romantic vision of the poet as a heroic figure who, like Billy the Kid, transgressed the rules of society, and who, in addition, produced work that united poetry with all the other art forms in a kind of 1960s variation on the Wagnerian *Gesamtkunstwerk*.[51] Warhol was extremely familiar with these dimensions of Malanga's self-image as a poet, having already worked closely with Malanga for three years when he cast him in his movie of *The Beard*.[52]

Warhol was aware, too, of McClure's conception of theater as a form of poetry, as is evident in his later explanation to an interviewer of why he thought *The Beard* was "beautiful." Using language that seems to be simultaneously serious and in jest (his characteristic way of indicating that he—and we—might hold more than one viewpoint about a thing, even contradictory viewpoints), Warhol said, "Well, it's a two character play and I think the person who wrote it wrote poetry, so the combined art and poetry . . . everything together and it was a great production. It's about Jean Harlow and a famous cowboy, sort of the James Dean type of his day. I think I've seen three productions of it. Did you see it at all?"[53]

Warhol here revealed his knowledge of McClure's exaltation of drama written by poets by simply repeating it.[54] He also intimated that the currency during the 1950s and 1960s of the idea of bringing together visual art and poetry had become, as a concept, an avant-garde cliché.

In 1966, Warhol screened *The Beard* in San Francisco, where the play had made its debut the year before. The screening occurred at a cocktail party, in the presence of McClure. Typically, then, the audience for the film was directly linked to its content. In this instance, the film-audience connection had at least one very specific aim—to appease McClure. McClure was at the time indignant toward Warhol for making the film version of his play without his permission (which, according to one account, McClure had initially offered but then withdrew prior to the signing of any contractual agreement). In the end, Warhol gave the film to McClure, which in effect put it out of circulation.[55] This history of the movie provides a key to understanding the significance—and humor—of the following exchange between Warhol and the interviewer with whom Warhol had discussed McClure's ideas about theater, art, and poetry:

INTERVIEWER: You've mentioned a play called "The Beard." I just wondered why that particular play would make you wish that all your films were as beautiful?

ANDY WARHOL: . . . They were going to make a movie of it, but I don't think they ever did.

INTERVIEWER: Why don't you?

ANDY WARHOL: I guess I should. Oh, maybe they did make a movie of it, but I can't remember.[56]

Warhol's movie of *The Beard* brought him to the outer limit of the socio-artistic world of *Floating Bear*. His varied involvements with the smaller units that comprised this world, beginning with his 1963 friendship with Billy Name and his ensuing production of haircut films, provided Warhol with a means to extend both the imagery of his art and the audience with which it was in direct dialogue. For Warhol, these two aspects of art—appearance and human engagement—were positively inseparable. Therefore, by viewing Warhol's art within the social contexts of its production—in this case, the poetry world of *Floating Bear*—we can see clearly its human dimensions and can thus confidently put to rest the commonly held assumption that his is a vapid art of empty images.

The poetry world represented by *Floating Bear* was of course not the only one into which Warhol inserted himself through his richly communicative art. Among these worlds was, as mentioned at the outset of this chapter, the one represented by *Fuck You / A Magazine of the Arts*. Warhol's involvement with this world culminated in early 1965 with the third anniversary of *Fuck You*.

There was a special anniversary issue of *Fuck You,* for which Warhol supplied the cover image (fig. 23). The image was a still from his 1964 silent black-and-white movie *Couch,* a series of 100-foot reels of film showing various activities occurring on and around a large second-hand couch at Warhol's Factory, and was undoubtedly selected for its appropriateness to the provocative make-love-not-war spirit of the magazine. This still, taken from the most taboo-breaking sequence in *Couch,* shows a ménage à trois consisting of Gerard Malanga, the actor Rufus Collins, and Kate Heliczer (who was then married to the young poet and filmmaker Piero Heliczer).[57] The suitability of this still for the cover of a magazine called *Fuck You* requires no explanation. Its deployment here was a logical extension of the suggestive Warhol kiss scenes that had earlier graced covers of *C* and *Kulchur* (see figs. 9, 10, and 20).

Plate 1. Andy Warhol, *Blue Butterfly Day*, ca. 1955. Collection of WATARI-UM, The Watari Museum of Contemporary Art, Tokyo. © 1997 Andy Warhol Foundation for the Visual Arts / Artists Rights Society (ARS), NY. Photograph courtesy of WATARI-UM.

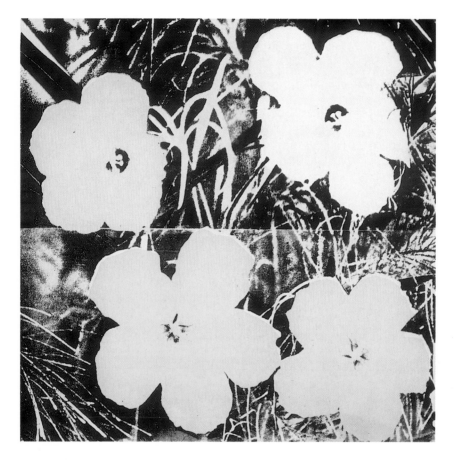

Plate 2. Andy Warhol, *Flowers*, ca. 1964. Private collection. © 1997 Andy Warhol Foundation for the Visual Arts / Artists Rights Society (ARS), NY.

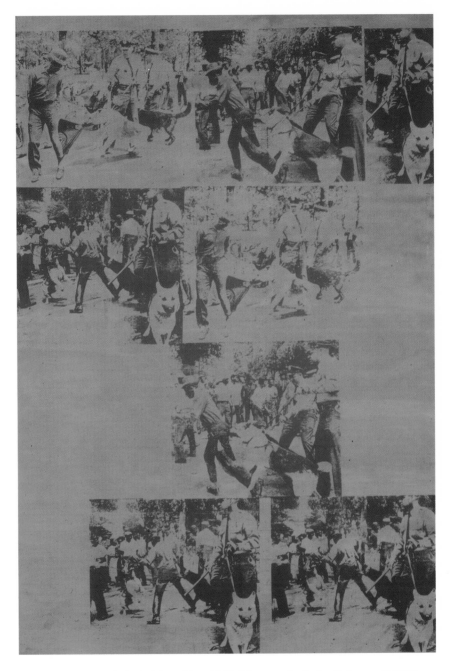

Plate 3. Andy Warhol, *Red Race Riot*, 1963. Museum Ludwig, Cologne. © 1997 Andy Warhol Foundation for the Visual Arts / Artists Rights Society (ARS), NY.

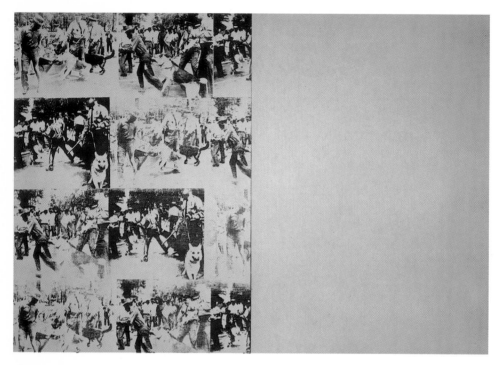

Plate 4. Andy Warhol, *Mustard Race Riot*, 1963. Private collection. © 1997
Andy Warhol Foundation for the Visual Arts / Artists Rights Society (ARS), NY.

Fig. 23. Andy Warhol, *Couch,* cover image of *Fuck You / A Magazine of the Arts* 5 (March 1965). © 1997 Andy Warhol Foundation for the Visual Arts / Artists Rights Society (ARS), NY. Photograph courtesy of the Fales Library, New York University.

However, in case readers of the magazine happened to miss the point, its editor Ed Sanders took measures to fortify the scandalous implications of the *Couch* still. He wryly labeled the movie "evil" on the cover page of the issue.[58] And in a regular column within its pages, Sanders included interpretive descriptions of the *Couch* still, which can be understood as his side of a dialogue set up by the choice to place the still on the cover of *Fuck You.*[59]

Sanders further replied to Warhol's *Fuck You* cover by chaffing Malanga's sexual adventures elsewhere in the magazine. First, he included within its pages an anonymous poem entitled "Friends of GERARD MALANGA / (commissioned by Ronnie Tavel)," the word "friends" here signifying men and women with whom Malanga presumably had had some sort of sexual or otherwise entangled relationship. The poem consists of two columns: on the left is a list of names of men and on the right, of women. Embedded in the selection of names are jokes of a variety apparent only to those who understood **49** the role each specified person played in Malanga's life.

A second place where Sanders poked fun at Malanga's sexual life in the

anniversary issue of *Fuck You* was in the burlesque-style "Notes on Contribu-tors." Here, readers were informed, in comically exaggerated terms, of Gerard Malanga's reputation for sexual escapades and his similarly copious ambitions as a poet.

The editor of *Fuck You* clearly played up the relationships between the cover design of this issue and its content. In so doing, he elaborated on a perception of Malanga's sexual comportment evident in Warhol's art, for in-stance in films such as *Couch* and in the cover for *C.* This was a perception that proved to be a double-edged sword for its creator—Malanga himself—since its seductive power, even as an idea, simultaneously brought him a great deal of desirable attention and led to the kind of undesirable taunting of which Sanders's words are but one example.

Thus Gerard Malanga was a central link in the two-way dialogues that developed between Warhol and the interlocking poetry worlds represented by *Fuck You, Floating Bear,* and *C.* In an effort to create and position himself, along with Warhol, at the epicenter of one of these worlds, Malanga in late 1963 conceived of his own "literary-arts magazine," to be designed by War-hol. The magazine was going to be called *Stable,* its title deriving from the name of the art gallery then representing Warhol. Eleanor Ward, Stable Gal-lery's owner, was to be the publisher, according to an advertisement appear-ing in the *Floating Bear* issue that contained the piece on Name's haircut party.[60]

Malanga's interest in relations between poetry and visual art had been formed in 1959–60 in classes taught by the poet, publisher, and filmmaker Daisy Aldan at the High School of Industrial Art (now called the High School of Art and Design) in Manhattan. Aldan gave her students assignments that brought together poetry and visual art, and they assisted her in putting to-gether her *Folder* and *New Folder* publications, which also wedded the two art forms (fig. 24).[61] These classes would prove formative to Malanga's work dur-ing his years with Warhol, in which he developed the painter-poet link in several fascinating directions—with Warhol invariably on the "painter" end of the link, sometimes as a collaborator.

Stable was to be one of these collaborations, but it never materialized. However, it planted an important seed that grew to become *Interview* maga-zine. Different individuals have been credited with the idea of initiating *Inter-view,* the first issue of which was published in the fall of 1969.[62] Whatever the precise genesis of the magazine, it is clear that Malanga's long-term desire to

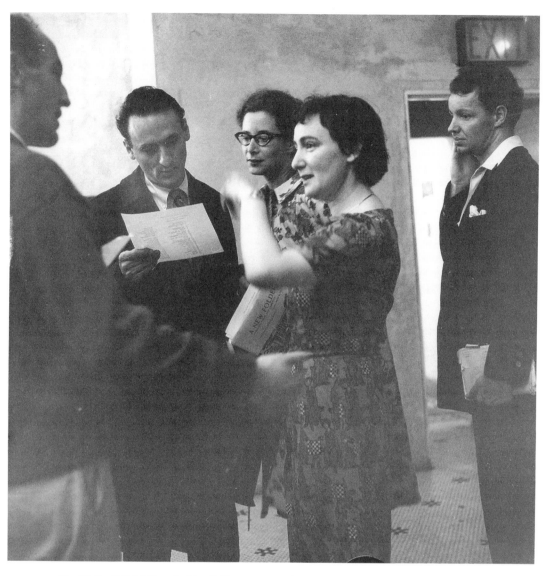

Fig. 24. Fred W. McDarrah, *New Folder* poetry reading at the
Living Theatre, New York, 12 June 1959, with Daisy Aldan (arm
raised), Frank O'Hara, Larry Rivers, and Nell Blaine.
© Fred W. McDarrah.

establish a serial publication with Warhol—evident in such projects as the
ambitious "Andy Warhol-Gerard Malanga Monster Issue" of the poetry jour-
nal *Intransit* (1968)—together with Warhol's own prior involvements with lit-
erary journals figured significantly in its realization. The earliest issues of *In-
terview* were co-edited by Malanga (assisted at times by Soren Agenoux, former
editor of *Sinking Bear*).[63] Malanga envisioned *Interview* as an organ focusing on
film and poetry; he copyrighted the magazine in the name of "Poetry on Film,

51

Fig. 25. Kenward Elmslie, "Time Step Ode," *Interview* 1, no. 2
(1969). Photograph courtesy of the McCormick Library of Special
Collections, Northwestern University Library. Poem reprinted by
permission of the author.

Inc." (and also devised the title's original orthography, *Inter/VIEW*).[64] In addition, Malanga's strong interest in relationships between poems and visual imagery is reflected in the fact that each of the first three issues contained poetry accompanied by photographs (fig. 25). But adverse circumstances at the Factory soon halted Malanga's vision of a poetry-affiliated *Interview,* along with his career at the Factory altogether.[65]

Despite the absence of Malanga, an important vestige of Warhol's 1960s interactions with Malanga and other poets remained a permanent and central feature of *Interview.* This was the interview format itself. An interview is by definition a dialogue, and thus can be understood as a literal translation of the kinds of exchanges that Warhol had participated in with the worlds of *Fuck You, Floating Bear,* and *C.*

The verbal medium of the interview is of course distinct from the visual media of film, painting, or photography. Yet Warhol's work in all these media partakes of the same basic impulse to create an interaction with another individual or with a group. There are other strands to the literary background of Warhol's extensive use of the interview format, and these will be taken up in later chapters. What I want to emphasize here is the degree to which dialogue informed Warhol's work in all media, in a consistent and ever-developing way.

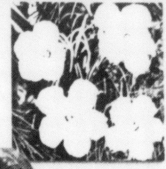
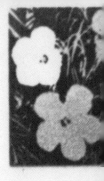

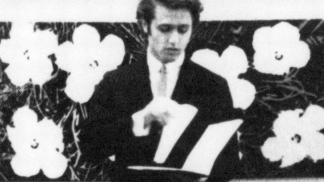

Expanding Worlds: Poetry off the Page

A film camera scans the room while Ed Sanders is interviewed about his life as a poet, publisher, and bookstore owner. At times the camera focuses in on Sanders as he reads one of his poems or talks about his mother's death. He sits at a desk in the Peace Eye Bookstore, located at 383 East Tenth Street in the East Village, which he established and owns (fig. 26). Occasionally, the camera moves up and to the right, revealing part of a banner of flowers made by Andy Warhol as a decoration for the bookstore (fig. 27). It is odd to hear the boldly anti-establishment Sanders discuss his magazine without seeming to mind that he is prohibited from calling it by name; since he is being filmed for the 1966 WNET public television series "USA: Poetry," speaking the words "fuck you" is prohibited.

Sanders's seemingly willing concession to the censorship laws of television is consistent with his broader aim to reach large audiences. This aim, which was fairly common among "underground" figures of the 1960s, had at its roots two distinct objectives: changing the world and achieving fame. These objectives, the one altruistic and the other self-centered, are seldom mutually exclusive, as both Sanders and Warhol well understood.

The interview format has a special life in media other than the printed page, as the made-for-television interview with Sanders shows us. Reading

Fig. 26. Peace Eye Bookstore, exterior view, from the documentary film *Frank O'Hara and Ed Sanders,* "USA: Poetry" series, 1966. Reproduced courtesy of Thirteen / WNET / New York, and Ed Sanders.

Fig. 27. Peace Eye Bookstore, interior view showing one of Warhol's Flower banners, *left,* from the documentary film *Frank O'Hara and Ed Sanders,* "USA: Poetry" series, 1966. Reproduced courtesy of Thirteen / WNET / New York, and Ed Sanders.

the purported actual words of someone is one thing, but seeing that person in the act of formulating these words is something altogether different. On television or in film, the person becomes more palpable and we, in turn, become more voyeuristic. Our sense of Sanders's presence infuses his words with a potency distinct from that of a published interview. This potency was rec-

ognized and tapped by even the most underground of poets during the 1960s, and it produced a special, vibrant attitude toward the poetry reading, whether on television or in an East Village cafe.

The physical presence of the poet at particular venues was important, as was the physical configuration of Sanders's bookstore and like purlieus (which the makers of the WNET documentary clearly knew). These details of environment contributed to the life of poetry off the page. Warhol held a keen interest in this dimension of the poetry worlds around him. In the discussion that follows, I will chart the range of ways in which performance and locale figured in Warhol's dialogues with these worlds, and, in turn, in their dialogues with Warhol.

The Warhol Flower banner in the television documentary about Sanders was one of approximately six made by the artist specifically for Peace Eye Bookstore. Particular ideas underlie Warhol's choice to use the flower motif for the Peace Eye banners. While Warhol's flower image, like many others in his work, is open to a wide array of iconographic significations, he highlighted specific meanings through his subtle sensitivity to context—in this instance, the site of a poet's bookstore.[1] On one level, his placement of the flowers at this location signals that he was tapping into established associations between flower imagery and poetry. The flower was a sanctified, centuries-old poetic motif that had generally been considered a more elevated subject in poetry than in painting.

Aside from this generic literary reference, in the mid-1960s flower imagery became for the population at large a trademark of pacifism. Warhol grafted this signification onto the flower-poetry association by placing his flower images in a bookstore owned by a poet and called Peace Eye. The peace allusion was especially resonant in 1965, the year in which the United States became openly and unpopularly involved in the Vietnam War. And Warhol's Peace Eye banners are but one indicator that he contributed (like virtually everyone around him) to the antiwar activities of the time, a point that tends to be overlooked.[2]

Even when Warhol showed his silkscreen Flower paintings at his first exhibition at Leo Castelli Gallery in late 1964 (fig. 28), he very probably had the peace connotation in mind. In that year, a notoriously sensational television advertisement for Lyndon B. Johnson's presidential campaign contrasted a picture of a girl picking a flower (representing Johnson's promise of peace) with that of an exploding atomic bomb (representing the position of Johnson's opponent, Barry Goldwater).[3] Warhol commented at the time that he

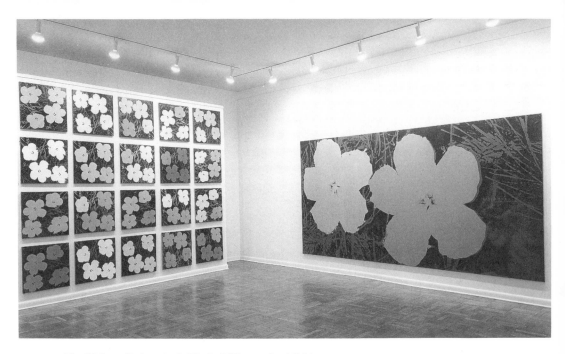

Fig. 28. Installation, Andy Warhol "Flowers" exhibition,
Leo Castelli Gallery, 1964. © 1997 Andy Warhol Foundation for
the Visual Arts / Artists Rights Society (ARS), NY.

decided to show the Flower paintings at the Castelli exhibition—which co-incidentally opened very shortly after the election in November 1964—because Johnson won, and that if Goldwater had won, he would have exhibited pictures of Goldwater, "because then everything would go, art would go" (destroyed, it can be inferred, by the atom bomb).[4] It is quite likely that Warhol had the Johnson television ad in mind when he made this comment.

An additional connection between flowers and peace, with a direct link to the poetry of Sanders, may well have been behind Warhol's production of the Peace Eye banners. This connection concerns his choice to use the banner format rather than the more traditional painting format of canvas on stretchers. The banners, aside from contributing to the celebratory atmosphere of Sanders's bookstore opening, may have been intended as a reference to banners in Sanders's poem "Soft-Man X." This poem was occasioned by a 1962 Walk for Peace in which Sanders participated; it was published in *Fuck You / A Magazine of the Arts* shortly after the walk and again in Sanders's 1965 book of verse, *Peace Eye.*[5] In the poem, banners are associated with war, flowers are associated with peace, and the Peace Eye (the eye of Horus, the Egyptian god of light) is given the status of a benevolent god. It is as if in Warhol's flower decorations for Peace Eye Bookstore, the banners of war are replaced, fittingly, by banners of peace, since here the Peace Eye god ruled.

Another artistic exchange between Warhol and Sanders revolved around an additional iconographic motif that had appeared in the figurative repertoire of each of them—namely, the banana—which for each was charged with unequivocal and purposefully sophomoric phallic associations. Around the same time that he made the *Couch* cover for *Fuck You* and the Flower banners, Warhol suggested to Sanders that he produce a compendium on the topic of bananas. This was to be among the thematic "Fuck You" Press mimeograph publications that Sanders produced in addition to his magazine. *Banana,* as the compendium was to be titled, never went beyond the concept stage, although plans for its realization were announced in the anniversary issue of *Fuck You.*[6] The banana is a recurring motif of Sanders's poetry that is especially conspicuous in "Soft-Man X," while several Warhol films of 1964 and 1965, such as *Couch* and *Harlot,* feature people eating bananas.[7]

When Warhol used a banana for the cover design of the first Velvet Underground album (fig. 29), which was released in 1967, he probably retained the association of bananas with Sanders. The poem "Soft-Man X" contains a group of "songs," one of which is called "Song of the Bull Dyke / (The Banana Harness Blues)." The fact that one of the "songs" in Sanders's poem concerns bananas, together with the fact that it was called a "song," suggests that the poem in some way figured in Warhol's conception of the Velvet Underground banana.

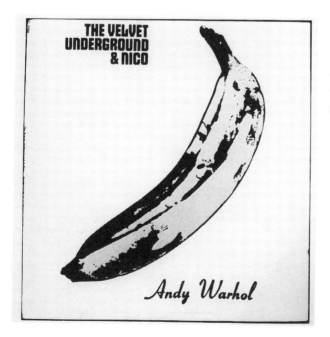

Fig. 29. Andy Warhol, album cover, *The Velvet Underground and Nico* (distributed by MGM, 1967), 1966. © 1997 Andy Warhol Foundation for the Visual Arts / Artists Rights Society (ARS), NY.

59

Indeed, Sanders's idea to use a song format in "Soft-Man X" developed into the creation of actual songs when he and fellow poet Tuli Kupferberg formed the rock group the Fugs early in 1965. The name of the group (which means unpleasant odors) and its song lyrics and titles (for example, the songs "Jack-Off Blues," "Coca-Cola Douche," and "What Are You Doing After the Orgy?"), like the title and contents of *Fuck You,* were of course intended to raise the establishment's eyebrows. Warhol was intrigued by the Fugs, who were filmed as a group while performing at the Factory and were photographed there by Billy Name—probably on the same occasion—with their original back-up band, the Holy Modal Rounders (fig. 30).[8]

Warhol attended some of the Fugs's performances as well. He saved a copy of the program from a Fugs concert that was presented at Diane di Prima's and Alan Marlowe's American Theatre for Poets on 29 and 30 March 1965 and included a guest appearance by Warhol's early film "superstar" Jane Holzer.[9] Gerard Malanga on occasion danced with the Fugs, as he soon would with the Velvet Underground, the group with which Warhol became directly involved in December of this same year.[10]

The formation of the Fugs contributed to Warhol's interest in associating himself with rock music, and the link to Sanders was embedded in his use

Fig. 30. Billy Name, photograph of the Fugs (with Ed Sanders, *bottom left,* and Tuli Kupferberg, *foreground*), accompanied by the Holy Modal Rounders, at Warhol's Factory, ca. 1965. Photograph courtesy of Billy Name.

60

of a banana for the cover design of the Velvet Underground's first record. The banana, like all Warhol's imagery, had numerous connotations, and the prominence of one connotation over the others was often determined by context. In this instance, he made a string of associations: Sanders, sex, rock music, poetry.

In fact, the lead performer of the Velvet Underground, Lou Reed, was, like Sanders, a poet. Reed had studied poetry at Syracuse University, which he attended from 1960 to 1964. There the well-known poet Delmore Schwartz became his mentor and friend.[11] The Velvet Underground song "European Son," which was included on the group's first album, was dedicated to Schwartz (who died in July 1966).[12] Schwartz disliked rock lyrics, and therefore, according to Sterling Morrison, a member of the Velvet Underground, "the piece employed the fewest words on the album";[13] Schwartz's distaste for rock probably explains the song's title, too—that is, his taste was European rather than American.

Although Schwartz may have disapproved, Reed did conceive of his lyrics as poems. In an essay of 1966, he argued that popular music should be considered a form of poetry.[14] And in 1972 he published in the *Paris Review* the lyrics to the song "The Murder Mystery" (recorded on the third Velvet Underground album, entitled, simply, *The Velvet Underground* [1969]).[15] Many years later, in 1991, he put out a collection of his lyrics in a book.[16]

By the mid-1960s the idea that a rock artist could be a poet was in circulation and often debated, in large part due to the activities of and critical writings about Bob Dylan, whom both Reed and Warhol then admired greatly.[17] A conspicuous instance of this debate, as it focused on Dylan, is the short piece "Is Bob Dylan the Greatest Poet in the United States Today?," which appeared in a 1965 issue of the *New York Times,* and included the diverse opinions of poets, a few teachers of literature, and a student.[18] Warhol himself, when he reminisced about Dylan's work of this same year, stated that "If Dylan had just been a poet with no guitar, saying those same things, it wouldn't have worked; but you can't ignore poetry when it shoots to the Top Ten."[19]

In this Dylan-saturated climate, two poets with the idea of setting their poetry to music put together the Fugs,[20] published their lyrics,[21] and played at venues such as the American Theatre for Poets. It was in this climate, too, that the Velvet Underground's 1966 mixed-media performances acquired the name Exploding Plastic Inevitable, words taken from the sleeve of Dylan's album *Bringing It All Back Home* (1965).[22]

My point is not to argue whether the music is or is not poetry—these are,

after all, only categories (although certainly there is something at stake in a category, and one aim of calling rock music poetry was to elevate its position within the hierarchy of artistic forms)—but rather to emphasize the currency of the debate at the time. The use of the term "poetry" in reference to rock music was, moreover, just the sort of artistic barrier-breaking move that spoke to Warhol, as it paralleled his own aesthetic as an artist. By choosing the banana motif for the Velvet Underground album cover and providing Sanders with the Flower banners, Warhol in his own way—through the use of a highly associative visual language—celebrated the concept of rock music as poetry.

A likely facilitator of the equation of rock-and-roll music with poetry was the popularity of the poetry reading during the 1950s and 1960s. The performance aspect of the poetry reading would have contributed to the comparison with rock music, just as the revival of a thriving poetry-reading circuit in the 1990s has been linked to rap music and its designation by some critics as poetry.[23] Locale figured into the equation too. For instance, Dylan's earliest performances in New York were at the Gaslight, a coffeehouse in Greenwich Village where both music and poetry readings were regularly scheduled (fig. 31).

Fig. 31. Fred W. McDarrah, view of Taylor Mead reading his poetry at the Gaslight Cafe, 7 June 1959. © Fred W. McDarrah.

The currency of the poetry reading at this time, which is directly connected to the popularization by the late 1950s of the beat poets, involved the media, and readings were often reported in the press. Some of the flavor of this particular mode of bringing together art and the media is drawn out in a passage from one of the semi-autobiographical short stories in Ed Sanders's book *Tales of Beatnik Glory,* called "The Poetry Reading." The setting is a crowded Gaslight, where newspaper cameramen aggressively seek suitable footage, someone wants to know whether Allen Ginsberg is present, and the narrator observes that the poetry readings here are so in vogue that they are reported prominently in publications such as the *Daily News*.[24]

Readings by beat writers, especially, were fashionable avant-garde events as well as, by extension, social activities. For these reasons, the poetry reading was an ideal meeting place for individuals who later might serve each other as collaborators, supporters of each other's work, new friends, or lovers.

It is worth emphasizing that the social atmosphere created by the reading was a central component in the actual production of art, just as it had been for the "San Francisco Renaissance" of the previous generation, as Michael Davidson has shown in an excellent study in which he argues for the importance of what he calls "nonliterary" contexts—coffeehouses, art galleries, and bars where poetry readings were held—for the flourishing of particular communities of writers.[25] Davidson's argument is highly relevant to the wider, cross-fertilizing artistic world of writers and visual artists that is my focus here.

The poetry reading was a place to discover the latest work of friends and colleagues, to respond to this work on the spot, and to exchange gossip. In this regard, it functioned much like the mimeograph publications of the time. As one denizen of Café Le Metro and similar Tenth Street venues recalled, "It was not uncommon for remarks to be made by people in the audience in approval or disapproval, and it was even more common for the reader to be ready to answer any comments. The give-and-take got heavy at times. These readings were more like living magazines. Poets and audience gathered to communicate about what they were doing. Each reading was a means of getting the latest news."[26]

The important place of the poetry reading in Warhol's life and work provides insight into his artistic endeavors and serves as a window through which to view the centrality of the poetry reading as a site where key steps in the working process, for both the writer and the visual artist, were realized. The most basic of such steps was, of course, simply being introduced to someone with whom you might want to work in the future.

63

I have already described how Warhol's introduction to Ted Berrigan at a 1963 Frank O'Hara reading proved to be fruitful for the work of each of them. (Additional ways in which their relationship bore artistic fruit are considered in chapter 4.) In surveying the broader picture, it becomes apparent that Warhol met some of his key associates of the 1960s at poetry readings. Warhol formally met Gerard Malanga at a poetry reading Malanga gave along with Tony Towle at the New School for Social Research. Warhol had been invited to this reading by another poet, his friend Charles Henri Ford, who then introduced him to Malanga.[27] Around a year later, in November 1964, Malanga in turn took Warhol to one of the Monday night readings at the popular Café Le Metro (figs. 32 and 33). There Warhol met Ronald Tavel, who participated in the reading and who soon after began to produce screenplays for Warhol's films.[28]

The stories of these meetings have been told often enough in the literature on Warhol. Yet no attention has been paid to the significance of the poetry reading as a specific venue, not to mention to Warhol's interest in the reading as a performance—as art. Moreover, the neglect of this dimension of his literary interests exists despite the fact that Warhol himself pointed it out in his own writings. In the 1980 book *POPism*, he singled out for discussion the Café Le Metro poetry readings as well as Malanga's role in his regular presence at them: "In the fall of '63 I started going around more and more to poetry readings with Gerard. I would go absolutely anywhere I heard there was something creative happening. We went down to the Monday night poetry readings organized by Paul Blackburn at the Café Le Metro on Second Avenue between 9th and 10th streets where each poet would read for five or ten minutes. On Wednesday nights there was a solo reading. Poets would just get up and read about their lives from stacks of papers that they had in front of them."[29]

Warhol's observation that the poets at Le Metro read about their own lives reflects his fascination with people who, with apparent unreserved freedom and shamelessness, opened themselves up to the world. This openness is often evident in the actors who performed in his movies. Poetry is a medium in which the personal is almost by definition the subject, and, given Warhol's intrigue with the personal lives of other people, it makes perfect sense that he would be drawn to poetry—all the more so if the poet were directly in front of him.

It is true, as Warhol himself stated, that he found in Gerard Malanga an informative literary companion. Warhol accompanied Malanga to the above-

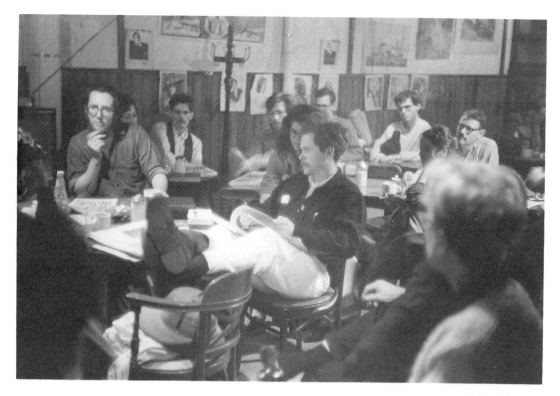

Fig. 32. Fred W. McDarrah, view of a Café Le Metro poetry reading with Ted Berrigan, *left,* and Ed Sanders, *center,* 4 October 1964. © Fred W. McDarrah.

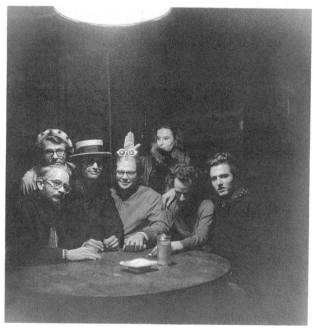

Fig. 33. John Palmer, photograph of Café Le Metro, with the poets Gerard Malanga, Harry Fainlight, Allen Ginsberg, Piero Heliczer, and Peter Orlovsky (and Kate Heliczer and Harry Smith). Photograph © Archives Malanga.

Expanding Worlds

mentioned O'Hara and Tavel readings at Café Le Metro, among others. However, it is also true that the poetry readings had become part of Warhol's life before his acquaintance with Malanga and even prior to his career as a pop artist. Café Le Metro carried on the poetry reading tradition that had been established at Greenwich Village coffeehouses, such as the Gaslight, during the 1950s. A brief account by Warhol of his existence back then appeared in *The Philosophy of Andy Warhol:* "I'd be making the rounds looking for jobs all day, and then be home drawing them at night. That was my life in the 50s: greeting cards and watercolors and now and then a coffeehouse poetry reading."[30]

Warhol's attendance of poetry readings during the 1950s should be understood within the context of a range of related activities with which he involved himself in that decade when he flourished as a commercial artist, such as his collaboration with the poet Ralph Pomeroy on the book *A la recherche du shoe perdu* (see figs. 4 and 5), his creation of art that includes what might be his own poetry (see fig. 8), and his acquisition of copies of *Semi-Colon,* the literary mimeograph publication produced by Tibor de Nagy Gallery.[31] All three of these activities are rooted in the visual artist-poet milieu that was prevalent in the 1950s, a milieu in which Warhol was as engaged as the artists who are ordinarily discussed in terms of artist-poet interactions of this period (Grace Hartigan or Larry Rivers, for example).[32]

Thus, when Warhol started attending poetry readings with Gerard Malanga in 1963, he was continuing what was for him a fairly routine activity. The two made suitable companions at these performances, since Malanga, like Warhol, was immersed in the painter-poet interrelationships—personal, social, and artistic—that were commonplace in New York at the time.

The poetry reading was one arena in which Malanga developed the painter-poet motif. This motif looms large in an announcement for his February 1964 Wednesday night reading at Café Le Metro, the design of which underscores Malanga's association with Warhol (fig. 34).[33] On the left of the collage composition is a profile view photograph of Malanga facing toward a small reproduction of a 1964 self-portrait painting by Warhol (in an anachronistically ornate frame). The juxtaposition of these portraits makes a patent connection between Malanga and Warhol: the combination of the profile view with the mug-shot-like frontal view implies that the two images together make up the two components of a standard police identification picture.

The mug shot as a subject was at the center of an intriguing literary and visual exchange between Warhol and various poets concerning the idea of the

Fig. 34. (*above, left*) Gerard Malanga, flyer announcing a poetry reading by Malanga at Café Le Metro, 5 February 1964. Collection of the Archives Study Center, The Andy Warhol Museum, Pittsburgh, Penn. Reproduced by permission of Gerard Malanga.

Fig. 35. (*above, right*) Gerard Malanga, flyer announcing a poetry reading by Malanga at Leo Castelli Gallery, 16 December 1964. Collection of the Archives Study Center, The Andy Warhol Museum, Pittsburgh, Penn. Reproduced by permission of Gerard Malanga.

artist as criminal, as will become apparent in chapter 4. Here I want to simply note that the use of portraits of both Malanga and Warhol in this instance foregrounded the link existing between poet and painter in much the same way that double portraits of the two did. In other words, ephemera such as this poetry-reading flyer, like the double portraits discussed in chapter 1, provided visual information—in this case of the sort that lends itself to multiple interpretations—about relationships between people.

To a similar effect, Malanga included one of the double-portrait photographs of him and Warhol (fig. 15) on the flyer announcing another one of his poetry readings (fig. 35). This reading occurred at Leo Castelli Gallery in December 1964. It was fairly common at the time to hold poetry readings at art galleries (see for example fig. 52), and such events belong, of

67

Fig. 36. Gerard Malanga reading his poetry at Leo Castelli
Gallery, 16 December 1964. Photograph © Archives Malanga.

course, to the prevalent visual art-poetry connections underlying this discussion.

These connections permeate Malanga's Castelli reading announcement. The reading was held in conjunction with the exhibition of Warhol's Flower paintings then on view at the gallery (fig. 36), which led Malanga to envision his performance as a collaboration between himself and Warhol. This conceptualization of the reading is immediately evident in the first words of the flyer, "Poem Visuals by Andy Warhol and Gerard Malanga." Here Malanga implied that his poetry and the art on view were, rather than distinct entities, pieces of a kind of *Gesamtkunstwerk*.

Although Warhol does not seem to have been a participant in either

68

the conceptualization of the reading or the reading itself (and according to Malanga, the artist turned up only at the end of it),[34] in Malanga's mind the event was a collaboration between the two. Indeed, it was quite typical of Malanga to test, often in intriguing ways, the limits of the then newly vital notions of collaboration and authorship with which Warhol, who in some ways served as a mentor to Malanga, was so engaged. "Mental collaboration" would be a fitting appellation for this sort of enterprise.

The calligraphic text used for the Castelli reading announcement is a component of this mental collaboration, and, like the photographic portrait of Warhol and Malanga that accompanies it, was meant to underscore Malanga's connections with Warhol. The script replicates the style of writing routinely used by Warhol in his commercial and other work of the 1950s, such as in *Blue Butterfly Day* (fig. 8). This script was actually the handwriting of the artist's mother, Julia Warhola.[35] Since some of the poems that Malanga recited at the reading were about fashion, as the word "Fashion" in the announcement is meant to indicate, it makes sense that he adapted this detail from Warhol's other life as a commercial artist who had several clients in the fashion industry. His adaptation of Julia Warhola's script, then, contributed to a consonance between form and content that Malanga set out to establish in his announcement.

Even the snake and three stars that punctuate the script of Malanga's flyer are taken from Warhol's commercial work, and specifically from work for clients in the fashion business. These two images appear on the cover of a coloring book that Warhol designed for the leatherwear company Fleming Joffe, Ltd., which specialized in reptile products (hence the snake). Moreover, the snake is included in some of the work Warhol did for this company in which poetry by Ogden Nash (written expressly for Fleming Joffe) in Julia Warhola's handwriting is combined with imagery by Warhol (fig. 37).

It is likely, then, that in his Castelli reading announcement, Malanga made an association with the merging of poetry and fashion of the Ogden Nash series. When Malanga began working as Warhol's fine art assistant in 1963, Warhol was still doing work for Fleming Joffe, and Malanga was fully aware that his employer continued doing commercial work after he had already become well known as a pop artist.[36] Indeed, Malanga has recalled that Warhol possessed Letraset pages of his mother's handwriting for use in his commercial work, which Malanga used for the text of the reading announcement.[37] The snake and star images on the announcement also came from this Letraset.[38]

The New Eden*

The serpent that deluded Eve
Would find it difficult to believe
That in America all the breaks
go to the ladies, not the snakes,
For modern girls at serpents scoff
And buy their skins from Fleming-Joffe.
Jentra

* a poem by ogden nash

Andy Warhol

Fig. 37. Andy Warhol and Ogden Nash, *The New Eden,* advertising publication for Fleming Joffe, Ltd., ca. 1962. © 1997 Andy Warhol Foundation for the Visual Arts / Artists Rights Society (ARS), NY.

In their new context within Malanga's poetry reading announcement, the significance of these two images acquires a new accent. The emphasis is placed on the homoerotic suggestiveness of the snake, due to its placement below the photograph of Malanga and Warhol and alongside their names, and the stardom suggested by the stars, which are placed beside Malanga's name.[39]

Another element of the Castelli announcement that weds it to the visual artist-poet motif is the presence of the word "Disaster." It refers to both Warhol's Death and Disaster paintings—several of which Malanga had assisted Warhol in silkscreening—and a group of poems inspired in part by the paintings. Malanga read some of these poems at the Castelli event. The poem "Fresh Death," for instance, contains what on one level is a descriptive analysis of the painting *Black and White Disaster* (1963) (fig. 38):

> He thought then of the fire
> Man holding a child in his arms
> Thirty times till his face and his arms and the child

70

Are all undefined, as if the paint tore up, the figures

Dissolving in water and smoke.

Malanga later published "Fresh Death" alongside a reproduction of *Black and White Disaster* in his 1971 book *Chic Death* (a title he had already formulated in the mid-1960s for a never-realized magazine),[40] which includes several of the poems that he presented at Castelli Gallery in 1964.

Other poems read by Malanga at Castelli associate death and human catastrophe with fashion as an echo of such associations in the Warhol works on exhibit at the gallery. A painting showing Jackie Kennedy shortly after her husband's assassination was on view in the back room and, as Charles F. Stuckey has observed, thereby served to underscore the funereal connotation of the flower imagery on exhibition in the main gallery.[41] The connotation is also apparent within the Flower paintings themselves, in the black silkscreened grass of the backgrounds, which plays off the fashionably bright colors of the petals (fig. 39; see also pl. 2).[42] Similarly, Jackie Kennedy silkscreened

Fig. 38. Andy Warhol, *Black and White Disaster*, 1963. Los Angeles County Museum of Art. Gift of Leo Castelli Gallery and Ferus Gallery through the Contemporary Art Council. © 1997 Andy Warhol Foundation for the Visual Arts / Artists Rights Society (ARS), NY.

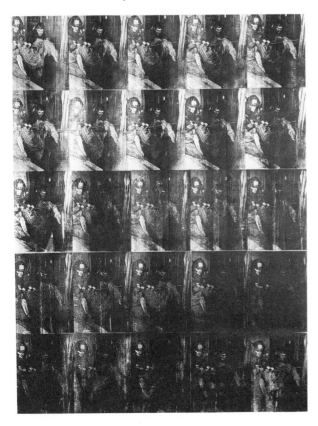

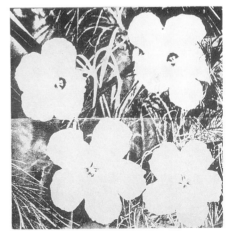

Fig. 39. Andy Warhol, *Flowers*, ca. 1964. Private collection. © 1997 Andy Warhol Foundation for the Visual Arts / Artists Rights Society (ARS), NY.

71

in black on a "designer" lavender ground stands for the death of the President but also for fashion, since being a fashionable woman was so important an element in her public persona as First Lady.

Among the poems Malanga recited at his Castelli reading that consciously reflect Warhol's visual associations of disaster, death, and fashion is "The Young Mod." This poem, dedicated to the model Jean Shrimpton, consists largely of language that mimics or is copied from the captions routinely accompanying fashion photographs—until we reach the last three lines, where the scene abruptly and potently shifts to an automobile accident (see fig. 42). The description of the accident immediately brings to mind certain Death and Disaster paintings, such as *Green Disaster Ten Times* (1963) and *Saturday Disaster* (1964) (figs. 40 and 41).[43]

"The Young Mod" is one of several poems that Malanga combined with press photographs of horrific deaths in a fascinating series of poem-pictures

Fig. 40. (*below, left*) Andy Warhol, *Green Disaster Ten Times,* 1963. Museum of Modern Art, Frankfurt. © 1997 Andy Warhol Foundation for the Visual Arts / Artists Rights Society (ARS), NY.

Fig. 41. (*below, right*) Andy Warhol, *Saturday Disaster,* 1964. Rose Art Museum, Brandeis University, Waltham, Massachusetts, Gevirtz-Mnuchin Purchase Fund. © 1997 Andy Warhol Foundation for the Visual Arts / Artists Rights Society (ARS), NY.

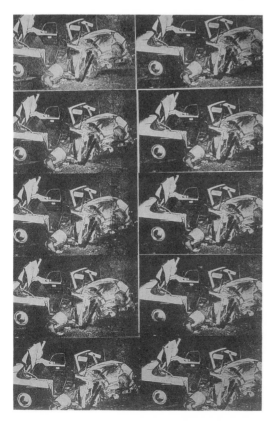
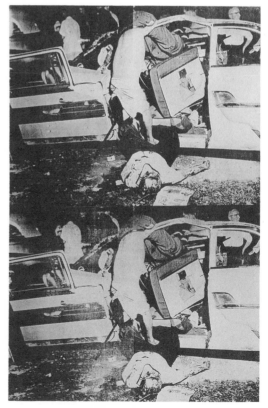

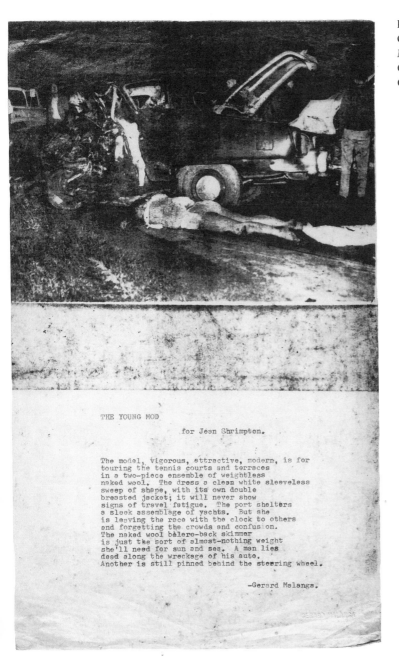

Fig. 42. Andy Warhol and Gerard Malanga, *The Young Mod*, ca. 1964. Collection of Gerard Malanga. Thermofax © Gerard Malanga.

THE YOUNG MOD

for Jean Shrimpton.

The model, vigorous, attractive, modern, is for
touring the tennis courts and terraces
in a two-piece ensemble of weightless
naked wool. The dress a clean white sleeveless
sweep of shape, with its own double
breasted jacket; it will never show
signs of travel fatigue. The port shelters
a sleek assemblage of yachts. But she
is leaving the race with the clock to others
and forgetting the crowds and confusion.
The naked wool balero-back skimmer
is just the sort of almost-nothing weight
she'll need for sun and sea. A man lies
dead along the wreckage of his auto.
Another is still pinned behind the steering wheel.

—Gerard Malanga.

made during 1964 and 1965 (fig. 42). Malanga's poetry reading title, "Poem Visuals by Andy Warhol and Gerard Malanga," refers partly to these works. The photographic images—a car crash in the case of "The Young Mod" (complementing the crash described at the end of the poem)—were copied onto sheets of paper using a Thermofax, a wet-process copier machine (a kind of Xerox of its day) that Warhol had at the Factory.[44] After a copy of the photo-

73

Fig. 43. Andy Warhol and Gerard Malanga, *To the Young Model, Name Unknown (photographed by Francesco Scavullo)*, ca. 1964. The Menil Collection, Houston. Thermofax © Gerard Malanga.

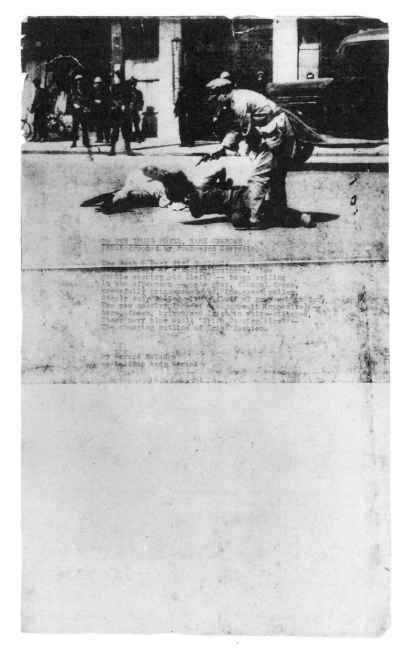

graph was made, the poems were either written by hand or, as in "The Young Mod," typed onto the Thermofax sheet.

Another poem from the Castelli reading that was also incorporated into a Thermofax poem-picture is "To the Young Model, Name Unknown (photographed by Francesco Scavullo)" (fig. 43). Once again the poem is based on fashion copy, but it lacks the reference to disaster of "The Young Mod." This makes its placement beneath a Thermofaxed image of a ruthless, politically motivated street execution especially chilling. Particularly effective in this regard is the positioning of the title, which refers to an actual fashion photograph, directly under the gruesome picture, as if it were a caption to the execution.[45]

Thus, in both the Thermofax poems and at the Castelli reading, Malanga's words were intended to correlate with pictures. At the reading an oblique reference to the Flower paintings on view is evident in the line "The flowers painted black by friendships" of the sonnet "The Hyphenated Family,"[46] which brings to mind the black backgrounds of Warhol's paintings (see fig. 39). Another poem, "To Come and Leave Nothing Behind," was dedicated to Freddy Herko,[47] whose dramatic suicide in the summer of 1964 Warhol himself had memorialized by dedicating one of his Flower paintings to Herko.[48] As with the Warhol Flower banners at the Peace Eye Bookstore, context means a great deal; the dedication of such a painting to Herko connects it with death, while Malanga played off this signification by consecrating a poem to Herko at the reading in the midst of a gallery full of Flower paintings (see fig. 36). Malanga's mention of Herko, then, was one of the many ways—some obvious and others subtle, as in this instance—that he connected his writing with Warhol's work.

An important source for Malanga's "poem visuals" was dada work that combined painting and poetry, which he had encountered as a student of Daisy Aldan and which was enjoying a general revival within avant-garde circles during the 1950s and 1960s. The artist Robert Motherwell's well-known 1951 compendium *The Dada Painters and Poets* is an index of—and contributed to—this dada painter-poet revival.[49] Frank O'Hara reminisced in 1965 that this book was, during the 1950s, "The Gospels [*sic*] for myself and many other poets."[50] The book's title highlights the dada penchant for bringing together painting and poetry, while within its pages were examples of the movement's general zeal for painting-poetry relations, as in, for example, Hugo Ball's 1916 declaration, "The word and image are one. Painting and composing poetry belong together."[51]

75

Fig. 44. "Pop Art, Poetry and Fashion," *New York* (magazine section of the *Herald Tribune*), 3 January 1965.

Pop Art, Poetry and Fashion

by Eugenia Sheppard

Pop art may have come first and become more famous, but pop fashion followed soon after. They meet these days at the art galleries. Just recently, to show how they go together, we asked to photograph some new clothes at the Leo Castelli Gallery, one of the temples of pop art. Poet Gerry Malanga was reading his works to a jam-packed crowd (overflow lines of people waited outside hoping to get in) with a back-drop of Andy Warhol's paintings. Actually, the clothes we brought turned out to be much less pop, or more square, to put it affirmatively, than the pop fashions the crowd was wearing. Men were in wild fur coats. Women ran the gamut from blue jeans and dingy turtle neck sweaters to a black mink coat, elegant but worn backwards. Writer Ann Buchanan was trailing an old-time calico dress that reached to the floor.

Gerard Malanga (two of his poems are reprinted here) is a 21-year-old poet whose work has appeared in the *New Yorker*, *Poetry Magazine*, and the new international review *Art and Literature*. That's for fun. For work he is Warhol's associate in his all-purpose studio where paintings and experimental movies are produced. The star of several of these movies himself, his most recent role was in what may be the first big budget underground movie, a 70-minute sound movie, a take-off on the Jean Harlow cult, which cost $4,000. Malanga's next project is to publish a magazine called *Chic Death*, which, as Malanga says, will "combine the death image with fashion, using fashion models posing in front of automobile wrecks."

Fig. 45. "Pop Art, Poetry and Fashion," *New York* (magazine section of the *Herald Tribune*), 3 January 1965. Poem, © Gerard Malanga, reprinted by permission of the author.

76

Yeah Yeah

The romantic idea—
pervasive and entirely personal.
Small-boned and fragile
in black Chantilly lace—
shadowing nude silk.
Its ruffles blowing restlessly
around the neck,
on the arms, on the knees.

On some rainy morning this spring
you pull on a little chopped
silk raincoat printed in fresh grass
greens, small matching boots,
the shimmer of legs
under transparent dark-lace stockings.
—GERARD MALANGA

Left: At left, Anne Goodman in Rudi Gern-
reich's purple and red stripe dress. She's one
of the women in Andy Warhol's movie, "The
Thirteen Most Beautiful Women." Center, a
lavender lightweight challis dress with band at
hip in pink. By O'Brien-Morris, $100 at Robert
Leader. Far right, Poet Gerard Malanga.

Right: Magenta, tobacco and black horizontal
stripes in a two-piece double-knit dress. By
Rudi Gernreich for Harmon Knitwear, it is
$45 at Lord and Taylor. Available mid-January.

(Continued on next page)

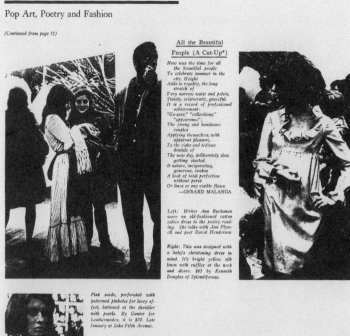

Fig. 46. "Pop Art, Poetry and Fashion," *New York* (magazine section of the *Herald Tribune*), 3 January 1965. Poem, © Gerard Malanga, reprinted by permission of the author.

Of special interest to poets in *The Dada Painters and Poets* were the instructions written up by Tristan Tzara for making collage poems by cutting out each word of a newspaper article and then reassembling them in an arbitrary order.[52] Malanga's disjunctive positionings of fashion copy with press photographs in such works as the Thermofax versions of "The Young Mod" and "To the Young Model, Name Unknown" derive from Tzara's poetry-writing method and variations of it that were developed during the 1950s, notably in the "cut-up" technique that William Burroughs began exploring in that decade with some of his friends.[53] Malanga was aware of these explorations, for he at the time labeled as a "cut-up" one of the poems he read at Castelli, "All the Beautiful People," when it was published as part of a story about the Castelli affair in the 3 January 1965 issue of *New York* (then the Sunday magazine section of the *Herald Tribune*) (see fig. 46).[54]

The generously illustrated three-page *New York* story (figs. 44–46) conveys to its audience that Malanga's reading was, among other things, a media event. In this regard, the reading belonged to the media-captivated side of Warhol's world, but also, as already noted, to the poetry reading world that was characterized, for example, in Ed Sanders's story "The Poetry Reading."

The photographs that appeared in the *New York* coverage show the poet and audience mingling, and illustrate what they are wearing, rather than showing the poetry reading itself. This emphasis on who and what can be explained by the fact that a fashion show took place concurrently with the actual reading, and indeed was the ostensible reason for the existence of the article. But neither Malanga nor Warhol had anything to do with this fashion show.[55] Nonetheless, the show fit well with the subject matter of poems such as "The Young Mod" and with Warhol's colorful Flower paintings, and, more broadly, his predilection for seeing the connections between fine art and fashion.

This congruence between poetry, art, and fashion is exactly what *New York* emphasized—in both implied and straightforward ways. An implied correlation of Malanga's verse to the fashion show is found in the positioning of the two poems published in the article contiguous to captions that describe the items displayed at the fashion show (see figs. 45 and 46). Thus we have a description of a "lavender lightweight challis dress with band at hip in pink" directly beneath lines of a poem that are based on similar fashion copy:

> a little chopped
> silk raincoat printed in fresh grass
> greens, small matching boots,
> the shimmer of legs
> under transparent dark-lace stockings.

(Interestingly enough, none of the poems combining fashion and disaster were reproduced in the article. The *Herald Tribune* editors may have deemed such work too disturbing for the magazine.)

More straightforwardly, the title of the *New York* story—"Pop Art, Poetry, and Fashion"—emphasized the confluence of genres, as does the two-paragraph article by the columnist Eugenia Sheppard that served as an introduction to the photographs and poems (see fig. 44): "Pop art may have come first and become more famous, but pop fashion followed soon after. They meet these days at the art galleries. Just recently, to show how they go together, we asked to photograph some new clothes at the Leo Castelli Gallery, one of the temples of pop art. Poet Gerry Malanga was reading his works to a jam-packed crowd (overflow lines of people waited outside hoping to get in) with a backdrop of Andy Warhol's paintings."

While on one level this amalgam of fashion, poetry, and visual art was mutually beneficial to all parties in terms of press coverage, it was also part of what can be called a worldview of culture. Malanga's mental collaborations fit

into such a worldview; while they allowed him to employ Warhol's name to further his own poetry career (Warhol often used poets for this same purpose), they were simultaneously a very real component of his art. In other words, the social and the artistic were for Malanga, as for Warhol himself, fundamentally interwoven. For both, the boundaries between art and life existed in order to be transgressed. When Malanga included the words "new realism" in the title of his Castelli Gallery reading (see fig. 35), it was exactly this concept of artistic creation that he had in mind.

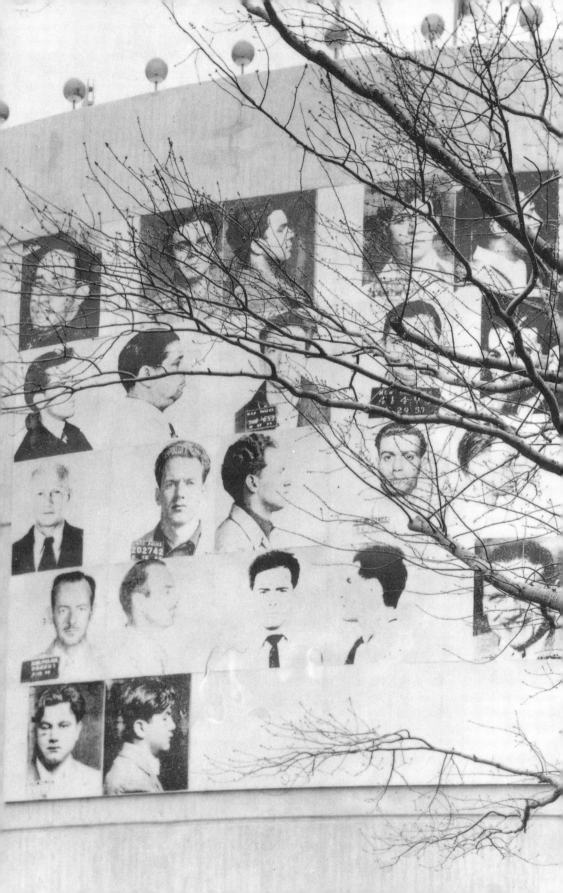

Artistic Appropriation and the Image of the Poet as Thief

4

Embedded in Gerard Malanga's inclusion of the term "new realism" in his 1964 Castelli reading was a range of interconnected ideas that a number of poets were exploring during the mid-1960s. The term was taken from a poem by John Ashbery, entitled "The New Realism." For Malanga, "new realism" came to stand for a way of creating art—and of living—that paralleled Warhol's practices and raised compelling questions about copying (or "stealing") words and images, about authorship, and about identity. Ashbery, Malanga, Ted Berrigan, Ron Padgett, Rene Ricard, and Warhol developed these questions through artistic "conversations" of great subtlety and richness. I now want to consider how Malanga and his colleagues worked through these questions in their art, and how these questions are grounded historically in the idea of the poet as thief, especially as represented by the figure of Jean Genet.

Ashbery included the poem "The New Realism" in his 1962 book *The Tennis Court Oath*. Although scathingly criticized in the press for its radical departures from traditional methods of composing poetry, the book for this same reason was truly momentous to Malanga and several of his poet friends (and in the long run may prove to be one of his most significant works).[1] Ashbery's use of dada-like collage techniques, phrases copied from a wide range of texts, disjunctive language, and media-saturated imagery was emu-

lated in intriguing ways by the younger generation of New York-based poets. This passage from Ashbery's "The New Realism" provides a good illustration of the kind of writing to which these poets were drawn:

> The arboretum is bursting with jasmine and lilac
> And all I can smell here is newsprint
> The tea went down
> All went down easily
> He keeps coming back, the curse
> of pliant dawns[2]

Malanga's first contact with Ashbery's work occurred around 1962, when some of Malanga's poems were published in the journal *Locus Solus*, which Ashbery coedited.[3] Malanga had learned of Ashbery through the poet Kenneth Koch. Koch was also an editor of *Locus Solus*, and Malanga attended his writing workshops at the New School for Social Research during 1961–62 and in the spring of 1963.[4] Ashbery's use of collage would have had a familiar ring to Malanga, since he had already written collage poems as a high school student in Daisy Aldan's classes.[5] Malanga often incorporated bits and pieces of an Ashbery poem into his own work. One of the earliest instances of this practice was in the following poem dedicated to Warhol and written shortly after Malanga had begun working for the artist:

NOW IN ANOTHER WAY for Andy Warhol

> Gradually it is the exultant cement factory that becomes us.
> I am thinking that the hand trembles like the obsessive
> lumberyard of a phrase
> As she stands confident beside the glamorous vending machine.
> And as her mouth finds for itself a drinking fountain
> Now in another way I become more involved
> with the uncontrolled climate of her breath
> For as long a time as this poem lasts and lasts,
> Like the difficult dawn of an arched eyebrow misplaced.
> Now in another way pausing at the end of a paintbrush,
> The artist is stretching and stapling as the determined look
> of somewhere ahead
> Becomes two faces destroying themselves, that turn black
> with repetition.[6]

The title of the poem, "Now in Another Way," is a line of Ashbery's "A Life Drama," from *The Tennis Court Oath*.[7] Malanga uses the line twice within the poem. It is repeated, just as the "two faces" at the end of the poem "turn black with repetition" (clearly a reference to Warhol's method of silkscreen painting). Malanga here used Ashbery's words in such a way as to produce a parallel between the painter and the woman for whom the speaker has a romantic yearning. To this end, he positioned the phrase "now in another way" within a passage about the woman and within one about the painter.[8] Combined allusions to Ashbery, Warhol, and a love interest appeared regularly in Malanga's work of the mid-1960s, and the connection he draws between Ashbery and Warhol is rooted partly in Ashbery's activity as an art critic at the time.

Ashbery himself was intrigued by Warhol's work, and by pop art generally, during the 1960s. He, like Frank O'Hara, was an art critic as well as a poet. Also like O'Hara, he made visual art an integral component of his verse-making. However, in contrast to O'Hara, Ashbery was receptive to pop art from its inception and was sensitive to its relation to his own poetry. Even so, critics who have considered the relevance of visual art to Ashbery's poetry have usually linked it to abstract expressionism or to the work of Jasper Johns and Robert Rauschenberg, not to pop art (as was also true of O'Hara's critics).[9]

Ashbery was perhaps more open to pop art than O'Hara because he was living in Paris when it emerged—he lived there from 1955 to 1957, and from 1958 to 1965[10]—and thus was somewhat removed from the battle over style that pop art provoked among artists of the previous generation who were his and O'Hara's friends. Moreover, in Paris Ashbery developed friendships with artists (such as Niki de Saint-Phalle) whose work was similar to pop and categorized as "new realist," a label put into circulation by the French art critic Pierre Restany.[11] This label, which can be traced back to earlier twentieth-century French writing on art—specifically, an essay by the painter Fernand Léger—was the source for the title of Ashbery's poem "The New Realism."[12]

Ashbery's interest in this art led him to contribute an essay to the catalog of the landmark *New Realists* exhibition that was held at the Sidney Janis Gallery in 1962 and displayed both European new realism and American pop art, including at least three works by Warhol (fig. 47).[13] This was the first exhibition of pop art at a 57th Street gallery—up to this point it had only been shown downtown—and some of the abstract expressionists Sidney Janis represented were so threatened by the exhibition that they disassociated themselves from the gallery altogether.[14] But Ashbery did not take sides in this con-

83

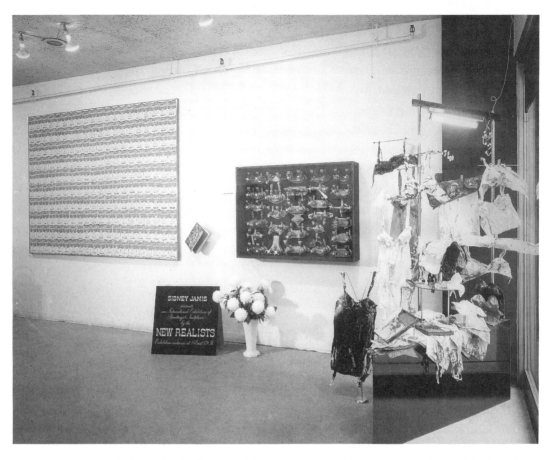

Fig. 47. Installation, "New Realists" exhibition, Sidney Janis Gallery, New York, 1962, with view of Andy Warhol's painting *200 Campbell's Soup Cans*. Reproduced by permission of the photographer, Jim Strong. Photograph courtesy of the Sidney Janis Gallery, New York.

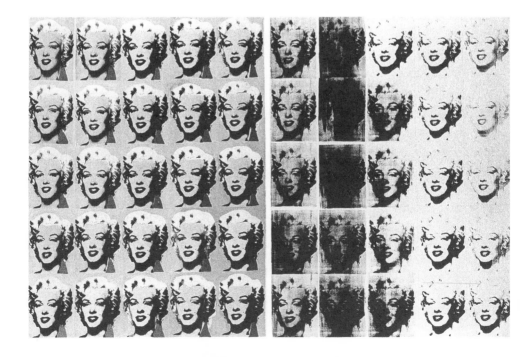

flict. In his essay for the Janis Gallery exhibit, he explained that new realism is the European term for current art that "in one way or another makes use of the qualities of manufactured objects," and that it represents "an advanced stage of the struggle to determine the real nature of reality which began at the time of Flaubert" and attempts to "come to grips with the emptiness of industrialized modern life."[15] Ashbery's explanation of this art encompasses many of the ideas he explored in his poem "The New Realism," in which he evoked the emptiness of modern life through juxtaposing "buzzing soda water" and the "grim engine" of industry with "blackening" space and "blankness":

> The one with peach halves and violets
> And buzzing soda water
> Out of the serene
> Blackening with space, its blankness
> Cast waterward, the grim engine
> Chugging [. . .][16]

Ashbery made another point in the exhibition catalog essay that was central to his poetry: the definition of art itself is unclear, as Marcel Duchamp had shown by using everyday objects as art in his "readymades" of the 1910s. As Ashbery expressed it, "What these artists are doing is calling attention with singular effectiveness to the ambiguity of the artistic experience; to the crucial confusion about the nature of art, which, let us remember, has never been properly defined."[17]

Ashbery viewed ambiguity as an inevitable component of art's place in the world. He admired the work of Warhol for what he perceived as its ambiguity when he first saw it in a group exhibition of American pop art held at the Paris gallery of Ileana Sonnabend in 1963. (Ashbery did not attend the *New Realists* exhibit of the previous year.) In a review of the Sonnabend show, he wrote, "Warhol's Marilyn Monroe repetitions [fig. 48], which I had not particularly noticed in reproduction, impressed me with their strength, their hardness and their absolute uncontrovertibility. Unlike Rosenquist's and Wesselmann's ambiguity, Warhol's is unambiguous; it makes a direct and unformulable point."[18] It is clear that Ashbery envisioned Warhol as a kindred spirit. The paradoxes that he perceived in Warhol's art—the "unambigu-

Fig. 48. (*opposite*) Andy Warhol, *Marilyn Diptych,* 1962. Tate Gallery, London. © 1997 Andy Warhol Foundation for the Visual Arts / Artists Rights Society (ARS), NY.

ous" ambiguity and the "direct and unformulable point"—were what he had aimed to produce in the poems of *The Tennis Court Oath*.

Shortly after writing this review, in September 1963, Ashbery met both Warhol and Malanga while on a trip to New York, on which occasion he gave a poetry reading at the Living Theatre.[19] This reading was a major literary event for poets such as Malanga, Berrigan, and Padgett, who were extremely enthusiastic about *The Tennis Court Oath* and now finally had the opportunity to hear, see, and meet its author.[20] All three poets attended the reading. There was also a party given for Ashbery by Frank O'Hara, where Ashbery probably met Malanga.[21] Ashbery remembers also meeting Warhol on this trip when Malanga took him to Warhol's studio.[22]

A few months later, Ashbery wrote an essay about Warhol's Death and Disaster paintings for the catalog of Warhol's first one-person exhibition in Paris (fig. 49). Ashbery's focus here was on how Warhol's use of press photographs in his silkscreen paintings echoed the unreliable nature of our knowledge of things and events when we learn about them through the media. He noted, "One cannot really say what is taking place in most of the photographs published by the press, above all when one views them as if like a rubbing on the surface of a kitchen table oilcloth (which is of course on par with our

Fig. 49. Installation, "Warhol" exhibition, Galerie Ileana Sonnabend, Paris, 1964. Reproduced by permission of the photographer, Harry Shunk, and Sonnabend Gallery.

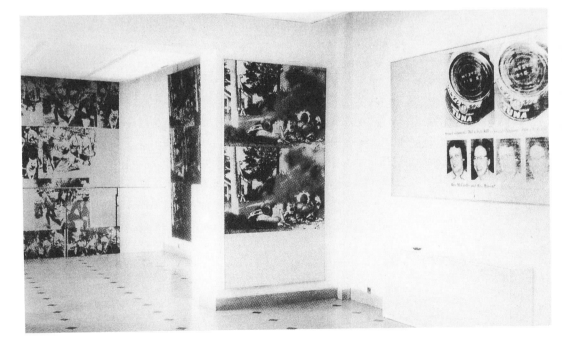

inability to discern the real nature of an event—what exactly happened—when we read a newspaper report)."[23] Ashbery himself had already explored the pervasiveness and limitations of the media's handling of the tragedies of contemporary life in several of the poems brought together in *The Tennis Court Oath* in such passages as "SECOND FUNERAL / [. . .] I was reading *Vogue* in the car,"[24] "to be dying, he gets them into magazines," and "solidifying disguises / / who died in an automobile accident / had developed a / then, imperceptibly."[25]

Our inability to know the truth of what we encounter in the newspaper—and in other corners of life—remained on Ashbery's mind, and he explored such limitations of knowledge extensively in a lengthy, powerful, and rather bleak (if partly parodic) poem, entitled "The Skaters," which he began writing around the time of the Warhol Death and Disaster exhibit.[26] In this poem, the agitated speaker ponders our distance from the events reported in the newspaper while observing that a revolution in Argentina is "offered as 'today's news,'" and suggests that we "have another—crime or / revolution? Take your pick."[27] Furthermore, allusions to, among many other things, works by Warhol seem to be woven into the challenges of the present-day world that are represented in "The Skaters." For example, the *Marilyn* paintings are evoked by these lines:

> Besides the storm is almost over
> Having frozen the face of the bust into a strange style with the lips
> And the teeth the most distinct part of the whole business.[28]

And, to take another example, Warhol's trademark use of repetition and his paintings *Red Race Riot* and *Mustard Race Riot* (figs. 50 and 51; see also pls. 3 and 4)—on view at the 1964 Sonnabend Gallery Death and Disaster exhibit (see fig. 49)—are brought to mind by this more critical passage:

> and all the clumsy seductions and
> amateur paintings done,
> Clamber to join in the awakening
> To take a further role in my determination. These clown-shapes
> Filling up the available space for miles, like acres of red and
> mustard pom-poms
> Dusted with a pollen we call "an air of truth." Massed mounds
> Of Hades it is true. I propose a general housecleaning
> Of these true and valueless shapes which pester us with their
> raisons d'être
> Whom no one (that is their weakness) can ever get to like.[29]

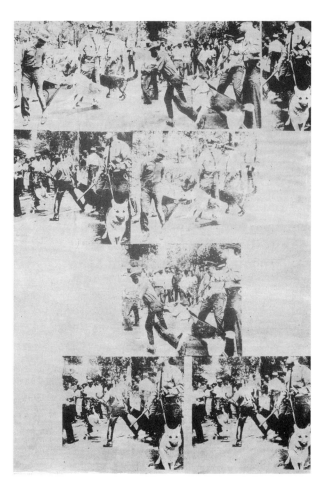

Fig. 50. Andy Warhol, *Red Race Riot,* 1963. Museum Ludwig, Cologne. © 1997 Andy Warhol Foundation for the Visual Arts / Artists Rights Society (ARS), NY.

Although these passages seem to contain allusions to paintings by War-hol, we cannot be sure they do, nor can we be certain that the speaker is Ashbery, and our inability to know was Ashbery's intention. He created in his poem a world of information that is as uncertain as the newspaper reports he described in it.[30] Concealment played a major role in this endeavor. A lot of what prompted this poem (and many others) is not overtly present in the poem, as Ashbery has stated.[31]

In this regard, Ashbery's approach to incorporating visual art into his po-etry is distinct from that of many other poets in his milieu, including Frank O'Hara, and also Malanga, whose allusions to both Ashbery and Warhol are deliberately very apparent. Thus, when Malanga took the passages from "The Skaters" evoking the *Marilyn* and *Race Riot* paintings and transformed them

88

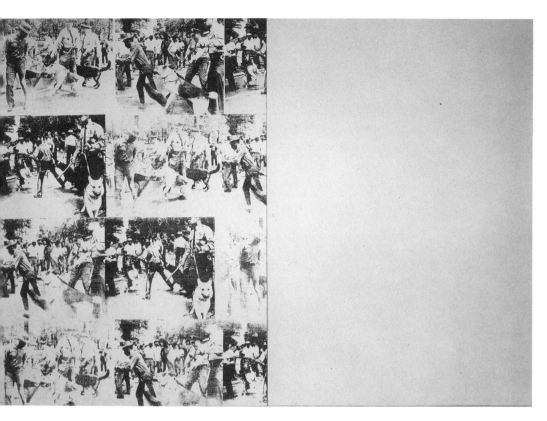

Fig. 51. Andy Warhol, *Mustard Race Riot,* 1963. Private collection. © 1997 Andy Warhol Foundation for the Visual Arts / Artists Rights Society (ARS), NY.

in his poem "A" (which was dedicated to Ashbery), what were in Ashbery possible allusions to Warhol now became definite ones, almost as if they were translations or decodings of Ashbery's poetry:

> All the while they were talking of the New Realism
> Thirty-six faces with teeth exploded at one time.[32]

and

> a canvas
> Bag already filled with a gathering of flowers, row
> Upon row of faces placed evenly and with
> Identical speed; [. . .][33]

While Malanga routinely adapted Ashbery's poetry in his work of the mid-1960s, he had a special reason for wanting to create adaptations from "The Skaters." For in this poem Malanga is mentioned by name, within a list of pieces of bad news:

> And I try to sort out what has happened to me. The bundle
> > of Gerard's letters,
> And that awful bit of news buried on the back page of
> > yesterday's paper.
> Then the news of you this morning, in the snow.
> > Sometimes the interval
> Of bad news is so brisk that . . . And the human brain, with its
> > tray of images
> Seems a sorcerer's magic lantern, projecting black and orange
> > cellophane shadows[34]

Ashbery did not provide the sort of information needed for us to know why he mentioned a "bundle of Gerard's letters" here, although its inclusion among "bad news" gives it a negative tone.

Ashbery recited "The Skaters," as well as "The New Realism," in a reading he gave on his next trip to New York in August 1964 (fig. 52).[35] The reading was held at the Washington Square Art Gallery and, like his New York reading of the previous year, was a special occasion for many poets; among those in the audience were Allen Ginsberg, Barbara Guest, Taylor Mead, Bill Berkson (who introduced Ashbery), and Malanga. Warhol was there, too (fig. 53). As he listened, Warhol undoubtedly recognized the connections between what he heard and his own work. It was surely at least in part on account of those connections (and perhaps in part because of Ashbery's support of Warhol's art) that Warhol was fond of Ashbery's poetry. In an interview several years later, when asked whether he had a favorite poet, Warhol replied, "John Ashbery, and Gerard Malanga. Do you know him?"[36]

The fact that Warhol mentioned Malanga in the same breath as Ashbery suggests he was aware that Malanga's poetry drew heavily on that of Ashbery. He certainly knew that Malanga created poetry by transforming lines written by other poets. In the book *POPism,* he recalled with characteristic deadpan humor, in describing life at the Factory in 1965: "Gerard was usually over in a corner doing poetry that he based on lines from other people's work, so he would have an open book in one hand and be writing poetry with the other."[37] Warhol also stated in retrospect, during an interview with the poet David Shapiro, that he was fascinated by Malanga's approach to writing: "I would like to be like Gerard. I think that I am fascinated by Gerard. I mean Gerard Malanga. How Gerard can write poetry, that is something I could never understand. I mean, can you understand it? I mean, the way he can

90

Fig. 52. Fred W. McDarrah, John Ashbery reading his poetry at the Washington Square Art Gallery, August 1964. © Fred W. McDarrah.

Fig. 53. Fred W. McDarrah, view of audience, John Ashbery poetry reading, Washington Square Art Gallery, August 1964, with Barbara Guest, Andy Warhol, Taylor Mead, John Gruen, and, with back to camera, Allen Ginsberg. © Fred W. McDarrah.

write it. I'm in awe to see that he takes, let's say, a sentence here and another one there, and then he puts them together and it sounds real, and therefore is true. I mean, it is really fascinating."[38] Shapiro then asked Warhol whether Malanga was influenced by him in his use of found materials. Warhol replied no and explained that Malanga was already writing in that fashion when Warhol met him.[39] Nonetheless, Warhol certainly understood the connections between his and Malanga's work.

For Malanga, as for Warhol, listening to Ashbery recite "The Skaters" at the 1964 reading had a personal dimension. In fact, Malanga responded to Ashbery's reference to him in the poem and mentioned the very date of this poetry reading in his poem "A." In "A," Ashbery, who was Malanga's senior

Artistic Appropriation

by over fifteen years, is portrayed as a paternal figure who has not been adequately attentive:

> The answer
> Lies in the question mark of his paternity.
> As with "the skaters" I am merely hinted at.[40]

Malanga repeats the feeling of having been neglected in a passage about a party that was held just after Ashbery's reading:

> The 23rd of
> The month of August I left "the Island
> People" a little before midnight. The room was
> Too small to hold all the friendships. "I am 37,"
> He said.[41]

The reference to "Island People" in this passage is a response to the island imagery that recurs in "The Skaters" (where it is a symbol of isolation, but also of community).[42] As with the numerous other appropriations of Ashbery's poem within "A," this imagery was a means by which Malanga communicated with—and paid homage to—his older colleague.

Malanga came to understand how to apply to his own work several of Ashbery's techniques—disjunctiveness, end-split lines, appropriation—through Berrigan, who served as a kind of mentor to Malanga (and to a number of other young poets who were his friends).[43] Berrigan's book *The Sonnets*, published in 1964, was the key that finally unlocked the door to Ashbery's poetry for Malanga.[44]

Notably, Malanga had learned from Berrigan the procedure of copying snippets of poetry that, in turn, were based on bits of other people's writing, and then imbuing these copied snippets with a new, personal meaning.[45] At times, it seems that Malanga even mined Berrigan's own adaptations of Ashbery's poetry. Consider these three passages, by Ashbery, Berrigan, and Malanga, respectively:

> We are nearing the Moorish coast, I think, in a bateau.
> I wonder if I will have any friends there
> Whether the future will be kinder to me than the past, for example,[46]

> I wonder if Jan or Helen or Babe
> ever think about me. I wonder if Dave Bearden still
> dislikes me. I wonder if people talk about me
> secretly.[47]

I wonder if Kenny Lane bought a new wristwatch today,
Or whether Charles Henri Ford is back at the *Dakota,*
And if everyone is beginning to talk about me, seriously,
For a change? [48]

These passages can be understood as pieces of a three-way conversation: Ashbery makes a statement, to which Berrigan responds, to which Malanga responds.

Early critics of Berrigan's and Malanga's writing failed to perceive the richness of this type of artistic conversation. In addition, they were unable to recognize that these two poets had turned Ashbery's language into something quite personal about themselves. In a review of *C: A Journal of Poetry,* Allan Kaplan praised the publication for being adventuresome and open to experimentation but expressed deep reservations about the numerous poems in it that seemed to be appropriated: "While reading *C,* it was my feeling that a number of poems slip past the line of being inspired by the original and, to varying degrees, are close to being adaptations of, say, Ashbery's style. Granted that these poems may be interesting in themselves and that the talent of the poet may be such that it is sometimes impossible to distinguish between the master and disciple; nevertheless, this path in the long run leads to the shadow of Ashbery and not his substance." [49]

Here Kaplan missed two key points: poets such as Berrigan and Malanga were not seeking to achieve Ashbery's "substance," but were instead seeking their own, and Ashbery's "shadow" was for them a means by which they communicated with each other and with him. It was the language of a community.

When the poet David Lehman some years later reviewed Malanga's book *Chic Death,* he was even less generous than Kaplan regarding the device of appropriating from Ashbery's work. Lehman acknowledged that the device itself was clever and could occasionally be fruitful but found that in the case of Malanga, in a poem like "A," "one experiences the unpleasant sensation of prying into a young poet's private practice sheets and homework book. Malanga's redundant use of this device is all the more annoying for being so parasitically fastened to the works of a poet as contemporary as Ashbery. Je préfère l'original, and who wouldn't?" [50]

Never mind that the original in this case was himself deeply engaged in using found language. Lehman's discomfort undoubtedly had to do with a sense that Malanga's borrowings from Ashbery were transgressive; they

93

broke the existing rules of how a poet should borrow. It is exactly this transgressive undercurrent that Malanga aimed for and that gave his work its bite. It is evident, furthermore, that behind Lehman's attack were personal affiliations. What else would explain the fact that in the same review he praised Berrigan's book *The Sonnets* as being "truly fine,"[51] when that book was similarly transgressive?

Berrigan adored the idea of composing verse by piecing together lines of poems by other writers. He loved to think about the multiple potential implications—artistic, legal, and those regarding identity—of the act of copying words. It is obvious that to write candidly about his "borrowings" gave him great pleasure and amusement. For instance, in "Personal Poem #7" (a title adapted from O'Hara's writing), he recorded that he "Made lists of lines to / steal" after reading Ashbery's poem "'How Much Longer Will I Be Able to Inhabit the Divine Sepulcher? . . .'"[52] Berrigan here played on Ashbery's own borrowings (notice the quotation marks of Ashbery's title). What intrigued him was the idea of making a copy of a copy and the question this raised about the "ownership" of words.[53]

Berrigan often linked Ashbery and Warhol in his poetic explorations of copying and ownership. He explained, regarding one of these explorations, "[M]y entire poem "Frank O'Hara's Question from 'Writers and Issues' by John Ashbery" in my book *Many Happy Returns* is entirely by John, i.e. some quotes from Frank surrounded by prose by John, which I 'found' à la Andy Warhol . . . (that is, I simply put a frame around the particular section which then became my whole poem. I neither changed nor shifted a word.) . . . I was never trying to hide what I was doing, but thought that I was extending (at least sideways) ideas used by Duchamp, Warhol, John."[54]

Berrigan experimented with the questions of copying and ownership in numerous ways, sometimes in conjunction with his friend and colleague Ron Padgett. In a review of Padgett's 1965 book *In Advance of the Broken Arm* (the title is taken from the eponymous Duchamp "readymade" of a shovel), Berrigan observed that Padgett's line "And you know and you know" was "plagiarized from John Ashbery's poem 'And You Know.'" "Ron's talent," Berrigan then explained, "may be seen in his brilliant repetition of the (Ashbery?) phrase."[55] Here, the parentheses and question mark accompanying the name Ashbery wittily underscore that because the phrase "and you know" is a common figure of speech, it simultaneously did and did not come from Ashbery's poem.

Padgett, like Berrigan and Malanga, associated his practice of copying words with Warhol's painting methods. He also wrote what he conceived of as verbal counterparts to Warhol's use of repetition, an early instance of which is the following 1963 poem, "Nothing in That Drawer" (originally entitled "Sonnet," in all likelihood to make an association with Berrigan's prolific production of sonnets at the time):

<div align="center">

Nothing in that drawer

Nothing in that drawer

Nothing in that drawer

Nothing in that drawer

Nothing in that drawer

Nothing in that drawer

Nothing in that drawer

Nothing in that drawer

Nothing in that drawer

Nothing in that drawer

Nothing in that drawer

Nothing in that drawer

Nothing in that drawer

Nothing in that drawer [56]

</div>

In composing this poem, Padgett wanted to call attention to how each line was both the same and different from the others, in the manner of Gertrude Stein, a feature of repetition that Warhol liked, too.[57]

Another sonnet that Padgett constructed out of a single repeating unit as a verbal counterpart to Warhol's work was written expressly as an homage to Warhol. It was created as a response to the movie *Sleep*. Here, the repeating unit can be viewed as being either the letter *z* or a line of thirty-five *z*'s.

SONNET/ HOMAGE TO ANDY WARHOL

```
Z  z z z z z z z z z z z z z z z z z z z z z z z z z z z z z z z z z z z
   z z z z z z z z z z z z z z z z z z z z z z z z z z z z z z z z z z z
   z z z z z z z z z z z z z z z z z z z z z z z z z z z z z z z z z z z
   z z z z z z z z z z z z z z z z z z z z z z z z z z z z z z z z z z z
   z z z z z z z z z z z z z z z z z z z z z z z z z z z z z z z z z z z
   z z z z z z z z z z z z z z z z z z z z z z z z z z z z z z z z z z z
   z z z z z z z z z z z z z z z z z z z z z z z z z z z z z z z z z z z
   z z z z z z z z z z z z z z z z z z z z z z z z z z z z z z z z z z z
```

Z Z

Z Z

Z Z

Z Z

Z Z

Z [58]

Padgett's sonnet to *Sleep* was one of a collection of writings about the film that was published in a 1964 issue of the journal *Film Culture*. Joe Brainard contributed to the collection a piece entitled "Andy Warhol's Sleep Movie," in which repetition is again the prevailing motif. After having stated in the third section of this five-part homage that "I've never really cared for sleep," Brainard then praised Warhol's film in a sequence of comically paradoxical prose statements and concluded his "essay" as follows:

PART IV

I like *Sleep.* I like *Sleep.*
I like *Sleep.* I like *Sleep.*
I like *Sleep.* I like *Sleep.*
I like *Sleep.* I like *Sleep.*
I like *Sleep.* I like *Sleep.*
I like *Sleep.* I like *Sleep.*
I like *Sleep.* I like *Sleep.*
I like *Sleep.* I like *Sleep.*
I like *Sleep.* I like *Sleep.*
I like *Sleep.* I like *Sleep.*
I like *Sleep.* I like *Sleep.*
I like *Sleep.* I like *Sleep.*
I like *Sleep.* I like *Sleep.*
I like *Sleep.* I like *Sleep.*
I like *Sleep.* I like *Sleep.*
I like *Sleep.* I like *Sleep.*
I like *Sleep.* I like *Sleep.*
I like *Sleep.* I like *Sleep.*
I like *Sleep.* I like *Sleep.*
I like *Sleep.* I like *Sleep.*
I like *Sleep.* I like *Sleep.*
I like *Sleep.* I like *Sleep.*
I like *Sleep.* I like *Sleep.*

I like *Sleep*. I like *Sleep*.

I like *Sleep*. I like *Sleep*.

I like *Sleep*. I like *Sleep*.

I like *Sleep*. I like *Sleep*.

I like *Sleep*. I like *Sleep*.

I like *Sleep*. I like *Sleep*.

I like *Sleep*. I like *Sleep*.

I like *Sleep*. I like *Sleep*.

PART V

Conclusion: I like *Sleep*.[59]

Around the time this piece was composed, Brainard wrote another appreciation of Warhol for *C* magazine that contains a paragraph written in the same mode as the "I like *Sleep*" refrain:

I like Andy Warhol. I like Andy Warhol. I like Andy Warhol. I like Andy Warhol. I like Andy Warhol. I like Andy Warhol. I like Andy Warhol. I like Andy Warhol. I like Andy Warhol. I like Andy Warhol. I like Andy Warhol. I like Andy Warhol. I like Andy Warhol. I like Andy Warhol. And that is why I like Andy Warhol.[60]

In this ode to Warhol's repetition, Brainard varied the line breaks of his repeating sentence as a way to manifest in writing the idea of the same thing being different each time it is repeated. The composition of his lines was subsequently "analyzed" by Padgett in an essay about techniques used in poetry, within a discussion of the caesura, or pause within a line. Padgett observed that the position of the caesura is not fixed, and, to illustrate his point, he asked, is the following a four-line or a two-line stanza? (noting that critics have argued both):

I like Andy Warhol, I like Andy Warhol.
I like Andy Warhol, I like Andy Warhol.[61]

As is by now abundantly clear, Padgett had a particular fascination for creating in his writing a parallel to the repetition characteristic of Warhol's work. Yet another product of this fascination is his book *Two Stories for Andy Warhol* of 1965, which consists of ten sheets of the exact same text—a page from an early twentieth-century novel (fig. 54).[62] (This was the sort of "found"

Fig. 54. Ron Padgett, page of *Two Stories for Andy Warhol* (New York: C Press, 1965). © 1965 Ron Padgett. Reprinted by permission of the author.

text that Ashbery liked to weave into his poems.)[63] Padgett selected the page so that it can be read as a loop; that is, the first sentence can read as if it follows from the last one.[64]

In performance, Padgett devised a way to show his audience that each page was the same as the next but, then again, also different. At a reading on 14 February 1964, Padgett, Brainard, Berrigan, and the poet Dick Gallup each recited a page.[65] The distinct voices, emphases, and expressions of the different readers underscored the uniqueness of every page of the book.

This recital of *Two Stories for Andy Warhol* took place at the studio of the painter Robert Dash, and Warhol attended (as well as, among others, Malanga, Edwin Denby, John Giorno, and a reporter from *Life* magazine).[66] Thus, once again, a specific venue served as a medium through which meaning accrued as one artist communicated to another in his work. It should be noted that Padgett's communication with Warhol concerned questions of an artistic variety—regarding repetition and appropriation—and not the ques-

98

tions about personal relations that, as we have seen, often figured in such exchanges.

Nonetheless, a grain of the personal was later added to this particular exchange, although not at Padgett's instigation. When Berrigan published *Two Stories* as a book, he procured for the cover design a Thermofax copy of a two-frame still (paralleling the "Two Stories" of the title) from one of Warhol's movies (fig. 55).[67] The image is difficult to make out, having been somewhat obscured due to Warhol's deliberately semi-abstract composition, but it is nevertheless apparent that it shows some sort of sexual activity (and the fact that we are unable to determine exactly what is pictured prompts us to conjecture that it must be something "bad"). Indeed, the still has been identified as a scene of Ondine (Robert Olivo), who appeared in several Warhol films of the mid-1960s, receiving oral sex in a bathroom, while Walter Dainwood, a friend of Ondine, is off to the side and looking into the camera.[68]

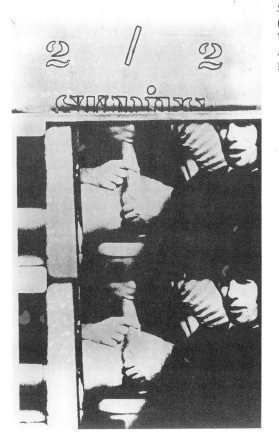

Fig. 55. Andy Warhol, cover image, *Two Stories for Andy Warhol,* by Ron Padgett (New York: C Press, 1965). © 1997 Andy Warhol Foundation for the Visual Arts / Artists Rights Society (ARS), NY. Photograph courtesy of Ron Padgett.

99

In a quirky way, the explicit sex of this scene fits exceedingly well with the sexual suggestiveness in—or at least adds an amusing sexually suggestive tenor to—such sentences of Padgett's text as "She enjoyed her rides on the brisk little pony's back" or "'You may trust me,' said Sibyl, 'I never tell things I'm told not to tell.'" In sum, the image that was selected for the cover of *Two Stories*, which can be viewed as a response to Padgett's text, served to heighten the vaguely erotic insinuations that can be read into it, while at the same time embellishing them with a bit of Factory gossip.

Padgett and Berrigan collaborated on a number of writings, and their joint creations were closely related to the questioning of the ownership of words that each was exploring separately through the techniques of appropriation and repetition. According to Padgett, in working closely together he and Berrigan so mastered each other's style that often they did not remember who wrote what, and they would jokingly argue over who composed the best passages of this or that collaboration.[69] Eventually, they published a group of their collaborations and works composed by each author alone (with no indication of who wrote what) in a book entitled *Bean Spasms* (1967).[70]

Berrigan gave a copy of the book to Warhol, having inscribed on the title page, "to Andy / With Love / & Admiration / Ted Berrigan."[71] On the dedication page, someone (it is unclear who) wrote, "TO ANDY / FROM JOHN ASHBERY."[72] This second inscription is fully in the "who owns it?" spirit of the volume. It was written just under the printed, or "real," dedication—*"TO ALLEN GINSBERG"*—and was a way by which to participate in the kinds of questions regarding identity that Berrigan, Warhol, and the rest were up to.

Nowhere was this questioning more at play than in the piece included in *Bean Spasms* called "An Interview with John Cage," which actually is not an interview at all, but rather an artistic invention created by Berrigan through the use of collage. He took passages from existing interviews, including the famous 1963 Gene Swenson interview with Warhol, and pieced them together, adding his own bits of prose to create a coherent dialogue.[73] Compare, for example, these excerpts from Berrigan's interview with Cage to Swenson's with Warhol:

CAGE: [. . .] I think everybody should be a
 machine. I think everybody should be alike.
INTERVIEWER: Isn't that like Pop Art?
CAGE: Yes, that's what Pop Art is, liking things, which incidentally is a
 pretty boring idea.[74]

[WARHOL:] I think everybody should be a machine. I think everybody should like everybody.

[SWENSON:] *Is that what Pop Art is all about?*

[WARHOL:] Yes. It's liking things.[75]

Berrigan provided occasional little clues to his sources—for instance, in the interviewer's line "Isn't that like Pop Art?"—and he assumed that his readers would recognize that the interview was concocted (although several of them did not).[76]

While this fabricated dialogue was on the one hand a very amusing gag, it was on the other a shrewd device for posing questions about the identity of the artist. One assumption built into the interview format is that it provides information about the personality of the interviewee through his or her speech. Berrigan's inventive adoption of the interview format thus undercut the basic premise that the interview reveals things about the interviewee (since Berrigan put words in Cage's mouth), while also underscoring that the interviewee often uses the format to create, through words, his or her personality. Berrigan in addition included certain lines in his Cage interview—notably, "everyone should be alike," which he derived from the Warhol interview—with an eye to how they would contribute to the questioning of identity that the interview presented.

Berrigan was fascinated by and extremely fond of Warhol—a feeling that was mutual.[77] He later remembered that during one period of his career, "I got more ideas off Andy Warhol than I did from anyone else."[78] In 1969, he wrote to Brainard that "Andy is a guy I'm interested in plenty, still."[79]

He felt a special affinity to the ways Warhol explored conceptions of artistic identity (a subject that Berrigan had begun to think about prior to moving to New York, while working on his master's thesis on George Bernard Shaw).[80] And he was drawn to the work of John Ashbery for the same reason, noting in his diary, for instance, that in a conversation with Edwin Denby, "Edwin said that John Ashbery once remarked that he had 'given a lot of thought to the personality of the poet.' & I said I had too."[81]

Berrigan pondered this topic through visual art as well. When he posed for a portrait by the painter Alex Katz in 1967, he held one finger over his mouth and another next to it, undoubtedly in imitation of the pose in Warhol's self-portrait of the previous year (figs. 56 and 57). Warhol evidently based this self-portrait on a photograph someone else had taken of him.[82] In copying Warhol's gesture, Berrigan was asking the question, to what extent

101

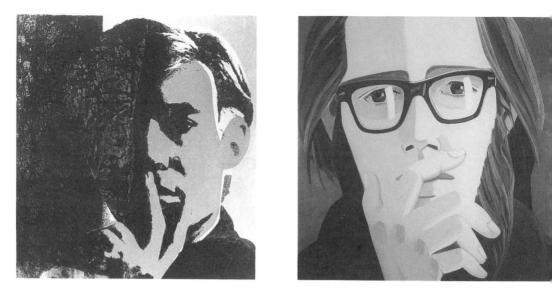

Fig. 56. (*above, left*) Andy Warhol, *Self-Portrait,* 1966–67. Private collection. © 1997 Andy Warhol Foundation for the Visual Arts / Artists Rights Society (ARS), NY.

Fig. 57. (*above, right*) Alex Katz, *Ted Berrigan,* 1967. Photograph courtesy of Robert Miller Gallery, New York. Photograph by eeva-inkeri.

does a gesture—or, more generally, an image—define a person's identity? This was, of course, a question that Warhol liked to ask, too, which was precisely why Berrigan chose to strike the Warhol pose for Katz's portrait of him.

Berrigan filled many pages of his personal diary with reproductions of Warhol's paintings and sculptures.[83] Among the reproductions is a self-portrait from 1964, a mug-shot-type pose in which Warhol cast himself as a criminal, or as "wanted" (fig. 58). This self-portrait, even more palpably than that of two years later, displays the sort of role-playing that Berrigan found to be such a riveting dimension of Warhol's work.

Berrigan created an intriguing and complex artistic response to Warhol's mug-shot self-portrait, in which he brought together references to Warhol, to Marcel Duchamp, and to the identification of the poet and the visual artist with the criminal. This response took the form of a remake of Duchamp's 1923 *Wanted: $2,000 Reward* (fig. 59, left side), a work that, as Berrigan no doubt was aware, had been an inspiration for the Warhol self-portrait. (Duchamp had incorporated *Wanted: $2,000 Reward* [fig. 60] into the design of a poster for his 1963 retrospective exhibition at the Pasadena Art Museum, which Warhol attended along with Malanga, the poet and actor Taylor Mead, and the artist Wynn Chamberlain.) In Duchamp's work, side and frontal view mug shots of the artist appear in a mock "wanted" poster, with the caption

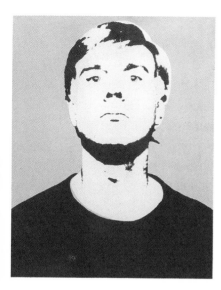 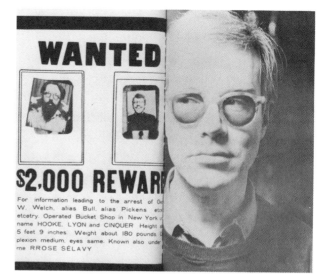

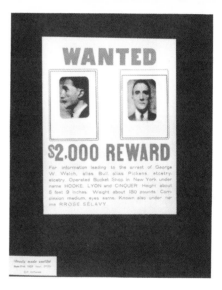

Fig. 58. (*above, left*) Andy Warhol, *Self-Portrait*, 1964. Private collection. © 1997 Andy Warhol Foundation for the Visual Arts / Artists Rights Society (ARS), NY.

Fig. 59. (*above, right*) Illustrations accompanying an Art Chronicle article by Ted Berrigan. *Kulchur* 5 (autumn 1965). Reproduced by permission of the Estate of Ted Berrigan, Alice Notley, executor.

Fig. 60. Marcel Duchamp, replica of *Wanted: $2,000 Reward*, 1923, from "Boite-en-Valise." Philadelphia Museum of Art, Louise and Walter Arensberg Collection. © 1997 Artists Rights Society (ARS), New York / ADAGP, Paris.

listing a number of aliases—including his well-known alter ego Rrose Sélavy (*eros, c'est la vie*)—that are brimming with puns. A falsification (or multiplication) of identity is implied, too, by the fact that the photographs of Duchamp are too small for the allotted space.[84] The empty space surrounding these photographs almost asks to be filled in, which is what Berrigan did in his remake.

Berrigan took a reproduction of Duchamp's work and covered over the profile and frontal views of Duchamp with photobooth portraits of himself and Brainard. The photobooth portraits were a tribute to Warhol, whose own mug-shot self-portrait was based on a photobooth picture, and who experi-

103

mented extensively with photobooth portraiture from 1963 to 1966.[85] These portraits, "taken" by a machine, were in line with the questioning of authorship that Warhol and Berrigan (not to mention Duchamp) liked to pose.

Berrigan otherwise poked fun at authorship and artistic identity by replacing Duchamp's portraits with those of two individuals—himself and Brainard—as if they were one person and then attributing the piece to Brainard.[86] This was not the only occasion in which Berrigan devised a spurious attribution. Berrigan noted in his diary on 9 March 1964 that "tonight I wrote a review of Ron's *Some Bombs* which might be published in KULCHUR under Gerard Malanga's name."[87] It was.[88] In the same tenor, a review of a book of poems by Bill Berkson, published under Berrigan's name, concludes with this query: "It's a book I might well wish to have signed my name to. Know who I am?"[89]

It should be noted here, to digress momentarily, that Gerard Malanga in his own way touched on this idea of assuming false identities. For example, in lines from three separate poems, Malanga wrote, "My name is John or Bill,"[90] "His Name was John, or Bill,"[91] and "His name is John,/but now his name is no longer John."[92] Here Malanga employed Ashbery's name as a way of acknowledging a source for his interest in the concept of the interchangeable persona (which Ashbery expressed through the use of shifting pronouns and in lines such as "you always tell me I am you").[93] The other name refers to Bill Berkson, whom Malanga admired as the first poet in his own peer group to be praised by the New York School poets.[94]

In one of these "John and Bill" lines, from the 1964 poem "The Pleasure Seekers," Malanga directly related a flip-flop identity to the appropriation of lines from somebody else's poetry:

> My name is John or Bill
> As the notebook is removed from the coat
> Pocket and placed within hand's reach of the dashboard[95]

These lines imply that whomever's words are written in the notebook, John's or Bill's, the speaker becomes that person.

Malanga again expressed this idea of ambiguous identity in the fascinating book *Screen Tests / A Diary* (1967), a collaboration with Warhol. The book consists of fifty-four stills from "screen tests," or film portraits, made between 1964 and 1966, each of which is matched on the facing page with a poem by Malanga about the person pictured.[96] The poem accompanying the rivetingly intense screen test portrait of Ashbery (fig. 61) begins with the first line of Ashbery's poem "The Tennis Court Oath," which reads "What had you been

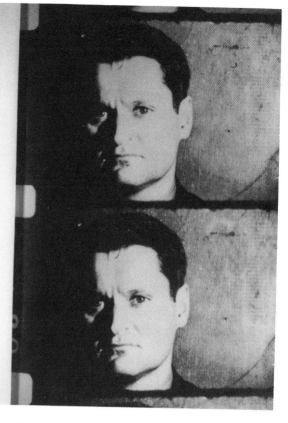

What had you been thinking about
the boy wrote in his diary
notebook for no one to read.
You misunderstood how it is not
possible to breathe under
water. I worry, sometimes.
But the Italian
collections for Fall are notable
for some of the newest coats in Europe
you missed
and I thought it was not Spring
to decide the sharp
edge of the cloudburst coming
over the hill. Somehow your fears are
justified in the details turned inside
out of the dream of the friends
who will not stay
behind the wind blowing across your face.

8/22/66

2

Fig. 61. Andy Warhol and Gerard Malanga, *John Ashbery,* in *Screen Tests / A Diary* (New York: Kulchur Press, 1967). © 1997 Andy Warhol Foundation for the Visual Arts / Artists Rights Society (ARS), NY. Poem reprinted by permission of Gerard Malanga.

thinking about."[97] Following the Ashbery line are the words "the boy wrote in his diary/notebook for no one to read." The boy might be Ashbery writing the line of poetry, or Malanga copying it, or both. For Malanga, this kind of identity mirroring was not just conceptual. In some ways Malanga did identify with Ashbery (as students often do with teachers); for instance, Ashbery, like Malanga, was an only child.[98]

With this broader context in mind, we now return to Berrigan's remake of *Wanted: $2,000 Reward,* which seems to compound the question of authorship as much as possible. Berrigan credited the reproduction, published in the fall 1965 issue of *Kulchur,* to "A. Malgmo." This was Arnold Malgmo, who was not a real person, but rather a character in the fiction writing of Berrigan's friend, Tom Veitch.[99] In addition to being nonexistent, "A. Malgmo" seems to have a double meaning. The name sounds like "amalgam," an accurate description of who made this work and an emulation of the well-known puns found in Duchamp's own alter egos (most conspicuously, Rrose Sélavy).[100]

Berrigan connected all this play on authorship and artistic identity di-

rectly to Warhol by positioning his doctored *Wanted: $2,000 Reward* within the journal *Kulchur* on the page facing a photograph of Warhol (by Berrigan's friend Lorenz Gude) (see fig. 59). The photograph is located so that Warhol's eyes, seen through his sunglasses, appear to look over at Berrigan and Brainard suspiciously in a sidelong glance, as if to question their pranks. Yet his slight smile suggests that he is also enjoying and approving of these pranks. This deliberate juxtaposition of *$2,000 Reward* with the photograph of Warhol, then, was Berrigan's acknowledgment that Warhol was a principle source of inspiration for his forays into questions of identity and authorship.

Both the Duchamp remake and Gude's photograph of Warhol ostensibly served as illustrations to an Art Chronicle article that Berrigan contributed to the same issue of *Kulchur*. In the article, Berrigan discussed the work of both Duchamp and Warhol, although in a manner that is as unorthodox as the accompanying illustrations. In reviewing a Duchamp exhibit held at the Cordier & Ekstrom Gallery, New York, he actually complained that most of the later works in it were copies.[101] He praised Warhol highly, defending him against his many detractors and emphasizing the breadth of his reach by highlighting his contributions to literary publications (and by inventing a role for Warhol as a popular music performer). He wrote,

> Warhol, who now shows at Castelli, made the Leonard Lyons column *must* reading for art-lovers, expanded the horizons of the film industry by making a movie a day (Ezra Pound wrote a sonnet a day at Warhol's age) and pulled off the coup of the year in avant-garde literary circles by simultaneously doing a cover for Ed Sanders' FUCK YOU (A Magazine of the Arts) and TWO STORIES FOR ANDY WARHOL, a "C" Press Publication written by Ron Padgett. At this writing Warhol is in Paris having a flower show and awaiting Capitol Records' release of his first LP, 12 incredible songs sung believe it or not by Andy Warhol and the Supremes![102]

Ashbery, too, entered into Berrigan's Art Chronicle article in a way that echoed the ideas embodied in the accompanying Duchamp and Warhol reproductions. About an exhibition of Brainard's work at the Alan Gallery (New York), Berrigan wrote, "To quote John Ashbery again, but why hedge?, to quote my own review of the Brainard show from ART NEWS. . . ."[103] Did he or didn't he quote Ashbery? Upon concluding his discussion of Brainard, Berrigan added, "I must confess that I plagiarized the last few lines of that review from John Ashbery's catalogue piece, but wouldn't you?" and "The fact is there was very little writing on art this season that one could read, let alone plagiarize."[104]

Dear Ted, I have climbed these many steps one month already.
And now with energy, restored and positive,
I enter my apartment, the window open
cartons of books unpacked, no hot-running water.
This year is next year now in which I stir
upon the mattress on the floor with thoughts of
what I have not done and what I now must do.
Nothing has occurred for days. I go unshaven.
And yet your words keep ringing in my ears
whose guiding spirit keeps me straight to reach
the future by a frail vessel thru unsounded depths.
This is the season of letting loose, and
I am tempted most not to return home
or to hate another nature. But I don't. I do.

8/29/66

6

Fig. 62. Andy Warhol and Gerard Malanga, *Ted Berrigan,* in *Screen Tests / A Diary* (New York: Kulchur Press, 1967). © 1997 Andy Warhol Foundation for the Visual Arts / Artists Rights Society (ARS), NY. Poem reprinted by permission of Gerard Malanga.

Berrigan's application of the verb "plagiarize" to describe what he was up to served to link his identity in the essay to his embodiment as a criminal in his *Wanted: $2,000 Reward* collage. The collage manifests this embodiment in another way as well. Berrigan placed his own photobooth picture at an angle; as if to elaborate on his self-envisionment as a criminal, he made himself "crooked."

Perhaps it is not coincidental that Berrigan is also shown at an angle in the screen test portrait which Warhol filmed of him at the Factory in March 1965 and later included in the book *Screen Tests / A Diary* (fig. 62).[105] Fortunately, the dialogue that occurred during the making of Berrigan's screen test was recorded in an interview, and Warhol's directorial instructions to his sitter strongly suggest that Warhol himself intended to film Berrigan with the camera at an angle, as a visual pun. The following segment of the interview shows that he knew exactly what effect he wanted, even though he did not articulate in specific terms what this effect was:

DE [DAVID EHRENSTEIN]: You're making a movie now? What do you do, going about making one?

AW: Uh nothing. Oh, pull that chair in so it's more out in the open. Move it over, uh yeah, over there. Yeah, just right there that's great Oh, I know. We're going to have to do something about that chair.

DE: What are you going to ask Ted to do?

AW: Just pretend he's not doing anything.[106]

Although Warhol claimed that to make the movie he did "nothing," we can see from his very specific instructions about where Berrigan should place the chair he was to sit on while posing and from his "Oh, I know" expression that a particular concept for this screen test had occurred to him. It therefore seems likely that Warhol deliberately filmed Berrigan "crooked."

Indeed, Berrigan seems to have had an ongoing artistic dialogue with Warhol regarding tilted pictures—in which Warhol's screen test of him figured—the exact significance of which is not always clear, although being "crooked" is certainly embedded in it. An early contribution to the dialogue is found in Berrigan's poem "The Upper Arm," dedicated to Warhol and first published in 1964.[107] In this instance, the word Berrigan uses to evoke crookedness is "tipped":

> In an automobile accident on the
> Face
> And achieved enemy face
> Paleface changed captive
> Photographs later
> Were tipped "What does this mean, my son?"[108]

The "tipped" photographs could indicate either "tipped in" pictures or tilted pictures (both of which describe those in Berrigan's later *Wanted: $2,000 Reward*). The "automobile accident" obviously refers to the car crash paintings of Warhol's Death and Disaster series (see figs. 40 and 41), while "paleface," a pun, refers to the very light-complexioned Warhol.[109]

It is likely that Warhol created an artistic response to the "tipped" of this poem, even over a decade later, in the painting *Black on Black Reversal* (circa 1979) (fig. 63). The crooked and reversed *Green Disaster* on top of Warhol's face may well be an illustration of the lines of Berrigan's poem that read "In an automobile accident on the / Face" and "Photographs later / Were tipped."

In celebration of Warhol's work, as he understood it, Berrigan concluded his poem "The Upper Arm" with a statement on the paradoxical nature of

108

Fig. 63. Andy Warhol, *Black on Black Reversal*, ca. 1979. Private collection. © 1997 Andy Warhol Foundation for the Visual Arts / Artists Rights Society (ARS), NY.

authorship and artistic identity. Developing the Native American motif of Warhol as "paleface," Berrigan described bows shot at targets "that spell/'MY PAINTINGS.'"[110] "MY PAINTINGS" implied the sense of possessiveness and ownership often connected to being an author. However, the two words are more complex than this in terms of the associations that Berrigan lodged within them.

To begin with, Berrigan's enclosure of MY PAINTINGS in quotation marks emulated a procedure regularly used by Ashbery. For example, in Ashbery's poem "The Recent Past" (published in 1963) we find the passage, "sinking ships that spelled out 'Aladdin,'" from which Berrigan obviously adapted "targets [. . .]that spell / 'MY PAINTINGS.'"[111] In such an intertextual milieu, the quotation marks themselves became references to Ashbery. "MY PAINT-INGS" also alludes to Ashbery's group of poems entitled *The Poems*. Berrigan often inserted this title, in quotation marks, into his own poems.[112] Again, Berrigan's idea was to echo Ashbery's own practice of confusing invented and appropriated language. What results is that the use of "the" in "The Poems" suggests that the verse is generic, while the quotation marks, on the other hand, suggest that it is particular, or belongs, to Ashbery.

Berrigan thought of all this activity in terms of what plagiarism meant to society. Regarding works such as *Wanted: $2,000 Reward,* Padgett has recalled, **109** "At the time, we were involved in making fun of the fear of plagiarism; most people thought of plagiarism as theft."[113] To view the question from another perspective, recently delineated by Susan Stewart in her book *Crimes of Writ-*

ing, the workings of the law tend to trivialize the often complex intentions and consequences of plagiarism.[114] But for Berrigan the question was not solely one of plagiarism, for on occasion his theft of words included actually stealing books.

In his diaries from the summer and fall of 1963, Berrigan recorded, "Went to steal books today. Got $10.00 worth," and "I get arrested for stealing books at Union Theological Sem.," and "ten days suspended sentence for stealing books."[115] Padgett has noted that on his regular outings with Berrigan to Wittenborn Books, Berrigan would sometimes steal the merchandise.[116] As with his appropriation of words, Berrigan did not keep his thievery too much of a secret; rather, he incorporated it into his idea of who he was as a poet.

The idea had both funny and sad sides. The funny side is reflected in Berrigan's attitude toward his impoverished circumstances, exemplified in this conclusion to one of his book reviews: "The price is absurd but the book is small and thin and slips easily under one's coat."[117] The sad side is that Berrigan wanted to possess books, understandably enough, but, like many poets, was in a quandary about how to live off his writing. His diaries include numerous comments about his lack of money, such as, "the problem of how to make a living still plagues me."[118]

In an interview of 1980, Berrigan termed his little thefts in the context of what it meant to be a poet within the structure of the society in which he lived. He explained, "[W]hen I refer to crime, petty crime, small-time crime, I'm speaking in the sense that Jean Genet talks about in *Thieves Journal* [sic]. And that is the poet, in my lifetime, in the United States of America, is, at least partially, an outlaw, partially criminal. It is literally partially 'against the law.'"[119]

This explanation of the poet as outlaw was part of a discussion of an auto-biographical poem written in 1979, in which Berrigan referred to his own petty crimes of the 1960s:

> I took that self to New York City, into
> poetry, to Art News, into Readings, thru marriage, into
> teaching and then into not teaching, and in and out of
> small-time crime.[120]

Berrigan told the interviewer that he was, in a sense, forced into this position, as would be anyone who viewed poetry as a profession:

> [A]s a person whose vocation is writing poetry, whose avocation is also that, and as one who considers that vocation an essential industry in any state, I'm

willing to resort to whatever means necessary for survival, short . . . of harming anyone. . . . But I only mean—when I talk of small-time crime, I think that the poet is—I don't think that the poet is a prophet, sage, or shaman, in the way that those words are generally used to apply to poets. But I think that poets occasionally are all of those. But I do think that poets are criminals in America.[121]

The poet, in short, is a criminal because he does not receive a regular payment for his work; his work is "illegitimate."

Berrigan's invocation of the French writer Jean Genet in this rumination about the poet as a criminal is significant. By the mid-1960s, Genet—who wrote his first poems and began his first novel, *Our Lady of the Flowers,* while imprisoned during the late 1930s and early 1940s—had become an exemplar of the poet as outlaw. Little by little, Genet became an increasingly familiar figure in the United States: his plays were produced with great success in New York from the late 1950s through the mid-1960s;[122] translations were published by Grove Press for the American distribution of his novels, *Our Lady of the Flowers* (1963) and *The Thief's Journal* (1964); the translation of Jean-Paul Sartre's lengthy and influential biography, *Saint Genet,* came out in 1963; and in 1964 there was a public screening of Genet's movie, *A Song of Love (Un chant d'amour).*[123] The novels and film are all set in prison, and their protagonists are all homosexual. In a 1964 interview in *Playboy* magazine, Genet spoke unabashedly about his pederasty.[124] This interview is a good index of both his popularity at the time and his tendency to play up those aspects of himself that society considered to be immoral and illegal.

Warhol was one of the many people who in the early 1960s became fascinated by this poet-outlaw. He was especially drawn to the dominant homoerotic component of Genet's work, to judge by his comment to Gene Swenson in the 1963 interview that "when you read Genet you get all hot, and that makes some people say this is not art."[125] Warhol owned the 1963 translation of *Our Lady of the Flowers,*[126] and he was also familiar with an earlier edition of it that was published abroad by Olympia Press in 1957.[127]

Genet's name was in the air, but Warhol probably paid special attention to his writings because Genet figured in the history of some of his literary friends, such as, to cite a conspicuous example, Charles Henri Ford. Ford had included a segment of *Our Lady of the Flowers,* as well as Genet's poem "A Song of Love," in a 1946 issue of *View,* a literary magazine which he founded in

111

1940 and edited until 1947 (the *View* translations in fact were the earliest publications of Genet in the United States).[128] Although *View* was a publication of the 1940s, predating Warhol's arrival in New York, he eventually acquired several issues of the magazine, including the one containing the Genet pieces.[129]

It is quite possible that Warhol had Genet in mind, in addition to Duchamp, as a model of the artist as criminal when he produced his 1964 mugshot self-portrait. Moreover, another work Warhol made in 1964 on the subject of the criminal, the *Most Wanted Men,* bears some curious resemblances to *Our Lady of the Flowers.* Warhol executed this group of paintings as a mural for the facade of the New York State Pavilion of the 1964–65 World's Fair in

Fig. 64. Andy Warhol, *Most Wanted Men,* 1964. As installed on the facade of the New York State Pavilion, 1964–65 World's Fair, Flushing Meadow, New York. Photograph by Eric Pollitzer.

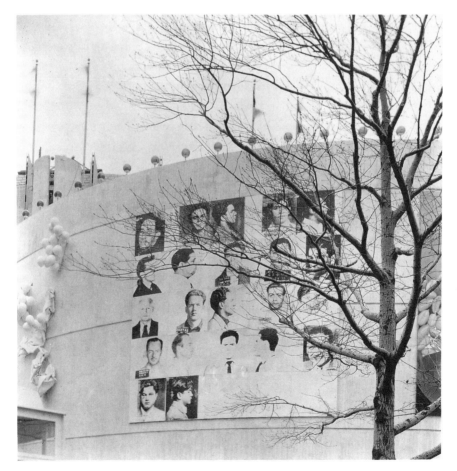

Flushing Meadow (fig. 64). However, shortly after the mural was installed, Warhol received an order to remove it. A few distinct reasons have been given for this censorship.[130] Whatever the details of the case may have been, it is easy to understand why pictures of wanted men were highly (and, one might add, deliciously) inappropriate to a fair that relied heavily on falsification to produce a wholesome "positive" image of the United States.[131]

It is obvious that for Warhol—as for Berrigan—to be "wanted" had various meanings. Sexual desirability undoubtedly was one. It is in light of this connotation of the word that an intriguing connection between the *Most Wanted Men* and *Our Lady of the Flowers* becomes clear. At the outset of Genet's novel, the protagonist tells us that he cut out newspaper and magazine pictures of convicts and pasted them on his prison cell wall for the purpose of sexual fantasy. (Genet himself owned a newspaper photograph of the German murderer Eugène Weidmann, which he is reported to have hung on his wall wherever he was living.)[132] The following passages of *Our Lady* show how Genet developed his protagonist's erotic attraction to images of criminals:

> I do not know whether it is their faces, the real ones, which spatter the wall of my cell with a sparkling mud, but it cannot be by chance that I cut those handsome, vacant-eyed heads out of the magazines.
>
> The newspapers are tattered by the time they reach my cell, and the finest pages have been looted of their finest flowers, those pimps, like gardens in May. The big, inflexible, strict pimps, their members in full bloom—I no longer know whether they are lilies or whether lilies and members are not totally they, so much so that in the evening, on my knees, in thought, I encircle their legs with my arms. . . .
>
> Still, I managed to get about twenty photographs, and with bits of chewed bread I pasted them on the back of the cardboard sheet of regulations that hangs on the wall.
>
> At night I love them, and my love endows them with life. . . . Beneath the sheet, my right hand stops to caress the absent face, and then the whole body, of the outlaw I have chosen for that evening's delight.
>
> So, with the help of my unknown lovers, I am going to write a story. My heroes are they, pasted on the wall, they and I who am here, locked up. . . . the story of Divine, whom I knew only slightly, the story of Our Lady of the Flowers, and, never fear, my own story.[133]

113

Just as Genet's character put pictures of several criminals on his wall, so Warhol put pictures of several of them on a wall, too (perhaps he even considered the World's Fair a kind of prison cell). Genet's criminals are figures of homosexual desire, and Warhol's, on one level, are too.[134]

Genet, like Warhol, liked to draw attention to the fact that one could become famous through being a criminal. The prisoner in *Our Lady* envisioned his criminals as celebrities (and as saints) by placing his pictures of them in star-shaped frames: "Using the same beads with which the prisoners next door make funeral wreaths, I have made star-shaped frames for the most purely criminal. . . . They watch over my little routines, which, along with them, are all the family I have and my only friends."[135]

By creating larger-than-life visages of criminals and placing them on an official government building, Warhol too made them famous. As Andrew Kagan has aptly observed, given Warhol's obsession with fame, it is clear that an impetus for his creation of the *Most Wanted Men* paintings was a fascination with how the media turned criminals into celebrities.[136]

In the context of the World's Fair, the mug shots of wanted men operated as stand-ins for the national heroes that we would expect to find in such a venue. Thus, they served to subvert—and to invert—the idea of the hero. Genet, too, conceived of the criminal this way: "My heroes are they," his protagonist states, "pasted on the wall."[137] Sartre underscored Genet's elevation of the criminal to the stature of a hero in his introduction to the 1963 edition of *Our Lady* (which was an excerpt from his book *Saint Genet*). "The rogues and wretches of whom it speaks," Sartre explained of the book, "all seem to be heroes, to be of the elect."[138]

During the summer of 1964, shortly after having produced his *Most Wanted Men* mural, Warhol made a large number of the Flower paintings that he exhibited at Castelli Gallery toward the end of the year (see figs. 28 and 39).[139] This chronology lends weight to the suggestion that the imagery in *Our Lady of the Flowers* lurks behind Warhol's creation of the *Most Wanted Men*. Flowers, like pictures of convicts, figure prominently in Genet's book (as its title intimates), in which they stand for both the sexual members and the deaths of the convicts, and the protagonist calls his practice of discovering convicts "that wonderful blossoming of dark and lovely flowers."[140] The Flower paintings may be on one level an homage to *Our Lady*, as Kenneth E. Silver has proposed,[141] given the ways they signify death. They even may be companion pieces to the most wanted series, the two together signifying the intertwined motifs—the criminal and the flower—of Genet's book.

114

But the *Most Wanted Men* and the Flower paintings may be a response to Genet's work in general, since a linking of criminals, flowers, and homosexuality appears in much of it. For example, in the opening passage of *The Thief's Journal,* Genet writes, *"[T]here is a close relationship between flowers and convicts. The fragility and delicacy of the former are of the same nature as the brutal sensitivity of the latter. Should I have to portray a convict—or a criminal—I shall so bedeck him with flowers that, as he disappears beneath them, he will himself become a flower, a gigantic and new one. . . . And each flower within me leaves behind so solemn a sadness that all of them must signify sorrow, death"* (Genet's emphasis).[142]

To take another example, in Genet's black-and-white silent film *A Song of Love* (1950), which Warhol saw when it was screened in mid-March 1964 at the Film-Makers' Cooperative in New York together with one of Warhol's own films,[143] homoerotic fantasies are symbolized by a bouquet of flowers swinging from the window of a prison cell and by blossoms that a convict holds in front of the fly of his pants.[144]

Genet may well have been an inspiration for some of Warhol's own work in film during 1964. *Couch,* which was made at the Factory in July 1964, opens showing the poet Piero Heliczer lying on a couch, as if either asleep or dead, and Malanga, who wears a black leather jacket, looking at him while lying on the back of the couch (fig. 65). One of the Flower paintings is behind the couch and serves as a backdrop for the scene. Heliczer's deathly appearance corresponds to the connotation of death embedded in the Flower image. Malanga, his head resting on his hand, seems to be in a reverie prompted by the deathly image of Heliczer. The scene—indeed, the entire film—has a dreamlike, otherworldly feel and brings to mind the protagonist's fantasies about convicts, some of whom are already dead, in *Our Lady of the Flowers.*[145]

The affinities between Genet and Warhol were not lost on the press. In December 1964, *Newsweek* ran a story about Warhol entitled "Saint Andrew," a title which would seem to be a play on Sartre's *Saint Genet.*[146] Sartre's study would have been familiar to many *Newsweek* readers, since the English translation received a great deal of attention in the press.[147] The immediate source of the *Newsweek* title was a comment by the art dealer Ivan Karp that was quoted in the article: "Andy is in a sense a victim of common things: he genuinely adores them. How can you describe him—like a saint—Saint Andrew."[148]

Hiding under his appellation "Saint Andrew" were Warhol's homosexuality and his Catholicism, neither of which were spoken of overtly in the press

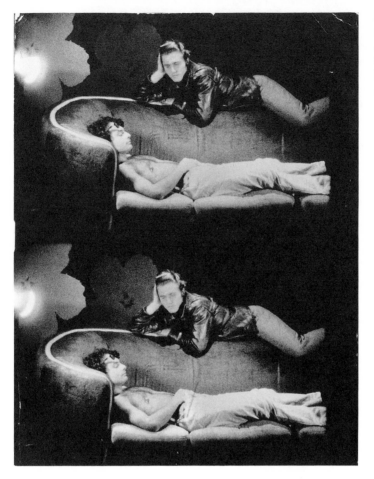

Fig. 65. Andy Warhol, *Couch*, 1964. © 1997 Andy Warhol Foundation for the Visual Arts, Inc. Film Enlargement © Archives Malanga.

during the mid-1960s. For Sartre, homosexuality was part of what made Genet—whose Catholic upbringing is strongly present in his writings—a "saint." Sartre filled several pages of *Saint Genet* with musings on the relation between homosexuality and crime in Genet's life and work, and conceived this relation to be central to Genet's saintliness. He argued that "the striking thing is that the erotic humiliations of a homosexual and the occupational risks of a thief are tinged with an aura of the sacred."[149] Sartre in addition equated the identity of the thief with that of the homosexual (at a time when homosexuality was literally illegal): "to want to be *the* thief and to decide that he will be a homosexual are one and the same thing."[150] He observed that for both the thief and the homosexual, "inner" reality becomes appearance, and appearance is reality.[151]

116 Sartre, moreover, viewed Genet's thievery as art. He asserted, "The essential point is that he thinks less of stealing than of engaging in imaginary experiments in appropriation."[152] Seen in this perspective, the view of Genet's

importance to Warhol and to such poets as Berrigan, Malanga, and Padgett becomes more expansive.

Sartre even discussed Genet as a poet who was a thief of words. Like the aforementioned writers of the 1960s, he stole words as an exploration of identity, of self-invention. Sartre said about the writing in *Our Lady of the Flowers,* "He knows three languages: the common language, argot, the dialect of the queens; and he cannot speak any of them and finally destroys them. Whenever he speaks, he steals words, he violates them. He is a real thief and the signification of the statements he utters is imaginary, he lies; he is a fake bourgeois, a fake tough, a fake woman, he plays roles; the words are perhaps true, but the speaker is imaginary." [153]

Sartre believed, in addition, that in a general way poetry (which is how he referred to Genet's prose) was itself a form of stealing language. He proclaimed, "Poetic language is a burglary; he steals words and subjects them to wrong uses; this language is artificial and false and has no real basis." [154]

Genet provided a potent model for the envisionment of the poet as a thief, one which was reshaped into a variety of configurations during the 1960s. An important dimension of Genet's example was that it posed difficult moral questions: what was the difference between stealing words and stealing books? between poetry and theft? The exploration of these questions moved the image of the artist as criminal beyond the realm of concept, as exemplified by Duchamp's *Wanted: $2,000 Reward,* and into that of reality. Berrigan appreciated this distinction, as his remarks about the poet as criminal reveal. His friend Malanga appreciated it too.

Malanga, perhaps taking his cue from Berrigan, explored the merging of the images of poet and thief in compelling ways. In one instance, Malanga made what by conventional rules was a false claim to the authorship of a work of art. The claim was made in Malanga's contribution to a section of the Museum of Modern Art's 1989 *Andy Warhol: A Retrospective* exhibition catalog. This catalog brought together, after Warhol's death, texts and works of art by various friends and associates of Warhol. Malanga submitted to this collective homage a "Xero copy" made up of one strip of Warhol photobooth self-portraits copied seven times and placed in rows (fig. 66). On one level, then, Malanga paid homage to Warhol by emulating his techniques of replication and repetition. On another level, however, he not only emulated but extended Warhol's use of replication by signing his name to this work, for it was actually a copy of another work, made around 1964, by the filmmaker Marie Menken, who was friends with Malanga and Warhol. Menken had given

117

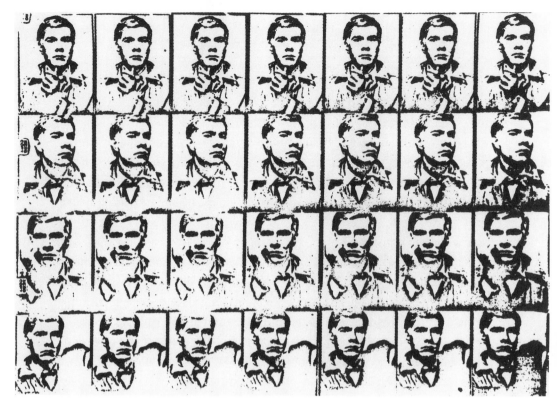

Fig. 66. Gerard Malanga, *Andy Warhol Photomation,* 1965, from
Andy Warhol: A Retrospective, ed. Kynaston McShine (New York: Museum of
Modern Art, 1989). Reproduced by permission of Gerard Malanga.

Warhol a "Xero copy" just like this one and wrote beneath it the affectionate
inscription "I love that Andy—my true love / Marie Menken" (fig. 67). A de-
tail of Menken's picture was then included in an issue of *Wagner Literary Maga-
zine* edited by Malanga, where it was attributed to Menken and given the title
Andy Warhol in the Photo Machine (fig. 68). Malanga, in later making this work
"his," pushed to their extreme end the questions of copying and authorship
that he earlier had conceived of as "new realism."

Sometimes Malanga's exploration of the image of the poet as thief con-
cerned stealing paintings, as in his performance in the 35-minute sound film
Bufferin (aka Gerard Malanga Reads Poetry) made by Warhol early in 1966 on
color stock. In *Bufferin,* Malanga is shown in a close-up view (fig. 69) reading
from his diary, while occasionally Rona Page—a friend of Jonas Mekas who
served as a confident to Malanga at the time—interrupts his solo performance
with a commentary. As Malanga reads, he replaces the names of the people
he mentions with the word Bufferin in order to veil their identities. For ex-
ample, at the beginning of the film, Bufferin stands for the model Benedetta

118

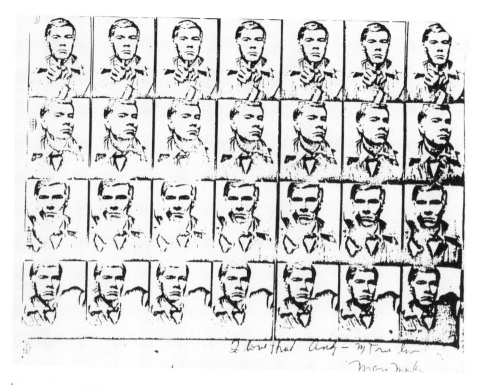

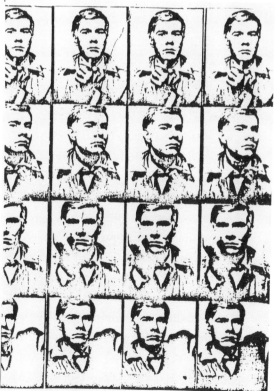

Fig. 67. (*above*) Marie Menken, "Xero copy" photobooth self-portrait of Andy Warhol, 1963–64. Archives Study Center, The Andy Warhol Museum, Pittsburgh, Penn. Reproduced by permission of the Estate of Marie Menken.

Fig. 68. (*left*) Marie Menken, *Andy Warhol in the Photo Machine.* Reproduced from *Wagner Literary Magazine* 4 (1963–64). Archives Study Center, The Andy Warhol Museum, Pittsburgh, Penn. Reproduced by permission of the Estate of Marie Menken.

119

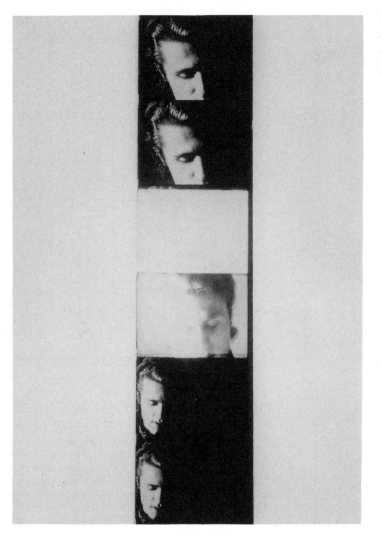

Fig. 69. Andy Warhol, *Bufferin,* 1966. © 1993 Andy Warhol Foundation for the Visual Arts, Inc.

Barzini, with whom Malanga had recently had an intense romance, and later on Bufferin becomes Warhol in a reference to paintings by Warhol that had been stolen. The person whom Malanga claimed had stolen the paintings is called Bufferin too.

From behind the camera, Warhol saw through these thinly veiled disguises and responded on the spot to the provocative subject matter of Malanga's words by occasionally editing them out of the film through the use of strobe-cuts (produced by quickly turning the camera on and off).[155] Warhol thus used his film to "speak back" to Malanga by silencing him. The film, then, is yet another clear instance of Warhol utilizing his art to communicate with another person.

Malanga's references to stolen paintings in *Bufferin* at once describe a po-

tentially real occurrence and constitute a literary conceit, in the tradition of Genet. Both real and literary descriptions of theft are found in Malanga's writings from the period when *Bufferin* was made, and for him the two go together, as they did for Genet.

In a published section of his diary for 1966, Malanga claimed that the poet Rene Ricard—who was a kind of protégé of Malanga—had stolen some Warhol paintings. Ricard, then, was very probably the Bufferin whom Malanga said stole paintings. Malanga wrote in his diary, "Today turned out to be rotten. Andy was informed by his gallery that Rene had secretly stolen a Marlon Brando portrait out of the factory and sold it to another gallery. René tells me at Max's that I should 'put a stop to those vicious rumors' of his stealing any of Andy's paintings out of the factory. I put so much confidence in René and pushed his presence at the factory and with Andy, who never really liked him,[156] and he has done so many awful things, burned so many bridges behind him."[157] Malanga's accusations place Ricard in the mold of Genet.

Malanga also placed Ricard into this mold through his poetry of the period. In the poem he wrote to accompany the screen test of Ricard in *Screen Tests / A Diary* (fig. 70), Ricard is called "the flower thief," an allusion to both the Ron Rice film of this title (1960; see fig. 71) and the poet as an actual thief of flowers. Malanga has said, regarding this passage of his poem, "René would steal flowers from the florist; it almost sounds like something Cocteau would have done."[158] Malanga had Ricard stealing flowers in another poem of the period, "Prelude to International Velvet Debutante," which is largely about Ricard's relationship with the eponymous Warhol "superstar," a young model from Boston (Ricard was also from Boston) whose actual name was Susan Bottomly.[159] Malanga wrote, addressing Bottomly, "René steals flowers from gardens for you."[160]

Ricard adored flowers, as is apparent in his insistence that the set for a movie made by Warhol in 1966, of which Ricard was the star, be filled with fine-quality orchids for the shoot. The production of this movie was an emotion-laden affair. It was called *The Andy Warhol Story,* and Ricard, at Warhol's urging, played the role of Warhol. (The movie had only one other actor, Edie Sedgwick, who played herself.) Ricard's antipathy toward Warhol was strong, and he acted his part by making fun of the artist and presenting him in an extremely nasty light. Warhol responded just as he had to Malanga's diary recital in *Bufferin:* he edited Ricard's words out of the film— all of them.[161]

It may seem peculiar that Warhol wanted his enemy to play him, and

A field of flowers is not invisible
in the day but they cover
the ground. If the friends had turned
René into the flower
thief's death the cult of the drop-out
or the beautiful book would take
a long time to forget
in the next year
when the young boy is faced
with being pursued.
Pages of life
stories systematically crossing each other
in the small room:
the South End of Boston,
summer in the city.
The new realism is not enough.

8/24/66

45

Fig. 70. Andy Warhol and Gerard Malanga, *Rene Ricard*, in *Screen Tests / A Diary* (New York: Kulchur Press, 1967). © 1997 Andy Warhol Foundation for the Visual Arts / Artists Rights Society (ARS), NY. Poem reprinted by permission of Gerard Malanga.

Ricard has interpreted the casting decision as masochism. However, it is worth considering the possibility that Warhol's idea for the film was to create a response to the accusation that Ricard had stolen some of his paintings, and, more to the point, to another accusation, that Ricard had forged some Warhol works.[162] In other words, Warhol cast Ricard as Warhol because Ricard, in his presumed making of forgeries, had cast himself as Warhol; it was Warhol's way of acknowledging Ricard's identity as the poet-thief.

Warhol himself had opened the door for someone like Ricard to embody such an identity. In his 1963 interview with Gene Swenson, he said about his use of the silkscreen, "I think somebody should be able to do all my paintings for me. I haven't been able to make every image clear and simple and the same as the first one. I think it would be so great if more people took up silk screens so that no one would know whether my picture was mine or somebody else's."[163]

Out of this question, Warhol developed myriad activities as the 1960s

moved forward: Allen Midgette appeared at lectures as if he were Warhol, Warhol claimed that his friend Brigid Polk (Brigid Berlin) made his paintings, and so on. On one occasion, at a midnight film screening, Warhol reportedly introduced Malanga as "Andy Warhol," and Malanga then signed autographs for Warhol.[164]

This casting of Malanga as Warhol may have had the same significance for Warhol as did his casting of Ricard in *The Andy Warhol Story*. For, some years after Malanga had stopped working for him, Warhol said he suspected that Malanga had made forgeries of his work. In his diary of 1978, Warhol twice brought up this suspicion, each time in a discussion of—appropriately enough—Flower paintings. In the first instance, he claimed that the French new realist artist Arman had sold eight Flower paintings without realizing they were fakes, and that "Gerard is still swearing up and down that he didn't do them."[165] In the second instance, Warhol betrayed his old fascination with the idea of fakes and apparently considered getting in on the act: "Rupert [Rupert Smith, then Warhol's painting assistant] was bringing by the Flower things. I decided I won't sign the fake ones that're turning up all over Europe—the ones the people told us they bought from Gerard. Maybe I should do new ones and make good on the fakes in Europe. I don't know. I'll see."[166]

Whether Malanga or Ricard forged works by Warhol, or whether Ricard stole them is unclear to me and beyond the scope of this study. What matters here, instead, is the intriguing ways in which the accusations, whether expressed artistically or not, overt or recondite, elaborate on the poet-as-thief model that was provided, above all, by Genet. This model became one medium through which the members of a community identified themselves and communicated to each other. It was a model that asked difficult moral questions about authorship, ownership, and what it meant to be a poet. These are questions that lack easy answers and will remain permanently attached to Warhol's work.

The "Flower Thief": The "Film Poem," Warhol's Early Films, and the Beat Writers

5

Ron Rice's *The Flower Thief* (1960) was one of a cluster of experimental films to which Jonas Mekas—a poet as well as filmmaker, critic, and spokesperson for independent film—applied the label "film poem." The term was central to the conceptualization of film that Mekas developed in his writings, from his establishment of the journal *Film Culture* in 1955 through the mid-1960s.[1] For Mekas, the experimental filmmaker was a "poet" with all the connotations the word implied during this period: bohemian outsider, lyrical, anti-establishment, vital, truthful, free.[2]

Mekas used the term "film poet" because "poet" most fully signified a series of values that "filmmaker," "artist," "playwright," or other such career-defining terms did not. His application of the term fit into an artistic context in which poets regularly collaborated with visual artists, wrote plays, performed, and published magazines, and in the process became the central figures in avant-garde artmaking activities in all media, including film.[3]

The star of *The Flower Thief*, for example, was the poet Taylor Mead, and several of the central characters in another film that Mekas referred to as a "film poem," *Pull My Daisy* (1959), were poets, too—Gregory Corso, Allen Ginsberg, and Peter Orlovsky. *Pull My Daisy*, a 28-minute black-and-white film with narration by Jack Kerouac, was loosely based on the third part of Kerouac's unproduced play *The Beat Generation*[4]

Fig. 71. Ron Rice, *The Flower Thief*, 1960.
Photograph courtesy of Arunas Kulikauskas /
Anthology Film Archives.

Fig. 72. Ron Rice, *The Flower Thief*, 1960.
Photograph courtesy of Arunas Kulikauskas /
Anthology Film Archives.

and was a whimsical portrayal of an ordinary day in the lives of a group of beat writers and their friends (see figs. 75 and 76). *The Flower Thief* was inspired by this film,[5] and its documentation of the wanderings of Taylor Mead through cityscapes and landscapes of San Francisco (figs. 71 and 72) evoked the spontaneous and adventuresome travels found in beat writings, especially in Kerouac's famous novel, *On the Road,* published in 1957.

It was against the backdrop of movies such as *Pull My Daisy* and *The Flower Thief,* and of Mekas's critical evaluations of them as "film poems," that Warhol began making films in the summer of 1963. In fact, Mekas's characterizations of the "film poem" have so much in common with Warhol's early films that it is as if Warhol employed them as a kind of blueprint for filmmaking.[6] For example, Warhol's use of his friends as actors and his practice of recording them engaged in activities that were part of their actual lives, in movies such as *Sleep* and the different versions of *Haircut* (see fig. 21), correspond to the following assessment by Mekas, published in 1962, of *The Flower Thief, Pull My Daisy,* and a few other films: "Didn't Rimbaud write his *Illuminations* out of the burning, intensified reality of his own life? Such are the lives of the modern film poets. . . . In a sense, they don't have to 'invent'; they just have to turn the camera upon themselves and their close friends, and it explodes into the pyrotechnics upon which no imagination could improve."[7] In an earlier essay, of 1960, Mekas advocated inexpensive and technically simple filmmaking—the kind that Warhol later practiced—and used the production of poetry as an analogy to it: "Films will soon be made as easily as written poems, and almost as cheaply."[8]

This particular association of poetry with film has its source in the history of critical writing about experimental film—a history of which Mekas and Warhol were well aware. An important figure in this history was the poet and critic Parker Tyler, who years earlier had worked with Warhol's friend Charles Henri Ford on, among other things, *View* magazine. In 1958, Mekas published an essay by Tyler in *Film Culture,* in which Tyler called experimental film "Avant-garde or Poetic" and noted that when filmmakers worked without the apparatus of Hollywood and on small budgets, they were allowed "to do imaginative work that used the camera the way a poet uses his pen: as an instrument of invention."[9]

In another piece published in *Film Culture,* "Poetry and the Film: A Symposium," Tyler provided a synopsis of the history of film as poetry, tracing its origins to European films such as Jean Cocteau's *Blood of a Poet* (1930) and its evolution in American surrealist films of the late 1940s and early 1950s.[10]

The symposium at which Tyler presented this synopsis was held in 1953 at Cinema 16 in New York, which was the first center for the screening of experimental film in the United States and a tremendous influence on Mekas's career.[11] The symposium was moderated by Willard Maas, who, like Tyler, was a strong advocate of the idea of film as poetry, while other panelists were adamantly against it.[12]

Mekas gave this 1953 debate new life by publishing the symposium proceedings in *Film Culture* ten years later, just when Warhol acquired his first camera. (In fact, Warhol possessed two copies of this particular issue of *Film Culture*.)[13] Warhol associated himself with this branch of experimental film by, for example, making a screen test of Maas (fig. 73) as well as a movie of him and Marie Menken in their Brooklyn Heights apartment (though he was unsatisfied with this movie and therefore did not release it).[14] Typically, Warhol became part of a historical continuum—in this instance, of experimental film—by literally involving himself with its members through his artmaking process.

In one important way, however, Mekas and Warhol broke from this historical continuum: they rejected the mythological symbolism, extensive editing, and trick camera devices found in European surrealist films such as those of Cocteau, and their American inheritors, including films by Maas and even Jack Smith. The influence of Smith on Warhol has been often and correctly noted but has been overstated.[15] In fact, Mekas's analogy of film to poetry is perhaps most significant for Warhol's work in film because it concerns realism, which had no place in earlier conceptualizations of the "film poem." Mekas noted, writing in 1962, that only at present could filmmakers express social and personal truths "as freely as the poet with his typewriter."[16]

Indeed, the virtue that Mekas saw in seeking truth at any cost in his formulations of the "film poem" was precisely what drew him to Warhol's work in film. In his 1964 essay "On Cinéma Vérité, Ricky Leacock, and Warhol," Mekas extolled Warhol's work for the ways in which it embodied ideas he had already articulated in his discussions of film poetry: "It is the work of Andy Warhol . . . that is the last word in the Direct Cinema. It is hard to imagine anything more pure, less staged, and less directed than Andy Warhol's *Eat, Empire, Sleep, Haircut* movies. I think that Andy Warhol is the most revolutionary of all film-makers working today. He is opening to film-makers a completely new and inexhaustible field of cinema reality."[17] Mekas had similar things to say about Warhol's *Chelsea Girls* (1966): "And one of the amazing things about this film is that the people in it are not really actors, or if they

Fig. 73. Andy Warhol, screen test, *Willard Maas,* ca. 1964–65. © 1997 Andy Warhol Foundation for the Visual Arts / Artists Rights Society (ARS), NY.

are acting, their acting becomes unimportant, it becomes part of their personalities, and there they are, totally real, with their transformed, intensified selves."[18] Here Mekas repeats, with only slightly different wording, his earlier description of the "burning, intensified reality" of the film poet's work.

Mekas's conceptualization of realism on film derives largely from beat ideas rather than from the European "film poem" tradition.[19] As we have seen, he valued *Pull My Daisy* for its sense of truthfulness. In its success in capturing life on the screen, this movie, according to Mekas, has the same feelings of "reality and immediacy" that are found in the first films made by Lumière.[20] Soon, Mekas would make exactly the same point about Warhol's films: "Andy Warhol is taking cinema back to its origins, to the days of Lumière. . . . [H]e records, almost obsessively, man's daily activities, the things he sees around him."[21]

The beat glorification of everyday reality had a strong impact on Mekas,

129

and, likewise, had a direct, deep, and lasting impact on Warhol's development in film as well as other media.[22] Warhol's fascination with the beats was one facet of his attraction to poets, to poetry, and to all that the two represented in the United States of the 1960s. A consideration of the links between some of his early movies and the two beat films *The Flower Thief* and *Pull My Daisy* in the discussion that follows will serve as a springboard for assessing the broader significance of his interest in the beats.

Warhol met Taylor Mead just as the former was launching his career as a filmmaker. Warhol had by then seen *The Flower Thief,* which was extremely successful in the world of experimental film and in 1962 broke the attendance records when it was screened at the Charles Theater on East Twelfth Street and Avenue B, where Warhol regularly attended the film programs put together by Mekas.[23]

Warhol had also by this time acquired some of Mead's poetry (which, when they met, Warhol asked him to autograph).[24] Charles Henri Ford remembered that Warhol "was buying the poems of Taylor Mead. . . . [H]e just sort of put his finger on Taylor Mead at that time, when I hadn't even read him."[25] Mead's privately published *Excerpts from the Anonymous Diary of a New York Youth* (1961, 1962) contained much that would have appealed to Warhol: a brazen frankness about the author's homosexuality, an adoration of movie stars and other celebrities, humor, straightforward language, and an all-around outrageousness. In this book, Mead identified himself with the beats and made references to writers Lawrence Ferlinghetti, Ginsberg, Kerouac, and Orlovsky, and to "beatniks." Thus, when Warhol formed his initial involvement with Mead, he possessed a clear knowledge of Mead's image as a beat poet and a film star.

Mead accompanied Warhol, Malanga, and the artist Wynn Chamberlain to Los Angeles in the late summer of 1963 to attend the opening of Warhol's *Liz* and *Elvis* exhibit. The trip was a significant moment in Warhol's absorption of beat ideas. This absorption is especially evident in the film he made in Los Angeles, starring Mead, and in the fact that the trip across country was made by car as a conscious "on the road" experience.

In the movie Warhol filmed while in Los Angeles, *Tarzan and Jane Regained . . . Sort of,* Mead plays Tarzan and Naomi Levine plays Jane (she also appeared in, among other experimental films, several of Warhol's *Kiss* movies of 1963–64).[26] *Tarzan and Jane Regained* is unlike most of Warhol's early films in that the camera is not stationary, the film stock is in both black-and-white and color, and there is a soundtrack (which Mead recorded after the film was shot).

Mead's role as Tarzan is similar to his role in *The Flower Thief:* he clowns his way through jungle gyms, streets, the Watts Tower, and bodies of water, makes funny expressions in front of the camera, and dances while his swimming trunks are falling off. In the second half of the film, he acts as if he is rescuing a drowning doll, and the toy recalls the teddy bear he plays with in *The Flower Thief.*

Tarzan and Jane Regained . . . Sort of contains verbal and thematic links to Mead's poetry. The words "sort of" in the movie's title appear in *Excerpts from the Anonymous Diary,* in such passages as "what I think I wrote in/Ms. sort of" and "be free and easy / and open sort of."[27] Mead even mentioned Tarzan in his book, describing how in New York he went into a "subterranean toilet with one of the movies' Tarzans"; the Tarzan had a "big peter" and Mead, a "small one."[28] This passage has a parallel in Warhol's film, in a scene in which Dennis Hopper flexes his arm muscle, which is fairly large, and then Mead flexes his small one. (The inappropriateness of Mead's diminutive physique for the role of Tarzan contributes to the comedy.)[29]

Tarzan and Jane Regained opens with of view of the highway, along which the camera moves until it reaches the sign "Tarzana Rezeda next exit." Mead proposed that he play the role of Tarzan when he saw this sign.[30] Signs are a recurring motif in the movie. We see signs for Coca-Cola and other products at a race track, and a root beer sign at a little fast-food restaurant. The signs in the film parallel the subject matter of Warhol's paintings of Coca-Cola bottles (fig. 74), soup cans, and the like. As Warhol later explained about the 1963 trip to Los Angeles, "The farther west we drove, the more Pop everything looked on the highways. Suddenly we all felt like insiders because even though Pop was everywhere—that was the thing about it, most people still took it for granted, whereas we were dazzled by it—to us, it was the new Art. Once you 'got' Pop, you could never see a sign the same way again."[31]

But signs were not only "pop," they were also "beat," just as the act of driving across the country became, with the publication of *On the Road* (which was so popular that the paperback Viking Compass edition of 1959 was reprinted each year until 1963 and in several subsequent years),[32] the quintessential beat statement. Indeed, in a 1960 review of an exhibition at the Museum of Modern Art, the *New Yorker* art critic Robert M. Coates saw "traces of the Beat philosophy" in the use of commonplace objects by artists such as Robert Rauschenberg, who was a key model for Warhol in the area of visual art.[33] In *On the Road,* the narrator, Sal Paradise, sees the sign "USE COOPER'S PAINT" as he looks out the car window, and he spots a Coca-Cola stand in the Nevada desert.[34]

131

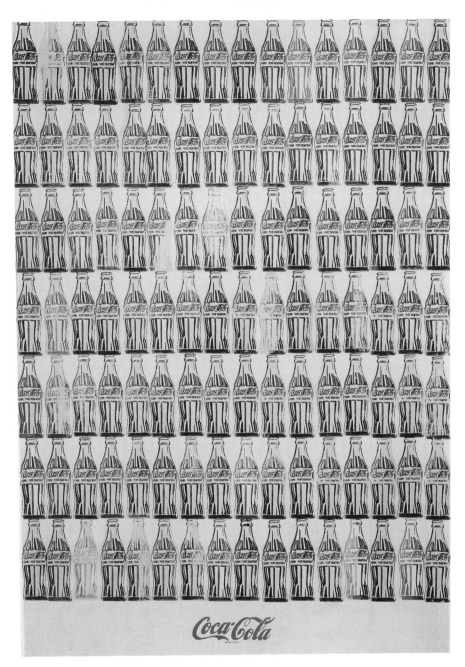

Fig. 74. Andy Warhol, *Green Coca-Cola Bottles*, 1962. Oil on canvas, 82½ × 57″ (209.6 × 144.8 cm). Collection of the Whitney Museum of American Art, New York. Purchase, with funds from the Friends of the Whitney Museum of American Art, 68.25. © 1997 Andy Warhol Foundation for the Visual Arts / Artists Rights Society (ARS), NY. Photograph © 1996 Whitney Museum of American Art.

Chapter Five

The opening scene of *Tarzan and Jane Regained . . . Sort of* on a Los Angeles road embodies the celebration of beat life that was behind Warhol's choice to go to Los Angeles by car rather than plane.[35] Warhol conceived of the trip as an event, not simply a means of getting from one place to another; "It was a beautiful time to be driving across America," he later wrote.[36] The presence of Mead made the trip an authentic beat experience, since he was a veteran cross-country traveler. As Warhol reminisced:

> When Taylor left his stockbroker job in Detroit, he had just fifty dollars in his pocket. "Kerouac's *On the Road* put me on the road," he said, "and Allen's *Howl*, which had just come out, had a big effect on me."
>
> Taylor was in San Francisco in '56 when the beat poetry scene got going. . . . He'd hitched cross-country five times by then.[37]

Taylor Mead, then, represented for Warhol a direct link to the beat life.

On the California trip, Mead gave a poetry reading at Venice Beach.[38] He claims that shortly before the reading was to begin, Warhol decided to be "cruel" and "tried to make me blow him."[39] What is interesting about this story is that Warhol's reported out-of-line behavior is altogether *in* line with the content of Mead's poetry. The opening of *Excerpts from the Anonymous Diary* reads, "I have blown / And been blown" (lines which consciously echo a segment of Ginsberg's poem "Howl"), an activity that is mentioned throughout the book, as in the passage "Give me your poor, your tired—and let me blow them."[40] Warhol's sensibility did lead him to at times be extremely literal, especially when he wanted to provoke a person or an audience, and so if Mead's story is true, the request was likely Warhol's response to the content of Mead's writing. Put differently, Warhol was giving Mead the opportunity to live out his poetry.

Moreover, the "blow-job" enthusiast image that Mead painted of himself in *Excerpts from the Anonymous Diary* had by this time entered into the dialogues of the mimeograph publications. Ed Sanders, who had become friends with Mead and Ron Rice by 1962, described Mead in an author's biography in the August 1962 issue of his magazine *Fuck You* as the star of *The Flower Thief*, a poet, and a thinker, and then made reference to Mead's talent at that particular sexual act.[41] In another issue of the same year, Sanders again mentioned Mead in association with "blow jobs," in an advertisement.[42]

Just as Warhol's interest in Mead as an actor and poet led him to involve himself with Mead directly through the making of *Tarzan and Jane Regained* (and several subsequent films),[43] so his interest in more famous beat writers—

133

Corso, Ginsberg, Kerouac, Orlovsky—led him to capture them on film. And, as he had done with Mead in the Tarzan and Jane movie, he placed these writers within a setting that deliberately recalled that of their prior film performances in the movie *Pull My Daisy*.

Warhol was familiar with *Pull My Daisy*, as he had been with *The Flower Thief*. He had even attended a special screening of the movie, the purpose of which was to dub it in French, with his friend, the filmmaker Emile de Antonio (who had been instrumental in distributing it in New York).[44] Jack Kerouac and the photographer Robert Frank, who did the cinematography for *Pull My Daisy*, were both at this screening.[45] The content of the movie was also easily accessible through an abundantly illustrated book about it that was published in 1961 and included the script of Kerouac's narration.[46]

Pull My Daisy is set in the loft studio of the painter Alfred Leslie, who, with Frank, was its director and editor. In the movie, Leslie's couch is a central locus of activity. At distinct moments, different groupings of people sit on this couch—for example, Ginsberg, Corso, and Orlovsky (who play themselves) (fig. 75), or the bishop's mother (played by the painter Alice Neel), Ginsberg, and the bishop's sister (played by Sally Gross) (fig. 76).

When Warhol included Corso, Ginsberg, Kerouac, and Orlovsky in *Couch* (1964), it was partly as an homage to *Pull My Daisy*. *Couch* consists of thirteen scenes, each the length of a 100-foot reel of film, of people doing various things on and around a couch at the Factory.[47] Warhol filmed several reels of the four beat writers all in one day, as a tape recording made during the visit reveals,[48] and then put only one of the reels in the movie, as the fifth scene.[49]

This scene was shot so that the couch is viewed from the side. Corso sits on it with a book in his hands as if to indicate his literary vocation. Someone else—it is often difficult to make out who is who due to the filming angle—is seated on the floor drinking beer from a can and then stands up and moves out of view. Another person, probably Kerouac, enters the frame and sits on the floor. Ginsberg soon enters the scene and sits beside him, in the foreground. We see him from the back, and the bobbing movements of his head suggest that he is chatting. The couch, beer can, book, and general animation of this scene all evoke the ambience of passages of *Pull My Daisy* such as the first few minutes, in which Kerouac's narration reads: "Gregory Corso and Allen Ginsberg there, laying their beer cans out on the table . . . falling on the couch, all bursting with poetry. . . ."[50]

To grasp the nature of Warhol's allusions to *Pull My Daisy*, we must look at its position within his movie overall. *Couch* is extremely rich, even brilliant,

134

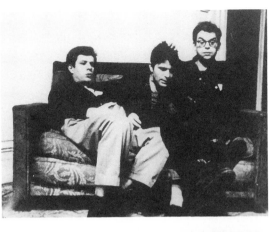

Fig. 75. Jack Kerouac, Robert Frank, and Alfred Leslie, *Pull My Daisy,* 1960. Scene with Allen Ginsberg, Gregory Corso, and Peter Orlovsky on couch. Photograph courtesy of Arunas Kulikauskas / Anthology Film Archives.

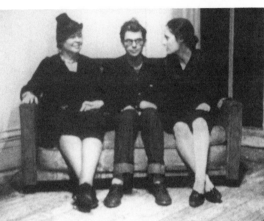

Fig. 76. Jack Kerouac, Robert Frank, and Alfred Leslie, *Pull My Daisy,* 1960. Photograph courtesy of Arunas Kulikauskas / Anthology Film Archives.

in its meshing of references to the social world revolving around Warhol and to the history of film. The various sexual encounters that take place on the couch (for example, in fig. 23)—which in some instances are either parodied or frustrated—bring to mind, as others have pointed out, the role of this piece of furniture in any number of Hollywood movies and in psychoanalysis.[51]

While *Couch* is thereby a recognition of establishment film, it at the same time encodes several key moments in the recent history of experimental film. A conspicuous reference to this other side of film history is embedded in the two reels of *Couch* just prior to the scene with Corso, Ginsberg, Kerouac, and Orlovsky. Here, we see Billy Name donning sunglasses while fidgeting with a motorcycle in imitation of the protagonist of Kenneth Anger's fascinating movie about a motorcycle gang, *Scorpio Rising* (1963).[52] Understood in this broader context, Warhol's evocations of *Pull My Daisy* become part of a kind of capsule history of film contained within *Couch.*

135

Warhol's inclusion of *Pull My Daisy* in this metahistory was his way of acknowledging its importance to his own work as a filmmaker. Like Warhol's early films, *Pull My Daisy* seemed spontaneous, even though it wasn't entirely (for this apparent quality, Mekas bestowed upon them all the label "realism").[53] It was filmed, as were many of Warhol's movies, in the studio of a painter who had branched out into filmmaking, and it was made by a group of friends and was about their lives. Jerry Tallmer observed in his introduction to the book *Pull My Daisy* that one reason he liked this film was because "it shows me people I know doing the things they do."[54] The film contained nuances of meaning, Tallmer intimated, that would not be fully comprehended by viewers who did not know the people in question.[55] It contained, that is, the kinds of "in-the-know" sub-stories that we have seen in such Warhol movies as *Haircut* or *Bufferin*.

The audio tape made during the production of the Corso, Ginsberg, Kerouac, and Orlovsky segment of *Couch* provides revealing glimpses of Warhol's endeavor to film these writers so as to provide a conceptual link to *Pull My Daisy*, and it also reveals that the dynamic that evolved between them in the filming process had a strong impact on the movie's final form. First of all, Kerouac, who could be quite difficult to work with—he had been banned from the set of *Pull My Daisy* after a fight with Alfred Leslie, and he had developed a tendency to behave outrageously[56]—was bent on taking over the role of director from Warhol. Meanwhile Warhol, although he exhibited some flexibility concerning the configuration of the set, kept grasping for control over his own movie in what seemed like a tug-of-war with Kerouac.

Three passages of the audio tape offer a vivid illustration of the way this tug-of-war played itself out:

KEROUAC: What's the pro-ce-dure?
WARHOL: Well, the movie's called *Couch*.
KEROUAC: The movie's called *Couch*.
WARHOL: Yeah. So it has to be on the couch.
KEROUAC: It has to be on the couch. So nothing off the couch. Can't there be something off the couch?
WARHOL: Yeah.

(An unidentified voice, possibly of Gerard Malanga, says that they can sit on the floor next to the couch, and Kerouac then says to one of his co-actors, "then you gotta get up.")

*

WARHOL: Let's do the four of you just kind of getting up and off on the couch. It'd be very nice.

KEROUAC: Getting on and getting off, and getting on and getting off, and getting on and getting off. The four of us, yeah. I think that'd be pretty mad. But there, it's gotta, sort of like, faster, faster, faster, faster. Now, are you game?[57]

*

(Warhol later asks if four of them would "just lie on the couch," and Kerouac says that he has to "take a piss" first;[58] when he returns from the bathroom he reports that it has two toilet bowls, which gives him the idea of using the superfluous one as a prop.)

KEROUAC: Allen, bring the yellow john out. Allen, bring it out and sit on it. . . .

WARHOL: No, no. It's a couch. This one's just going to be the couch. You're all getting up and off.

The first of these three interactions explains why Kerouac and Ginsberg are seated on the floor in Warhol's movie. In the second, as in the first, Kerouac takes Warhol's instructions and provocatively elaborates on them. It is intriguing to consider the ways in which Kerouac's idea that he and his co-actors repeatedly and with increasing haste get on and off the couch relates at once to Warhol's art and to Kerouac's own interests.

The repetition is consonant with Warhol's painting method, while the speed is like that of comic actors in early silent films, and, of course, *Couch* was a silent film (although, ironically enough, since Warhol filmed his movies at sound speed, 24 fps, but screened them at silent speed, 16 fps, the resultant slowing of the action tends to imbue it with a sexily languid feeling that the speedy movements recommended by Kerouac would all but eliminate). Indeed, soon after Kerouac ordered his friends to ever more quickly get on and off the couch, he said to one of them (it is unclear to whom), "Now you look like Buster Keaton," and then laughed. All this reflected Kerouac's admiration for certain comedians of the early silent and talking films, whom he often mentioned in his fiction and in interviews.[59]

The exchange between Kerouac and Warhol concerning the toilet is perhaps the most revelatory regarding Warhol's filmmaking procedures. It demonstrates concretely how very mistaken is the commonly held assumption that Warhol's role as a director consisted of simply turning on the camera and

walking away (even though he may have on occasion done just that).[60] This exchange, in which Kerouac endeavored to virtually be the director, shows that, on the contrary, Warhol was extremely engaged in the production of his films. Some input from the actors was acceptable (and often desirable), such as Kerouac's suggestion that they sit off rather than on the couch, but the basic scenario and visual composition were Warhol's, and he was capable of being insistent if someone—in this case, Kerouac—tried to change them.

The sense of general chaos that one gets from listening to the audio tape may well provide an explanation of why Warhol decided to film the beat sequence of *Couch* from the side of the couch in such a way as to obscure identities and actions. This peculiarity of the scene is often pointed out as a kind of perversity on Warhol's part.[61] Taylor Mead was not pleased with Warhol's cinematography on this occasion,[62] yet he later intuited that there was a reason for it: "[H]e wouldn't turn the camera around; he has his own ideas, and nothing would interrupt them. . . . He had a great integrity in a very funny way."[63]

It is quite possible—and certainly understandable—that Warhol refused to turn the camera around out of sheer exasperation with Kerouac's aggressive behavior, as a way to at once stay in control of his own film and get back at Kerouac for being uncooperative. (And it should also be kept in mind that in the distinct reels of film that make up *Couch,* the vantage point ranges from frontal to sharply angled, so that the side view is one in a sort of repertoire of viewpoints.)

In the years after the *Couch* filming, Ginsberg was the one figure in the group who remained in friendly contact with Warhol, probably in part through Ginsberg's associations with Malanga, Mekas, and the filmmaker Barbara Rubin. Ginsberg sat for a screen test, which was incorporated into the film *Fifty Fantastics and Fifty Personalities* (1964–66) as well as into the book *Screen Tests / A Diary* (fig. 77), he stopped by the Factory occasionally, and he sang "Hare Krishna" on stage at a Velvet Underground performance in 1966.[64]

Ginsberg was drawn to Warhol's art because he could see in it an analogue to his own concerns. He once remarked, "I was interested in the Zen aspect of the taking an object of ordinary consciousness or ordinary mind or ordinary use and enlarging it and focusing attention on it so that it became a sacred object or a totemic object, mythological. And that seemed very much parallel to the notion of a kind of attentiveness you get in Zen or Buddhist meditative attitude."[65] It is worth noting here that already in 1964 Jonas Mekas had articulated the same connection between the ideas of the beat writers and Warhol's work in film. Mekas, referring to the "subtle play of nuances" in the films, wrote,

We are kept cold, sometimes,
while advice lasts
in the miraculous reflection of so much that is
to come in our lives.
The friends had not expected that
the headlights would be like
this to discover the road
markings not to cross on the sharp
turns, and dreams might occur into something
for life, the fear dismantled
to be the deception which surrounds us
for the white rose
growing restlessly as the sun
light reappears after night
fall, exalting the impossibility of the peace
formula in our time we may never achieve.

8/26/66

19

Fig. 77. Andy Warhol and Gerard Malanga, *Allen Ginsberg,* in *Screen Tests / A Diary* (New York: Kulchur Press, 1967). © 1997 Andy Warhol Foundation for the Visual Arts / Artists Rights Society (ARS), NY. Poem reprinted by permission of Gerard Malanga.

There is something religious about this. It is part of that "beat mentality" which Cardinal Spellman attacked this week. There is something very humble and happy about a man (or a movie) who is content with eating an apple. It is a cinema that reveals the emergence of meditation and happiness in man. Eat your apple, enjoy your apple, it says. Where are you running? Away from yourself? To what excitement? If all people could sit and watch the Empire State Building for eight hours and meditate upon it, there would be no more wars, no hate, no terror—there would be happiness regained upon earth.[66]

For his part, Warhol kept up with Ginsberg's activities and in 1966 accompanied Gerard Malanga to a reading by Ginsberg at Town Hall theater in New York.[67] Two decades later, he included Ginsberg in a literary "Portrait Gallery" published in *Paris Review* (fig. 78). Here, Warhol expressed his strong admiration for Ginsberg: "I love Allen's things. . . . He's such a great poet."[68]

This opinion evidently inspired a never-realized film project that had a direct connection to Ginsberg's poetry. In 1969, the *New York Times* reported that

139

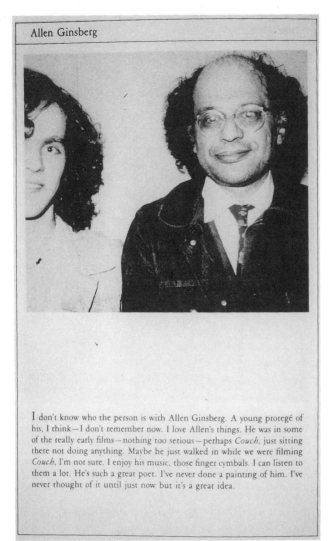

Allen Ginsberg

I don't know who the person is with Allen Ginsberg. A young protegé of his, I think—I don't remember now. I love Allen's things. He was in some of the really early films—nothing too serious—perhaps *Couch*, just sitting there not doing anything. Maybe he just walked in while we were filming *Couch*, I'm not sure. I enjoy his music, those finger cymbals. I can listen to them a lot. He's such a great poet. I've never done a painting of him. I've never thought of it until just now but it's a great idea.

Fig. 78. Andy Warhol, photograph of Allen Ginsberg and a friend, in "A Warhol Portrait Gallery: Literary Section," ed. Robert Becker, *Paris Review* 26 (winter 1984). © 1997 Andy Warhol Foundation for the Visual Arts / Artists Rights Society (ARS), NY.

Warhol was planning to make a film in which Ginsberg would play the part of Walt Whitman.[69] The casting was extremely apt, since, aside from the fact that both poets had beards, Whitman was, for Ginsberg, a liberating spirit in terms of poetic language as well as sexuality.[70] Ginsberg himself often acknowledged this progeny, the most famous expression of which is his poem "A Supermarket in California" (1955). In this poem the speaker thinks about Whitman as he strolls down the streets and then has a vision of his nineteenth-century mentor in the supermarket: "I saw you, Walt Whitman, childless, lonely old grubber, / poking among the meats in the refrigerator and eyeing the grocery / boys."[71]

Warhol's film was to be set during the Civil War, with Whitman caring for wounded young soldiers. Whitman had in fact been a nurse during the war

and wrote about the experience in a book of poetry, *Drum-Taps* (1865) (which in 1868 he added to *Leaves of Grass*), and in the prose notes *Memoranda During the War* (1875) (included in 1882 in the book *Specimen Days*).[72] In both these works, especially the latter, Whitman described the young age of many of the soldiers for whom he cared, and his affection for them.[73] (Whitman nursed soldiers on both sides of the conflict, a fact that resonated with the anti–Vietnam War protests of Ginsberg, which were at a high point in 1969 when the Warhol film idea was being considered.)

Apparently, Ginsberg's own attraction to handsome boys, which is embedded in his envisionment of Whitman's comportment at the supermarket, led him to seriously consider playing the role, when, in 1971, Warhol's film collaborator Paul Morrissey began to actively pursue the realization of the Whitman movie.[74] However, in the end, according to one account, the film studios (with which Warhol and Morrissey were by this time working in an endeavor to now produce commercial films) were unwilling to support such a venture,[75] while Ginsberg has stated that he decided not to play the role because he was busy and "I wasn't quite sure what they were going to do with Whitman. I didn't feel like making fun of Whitman."[76]

The idea of casting Ginsberg as Whitman exemplifies Warhol's penchant for seeing the relationships between and then weaving together into a tight fabric the artistic (Ginsberg's debt to Whitman's writings) and the personal (Ginsberg's interest in boys and political activities as echoing aspects of Whitman's biography). Ginsberg himself did not draw lines between the artistic and personal, and he shared this approach to creativity with other beat writers, especially Jack Kerouac.

Nowhere are the artistic and personal more intertwined in Kerouac's writings than in his novel *Visions of Cody*, which seems to have been a model for Warhol when, in the mid-1960s, he decided to write—or more accurately, to produce—his own novel. Warhol's *a: a novel*, published in 1968, was made up of audio tapes that he had recorded of Ondine in 1965. His idea was to record twenty-four hours of Ondine's life, but such a marathon proved to be an impossible feat and recordings had to be made on a few separate days.[77] Kerouac had introduced tape-recorded dialogue into fiction in *Visions of Cody*, of which the third part, "Frisco: The Tape," comprises his transcriptions of taped conversations primarily between Kerouac (who here goes by the name of Jack Duluoz) and Neal Cassady (who goes by Cody Pomeray). *Visions of Cody* has

so much in common with *a: a novel*, ranging from its premise and structure to details of content, that it appears to have been the key literary model for Warhol's book.

Although Kerouac's novel was published in full only posthumously, in 1972, segments of it did appear during the late 1950s and early 1960s, the most extensive of which was a 120-page excerpt put out by New Directions in late 1959.[78] Since Warhol designed a number of jacket covers for New Directions from the early 1950s to around 1961, it is likely that he was familiar with this volume.[79] The New Directions limited edition excerpt was released just as Kerouac was reaching the peak of his publishing career, and it began to sell out by spring 1960.[80] Its rarity contributed to a curiosity about the volume as news of it spread by word of mouth and through its circulation among friends (for example, Padgett had given Berrigan a copy).[81]

When Warhol acquired his first tape recorder, probably in 1964,[82] an interest in using audio tapes for artistic purposes was stirring, in large part due to an awareness of Kerouac's experiments with them. William Burroughs, for instance, created several "cut-up" recordings during the 1960s,[83] and Jonas Mekas was by 1964 making taped diaries that were a counterpart to his "film diaries."[84] But only Kerouac used actual transcriptions of taped conversations with a friend as part of a novel.

Kerouac's undisguised deployment of his own life, and the lives of his friends—in all the disorderliness and minutiae of the everyday that is life—as the content of *Visions of Cody* corresponded to Warhol's conception of art, as John Tytell has aptly pointed out in his analysis of Kerouac's book.[85] The idea of creating characters was entirely alien to Warhol. The following anecdote told by Stephen Koch amusingly illustrates the fiber of Warhol's aesthetic: "I once mentioned to Warhol that I was writing a novel, and he looked at me doubtfully, with his peculiar worried look. 'But you need an awful lot of people for that, don't you?' I answered that I didn't really need a very large crowd. 'Oh . . . oh . . . uh, you mean you just make people *up?*' A nervous incredulity spread over his face. I was speaking of a literally unimaginable artistic process."[86]

For Kerouac, as for Warhol, drug consumption was an important element in the actual process of making the tapes and in their content. Kerouac explained in the author's note preceding *Visions* that "The tape recordings in here are actual transcriptions I made of conversations with Cody who was so high he forgot the machine was turning."[87] The drug that Cody and Jack had taken (in addition to alcohol and marijuana) was Benzedrine (a form of amphetamine), as we learn in the tape section of the novel.[88] Likewise, Ondine's words in *a: a novel* were fueled by amphetamine, and the drug also became a topic of discussion in Warhol's novel.[89] Amphetamine seemed to produce an

openness and a loquaciousness that were well suited to an art form based on conversation.[90]

In its overall structure, too, *a: a novel* has striking counterparts in *Visions of Cody*. In both, the end of the transcribed tapes (which in *a* is also the end of the novel) includes dialogue taken from the radio. Each draws on many of the same literary sources and most conspicuously on James Joyce's *Ulysses:* the second to last chapter of *a* is entitled "OND INE SO LILIQUY [*sic*]"; the second to last section of "Imitation of the Tape" in *Visions*—the chapter after "Frisco: The Tape"—contains a monologue that consciously emulates that found in *Ulysses*.[91] In both novels, furthermore, some of the same kinds of outside elements—notably telephone conversations and music—get recorded and transcribed as they affect, overtake, or interrupt the conversation.[92]

Woven into the dialogue in each novel are nonsensical word plays, or what in beat terminology was called "goofing."[93] Following are passages from *Visions* and *a*, respectively, that contain such word plays. Each passage ends with what seems to be a commentary on the senselessness of what is being said:

CODY. And merriment! No I said melliment, mellimist—
PAT. —I thought you said merriness—
CODY. . . . sepurious . . .
PAT. What, su*per*fluous
CODY. Superflous, that's it . . . wine has become superflous
PAT. Superious
CODY. Sup*ee*rious, that's the word
EVERYBODY. What word?
CODY. Spoorious . . . spurious[94]

O—What would you, what symbol
 would you give a schlitz-
 monger?
Uh, sch . . .
T—Think of what it is. It's a spit,
 shit and split. (*Laugh.*)
 A monger is somebody who sells.
Sell, yeah.
T—Somebody who sells but like it's
 saying
 Schlitzmonger is like saying

crap (*simultaneous conversation:*

I—Did Drella do that? O—

No, I did them myself. You

know I'm very, I got lessons

from Allen Ginsberg y'know.)

T—Bu it's saying it with spit, shit,

and split which is also divided in,

in, well it's uh ridiculous but.[95]

In both *Visions* and *a,* the consumption of drugs that was meant to produce uninhibited dialogue to fill up the tapes did not entirely work. On several occasions, the speakers became self-conscious about being recorded. Jack, for example, at one point in the conversation felt overwhelmed by the challenge of filling up an entire tape:

JACK. Wow, are you high now?

CODY. Yeah, I feel it

JACK. We got another big . . . long . . . sonofabitch to go!

CODY. Yeah . . . yeah . . . well not really

JACK. W-whole big reel—ass!

CODY. Yeah but that's nothing compared to all the things we can talk about, or say

JACK. Oh I'll—that can be solved easily

CODY. How?

JACK. Wal, by stopping it now (REEL ENDS)

(MACHINE BEGINS)

CODY. (*from a month-old tape*) [. . .][96]

And Ondine periodically insisted that Warhol turn off the tape recorder for a while: "let's relax 'cause we'll go crazy"; "Please shut it off, I'm so horrifying."[97] Thus, in each case the very act of recording conversation on tape affected the content of the conversation and thereby raised questions about all existing distinctions between authentic behavior and artifice.[98]

In addition, the taped dialogue was inevitably changed when it was transcribed for publication, due to the inflections produced in the process of turning sounds into written words. Such details as the parenthetical commentaries and the layout of the text on the page metamorphosed the dialogue. In the case of *Visions of Cody,* Kerouac made the transcriptions, but in the case of *a,* several people made them, and their typographical and other errors became part of the novel.[99] In this way, Warhol expanded on Kerouac's idea of using a

144

tape recording as part of a novel, which he took to its logical conclusion by making an entire novel, as opposed to only one chapter, based on audio tapes.

Kerouac was unsuccessful in getting *Visions of Cody* published during his lifetime because parts of it were considered "obscene," and because of its radical format, particularly that of the tape transcriptions. Even his friends criticized the use of these transcriptions in the novel.[100] When Warhol adapted the same format for an entire novel, he created a sure formula for the negative criticism that his novel almost unanimously received.[101] (Warhol later said that he had wanted to write a "bad" novel, because doing something the wrong way always opens doors).[102]

The negative criticisms of the writings of the beats, like those of Warhol's work, were abundant and became part of the authors's cultural identities—that is, part of how the press presented them, and conversely, how they interacted with the press. A consideration of these cultural identities shows us that in addition to the connections between the beat writers and Warhol that are evident in specific works, such as *Couch,* the unrealized Walt Whitman film project, and *a: a novel,* there are connections of a general nature concerning public image. The most prominent of these connections are in 1) particulars of the artists's relationships with the mass media; and 2) a celebration of the commonplace that led numerous critics to deem the work "boring."

The beat writers—above all, Kerouac—received an enormous amount of attention, mostly negative, in the mass media during the late 1950s and early 1960s.[103] The fame, not to mention wealth, that these self-styled outcasts acquired was undoubtedly a model for Warhol in his unabashed quest for fame, which, as was true of the beats, came in the form of notoriety.[104] Several articles in the press attacked the fame of the beat movement. Somehow the critics failed to recognize that, by attacking this fame in high-circulation periodicals, they only fostered what they were attacking (and it is this kind of hypocrisy that Warhol in numerous ways brought to light in his work). A good example of such hypocritical reporting is found in a lengthy article that appeared in *Life* magazine in 1959, entitled "The Only Rebellion Around" and written by Paul O'Neil. O'Neil here stated,

> [The Beat Generation] is seldom out of the news for long. . . . Awareness of the Beat message is almost a social necessity today, and the name-dropper who cannot mention Beat Novelist Jack Kerouac (*On the Road, The Dharma Bums*), Allen Ginsberg (the Shelley of the Beat poets whose *Howl and Other Poems* has sold 33,000 copies) or Lawrence Lipton (author of last summer's best-seller, *The Holy Barbarians*) is no name-dropper at all. . . . [M]ost Americans . . .

experience a morbid curiosity about them. All sorts of entrepreneurs have rushed in to capitalize on this fact.[105]

O'Neil's unflattering essay reached an especially wide audience because in addition to appearing in *Life*, it was disseminated through its inclusion in the paperback compendium *A Casebook on the Beat*, the first anthology of writings by and about the beats. Like *Life*, the *Casebook* targeted a broad audience. It contained a variety of opinions, positive and negative. An especially harsh negative vision of the beats reprinted in this volume was "The Know-Nothing Bohemians" by the extremely conservative Norman Podhoretz, who called attention to the media fascination with Kerouac especially: "[S]oon his photogenic countenance (unshaven, of course, and topped by an unruly crop of rich black hair falling over his forehead) was showing up in various mass-circulation magazines, he was being interviewed earnestly on television, and he was being featured in a Greenwich Village nightclub."[106]

Such reporting about reporting became, a few years later, standard fare in articles about Warhol. For instance, John Leonard, who had the ability to be more self-reflective than O'Neil or Podhoretz, explained in a *New York Times* article of 1968, "Warhol, a child of the media, is unfailingly courteous to their janissaries. Every impertinence, every ghoulish probe, is patiently endured, for he needs us as much as we need him."[107]

Shortly prior to the emergence of Warhol's symbiotic relationship with the media, strategies of self-promotion had been developing within the beat movement itself. The most conspicuous of these was the photographer Fred W. McDarrah's Rent-a-Beatnik business, which he started in 1960 and advertised in the *Village Voice*. McDarrah rented out his beatnik poet friends for parties, at which they would read their work and provide the desired "hip" atmosphere (fig. 79).[108] Such marketing from within a bohemian movement helped to pave the way for Warhol's self-promotion activities.[109]

The second way in which the public image of the beat writers was later echoed by Warhol concerns a glorification of the commonplace, and a resulting implied lack of discrimination between good and bad, right and wrong, high and low.[110] One of Jack Kerouac's most quoted statements, a reply to the question of what it meant to be beat, was that "We love everything. Billy Graham, the Big Ten, rock and roll, Zen, apple pie, Eisenhower—we dig it all."[111] Around five years later, when Warhol was asked by Gene Swenson what pop art is, he replied, in a concise variation on Kerouac's definition of beat, "It's liking things."[112]

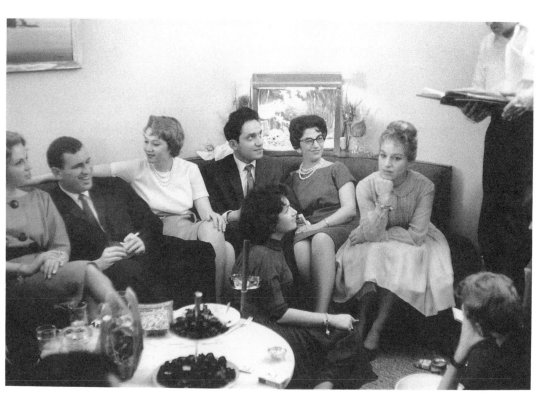

Fig. 79. Fred W. McDarrah, Rent-a-Beatnik party
given by Seymour Winuk, Brooklyn, N.Y., 9 April 1960.
© Fred W. McDarrah.

Kerouac had also expressed this idea in *On the Road,* in which Sal Paradise
says of a friend, "He began to learn 'Yes!' to everything, just like Dean at this
time." [113] This terminology was taken over by Mekas in his description of War-
hol's early films. Mekas is quoted in a 1964 *Newsweek* article as characterizing
Warhol's films as "a look at daily activities like sleeping or eating. It's saying
Yes to life." [114]

Both Kerouac's writings and Warhol's works were, because of their focus
on the commonplace, repeatedly criticized—and also on occasion praised—
for producing boredom in the audience. A 1959 review of Kerouac's novel *Dr.
Sax* called the book "boring," while Herbert Gold, in his 1958 article "The Beat
Mystique," lamented the beat life itself for being rooted in boredom.[115] Sure
enough, one reviewer who discussed the "boredom" of Warhol's films related
it to the lifestyle of the "hipster" (a term generally interchangeable with
"beat"): "[T]he eight-hour 'Sleep' or 'Empire State,' in which unsteady cam-
eras were simply aimed at their subjects, are the masterworks of a hipster sub-

culture that is bored with life."[116] Repeatedly, the boredom of *Empire, Sleep,* and other early Warhol films was attacked.[117]

Warhol responded to such criticism by simply repeating it when he was interviewed. He would tell his interviewers, for instance, that his films were boring because he liked boring things. Thus he entered into dialogues with his critics—fascinating dialogues meriting a serious analysis of their own— just as he had with poets.

The numerous instances in which Warhol "conversed" with poets through his art reveal the extent to which he was not only aware of the various worlds around him, but involved himself with them. Thus, while he may have had voyeuristic tendencies, it is reductionist to understand him simply as a voyeur, as is often done. He was a participant, too, and a highly engaged one at that. The problem is that once art historians attach a label such as "voyeur" or "impersonal" to an artist, it tends to set in; it becomes repeated, rather mechanically, over time. Only a concrete questioning of a given conception of an artist, brought about by scholarship in archives and elsewhere, as I have sought to do here, can provide a substantial alternative to or enrichment of that conception.

Through this kind of scholarship, we are now able to see, for one, that Warhol was both inspired by and an inspirational figure to many poets. He was extremely aware of his role, and it was echoed in his art many years later. For example, in 1982 Warhol produced a series of paintings based on earlier twentieth-century compositions by the artist Giorgio de Chirico, one of these being *The Poet and His Muse* (fig. 80). The two figures in this painting, one seated and the other standing, bring to mind the two poets in Warhol's 1963 cover for *C: A Journal of Poetry* (see figs. 9 and 10), and are emblematic of the social nature of his, and all, artistic pursuits.

My use of social context as a means of interpreting art and poetry has many applications beyond the scope of this book. To remain for the moment with Warhol as a case in point, the following example shows that this approach can assist us in comprehending not only the work he produced in connection with poets in the 1960s, but also work produced in connection with other individuals, and in the subsequent decades of his career.

Warhol's personal involvement with Jon Gould, a vice president of Paramount Pictures, helps to explain the appearance of that company's logo in, among other works, a painting on which he collaborated with Jean-Michel Basquiat in 1984–85 (fig. 81). Warhol met Gould in 1980, and eventually Gould moved into the artist's home.[1] However, by the time the painting in question was made, Gould had become ill—he died of an AIDS-related illness

149

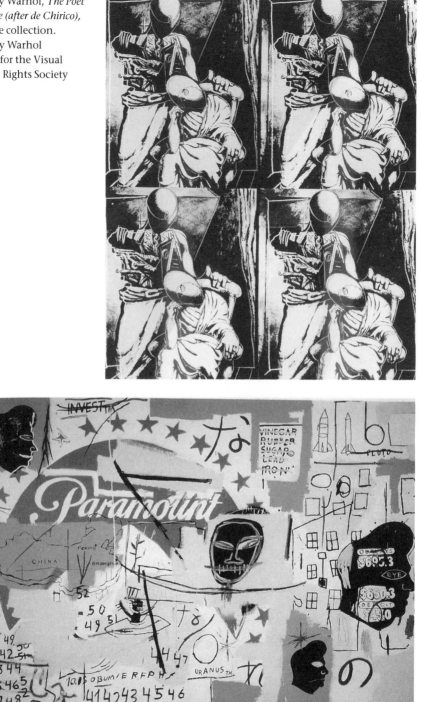

Fig. 80. Andy Warhol, *The Poet and His Muse (after de Chirico)*, 1982. Private collection. © 1997 Andy Warhol Foundation for the Visual Arts / Artists Rights Society (ARS), NY.

Fig. 81. Andy Warhol and Jean-Michel Basquiat, *Untitled*, 1984. Private collection. © 1997 Andy Warhol Foundation for the Visual Arts / ADAGP, Paris / Artists Rights Society (ARS), NY.

Conclusion

in 1986—and his relationship with Warhol had taken a bad turn, both events being sources of great pain for Warhol.[2] These feelings got expressed through art, as in the encoded sign language of the Paramount logo. Therefore, while it is true, as one scholar has observed, that this logo was included in the painting for the "obvious movie star associations,"[3] it is equally true that it was put there as a personal symbol, addressed to Gould.

The foregoing instance of personal symbolism suggests how fruitful such readings of Warhol's work can be. Those that I have pursued in these pages, in relation to poetry, are really only the beginning of a rethinking of who Warhol was and of what the multiple levels of meaning in his art are. These instances are, by extension, the starting point for reconsidering why Warhol touched so many people and had an influence on so many arenas of culture. For, a deep human presence is required for an artist to have so broad a reach.

APPENDIX

Here is "Billy Linich's Party" by John Daley,
to which I refer in chapter 2. It was first published
in *The Floating Bear* 27 (November 1963).

```
                    BILLY LINICH'S PARTY

        The pronouns in the following review
        are dedicated to Yvonne Rainer.

                    First Haircut

The worst thing about Billy Linich's party was that Dorothy Podber
(the meanest girl in town) had removed M. C. Richards' ashtrays.

The next worst thing was that Lucinda Childs didn't come.

Alan Marlowe had a new gleam in his eye and a new gash above
it. Diane Di Prima wore black and blue velvet. Who should
be angry?

Ralph Di Padova made declarative sentences without alluding to
Ouspensky. He said, "I want a cowboy haircut."

Ralph Strauss's haircut took longer.

                    Second Haircut

Timothy Baum prefers shoulder holsters: they're especially
useful at the Automat. He resents Eleanor Roosevelt: she packed
a pistol in her purse.

James Bond prefers a Beretta .25.

Joanne Beretta prefers Ferrara. She is going to Chicago for
six months.

Claire and Jean-Jacques Tschudin live upstairs from a holster
you can wear under your shorts.

Painters in fourteenth-century Florence belonged to the apothe-
caries' guild.

                    Third Haircut

Why are you so mysterious?

I have no wish to be indiscreet.
```

Fourth Haircut

Corrosive? I don't even sweat.

-Timothy Baum

Fifth Haircut

"Simone Weil died on August 24, 1943. Her death, like her
life, was exemplary: practically unknown, with four-fifths of
her writings, and the best part, unread and unpublished, a victim
of war and of her own love of peace! A recurrent theme in her
thinking was that evil and pain were a false currency which was
passed from hand to hand until it reached one who receives it but
does not pass it on. Through such a one the world was made
better...."

A very sexy party.
 -Michael Katz

A timeless and sexy party.
 -James Waring

Sixth Haircut

 Well, Gerry Malanga
 was a-doin' the conga
 in a little cabana
 in old Havana

 and someone* stuffed his hair** into his fly.

Lester: This party isn't quite ready yet. Let's come back later.

Malka: Yeah, later.

John: But how does Chris think people treat Dorothy?

Ralph: He takes a lot of bennies.

De Flores: I'm up to the chin in Heaven!

 Hark! by my horrors,
 Another clock strikes two!

Seventh Haircut

A Brescia,
mentre la pioggia
scroscia,
e sulla strada la biscia
striscia,
Natascia,
la bagascia,
alza la coscia
e piscia.

<div align="right">

-attributed to Carlino Dolcini

</div>

Eighth Haircut

Cerberus, not Cerebus.
Binghamton, not Binghampton.
Biotin, not inositol.

Ninth Haircut

Ask Remy Charlip to sing the Snip Snip song from Samson and Delilah.
He sang it on June 10, 1961, the night my grandmother died, I first
saw La Dolce Vita, and George Zahn broke Malka Safro's leg.

*who requests anonymity and wants his beard trimmed
**it may have been a mushroom

<div align="right">

--John Daley

</div>

NOTES

Introduction

1. Donald Kuspit, *The Cult of the Avant-Garde Artist* (Cambridge: Cambridge University Press, 1993), 67–68 and 77, respectively.

2. See Francine du Plessix, introduction to "Painters and Poets," *Art in America* 53 (October–November 1965): 24.

3. These comments were made by, respectively, Charles Henri Ford, interview by author, New York, 20 February 1991, tape recording; and John Giorno, interview by author, New York, 15 April 1991, tape recording.

4. Patrick S. Smith, interview with Ted Carey, 16 October 1978, in Smith, *Andy Warhol's Art and Films* (Ann Arbor: UMI Research Press, 1986), 262.

5. See Sotheby's, *The Andy Warhol Collection*, vol. 2, Collectibles, Jewelry, Furniture, Decorations and Paintings (New York: Sotheby's, 1988), lot nos. 1550–1611.

6. Stephen Koch, *Stargazer: The Life, World and Films of Andy Warhol*, rev. ed. (New York: Marion Boyars, 1991), 69.

7. Phyllis Rose, "Literary Warhol," *Yale Review* 79 (autumn 1989): 21–33.

8. Ibid., 33.

9. Du Plessix, introduction, "Painters and Poets," 24.

10. Ibid.

11. Sally Banes, *Greenwich Village 1963: Avant-Garde Performance and the Effervescent Body* (Durham: Duke University Press, 1993).

12. On the Gotham Book Mart party photograph, see Victoria Glendinning, *Edith Sitwell: A Unicorn Among Lions* (New York: Alfred A. Knopf, 1981), 277; and on the group photograph of the abstract expressionists, see Bradford R. Collins, "*Life* Magazine and the Abstract Expressionists, 1948–51: A Historiographic Study of a Late Bohemian Enterprise," *Art Bulletin* 73 (June 1991): 297–98.

13. For an interesting explanation of this difference between the world of the writer and that of the visual artist, see Trevor Fairbrother, "Tomorrow's Man," in *"Success is a job in New York . . .": The Early Art and Business of Andy Warhol,* ed. Donna M. De Salvo (New York: Grey Art Gallery and Study Center; Pittsburgh: Carnegie Museum of Art, 1989), 55.

14. The pages of the *Life* photograph of the Sitwell Gotham Book Mart party that Warhol saved are now in the Archives Study Center of the Andy Warhol Museum, Pittsburgh, Penn. The painter Philip Pearlstein has recalled that when he moved with Warhol to New York, Warhol's favorite among the items in Pearlstein's record collection was the Edith Sitwell and William Walton *Facade* recording; see Pearlstein, in "Andy Warhol 1928–87: A Collage of Appreciations from the Artist's Colleagues, Critics and Friends," *Art in America* 75 (May 1987): 138.

15. This kind of homosexual literary genealogy has been traced in the literary allusions contained within the work of Jasper Johns, who, unlike Warhol, has always been thought of as a highly intellectual artist; see Kenneth E. Silver, "Modes of Disclosure: The Construction of Gay Identity and the Rise of Pop Art," in *Hand-Painted Pop: American Art in Transition, 1955–62,* ed. Russell Ferguson (Los Angeles: Museum of Contemporary Art; New York: Rizzoli, 1992), 183–90.

16. Gregory Woods, *Articulate Flesh: Male Homo-Eroticism and Modern Poetry* (New Haven: Yale University Press, 1987), 3.

17. Paul Morrissey, in "Andy Warhol as a Film-maker: A Discussion between Paul Morrissey and Derek Hill," *Studio International* 181 (February 1971): 58.

18. Ralph Pomeroy, *Stills and Movies* (San Francisco: Gesture, 1961), back cover.

19. On these assignments, see Bennard B. Perlman, "The Education of Andy Warhol," in *The Andy Warhol Museum: The Inaugural Publication* (Pittsburgh: Andy Warhol Museum, 1994), 161, 163.

20. On this point, see also Fred Lawrence Guiles, *Loner at the Ball: The Life of Andy Warhol* (London: Bantam Press, 1989), 41. Evidently the drawings are lost. See Rainer Crone, *Andy Warhol: The Early Work 1942–1962,* trans. Martin Scutt (New York: Rizzoli, 1987), 71–72.

21. See Andy Warhol, *The Philosophy of Andy Warhol (From A to B and Back Again)* (San Diego: Harcourt Brace Jovanovich, 1975), 147–48.

22. Postcard addressed to "andy," postmarked 28 November 1951. Archives Study Center, the Andy Warhol Museum. Jackson in addition sent Warhol the first issue of the *Black Mountain Review* (June 1951), also now housed in the Archives Study Center.

23. Warhol, postcard addressed to "tommie jackson p," undated. Archives Study Center, the Andy Warhol Museum.

24. Warhol, *The Philosophy of Andy Warhol,* 117–18.

25. For an overview of the history of poems that are representations of works of visual art, see James A. W. Heffernan, *Museum of Words: The Poetics of Ekphrasis from Homer to Ashbery* (Chicago: University of Chicago Press, 1993).

26. Wendy Steiner, *The Colors of Rhetoric: Problems in Relations between Modern Literature and Painting* (Chicago: University of Chicago Press, 1982).

27. W. J. T. Mitchell, *Iconology: Image, Text, Ideology* (Chicago: University of Chicago Press, 1986) and *Picture Theory* (Chicago: University of Chicago Press, 1994).

28. Roland Barthes, "The Death of the Author," in *Image—Music—Text,* trans. Stephen Heath (1977; New York: Noonday Press, 1988), 142–48; and Michel Foucault, "What Is an Author?" in Foucault, *Language, Counter-Memory, Practice: Selected Essays and Interviews,* ed. and intro. Donald F. Bouchard, trans. Donald F. Bouchard and Sherry Simon (Ithaca: Cornell University Press, 1977), 113–38, and in *Textual Strategies: Perspectives in Post-Structuralist Criticism,* ed., intro., and trans. Josué V. Harari (Ithaca: Cornell University Press, 1979), 141–60.

Chapter One

1. Hugh Kenner, "Literary Biographies," in Kenner, *Historical Fictions: Essays* (San Francisco: North Point Press, 1990), 52.

2. The literature on gossip is astonishingly vast. Some key studies in which it is argued that gossip should be taken seriously as an important and powerful element in life are Max Gluckman, "Gossip and Scandal," *Current Anthropology* 4 (1963): 307–16; and John Sabini and Maury Silver, "A Plea for Gossip," chap. 5 in *Moralities of Everyday Life* (Oxford: Oxford University Press, 1982), 89–106. On gossip and literature, see Margaret Drabble, "Novelists as Inspired Gossips," *Ms.* 11 (April 1983): 32–34; and Patricia Meyer Spacks, *Gossip* (New York: Alfred A. Knopf, 1985).

3. John Giorno, interview by Winston Leyland, July 1974, in *Gay Sunshine Interviews,* ed. Winston Leyland, vol. 1 (San Francisco: Gay Sunshine Press, 1978), 159–60 (first published in *Gay Sunshine* 24 [spring 1975]).

4. Elaine de Kooning, et al., "5 Participants in a Hearsay Panel," in Frank O'Hara, *Art Chronicles 1954–1966,* rev. ed. (New York: George Braziller, 1990), 149, 150 (first published in *It Is* 3 [winter–spring 1959]).

5. Frank O'Hara and Larry Rivers, "How to Proceed in the Arts," in O'Hara, *Art Chronicles,* 95 (first published in *Evergreen Review* 5 [1961]). Larry Rivers also discussed gossip in art in "Life Among the Stones," *Location* 1 (spring 1963): 98.

6. O'Hara, "Personal Poem," *The Collected Poems of Frank O'Hara,* ed. Donald Allen

(1971; reprint, New York: Alfred A. Knopf, 1979), 335–36. © 1971 Maureen Granville-Smith, administratix of the Estate of Frank O'Hara. Reprinted by permission of Alfred A. Knopf, Inc. (First published in *Yugen* 6 [1960], and in Elias Wilentz, ed., *The Beat Scene* [New York: Corinth Books, 1960].)

7. O'Hara, *Collected Poems* (see n. 6 above), 328.

8. Pearl K. Bell, "The Poverty of Poetry," in *Frank O'Hara: To Be True to a City*, ed. Jim Elledge (Ann Arbor: University of Michigan Press, 1990), 39 (first published in *New Leader*, 10 January 1972).

9. Allen Ginsberg, "City Midnight Junk Strains," in *Homage to Frank O'Hara*, ed. Bill Berkson and Joe LeSueur, 3d ed. (Bolinas, Calif.: Big Sky, 1988), 148–49 (first published in *Paris Review* 11 [winter–spring 1968]).

10. O'Hara, "Art Chronicle III," in O'Hara, *Standing Still and Walking in New York*, ed. Donald Allen (San Francisco: Grey Fox Press, 1983), 149, 151 (first published in *Kulchur* 3 [spring 1963]). By 1965, O'Hara had a change of heart and began to view Warhol as a "serious" artist; see Edward Lucie-Smith, "An Interview with Frank O'Hara" (October 1965), in O'Hara, *Standing Still*, 8, 20. The artist Joe Brainard wrote, "I remember Frank O'Hara putting down Andy Warhol and then a week or so later defending him with his life," in "Frank O'Hara" (1968), Berkson and LeSueur, *Homage to Frank O'Hara*, 167.

11. See, for example, "Art Chronicle III," in O'Hara, *Standing Still*, 147.

12. John Giorno, interview by author, New York, 15 April 1991, tape recording. An abbreviated version of this story is told in Leyland, *Gay Sunshine Interviews*, 156: "in the early days, Frank used to laugh at Andy, make fun of him to his face and torture him." On Giorno's account, and for a general assessment of O'Hara's attitude toward Warhol, see also Brad Gooch, *City Poet: The Life and Times of Frank O'Hara* (New York: Alfred A. Knopf, 1993), 394–99.

13. See Andy Warhol and Pat Hackett, *POPism: The Warhol '60s* (New York: Harcourt Brace Jovanovich, 1980), 11. O'Hara was an early supporter of the work of Johns and Rauschenberg; see, for example, "Art Chronicle I," in O'Hara, *Standing Still*, 131 (first published in *Kulchur* 2 [spring 1962]). For an excellent analysis of the story in *POPism* regarding Johns's and Rauschenberg's dislike of Warhol, see Kenneth E. Silver, "Modes of Disclosure: The Construction of Gay Identity and the Rise of Pop Art," in *Hand-Painted Pop: American Art in Transition, 1955–62*, ed. Russell Ferguson (Los Angeles: Museum of Contemporary Art; New York: Rizzoli, 1992), 193–97.

14. Warhol and Hackett, *POPism*, 187.

15. The two poems are in O'Hara, *Collected Poems*, 325, 360.

16. See, for example, Anthony Libby, "O'Hara on the Silver Range," in Elledge, *To Be True to a City*, 134 (first published in *Contemporary Literature* 17 [spring 1976]); and Fred Moramarco, "John Ashbery and Frank O'Hara: The Painterly Poets," *Journal of Modern Literature* 5 (September 1976), 442–43. On O'Hara's own thoughts about the relation of his poetry to abstract expressionist painting, and in particular to the work of Jackson Pollock, see Alice C. Parker, *The Exploration of the Secret Smile: The Language of Art and Homosexuality in Frank O'Hara's Poetry* (New York: Peter Lang, 1989), 4–6, 25–26. Studies in which the connections of O'Hara's work to that of Andy Warhol have been pointed out are Paul Carroll, "An Impure Poem About July 17, 1959," in Elledge, *To Be True to a City*, 377–78 (first published in Carroll, *The Poem In Its Skin* [Chicago: Follett, A Big Table Book, 1968]); and Andrew Ross, "The Death of Lady Day," in Elledge, *To Be True to a City*, 380–81 (first published in *Poetics Journal* [1989]).

17. See, for instance, Warhol and Hackett, *POPism*, 73.

18. Gene R. Swenson, "What Is Pop Art?" *ARTnews* 62 (November 1963): 26.

19. Ibid., 61.

20. John Gruen, *The Party's Over Now: Reminiscences of the Fifties—New York's Artists, Writers, Musicians, and Their Friends* (1972; reprint, Wainscott, N.Y.: Pushcart Press, 1989), 161.

21. Ibid., 166.

22. According to Malanga, his mentor Willard Maas had spoken badly of Malanga to O'Hara, describing him as "an undesirable," lacking in manners, and uncouth. Telephone interview by author, 13 August 1990, tape recording.

23. Perhaps O'Hara experienced the kind of feeling tenderly described by Roland Barthes under the heading "gossip" in *A Lover's Discourse: Fragments,* trans. Richard Howard (New York: Noonday Press, 1978), 183: "Pain suffered by the amorous subject when he finds that the loved being is the subject of gossip and hears that being discussed promiscuously." I am grateful to Debra Balken for having referred me to this discussion of gossip.

24. See, respectively, Marjorie Perloff, *Frank O'Hara: Poet among Painters* (1977; reprint, Austin: University of Texas Press, 1979), 169, and Ted Berrigan, Art Chronicle, *Kulchur* 5 (autumn 1965): 24.

25. Ted Berrigan, Diaries, undated entry of the final Tuesday in July 1963. Berrigan Collection. Rare Book and Manuscript Library, Columbia University, New York.

26. Gerard Malanga, telephone interview by author, 22 October 1990, tape recording. Malanga recalled that the reading at which Warhol made this film took place at Café Le Metro in the East Village, an important venue for the presentation of new poetry at the time. Malanga thinks that the filming occurred in spring 1964, a date repeated without documentation in Gooch, *City Poet,* 398. It is quite possible that this footage is among the as yet unrestored film material belonging to the Andy Warhol Foundation for the Visual Arts, and that a precise date for it can be established once it is identified.

27. The poem to which Berrigan referred here is dedicated to Warhol and entitled "Now in Another Way" (see chapter 4).

28. Berrigan to Warhol, 1 August 1963, Archives Study Center, the Andy Warhol Museum, Pittsburgh, Penn. Reprinted by permission of the Estate of Ted Berrigan, Alice Notley, executor. A copy of each of the issues of *C* mentioned by Berrigan in this letter is also in the Archives Study Center.

29. Berrigan, Diaries, Thursday and Tuesday, respectively, the first week in August 1963. Berrigan Collection. Reprinted by permission of the Estate of Ted Berrigan, Alice Notley, executor.

30. This manuscript is in the Archives Study Center, the Andy Warhol Museum. O'Hara's essay "The Poetry of Edwin Denby" first appeared in *Poetry* 89 (1957); "Edwin's Hand" was first published in the Denby issue of *C.*

31. An excellent eyewitness account of Warhol's working process in the production of Polaroid portraits is found in Vincent Fremont, introduction to *Andy Warhol Polaroids 1971–1986* (New York: Pace MacGill Gallery, 1992), 4–7.

32. A history of homosexual parodies of heterosexual domesticity in portraits would be a worthwhile undertaking. A probable eighteenth-century example of this sort of parody is found in William Hogarth's conversation piece, *Lord Hervey and His Friends* (Ickworth, ca. 1738); see Jill Campbell, "Politics and Sexuality in Portraits of John, Lord Hervey," *Word & Image* 6 (October–December 1990): 287–97.

33. These five Polaroids were in the collection of the Andy Warhol Foundation for the Visual Arts in the early 1990s. I am grateful to Ann Sass, former curator of photographs at the Foundation, for helping me identify these Polaroids, and for showing them to me.

34. For a discussion of an instance in which Warhol used a portrait printed in negative for a back cover in order to associate death with the end of a volume, see my essay "Collaboration as Social Exchange: *Screen Tests / A Diary* by Gerard Malanga and Andy Warhol," *Art Journal* 52 (winter 1993): 60–61.

35. The idea of concluding a book with a scandalous image had already been explored by Warhol in a few of the collaborative volumes he produced during the 1950s, such as *25 Cats Name* [sic] *Sam and One Blue Pussy* (ca. 1954), made with Charles Lisanby, in which the risqué finale is signaled by the last two words of the book's title.

36. Malanga, interview by author, New York, 15 August 1989, tape recording.

37. A reproduction of this variant of the text is found in Andreas Brown, *Andy Warhol: His Early Works 1947–1959* (New York: Gotham Book Mart, 1971), no pagination. Another book by Warhol from this period, *A Is an Alphabet* (1953), produced in collaboration with Ralph T. (Corkie) Ward—as was *Love Is a Pink Cake*—illustrates, for the letter "o," two men about to kiss. For the homosexual content of both these books, see Trevor Fairbrother, "Tomorrow's Man," in *"Success is a job in New York . . .": The Early Art and Business of Andy Warhol,* ed. Donna M. De Salvo (New York: Grey Art Gallery; Pittsburgh: Carnegie Museum of Art, 1989), 59–60.

38. According to the sociologist Tamotsu Shibutani, the "most effective offensive use of rumors involves the staging of events; situations rather than communication content are manipulated and definitions develop spontaneously." *Improvised News: A Sociological Study of Rumor* (Indianapolis: Bobbs-Merrill, 1966), 213. On the importance of the appearance of spontaneity for the effectiveness of gossip, see Roger D. Abrahams, "A Performance-Centred Approach to Gossip," *Man: The Journal of the Royal Anthropological Institute* 5 (1970): 300.

39. Boone analyzes the gossip in O'Hara's poetry as a form of homosexual language in "Gay Language as Political Praxis: The Poetry of Frank O'Hara," *Social Text: Theory / Culture / Ideology* 1 (winter 1979): 81, 82. Interesting discussions of gossip and gender are found in Jack Levin and Arnold Arluke, *Gossip: The Inside Scoop* (New York: Plenum Press, 1987), 6; and Spacks, *Gossip,* 31–33, 38–45.

40. On this feature of O'Hara's work, see John Lowney, "The 'Post–Anti-Esthetic' Poetics of Frank O'Hara," *Contemporary Literature* 32 (summer 1991): 248.

41. Berrigan, Diaries (see n. 29 above), entry composed between 2 and 11 December 1963, Berrigan Collection. In a 15 October 1963 diary entry, Berrigan recorded that the Denby issue had been distributed.

42. Berrigan noted in his diary on 2 December 1963 that he had attended a cocktail party given that day by Larry Rivers to celebrate O'Hara's return from Europe. Berrigan Collection.

43. Malanga, interview by author, New York, 15 August 1989, tape recording. Malanga recalled having heard this story from John Gruen.

44. Gluckman, "Gossip and Scandal," 314.

45. Pliny the Elder, *Natural History,* Loeb Classical Library (1952), 140. This story is recounted in Ernst Kris and Otto Kurz, *Legend, Myth and Magic in the Image of the Artist,* ed. and trans. E. H. Gombrich (New Haven: Yale University Press, 1979), 106. Some additional stories of artists responding to negative criticism by portraying their critics in an unflattering light are told in Kris and Kurz, 104–7. On the use of gossip as a convenient form of revenge, see Rebecca Birch Stirling, "Some Psychological Mechanisms Operative in Gossip," *Social Forces* 34 (1955–56): 262; and Levin and Arluke, *Gossip: The Inside Scoop,* 20.

46. Malanga, telephone interview by author, 13 August 1990, tape recording. Berrigan noted in his diary on 25 July 1963 that he had rejected two poems by Malanga. Berrigan Collection.

47. Stirling, "Some Psychological Mechanisms Operative in Gossip," 267, and Gluckman, "Gossip and Scandal," 313.

48. Denby and his friend, photographer and filmmaker Rudy Burckhardt, had been among the first supporters of de Kooning's work. See Ron Padgett, introduction to Denby, *The Complete Poems* (New York: Random House, 1986), xviii.

49. Tibor de Nagy recalled that Warhol came to his gallery, which represented the work of Fairfield Porter, and asked him if he would secure the commission for Porter's portrait of him and Carey; telephone conversation with author, 4 March 1992. Warhol had regularly visited this gallery during the 1950s and had purchased at least one work by Larry Rivers there; see John Bernard Myers, *Tracking the Marvelous: A Life in the New York Art World* (New York: Random House, 1983), 136. O'Hara was closely linked to the Tibor de Nagy Gallery, which, among other activities, published a modest literary serial entitled *Semi-Colon.* The

first issue of *Semi-Colon* (which was undated) included, on the front page, short prose pieces by O'Hara and Denby. Warhol probably obtained the copy of this issue that is now in the Archives Study Center of the Warhol Museum on one of his visits to the gallery.

50. Warhol's own self-mocking explanation of why he and Carey posed together for the Porter portrait was that they thought it would be cheaper to commission one portrait and then cut it in half than to commission two separate portraits. See Warhol and Hackett, *POPism*, 6.

51. For Berkson's account of this aspect of his relationship with O'Hara, see Gooch, *City Poet*, 385.

52. Billy Name, telephone interview by author, 9 June 1992, tape recording.

53. See Victor Bockris, *The Life and Death of Andy Warhol* (New York: Bantam Books, 1989), 139. For a discussion of Warhol's interest in younger men during the 1960s, see ibid., 131.

54. A detailed account of the gossip these two *carte de visite* images produced is found in Vicki Goldberg, *The Power of Photography: How Photographs Changed Our Lives* (New York: Abbeville Press, 1991), 109–11.

55. See Walter Benjamin, "The Work of Art in the Age of Mechanical Reproduction," in *Illuminations*, ed. Hannah Arendt and trans. Harry Zohn (New York: Schocken Books, 1969), 225–26.

56. One of these pillowcases was advertised in *Ed Sanders' Catalogue #1* (June–July 1964), no pagination, item no. 48. Fales Library, New York University.

57. Malanga, interview by author, New York, 15 August 1989, tape recording.

58. Several poems that include the words "dear Chris" are found in Berrigan, *The Sonnets*, rev. ed. (New York: United Artists Books, 1982).

59. See Lita Hornick, *The Green Fuse: A Memoir* (New York: Giorno Poetry Systems, 1989), 31.

60. Ibid.

61. James Stoller, "Beyond Cinema: Notes on Some Films by Andy Warhol," *Film Quarterly* 20 (fall 1966): 38.

62. Howard Junker, "Andy Warhol, Movie Maker," *The Nation,* 22 February 1965, 207. I am grateful to Callie Angell for calling my attention to this article.

63. In an attempt to list the defining characteristics of gossip, the sociologist Albert Blumenthal argued that "all gossip is spread by word of mouth" in "The Nature of Gossip," *Sociology and Social Research* 22 (1937): 34. Few writers have considered the potential of visual imagery to function as gossip. Aside from Vicki Goldberg's account of two *carte de visite* portraits discussed here, the only studies I have found that address directly this possibility are Henry Lanz, "Metaphysics of Gossip," *Ethics: An International Journal of Social, Political and Legal Philosophy* 46 (1936): 492–99 (a somewhat eccentric but interesting account); and Levin and Arluke, *Gossip: The Inside Scoop*, 180–81. Although it does not deal with gossip itself, David Freedberg's study of reception, which concerns cases in which the "sign and signified elide and conflate," and "contexts where superior terms are less articulated," is highly pertinent to instances in which visual imagery functions as gossip; *The Power of Images: Studies in the History and Theory of Response* (Chicago: University of Chicago Press, 1989).

64. A groundbreaking examination of the autobiographical elements in Warhol's work of the 1960s is Patrick S. Smith, *Andy Warhol's Art and Films* (Ann Arbor: UMI Research Press, 1986).

Chapter Two

1. Ted Berrigan, interview by Ruth Gruber, in *Talking in Tranquility: Interviews with Ted Berrigan,* ed. Stephen Ratcliffe and Leslie Scalapino (Bolinas, Calif.: Avenue B; Oakland, Calif.: O Books, 1991), 55–56 (first published in *Chicago* [October 1973]). Berrigan's place in the development of "côteries" of poets is considered in Geoff Ward, *Statutes of Liberty: The New York School of Poets* (New York: St. Martin's Press, 1993), 178–79.

2. *The Floating Bear* 27 (November 1963), reprinted in *The Floating Bear: A Newsletter 1961–1969,* ed. Diane di Prima and LeRoi Jones, intro. Diane di Prima (La Jolla, Calif.: Laurence McGilvery, 1973), 328.

3. For Warhol's comment on this aspect of his silkscreen painting technique, see Gene R. Swenson, "What Is Pop Art?" *ARTnews* 62 (November 1963): 26.

4. *Ed Sanders' Catalogue #1* (June–July 1964), no pagination, item no. 48, Fales Library, New York University.

5. Interview by Barry Alpert, in Ratcliffe and Scalapino, *Talking in Tranquility,* 49 (first published in *Vort* 1 [1972]). For another account of such exchanges, see Ed Sanders, "Siobhan McKenna Group-Grope," *Tales of Beatnik Glory* (New York: Citadel Press, 1990), 136.

6. Ron Loewinsohn, "Reviews: After the (Mimeograph) Revolution," *Triquarterly* 18 (spring 1970): 222.

7. In another account of the importance of the mimeograph as a means of disseminating material quickly, Diane di Prima, the coeditor of *Floating Bear,* also stressed the role this feature played in the production of dialogue:

> I remember that the last time I saw Charles Olson in Gloucester, one of the things he talked about was how valuable the Bear had been to him in its early years because of the fact that he could get new work out that fast. He was very involved in speed, in communication. We got manuscripts from him pretty regularly in the early days of the Bear, and we'd usually get them into the very next issue. That meant that his work, his thoughts, would be in the hands of a few hundred writers within two or three weeks. It was like writing a letter to a bunch of friends. . . . What we [di Prima and her coeditor LeRoi Jones, aka Amiri Baraka] did have in common was our consciousness that the techniques of poetry were changing very fast, and our sense of the urgency of getting the technological advances of, say, Olson, into the hands of, say, Creeley, within two weeks, back and forth, because the thing just kept growing at a mad rate out of that.

Di Prima, introduction to *The Floating Bear: A Newsletter,* x–xi. A consideration of the importance of the small press in general for the publication of American poetry since World War II is found in Ward, *Statutes of Liberty,* 179–80.

8. For example, one version of the movie *Haircut* was filmed in late 1963 and screened in January 1964, while *Ivy and John* and *Screen Test No. 2* were filmed and screened publicly in the same month, January 1965; see Miles McKane and Catia Riccaboni, "Filmographie," in *Andy Warhol, Cinema* (Paris: Éditions CARRÉ and Centre Georges Pompidou, 1990), 254, 256.

9. On the role the audience plays in investing meaning in Warhol's films, see Stephen Koch, *Stargazer: The Life, World and Films of Andy Warhol,* rev. ed. (New York: Marion Boyars, 1991), 57. For instances in which the audience response to a Warhol film is affected by a person's knowledge of someone appearing in the it, see my essay "Collaboration as Social Exchange: *Screen Test / A Diary* by Gerard Malanga and Andy Warhol," *Art Journal* 52 (winter 1993): 62.

10. Warhol made at least three movies entitled *Haircut* between November 1963 and early 1964. A thorough assessment of these distinct *Haircut* films remains to be written, but a summary of the literature on them is found in McKane and Riccaboni, "Filmographie," 254. Additional information about the three films has been brought to light in Callie Angell, *The Films of Andy Warhol: Part II* (New York: Whitney Museum of American Art, 1994), 12. For her publication, Angell added a number to the title of each of the known *Haircut* films so that they would not be confused with each other. I have followed her system.

11. Name reminisced, "I had covered [my] entire apartment with silver foil. . . . Andy came once and he asked if I would do the decor for his new studio, the Factory, just the way I had done my apartment. It took me so long to do the Factory that I just stayed there." Jean Stein, *Edie: An American Biography,* ed. with George Plimpton (New York: Alfred A. Knopf, 1982), 204–5. This decorating job apparently occurred from January to April 1964. The date

163

of Warhol's burgeoning friendship with Name, which was clearly cemented by around November 1963 when *Haircut* was filmed, remains somewhat vague. On both points, see Debra Miller, *Billy Name: Stills from the Warhol Films* (Munich: Prestel, 1994), 10, 12 nn. 3, 4.

12. According to di Prima, she unintentionally drove Name away when she came into conflict with him over her annoyance with his tendency to invent his own punctuation for pieces by other writers as he typed them up on the mimeograph stencils. See di Prima's introduction to *The Floating Bear: A Newsletter*, xvii.

13. On this feature of *Floating Bear*, see also this chapter, note 7.

14. A copy of this issue of *Floating Bear* addressed to Warhol is in the Archives Study Center, the Andy Warhol Museum, Pittsburgh, Penn.

15. Name had learned to cut hair as a boy from his grandfather, who was a barber; see David Bourdon, *Warhol* (New York: Harry N. Abrams, 1989), 170. An account by Name of his haircut parties is found in Stein, *Edie*, 204.

16. Miller, *Billy Name*, 12 n. 4.

17. On Ray Johnson and the New York Correspondence School, see David Bourdon, introduction, "The New York Correspondence School," *Artforum* 6 (October 1967): 50–55; William Wilson, introduction, *Correspondence: An Exhibition of the Letters of Ray Johnson* (Raleigh: North Carolina Museum of Art, 1976); Ed Plunkett, et al., "Send Letters, Postcards, Drawings, and Objects . . . : The New York Correspondence School," *Art Journal* 36 (spring 1977): 233–41; and Clive Phillpot, "The Mailed Art of Ray Johnson," in *More Works by Ray Johnson, 1951–1991* (Philadelphia: Goldie Paley Gallery, Moore College of Art and Design, 1991).

18. *The Sinking Bear: A Newsletter* 2 (December 1963): 4. Several other references to Warhol appear in the issues of *Sinking Bear*.

19. *The Sinking Bear* 5 (January 1964): 4. See also, on Name's identity as a haircutter, *Sinking Bear* 2 (December 1963): 2, and 4 (December 1963): 3–5. A poem by Gerard Malanga on the theme of haircutting, entitled "Anti-Sonnet XXXVII," which is based on a sonnet by Ted Berrigan, appeared in *The Sinking Bear* 4 (December 1963): 5. Malanga's emulations of Berrigan's sonnets are discussed in chapter 4.

20. On Daley, see di Prima and Jones, *The Floating Bear: A Newsletter*, 570 n. 66.

21. Di Prima, introduction to *The Floating Bear: A Newsletter*, xii and xiv. Herko also contributed two reviews to *Floating Bear;* see *The Floating Bear: A Newsletter*, 118, 192.

22. On the homoerotic tenor of this film, see Angell, *The Films of Andy Warhol: Part II*, 12. For a description of the scene in *Haircut* (no. 1) in which Herko is naked, see Koch, *Stargazer*, 54.

23. On Waring's involvement in putting together issues of the journal, see di Prima's introduction to *The Floating Bear: A Newsletter*, xii. Reviews of Waring's performances are found in *The Floating Bear: A Newsletter*, 191, 215–16. A poem, an art review, and a few letters by Waring were published in *Floating Bear* as well.

24. On Name's and Herko's involvements in Waring's programs, see Sally Banes, *Democracy's Body: Judson Dance Theater 1962–1964* (Ann Arbor: UMI Research Press, 1983), xii–xiii, 16, 134, 152–53, 165.

25. On Waring's interest in Zen, see ibid., 29, 208.

26. See "Question à La Monte Young," in *Andy Warhol, Cinema*, 55. La Monte Young also discusses here the often-noted influence of his music on Warhol's early films. Billy Name believes he knew James Waring by 1960, when the poem was written. He met Waring through his friend the lighting designer Nick Cernovich (who, like Ray Johnson, had studied at Black Mountain College). Billy Name, interview by author, Poughkeepsie, N.Y., 3 June 1995, tape recording.

27. James Waring to La Monte Young, December 1960, La Monte Young Archives, New York. Quoted in Barbara Haskell, *Blam!: The Explosion of Pop, Minimalism, and Performance, 1958–1964* (New York: Whitney Museum of American Art in association with W. W. Norton,

1984), 53. Although Fluxus was not officially founded until 1962, several productions typical of the movement, such as Waring's poem, were created in the previous few years; see Owen F. Smith, "Fluxus: A Brief History and Other Fictions," in Walker Art Center, *In the Spirit of Fluxus* (Minneapolis: Walker Art Center, 1993), 24–25. For a generous sampling of other Fluxus texts that were composed in the format of a set of instructions, see Kristine Stiles, "Between Water and Stone—Fluxus Performance: A Metaphysics of Acts," in *In the Spirit of Fluxus*, 62–99. For a consideration of some of La Monte Young's musical compositions of 1960 that also use this format, see Douglas Kahn, "The Latest: Fluxus and Music," in *In the Spirit of Fluxus*, 100–20. Warhol knew several members of Fluxus, as is evident from the Fluxus works in the Archives Study Center of the Andy Warhol Museum. Among these works are George Brecht's *Motor Vehicle Sundown (Event)*, dedicated to John Cage (East Brunswick, N.J.: Contingent Publications, 1960); and *E Newspapaper,* ed. George Brecht and Robert Watts (Metuchen, N.J.: Yam Festival Press, [late 1962–early 1963]). Billy Name's involvement with Fluxus included "The Billy Linich Show"—events featuring members of Waring's dance company organized with the May 1963 Fluxus Yam Festival; see Banes, *Democracy's Body,* 131.

28. On Name's haircut parties and amphetamine, see McKane and Riccaboni, "Filmographie," 254.

29. On another level, both the numbered subtitles and the cut-and-paste aesthetic of "Billy Linich's Party" were probably intended as parodies of a piece appearing in a previous issue of *Floating Bear,* "The Ascetic Sensualists" by John Ashbery, a collage poem in which there are eleven subtitles, beginning with "First Funeral" and ending with "Eleventh Funeral." *The Floating Bear* 12 (August 1961), reprint ed., 124–27. The collage structure of "Billy Linich's Party" in addition echoes the format of James Waring's choreography and visual art. On Waring's use of collage, see Banes, *Democracy's Body,* xvii.

30. On the production and early screening of *Kiss,* see McKane and Riccaboni, "Filmographie," 253.

31. But, for a different interpretation, see Bourdon, *Warhol,* 171. An excellent analysis of the composition, lighting effects, cropping, and many other details of this particular haircut movie is found in Yann Beauvais, "Fixer des images en mouvement," *Andy Warhol, Cinema,* 93–95.

32. *The Floating Bear* 26 (October 1963), reprint ed., 289. This letter is attributed to John Daley by Diane di Prima in di Prima and Jones, *The Floating Bear: A Newsletter,* 570 n. 66.

33. Diane di Prima has noted that the issue of *Floating Bear* edited by Name contained an especially ample number of inside jokes: "[Name's issue] turned out to be very like *The Sinking Bear.* Lots of letters and puns and in-group jokes. Like, somebody would steal a painting off the walls of a theatre, and seven other people would know about it, but only those seven people would know what was going on." Di Prima, introduction to *The Floating Bear: A Newsletter,* xvii. Warhol himself figures in one of the satires in Billy Name's issue of *Floating Bear.* This piece, called "Voices from the Art World (or, Bright Sayings)," consists of a sequence of invented statements that are attributed to—and poke fun at—specific visual artists and writers. One statement in this sequence is a parody of Warhol being interviewed and satirizes the inarticulate interview manner that had already become one of his trademarks. It reads: "Question: Can you explain why you paint this way? Answer: Uh—it gets—uh—very complicated when you—uh—talk about it. —Andy Warhol." *The Floating Bear* 26 (October 1963), reprint ed., 292. "Voices from the Art World" is pseudonymously signed "Duke Mantee." Diane di Prima has pointed out that LeRoi Jones used this pseudonym on other occasions, but does not believe that he authored this piece; di Prima and Jones, *The Floating Bear: A Newsletter,* 570 n. 70.

34. Near the end of the reel, the camera moves back to reveal, propped up on the back of the couch at the viewer's far left, one of Warhol's Jackie Kennedy pictures from the painting series he began shortly after the assassination of John Kennedy on 22 November; this

reel can thus be dated to late 1963 or early 1964. It and most of the other reels of *Kiss* are dated to November or December 1963 in McKane and Riccaboni, "Filmographie," 253. Given that the painting represents Jackie in mourning, it would seem that Warhol here meant to associate homosexuality with death or mourning.

35. McKane and Riccaboni, "Filmographie," 254.

36. Diane di Prima has recalled that "There is a short haircut movie and a long haircut movie. We showed them both at our theatre." Di Prima and Jones, *The Floating Bear: A Newsletter,* 570 n. 77. An advertisement for a program of the American Theatre for Poets, called "Sight and Sounds IV," includes "Haircut Movie by Andy Warhol" among the billed events; the program was presented at the New Bowery Theatre, 4 St. Mark's Place. Advertisement, *Village Voice,* 12 March 1964; I am grateful to Ron Padgett for sending me a photocopy of this advertisement. According to the mimeographed program for "Sight and Sounds IV," the Warhol film screened that evening was *The End of Dawn* rather than *Haircut. The End of Dawn* had the same cast members as *Haircut* (no. 1)—John Daley, Fred Herko, William Linich, and James Waring—according to the transcription of the mimeographed program included in a letter from Diane di Prima to the author, 23 October 1991, in which di Prima suggests that *The End of Dawn* was perhaps one of the haircut movies. It is conceivable that *Haircut* (no. 3) and *The End of Dawn* were indeed the same film, but this supposition is difficult to test at present, as *The End of Dawn* is described in only the sketchiest terms, when at all, in the existing Warhol filmographies; see McKane and Riccaboni, "Filmographie," 254; and Koch, *Stargazer,* 145.

37. Di Prima to Warhol, postmarked 29 January 1964, Archives Study Center, the Andy Warhol Museum. The immediate occasion of this letter was to ask Warhol for money to assist in transporting the artist George Herms and his wife from California to New York.

38. Diane di Prima, telephone interview by author, 6 October 1991, tape recording. Di Prima remembers that this film was shown at the American Theatre for Poets. She is unsure of its title but thinks it might be *The Queen of Sheba Meets the Wolfman* (the title being a play on that of another underground film, *The Queen of Sheba Meets the Atom Man* by Ron Rice), which was listed, along with *The End of Dawn* and a third Warhol movie, *Tarzan Revisited,* in a flyer announcing the programming for the American Theatre for Poets February–March 1964 season; transcription of the flyer text in a letter from di Prima to the author, 23 October 1991. *The Queen of Sheba Meets the Wolfman* is not listed in the standard Warhol filmographies.

39. *Poets' Vaudeville* is discussed briefly in Banes, *Democracy's Body,* 165. A favorable review of the performance was written by the dance critic Doris Hering; "James Waring and Dance Company: Judson Memorial Church, August 25, 1963," *Dance Magazine* 37 (October 1963): 28, 60.

40. Diane di Prima, *Poets' Vaudeville* (New York: Feed Folly Press, 1964), no pagination. © 1964 Diane di Prima. I am grateful to Diane di Prima for kindly providing me with a copy of this libretto. According to di Prima, the individual parts of it were devised by Waring; telephone interview by author, 28 November 1995.

41. Here are two such instances of this refrain: "Herbert Huncke gave Alan Marlowe a check to cash at Michael Malce's store. / It bounced. Who should be angry?"; and "George Herms hasnt written Billy Linich a single letter since he got back to / New York. // Who should be angry?" Di Prima, *Poets' Vaudeville.* (Huncke was the heroin addict and hustler mythologized by the beat writers as the first hipster, and Herms was a visual artist from the West Coast.) Other parodies of *Poets' Vaudeville* in "Billy Linich's Party" include corrections to di Prima's spellings of Cerberus and Binghamton ("Eighth Haircut" and *Poets' Vaudeville*), and the passage "The worst thing about Billy Linich's party was that Dorothy Podber (the meanest girl in town) had removed M. C. Richards' ashtrays," which is a play on a passage of *Poets' Vaudeville* that reads "The Nicest Thing about Remy Charlip's party was M. C. Richards' dishes" ("First Haircut" and *Poets' Vaudeville*). I am grateful to Diane di Prima for draw-

ing my attention to the parodies of *Poets' Vaudeville* in "Billy Linich's Party"; telephone interview by author, 6 October 1991, tape recording. A connection of the pouncing in *Poets' Vaudeville* to trampling on Shiva was pointed out by di Prima, telephone interview by author, 28 November 1995.

42. On di Prima's relationship with O'Hara, see di Prima's introduction to *The Floating Bear: A Newsletter,* vii–ix; and Brad Gooch, *City Poet: The Life and Times of Frank O'Hara* (New York: Alfred A. Knopf, 1993), 368–71, 417, 425.

43. Di Prima recalls that the little story in Warhol's film of her and Marlowe was collaboratively made up on the spot by the couple and Warhol. Telephone interview by author, 6 October 1991, tape recording.

44. *The Floating Bear* 14 (October 1961), reprint ed., 143–55. On McClure's use of beast language in this play, see Michael McClure, interview by David Meltzer, in *The San Francisco Poets,* ed. Meltzer (New York: Ballantine Books, 1971), 251.

45. *The Blossom, or Billy the Kid,* New York Poets Theatre and American Arts Project, undated program, Archives Study Center, the Andy Warhol Museum. This program for *The Blossom* contains extensive notes by McClure, in the form of a poem, in which he discusses his desire to create theater that functions like a living organ that correlates the human and animal: "SOME OF IT WILL UTILIZE THE HALL AS IF IT WERE THE EMBODIED / CONSCIOUSNESS OF A LION SYMBOLIZING A MAN!"; "Without the spectator the theater is a sculpture and not / a living creature"; "The auditorium must become a breathing creature!" In other words, not only does McClure aim to give his actors the language of beasts, as in *The Feast,* but also to imbue his audience with an animal energy.

46. This ridicule appears in Duke Mantee [pseudonym], "Voices from the Art World (Or, Bright Sayings)," *The Floating Bear* 26 (October 1963), reprint ed., 293: "I'm Billy the Kid. Who are you? —Mike McClure."

47. See McClure, *The Beard & VKTMS* (New York: Grove Press, 1985), 6.

48. Claire Demers, "An Interview with Andy Warhol," *Christopher Street* (September 1977): 40.

49. McClure represents the androgyny of the two characters in *The Beard* in a variety of ways, such as by making certain lines interchangeable so that the line "You want to be as beautiful as I am" is repeatedly spoken by Harlow at the beginning of the play, and then by Billy the Kid toward the end. The convolution of public and private is also expressed on several levels and recurs throughout *The Beard* in lines whereby one character dares the other to "pry" into his or her secrets or asserts that the two can perform any action since no one is watching them. On the censorship and closing down of performances of this play, see the afterword in McClure, *The Beard & VKTMS,* 94–95, and Meltzer, *San Francisco Poets,* 255, 260–61.

50. For the specifics of each of these features of *Harlot,* see the scenario for and notes about this film in Ronald Tavel, "The Banana Diary: The Story of Andy Warhol's 'Harlot,'" in *Andy Warhol: Film Factory,* ed. Michael O'Pray (London: British Film Institute, 1989), 66–93 (first published in *Film Culture* 40 [spring 1966]).

51. In the program for the American Theatre for Poets production of *The Blossom,* McClure explained, "The Theater will use all equipment and all possibilities."

52. It is worth noting here that Warhol regularly cast Malanga in roles which he believed captured fundamental aspects of the poet's character. In the movie *Vinyl* (1965), for example, which was based on Anthony Burgess's novel *A Clockwork Orange* (1962), Malanga played the part of Victor, modeled after Alex, the protagonist of Burgess's book. Warhol had undoubtedly recognized something of Malanga in the androgyny of Alex. (It is worth noting, too, that, like Billy the Kid, Alex is an outlaw who becomes a hero. Warhol's interest in the outlaw as hero is discussed in chapter 4.)

53. Demers, "An Interview with Andy Warhol," 40.

54. McClure discussed his ideas about poetry and theater in the notes he composed for

the program of the American Theatre for Poets production of *The Blossom,* a copy of which, as already noted, Warhol owned. McClure boldly asserted in these notes, "The theatre is divine and it will come from poets" and "THERE IS NO TASTE IN THE THEATRE: IT IS A MEDIUM / on which sometimes poetry may appear / or speak. // FINALLY THE MEDIUM MAY BECOME A POEM."

55. This account of the production, screening, and fate of Warhol's film is told in Victor Bockris, *The Life and Death of Andy Warhol* (New York: Bantam Books, 1989), 199.

56. Demers, "An Interview with Andy Warhol," 40. In 1973, another film version of *The Beard,* to be directed by Donald Cammell, was in the works, and the part of Jean Harlow was offered to—appropriately enough—Candy Darling, a transvestite who had acted in some of Warhol's films of the early 1970s (she decided against playing this part); see Bob Colacello, *Holy Terror: Andy Warhol Close Up* (New York: HarperCollins, 1990), 186.

57. The film *Couch* is discussed in further detail in chapters 4 and 5.

58. *Fuck You / A Magazine of the Arts* 8 (March 1965).

59. "Fuck You Talk of the Town," *Fuck You* 8 (March 1965), no pagination. Sanders here described *Couch* as a banned film, even though it seems not to have been banned officially; rather, it had not yet been publicly screened. *Couch* premiered on 17 April 1966, according to McKane and Riccaboni, "Filmographie," 255. Koch believed that the film was made "not for release"; *Stargazer,* 99. Sanders also noted in his "Talk of the Town" column that Billy Name was responsible for the production of the *Couch* cover of *Fuck You,* explaining that it was made with the Thermofax copy machine that Warhol then kept at the Factory. On the Thermofax, see chapter 3.

60. The advertisement reads: "STABLE - a literary arts magazine. 1st issue Feb. 1. New work by Berrigan, Di Prima, Ceravolo, Shapiro, Malanga, Ashbery, Agenoux, Brodey, et al. designed by Andy Warhol; edited by Gerard Malanga. $1.00 Mss. & orders to Gerard Malanga, c/o Andy Warhol, 1342 Lexington Ave. .NYC (published by Eleanor Ward of Stable Art Gallery)." *The Floating Bear* 27 (November 1963), reprint ed., 328.

61. Daisy Aldan, interview by author, New York, 15 April 1991.

62. Distinct explanations of the formation of *Interview* exist. Compare, for example, Bourdon, *Warhol,* 301–2, and Colacello, *Holy Terror,* 6.

63. On Soren Agenoux, see Colacello, *Holy Terror,* 7, 37; di Prima, introduction to *The Floating Bear: A Newsletter,* xvi; and Banes, *Democracy's Body,* 57.

64. See Colacello, *Holy Terror,* 7. Malanga used the appellation "Poetry on Film" a few months prior to the establishment of *Interview,* in the summer of 1969, for a company he ran with the poet Jim Carroll that screened homosexual pornographic films at a theater rented by Warhol; see Bockris, *Life and Death,* 248–49. "Poetry on Film" is rooted in the concept of the "film poem," the history of which is considered in chapter 5.

65. Again, distinct accounts exist regarding the source of the negative reactions to the publication of poetry in *Interview.* According to Bob Colacello, Warhol himself disliked the inclusion of poetry in the magazine; according to David Bourdon, Paul Morrissey (who was then actively collaborating with Warhol on making films) wanted to eliminate the poetry component. See, respectively, Colacello, *Holy Terror,* 44–45, and Bourdon, *Warhol,* 307.

Chapter Three

1. Warhol's conscious use of context to generate meanings has been fruitfully discussed in Charles F. Stuckey, "Warhol in Context," in *The Work of Andy Warhol,* ed. Gary Garrels, Dia Art Foundation Discussions in Contemporary Culture Number 3 (Seattle: Bay Press, 1989), 3–32. For a consideration of the range of meanings embedded in the Flower paintings, see Stuckey, "Warhol in Context," 16–18. The funereal connotations emphasized by Stuckey are taken up at a later point in this chapter.

2. Warhol's antiwar statements are additionally evident in 1) the movie *Nude Restaurant* (1967), which was to some extent a parody of Arlo Guthrie's song "Alice's Restaurant" (this explains why the movie was filmed in a restaurant called The Mad Hatter); 2) a cover design

for the winter 1966 Fluxus-related literary journal *some / thing,* a thematic issue called "A Vietnam Assemblage" (the design is a sheet of stamps that say "Bomb Hanoi"); and 3) the appearance of Warhol's name among the participants in both the 1967 "Week of the Angry Arts Against the War in Vietnam" (as listed in the *New York Times,* 29 January 1967) and an undated flyer for the "Literary Auction for Peace" to benefit the Fifth Avenue Vietnam Peace Parade Committee (of which there is a copy in the Archives Study Center of the Andy Warhol Museum).

3. The television advertisement and the media sensation it produced are both detailed in Erik Barnouw, *The Image Empire: A History of Broadcasting in the United States,* vol. 3 (New York: Oxford University Press, 1970), 253–55.

4. Jack Kroll, "Saint Andrew," *Newsweek,* 7 December 1964, 103; the quoted statement is also discussed in Stuckey, "Warhol in Context," 17.

5. *Fuck You / A Magazine of the Arts* 3 (1962): no pagination, and Ed Sanders, *Peace Eye* (Buffalo, N.Y.: Frontier Press, 1965), no pagination.

6. "Fuck You Talk of the Town," *Fuck You* 8 (March 1965): no pagination, col. 2.

7. Among the other themes common to the work of Sanders and Warhol during the first half of the 1960s are 1) the blow job, about which Sanders wrote a poem ("Blow Job Poem," *Fuck You* 1 [December 1962]: no pagination) and Warhol filmed a movie (*Blow Job,* 1964); and 2) Marilyn Monroe, the subject of a special *Fuck You* publication prompted by the actress's death (*Poems for Marilyn,* 1962) and of numerous Warhol paintings, the first of which were made, likewise, shortly after she died (see fig. 48).

8. See Debra Miller, *Billy Name: Stills from the Warhol Films* (Munich: Prestel, 1994), 66–67. The Fugs's use of the Holy Modal Rounders as a backup band is discussed in Clinton Heylin, *From the Velvets to the Voidoids: A Pre-Punk History for a Post-Punk World* (Middlesex, England: Penguin Books, 1993), 21.

9. Fugs concert program, Archives Study Center, the Andy Warhol Museum. The concert took place at the East End Theatre, 85 East 4th Street.

10. On the establishment of Warhol's association with the Velvet Underground, see Victor Bockris and Gerard Malanga, *Up-Tight: The Velvet Underground Story* (New York: Quill, 1983), 8–12. Malanga's dance performances with the Fugs are recounted in ibid., 33.

11. On Reed's relationship with Schwartz, see Bockris and Malanga, *Up-Tight,* 16; Bockris, *Transformer: The Lou Reed Story* (New York: Simon and Schuster, 1994), 60–62; and Lou Reed, *Between Thought and Expression: Selected Lyrics of Lou Reed* (New York: Hyperion, 1991), 84. For an interesting assessment of the importance for Reed of Schwartz's conception of the role of the poet, see Heylin, *From the Velvets to the Voidoids,* 16.

12. Bockris and Malanga, *Up-Tight,* 75.

13. Ibid.

14. *Aspen* (December 1966); cited in Bockris, *Transformer,* 96–97 (*Aspen* was a boxed magazine, the December 1966 issue of which was put together by Warhol and several of his associates, including Gerard Malanga and Ronald Tavel). Reed later stated that he considered his lyrics to be poetry "from day one," in an interview with Ted Drozdowski, cited by Drozdowski in "Lou Reads," review of *Between Thought and Expression, Boston Phoenix,* 1 November 1991.

15. Lou Reed, "The Murder Mystery," *Paris Review* 53 (winter 1972): 20–27.

16. Reed, *Between Thought and Expression.* Regarding Reed's conception of his music as poetry, in an interview for an article that appeared a few years prior to the publication of *Between Thought and Expression* he responded to the question of whether one can become too old to create rock and roll by saying, "[W]hat if we don't have the constraints of rock and roll? What if we just said this is Lou Reed's music or Lou Reed's writing set to music? Presumably, lots of writers get better as they get older. So why shouldn't I?" Peter Blauner, "Rock Noir," *New York,* 27 November 1989, 46.

17. On Warhol's admiration for Dylan, see Andy Warhol and Pat Hackett, *POPism: The Warhol '60s* (New York: Harcourt Brace Jovanovich, 1980), 108; the souring of Warhol's re-

169

lationship with Dylan is also described here. Reed's interest in Dylan is noted in Bockris, *Transformer,* 67–68.

18. "Is Bob Dylan the Greatest Poet in the United States Today?" in *Bob Dylan, The Early Years: A Retrospective,* ed. Craig McGregor (1972; reprint, New York: Da Capo Press, 1990), 167 (first published in the *New York Times,* 1965). Already in 1963, reviews of Dylan's concerts referred to him as an "inspired poet" (Robert Shelton, "Bob Dylan Sings His Compositions," *New York Times,* 13 April 1963) and as possessing "all the bright rhythm of a poet aware of the world" (Sidney Fields, "Only Human," *New York Mirror,* 12 September 1963); both reviews are reprinted in McGregor, 28–29 and 34–35, respectively. By 1967, the extremely perceptive critic Ellen Willis observed that the labeling of Dylan as a poet of rock and roll was a "truism" ("Dylan," *Cheetah* [1967], reprinted in McGregor, *Bob Dylan, The Early Years,* 219). Dylan contributed greatly to this image of himself through reading poems at concerts and by including poems in concert program notes and on his album sleeves (although, unlike many of his critics, he always separated these writings from his song lyrics, which he did not refer to as poems). On Dylan's non-musical writings, see Clinton Heylin, *Bob Dylan, Behind the Shades: A Biography* (New York: Summit Books, 1991), 92–94, 126, 128, 131.

19. Warhol and Hackett, *POPism,* 116.

20. According to Sanders, in late 1964 he and Kupferberg regularly went to the Dom in their East Village neighborhood to dance after poetry readings, and one night he suggested that the two set their poetry to music. See Ronald Sukenick, *Down and In: Life in the Underground* (New York: William Morrow, Beech Tree Books, 1987), 166.

21. The program in Warhol's Archives for the Fugs's performance at the American Theatre for Poets of 1965 contains the lyrics to two songs, "Coca-Cola Douche" and "Jack Off Blues." The Fugs also published a collection of their lyrics in mimeograph form, *The Fugs' Song Book!,* which Sanders sold in his book store. On this book, see John Gruen, *The New Bohemia,* with photographs by Fred W. McDarrah (1966; reprint, Pennington, N.J.: a capella books, 1990), 120–22.

22. Paul Morrissey devised the name while looking at the album sleeve with Malanga and Barbara Rubin, a filmmaker and friend of Dylan who is in a photograph on the sleeve. See Bockris and Malanga, *Up-Tight,* 31.

23. See, for example, Henry Louis Gates, Jr., "Sudden Def," *New Yorker,* 19 June 1995, 34–42; and Dinitia Smith, "The Poetry Kings and the Versifying Rabble," *New York Times Magazine,* 19 February 1995, 36–38.

24. Ed Sanders, "The Poetry Reading," in *Tales of Beatnik Glory* (New York: Citadel Press, 1990), 13.

25. Michael Davidson, *The San Francisco Renaissance: Poetics and Community at Midcentury* (Cambridge: Cambridge University Press, 1989), especially x and 22.

26. Harry Lewis, "The Circuit / New York City Public Readings: A Short History," in *The Poetry Reading: A Contemporary Compendium on Language and Performance,* ed. Stephen Vincent and Ellen Zweig (San Francisco: Momo's Press, 1981), 87.

27. On this meeting, see Warhol and Hackett, *POPism,* 26, and Charles Henri Ford, interview by John Wilcock, in *The Autobiography and Sex Life of Andy Warhol,* ed. Wilcock (New York: Other Scenes, 1971), no pagination.

28. On this meeting, see Warhol and Hackett, *POPism,* 90, and David Bourdon, *Warhol* (New York: Harry N. Abrams, 1989), 199. On Café Le Metro, see Gruen, *The New Bohemia,* 69, and Sukenick, *Down and In,* 152–53.

29. Warhol and Hackett, *POPism,* 51. On the Monday and Wednesday night programs

of Café Le Metro, see Lewis, "The Circuit / New York City Public Readings," 86–87.

30. Warhol, *The Philosophy of Andy Warhol (From A to B and Back Again)* (San Diego: Harcourt Brace Jovanovich, 1975), 22–23.

31. On Warhol's acquisition of issues of *Semi-Colon,* see chapter 1.

32. On the omission of Warhol from the standard studies of relations between poets

and visual artists, see my essay "Collaboration as Social Exchange: *Screen Tests / A Diary* by Gerard Malanga and Andy Warhol," *Art Journal* 52 (winter 1993), 59.

33. According to Malanga, the reading could not be held at Café Le Metro, as planned, because the owner had gotten into trouble with the police, which led to the closing down of the cafe on the night when the reading was scheduled. Malanga, telephone conversation with author, 7 June 1995.

34. Malanga later commented, "He came in just shortly before the reading ended. He was having lunch that day with, I believe, Ethel Scull. And, I felt kind of peculiar that he wasn't there . . . from the very beginning, that he opted for lunch. But I have a theory that he may have wanted to distance himself from the reading because it was so much me and less of him, on a certain level." Warhol did attend a reading by Malanga the following May at the showing of Warhol's Flower paintings at the Galerie Ileana Sonnabend in Paris. Malanga, telephone interview by author, 24 July 1990, tape recording.

35. On Warhol's incorporation of his mother's handwriting into his commercial work, see Ellen Lupton and J. Abbott Miller, "Line Art: Andy Warhol and the Commercial Art World of the 1950s," in *"Success is a job in New York . . .": The Early Art and Business of Andy Warhol,* ed. Donna M. De Salvo (New York: Grey Art Gallery and Study Center; Pittsburgh: Carnegie Museum of Art, 1989), 32. In 1959, Julia Warhola was awarded for her contribution to commercial art by the Art Directors Club and the American Institute of Graphic Arts; see Margery King, chronology, *The Andy Warhol Museum: The Inaugural Publication* (Pittsburgh: Andy Warhol Museum, 1994), 173.

36. As Malanga recalled it, "At that time [1963–64], Andy was still doing some free-lance advertising—commercial work. He was illustrating something, and Nathan [Gluck] was hired by Andy to do the work for Andy. . . . Nathan worked at Andy's house. He wasn't at the Factory at all." Malanga, interview by Patrick S. Smith, 1 November 1978, in Smith, *Andy Warhol's Art and Films* (Ann Arbor: UMI Research Press, 1986), 396–97. As these words suggest, Warhol attempted to keep his fine and commercial art worlds in separate compartments of his life. Warhol had started to do commercial work for Fleming Joffe in the late 1950s and was still working for this client in 1963; see *"Success is a job in New York . . .",* ed. Donna M. De Salvo, 49, 82 (cat. nos. 152–57). A book of reptile samples with the Nash verses on its cover, entitled *Reptiles of the World, Unite: Seven Poems by Ogden Nash* and put out by the company in 1953, is in the Archives Study Center of the Andy Warhol Museum. It seems that Warhol took the Nash poems he used in his own work from this book. A typed file label on the cover of it reads "Spring 1962—Fashion Office," suggesting that he designed "The New Eden" around spring 1962 or soon afterward (it is dated ca. 1960 in Jesse Kornbluth, *Pre-Pop Warhol* [New York: Random House, Panache Press, 1988], 86).

37. For Malanga's description of the Letraset of Julia Warhola's script, see Patrick S. Smith, *Andy Warhol's Art and Films,* 402. Malanga stated in a telephone conversation with the author, 7 June 1995, that he used this Letraset to design the Castelli Gallery reading flyer.

38. Gerard Malanga, telephone conversation with author, 7 June 1995.

39. The snake as a symbol of homosexuality can very probably be traced to classical sources, as John Shoptaw has observed in *On the Outside Looking Out: John Ashbery's Poetry* (Cambridge: Harvard University Press, 1994), 360 n. 55. It should be noted here that Ray Johnson routinely used snakes in his collages and mail art.

40. Gerard Malanga, *Chic Death* (Cambridge, Mass.: Pym-Randall Press, 1971), 74–77; tape recording #48, Harry Ransom Humanities Research Center, University of Texas at Austin. The magazine project was reported in Eugenia Sheppard, "Pop Art, Poetry and Fashion," *New York, Herald Tribune,* 3 January 1965, 10 (see fig. 44). Malanga had planned to publish the magazine *Chic Death,* which was to include photographs of fashion models in front of actual car accidents, in collaboration with the photographer and filmmaker John Palmer (who assisted in the production of Warhol's 1964 film *Empire*), but the idea proved to be unrealistic; Malanga, telephone conversation with author, 1 November 1989.

41. In a review of the exhibition, the critic Thomas B. Hess observed that "in a back

171

room was a rectangle made of 42 identical closeups of Jacqueline Kennedy, bereft and aghast, screened from the famous news photo where she watches Lyndon Johnson being sworn in. Here Warhol blurts a certain tenderness and respect, in his choice of image, in the ghastly lilac colors." "Andy Warhol," *ARTnews* 63 (January 1965): 11. The inclusion of this *Jackie* painting in the exhibition is connected to the funereal association of the Flower images by Stuckey in "Warhol in Context," 18.

42. For an excellent analysis of the way in which the black of the Flower paintings serves to envelope the brightly colored flowers in an atmosphere of death, see John Coplans, "The Early Work of Andy Warhol," *Artforum* 8 (March 1970): 59. The connotation of death suggested by the black backgrounds of these paintings is also discussed in Stuckey, "Warhol in Context," 17. I thank Neil Printz for sharing with me his thoughts on how the Flower paintings were made.

43. *Saturday Disaster* was later used by Malanga as the jacket cover image for the book *Chic Death*.

44. Three of the Thermofax works are reproduced in *Andy Warhol: Death and Disasters*, essays by Neil Printz and Remo Guidieri (Houston: The Menil Collection and Houston Fine Art Press, 1988), 25–27, where they are attributed to Malanga, Billy Name, and Warhol (whose stamp appears on some of the pieces). According to Malanga, Warhol and Name had little to do with the creation of the Thermofaxes. Malanga, telephone interview by author, 29 September 1989, tape recording.

45. The model in the fashion photograph was Beate Schultz. Malanga had discovered her identity soon after he had written the poem, but for artistic reasons decided to leave it unknown in the title of the poem, as he explained as an introductory remark when he read it at Castelli Gallery; tape recording #48, Harry Ransom Humanities Research Center, University of Texas at Austin.

46. Tape recording #48, Harry Ransom Humanities Research Center, University of Texas at Austin. "The Hyphenated Family" was published in Malanga, *Chic Death*, 33.

47. Tape recording #48, Harry Ransom Humanities Research Center, University of Texas at Austin. This poem was later published in an article about Freddy Herko by Donald McDonagh, "The Incandescent Innocent," *Film Culture* 45 (summer 1968): 56.

48. David Bourdon, "Andy Warhol," *Village Voice*, 3 December 1964; and Bourdon, *Warhol*, 191.

49. *The Dada Painters and Poets: An Anthology*, ed. Robert Motherwell, 2d ed. (1981; reprint, Cambridge: Harvard University Press, Belknap Press, 1989).

50. "The Grand Manner of Motherwell," in Frank O'Hara, *Standing Still and Walking in New York*, ed. Donald Allen (San Francisco: Grey Fox Press, 1983), 176 (first published in *Vogue*, October 1965).

51. Hugo Ball, "Dada Fragments (1916–1917)," trans. Eugene Jolas, in Motherwell, *Dada Painters and Poets*, 52.

52. Tristan Tzara, "Manifesto on Feeble Love and Bitter Love," *Seven Dada Manifestos* (1924), trans. Ralph Manheim, in Motherwell, *Dada Painters and Poets*, 92.

53. On the cut-up method of writing, see William S. Burroughs and Brion Gysin, *The Third Mind* (New York: Viking Press, 1978), in which the method is described in a how-to manner that seems to mimic Tzara's formulation for writing a dada poem. Compare Burrough's "Cut right through the pages of any book or newsprint . . . lengthwise, for example, and shuffle the columns of text. Put them together at hazard and read the newly constituted message" (Burroughs and Gysin, *Third Mind*, 34) to Tzara's "To make a dadaist poem / Take a newspaper. / Take a pair of scissors. / Choose an article as long as you are planning to make your poem. / Cut out the article. / Then cut out each of the words that make up this article and put them in a bag. / Shake it gently. / Then take out the scraps one after the other in the order in which they left the bag. / Copy conscientiously. / The poem will be like you" (Motherwell, *Dada Painters and Poets*, 92).

54. In this article, the cut-up is explained as an "avant-garde form of poetry" whereby a text was "written, snipped apart, then put back together, the lines shuffled to fall into place at random" (see fig. 46). Compare this description with the Burroughs and Tzara instructions in the previous note.

55. Malanga has explained that the fashion show "had nothing to do with me. I was only going to do a reading, but I found out that day that . . . Barbara Waterson, who was married to Sam at the time, came—she was a fashion coordinator—with the photographers and models, and of course Ivan Karp, who helped arrange this, told me at the last minute [about the fashion show] and I said, yeah, I said okay, sure, whatever they want to do, because it was PR for me, because then I had three pages in the *Tribune* that week." Malanga, telephone interview by author, 29 September 1989, tape recording.

Chapter Four

1. Berrigan noted that *The Tennis Court Oath* "made a big change in all our lives at the time it came out" in "The Business of Writing Poetry" (1976), in *Talking Poetics at the Naropa Institute,* ed. Anne Waldman and Marilyn Webb, vol. 1 (Boulder: Shambhala Publications, 1978), 50. Ron Padgett recalled that he "loved that book" at the time, a feeling partly incited by the poet Kenneth Koch, who was then one of Padgett's teachers at Columbia University; telephone interview by author, 11 October 1989. On the influence of *The Tennis Court Oath,* see also John Koethe, "The Absence of a Noble Presence," in *The Tribe of John: Ashbery and Contemporary Poetry,* ed. Susan M. Schultz (Tuscaloosa: University of Alabama Press, 1995), 84; and John Gery, "Ashbery's Menagerie and the Anxiety of Affluence," in Schultz, *The Tribe of John,* 130–31, 143. For the early strongly negative criticism of *The Tennis Court Oath,* see Fred Moramarco, "The Lonesomeness of Words: A Revaluation of *The Tennis Court Oath,*" in *Beyond Amazement: New Essays on John Ashbery,* ed. David Lehman (Ithaca: Cornell University Press, 1980), 278 n. 1. The negative assessment of *The Tennis Court Oath* was cemented by the influential critic Harold Bloom, who has had positive things to say about every Ashbery book except this one; see Bloom, *Figures of Capable Imagination* (New York: Seabury, 1976), 172–74. Less conservative critics have recognized the merit of the poetry in *The Tennis Court Oath.* See, for example, Marjorie Perloff, *The Poetics of Indeterminacy: Rimbaud to Cage* (Princeton: Princeton University Press, 1981), 269–70. An insightful explanation of Bloom's extreme dislike of the book is found in Geoff Ward, *Statutes of Liberty: The New York School of Poets* (New York: St. Martin's Press, 1993), 110–17.

2. John Ashbery, *The Tennis Court Oath* (Middletown, Conn.: Wesleyan University Press, 1962), 60. © 1962 John Ashbery. Reprinted by permission of the University Press of New England.

3. These poems include "Psyche," *Locus Solus* 3–4 (winter 1962): 176–78 (the issue was devoted to new poetry and contained Ashbery's "The New Realism" [184–89]); and "Ode to Turchetti," "The Girl Stands Under the Mobile at the Museum," and "Amour, Amour, Amour," *Locus Solus* 5 (1962): 7–14. "Amour, Amour, Amour" was one of the dada-style collage poems that Malanga had written in Daisy Aldan's high school classes, according to Malanga, telephone interview by author, 21 November 1989.

4. Gerard Malanga, interview by author, New York, 15 August 1989, tape recording.

5. See this chapter, note 3.

6. *C: A Journal of Poetry* 1 (July–August 1963): no pagination. © Gerard Malanga. Reprinted by permission of Gerard Malanga. The poem was published with this cryptic note: "The repeated, off-register images of a painting that destroys itself, commissioned, but not started." Ashbery himself had written a poem in which a painting is destroyed, "The Painter," which concerns his decision not to become a painter. This poem appeared in Ashbery's first book, *Some Trees* (1956; reprint, New York: Ecco Press, 1978), 54–55.

7. Ashbery, *Tennis Court Oath,* 39–40.

8. Malanga incorporated other snippets of poetry from *The Tennis Court Oath* into "Now

173

in Another Way," including, curiously, the word "factory." The factory is a recurring motif in Ashbery's book, where it is repeatedly associated with royalty, often with a palace. The "high and low" that the two kinds of buildings represent are also central in the work of Warhol. When Malanga wrote his poem, Warhol had not yet moved into the studio he called the Factory, and I cannot say whether Ashbery's repeated use of this word had any significance for Warhol, but it is curious that in one poem of *The Tennis Court Oath,* Ashbery writes of a "silver regal porch factory" ("The Ascetic Sensualists," 52), since Warhol's Factory was covered in silver.

9. See, for example, Fred Moramarco, "John Ashbery and Frank O'Hara: The Painterly Poets," *Journal of Modern Literature* 5 (September 1976): 448–62; Leslie Wolf, "The Brush-stroke's Integrity: The Poetry of John Ashbery and the Art of Painting," in Lehman, *Beyond Amazement,* 224–54; and Charles Altieri, "John Ashbery and the Challenge of Post-modernism in the Visual Arts," *Critical Inquiry* 14 (summer 1988): 805–30. The poet David Shapiro, on the other hand, did recognize various connections between Ashbery's work and pop art, in *John Ashbery: An Introduction to the Poetry* (New York: Columbia University Press, 1979), 55, 69, 115. For a consideration of the limitations of the comparison of Ashbery's poetry to abstract expressionism, see Andrew Ross, *The Failure of Modernism: Symptoms of American Poetry* (New York: Columbia University Press, 1986), 167–69.

10. Biographical Sketch, *Contemporary Authors,* rev. ed., vols. 5–8, ed. Barbara Harte and Carolyn Riley (Detroit: Gale, 1969), 44.

11. For a concise history of new realism, see Alfred Pacquement, "The Nouveaux Réalistes: The Renewal of Art in Paris around 1960," in *Pop Art: An International Perspective,* ed. Marco Livingstone (London: Royal Academy of Arts, 1991), 214–18. Niki de Saint-Phalle was married to Harry Mathews, who was the publisher of *Locus Solus.*

12. Léger had praised the beauty of the everyday object in his essay entitled "A New Realism—The Object," *The Little Review* (Paris) 11 (winter 1926): 7–8. Ashbery may well have been aware of this earlier use of the term "new realism," as he was interested in Léger and wrote four reviews of the artist's work between 1960 and 1962—the period in which he wrote his poem "The New Realism." His reviews of Léger's work appeared in the following issues of the *New York Herald Tribune* (Paris edition): 14 December 1960; 14 November 1961; 27 June 1962; and 17 October 1962. It is possible that Ashbery alluded to Léger's work in his poem, too, in the phrase "buzzing soda water" (*Tennis Court Oath,* 59), which brings to mind Léger's painting *The Syphon* (1924).

13. The works by Warhol listed in the exhibition catalog are *Nineteen Cents* (1960), *Do It Yourself* [flowers] (1962), and *Fox Trot* (1962). *New Realists* (New York: Sidney Janis Gallery, 1962), cat. nos. 50–52, no pagination. Ashbery's essay for this catalog was reprinted in *C: A Journal of Poetry* 1 (October–November 1963): no pagination.

14. On the reaction of some abstract expressionist artists to this exhibition, see Irving Sandler, *American Art of the 1960s* (New York: Harper and Row, Icon Editions, 1988), 159. Frank O'Hara wrote to Ashbery on 20 November 1962 complimenting his essay for the *New Realists* catalog and then adding that "Around here, the Abstract-Expressionism New-Realism situation is pretty 'Thou art either for me or agin me' as the good book say." Shelf mark AM 6, John Ashbery Papers, Houghton Library, Harvard University. Reprinted by permission of the Houghton Library.

15. "The New Realists," in Ashbery, *Reported Sightings: Art Chronicles, 1957–1987,* ed. David Bergman (New York: Alfred A. Knopf, 1989), 80 (first published in the *New Realists* exhibition catalog).

16. Ashbery, *Tennis Court Oath* (see n. 2 above), 59.

174 17. Ashbery, *Reported Sightings,* 82.

18. John Ashbery, "Paris Notes," *Art International* 7 (25 June 1963): 76.

19. John Ashbery, telephone interview by author, 25 July 1989.

20. Frank O'Hara wrote to Ashbery on 14 June 1963 that there "will be considerable

poetic excitement when you get here as several of Kenneth's [Koch's] and my cuter students think you are a genius." Shelf mark AM 6, John Ashbery Papers, Houghton Library, Harvard University. Reprinted by permission of the Houghton Library.

21. Ted Berrigan wrote in his diary, in an undated passage of August 1963, that he and his wife Sandy had been invited to a cocktail party at O'Hara's home to meet John Ashbery. Berrigan Diaries, Berrigan Collection, Rare Book and Manuscript Library, Columbia University, New York. Ron Padgett remembers attending the poetry reading, and that he met Ashbery either at a reception in the lobby following it or at a party that night; telephone interview by author, 11 October 1989.

22. John Ashbery, telephone interview by author, 25 July 1989.

23. "On ne peut réellement dire ce qui se passe dans la plupart des photographies publiées par la presse, surtout lorsqu'on est en train de les regarder comme un frottage sur la toile cirée d'une table de cuisine (ce qui va naturellement de pair avec notre incapacité de discerner la nature réelle d'un événement—ce qui est arrivé exactement—quand nous en lisons un compte rendu dans un journal)." Ashbery, untitled essay in *Warhol* (Paris: Galerie Ileana Sonnabend, 1964), no pagination. For a discussion of this exhibition and its reception, see Michel Bourel, "Andy Warhol à Paris dans les années 60," *Artstudio* 8 (spring 1988): 96–97.

24. Ashbery, "The Ascetic Sensualists," *Tennis Court Oath* (see n. 2 above), 52.

25. Ashbery, "Europe," *Tennis Court Oath* (see n. 2 above), 80, 81.

26. "The Skaters" was written between the fall of 1963 and spring of 1964. John Shoptaw, *On the Outside Looking Out: John Ashbery's Poetry* (Cambridge: Harvard University Press, 1994), 89. The poem was originally published in *Art and Literature* 3 (autumn–winter 1964), and Ashbery included it in his book *Rivers and Mountains* (1966; reprint, New York: Ecco Press, 1977), 34–63. Although "The Skaters" has been interpreted as being a parody, it is perhaps more a questioning of the significance of parody than being a parody per se; this alternative viewpoint is suggested by the fact that the speaker in the poem says he is creating a parody:

> For it is you I am parodying,
> Your invisible denials. And the almost correct impressions
> Corroborated by newsprint, which is so fine.
> I call to you there, but I do not think that you will answer me.

Ashbery, *Rivers and Mountains*, 42. © 1967 John Ashbery. Reprinted by permission of Georges Borchardt, Inc. for the author. The role of parody in "The Skaters" is discussed in Shapiro, *John Ashbery*, 93–95, 105, 125.

27. Ashbery, *Rivers and Mountains* (see n. 26 above), 57.

28. Ibid. (see n. 26 above), 39.

29. Ibid. (see n. 26 above), 49. For a comparison of other imagery in this poem to the work of Warhol, see Shapiro, *John Ashbery*, 115.

30. It is worth noting here that Ashbery has stated in interviews that Warhol's double-screen film *Chelsea Girls* (1966) probably influenced the double-column format of his poem "Litany" (1978). See "An Interview with John Ashbery" [1980 radio broadcast, Voice of America Forum Series], in *American Writing Today*, vol. 1, ed. Richard Kostelanetz (Washington, D.C.: USICA, 1982), 268–69; and Ashbery, "Interview with John Murphy," *Poetry Review* 76 (August 1985): 25. Several literary critics have noted the centrality of indeterminacy in Ashbery's work overall. See, for example, Perloff, *The Poetics of Indeterminacy*, 248–87; and Charles Altieri, *Self and Sensibility in Contemporary American Poetry* (Cambridge: Cambridge University Press, 1984), 141.

31. Ashbery's use of concealment is a commonplace in the scholarship on his poetry. On Ashbery's own description of how a person or situation that prompted a poem is often not evident in the poem itself, see Janet Bloom and Robert Losada, "Craft Interview with

John Ashbery," in *The Craft of Poetry: Interviews from the New York Quarterly,* ed. William Packard (Garden City, N.Y.: Doubleday, 1974), 127 (first published in *New York Quarterly* 9 [winter 1972]).

32. Gerard Malanga, *Chic Death* (Cambridge, Mass.: Pym-Randall Press, 1971), © Gerard Malanga. Reprinted by permission of Gerard Malanga.

33. Ibid. (see n. 32 above), 24.

34. Ashbery, *Rivers and Mountains* (see n. 26 above), 36. Both Ashbery and Malanga have stated that the "Gerard" of this passage is Malanga. Ashbery, telephone interview by author, 25 July 1989; and Malanga, interview by author, New York, 15 August 1989, tape recording.

35. The other poems that Ashbery included in this reading are "The Tennis Court Oath," "Thoughts of a Young Girl," "Rain," and "The Suspended Life." This list comes from a tape recording of the reading, dated 23 August 1964, in the collection of Ron Padgett. I am grateful to Ron Padgett for providing me with a list of the poems on the tape.

36. Claire Demers, "An Interview with Andy Warhol," *Christopher Street* (September 1977), 40.

37. Andy Warhol and Pat Hackett, *POPism: The Warhol '60s* (New York: Harcourt Brace Jovanovich, 1980), 111.

38. "Vorrei essere come Gerard. Penso che Gerard mi affascini. Dico Gerard Malanga. Come riesce a scrivere poesie, non l'ho mai potuto capire. Cioè, lei riesce a capirlo? Cioè, come faccia a farle. Io resto incantato a vedere come prende, mettiamo, una riga qua e una riga là, e poi le riunisce insieme e allora suonano vere, e allora è vero. Voglio dire . . . è proprio incantevole." David Shapiro, "Polvere di diamanti" [interview with Andy Warhol], in *PopArt: evoluzione di una generazione* (Milan: Electa, 1980), 133. The English translation is by Marcella Beccaria.

39. Ibid., 133.

40. Malanga, *Chic Death* (see n. 32 above), 24.

41. Ibid. (see n. 32 above), 25.

42. Two instances in which the speaker in "The Skaters" refers to life on an island are: "I am beginning to forget everything on this island"; and "The man on the street turns his face away. Another island-dweller, / no doubt." Ashbery, *Rivers and Mountains* (see n. 26 above), 55, 56.

43. The poet Anne Waldman has stated, "Ted Berrigan was a wonderful teacher for me at this time [the 1960s], as he's been for many poets at some time or other," in "My Life a List" (1979), *Talking Poetics from Naropa Institute,* vol. 2, ed. Anne Waldman and Marilyn Webb (Boulder: Shambhala Publications, 1979), 299.

44. Malanga, interview by author, New York, 15 August 1989, tape recording.

45. On Berrigan's use of appropriation in *The Sonnets,* see Ron Padgett, "On *The Sonnets,*" in *Nice to See You: Homage to Ted Berrigan,* ed. and intro. Anne Waldman (Minneapolis: Coffee House Press, 1991), 9–10.

46. Ashbery, "The Skaters," *Rivers and Mountains* (see n. 26 above), 43.

47. Berrigan, "Sonnet LXXVI," *The Sonnets,* rev. ed. (New York: United Artists Books, 1982), 70. Reprinted by permission of the Estate of Ted Berrigan, Alice Notley, executor. Berrigan explained in one interview, regarding his practice of copying fragments of other poets' work, that "having been given permission to do this by my readings of Duchamp, John Cage, Bill Burroughs, John Ashbery and people like that, I took these six poems and put them next to the typewriter and started typing up one line from the first one, one line from the second and so on until I had six lines." Interview by George Macbeth, London, 1970, in *Talking in Tranquility: Interviews with Ted Berrigan,* ed. Stephen Ratcliffe and Leslie Scalapino (Bolinas, Calif.: Avenue B; Oakland, Calif.: O Books, 1991), 25.

48. Malanga, "Some Suicides," *Chic Death* (see n. 32 above), 49. Malanga recited this poem at his 1964 Castelli Gallery reading; tape recording #48, Harry Ransom Humanities Research Center, University of Texas at Austin.

49. Allan Kaplan, review of *C: A Journal of Poetry, Kulchur* 4 (winter 1964–65): 95.

50. David Lehman, "The Whole School" (review essay), *Poetry* 119 (January 1972): 230–31.

51. Ibid., 232.

52. Berrigan, *Many Happy Returns* (New York: Corinth Books, 1969), 7. Ashbery's poem was published in *Big Table* 1 (1959): 42–45; and in *Tennis Court Oath,* 25–27. Berrigan wrote of his admiration for it in his diary on 11 July 1962, where, from the summer of 1962 through 1963, he often recorded that he was reading Ashbery's poems or writing imitations of them. Berrigan Collection.

53. A poem by Ashbery entitled "Copy of a Copy" was published by Berrigan in *C: A Journal of Poetry* 1 (October–November 1963): no pagination. Berrigan sometimes attributed his writings to other authors (a practice I discuss later in this chapter), and it is worth asking whether "Copy of a Copy" was one such work.

54. Berrigan's explanation of his wholesale use of part of Ashbery's essay was published in David Kermani, *John Ashbery: A Comprehensive Bibliography, Including His Art Criticism, and with Selected Notes from Unpublished Materials* (New York: Garland Publishing, 1976), 83. The piece by Ashbery that Berrigan here appropriated was published in *Book Week* 4 (September 25, 1966): 6. For Berrigan's poem, see *Many Happy Returns,* 43.

55. Berrigan, review of *In Advance of the Broken Arm,* by Ron Padgett, *Kulchur* 5 (spring 1965): 101. Ashbery's poem "And You Know" had been published in *Some Trees,* 56–59.

56. The poem was published as "Sonnet" in Ted Berrigan and Ron Padgett, *Bean Spasms,* illustrated and with drawings by Joe Brainard (New York: Kulchur Press, 1967), 54; it was reprinted under the title "Nothing in That Drawer" and with a period added at the end of each line in Padgett, *Great Balls of Fire,* rev. ed. (Minneapolis: Coffee House Press, 1990), 3. © 1990 Ron Padgett. Reprinted by permission of the publisher. The poem was written 30 November 1963; Ron Padgett, letter to author, 12 October 1989.

57. Padgett stated in a telephone interview by the author, 11 October 1989, that he was interested in the idea of each line being distinct from the others. On Warhol's interest in this facet of repetition, see his interview with Gene R. Swenson, "What Is Pop Art?" *ARTnews* 62 (November 1963): 26; and on Gertrude Stein's, see "Portraits and Repetition," in *Lectures in America* (1935; reprint, Boston: Beacon Press, 1985), 165–206.

58. *Film Culture* 32 (1964): 13. Later reprinted, in slightly different form, in Berrigan and Padgett, *Bean Spasms.* © 1967 Kulchur Press. Reprinted by permission of Ron Padgett.

59. Ibid., 12. Reprinted by permission of John Brainard.

60. Joe Brainard, "Andy Warhol: Andy Do It," *C: A Journal of Poetry* 1 (December 1963–January 1964): no pagination (and also in Brainard, *Selected Writings: 1962–1971* [New York: The Kulchur Foundation, 1971], 20–21). Reprinted by permission of John Brainard.

61. Padgett, "Sound and Poetry: A New Approach," *Kulchur* 5 (spring 1965): 76.

62. The source of the text was identified by Padgett in an interview by the author, New York, 17 June 1990.

63. For example, Ashbery incorporated fragments of early twentieth-century children's books into his poems "Europe" and "The Skaters"; see Kermani, *John Ashbery: A Comprehensive Bibliography,* 76, 80–81. There were earlier instances of poets appropriating from texts such as popular novels, of which Padgett may also have been aware. A few years later, he noted in an essay about interactions between painters and poets that it recently had been "shown that every line in *Kodak* [a book of poems by Blaise Cendrars published in 1924] was lifted out of a popular novel series *The Mysterious Doctor Cornelius* by Gustave Le Rouge." Padgett, "Poets and Painters in Paris, 1919–39," *The Avant Garde: ARTnews Annual* 34 (1968): 90. For another instance of Cendrars's "found" poetry, see the special issue on appropriation of *The Poetry Project Newsletter* 139 (December 1990–January 1991): 1. I am grateful to Gillian McCain for alerting me to this issue of the newsletter.

64. Padgett, interview by author, New York, 17 June 1990.

65. Padgett, telephone interview by author, 29 December 1990.

66. The reading is described in some detail by Ted Berrigan in a diary entry of 17 Feb-

ruary 1964, in which he provided a partial list of who was in the audience. Ron Padgett identified this reading as the one in which the recital of *Two Stories for Andy Warhol* was performed. Telephone interview by author, 29 December 1990.

67. According to Padgett, Berrigan had asked Warhol for the cover image, and Padgett himself knew nothing of the selection process. Interview by author, New York, 17 June 1990.

68. Billy Name identified the film in an interview by the author, Poughkeepsie, N.Y., 3 June 1995, tape recording. The film is not listed in the existing Warhol filmographies.

69. Padgett, telephone interview by author, 11 October 1989.

70. Most of the collaborations in this book were produced between 1962 and 1965, according to an author's note; see Berrigan and Padgett, *Bean Spasms,* 199. Berrigan and Padgett wrote a few poems together during the late 1950s, in Tulsa, Oklahoma; Padgett, telephone interview by author, 11 October 1989. The impetus for exploring collaboration more extensively in the early 1960s, however, came from reading six collaborative poems by Ashbery and Koch (and other works) in an issue of their journal devoted to collaboration; see *Locus Solus* 2 (summer 1961): 157–69. For a succinct discussion of the importance in general of the *Locus Solus* issue to the flourishing of collaborations during the 1960s, see Ward, *Statutes of Liberty,* 126–27.

71. This copy of the book is now in the Archives Study Center of the Andy Warhol Museum. *Bean Spasms* included the two previously mentioned sonnets by Padgett that were inspired by Warhol's work, accompanied by a reproduction (or perhaps copy) of a Warhol Flower painting. Berrigan and Padgett, *Bean Spasms,* 54–55. The sonnet on "Sleep" appears in a slightly different form here than it did when first published in *Film Culture:* there are a few more *z*'s per line, and each line begins with an uppercase *z*. Other works by the authors in Warhol's archives include Berrigan, *Many Happy Returns* (San Francisco: Angel Hair, 1967) (signed by the author); Berrigan, Padgett, and Brainard, *Some Things: Drawings / Poems* (n.p., 1966) (signed by the authors); Padgett, *Quelques Poèmes / Some Translations / Some Bombs* (New York: n.p., 1963); Padgett, "Remembrance of Things Past," loose sheet (1966).

72. Ron Padgett stated, in a letter to the author, July 1995, that he is sure the handwriting of this dedication is not Berrigan's, but that it does resemble Ashbery's. According to Ashbery, however, the handwriting is not his; letter to the author from Ashbery's secretary Eugene Richie, 24 August 1995.

73. Berrigan and Padgett, *Bean Spasms,* 62–67. For Berrigan's explanation of how he wrote his interview, and the ideas behind it, see Berrigan, interviews by Barry Alpert and by Rosanne Erlich, Ron Kostar, and Zack Rogow in Ratcliffe and Scalapino, *Talking in Tranquility,* 31–34, 99–101 (first published in *Vort* 1 [1972], and in *CITY* 6 [fall 1977]). There is also an invented interview with John Ashbery, probably written by Berrigan or Padgett, or both, and published under the pseudonym of Harlan Dangerfield in *The World* 8 (November 1967): no pagination.

74. Berrigan and Padgett, *Bean Spasms,* 62.

75. Swenson, "What Is Pop Art?" 26.

76. Berrigan has discussed the reader response to "An Interview with John Cage" in an interview by Rosanne Erlich, Ron Kostar, and Zack Rogow in Ratcliffe and Scalapino, *Talking in Tranquility,* 100. When the piece was first published, Berrigan did not reveal that it was fabricated; however, in *Bean Spasms* he added a note below the conclusion explaining that he was its sole author, and that "John Cage served neither as collaborator nor as interviewee"; Berrigan and Padgett, *Bean Spasms,* 67.

77. Gerard Malanga, interview by author, New York, 15 August 1989, tape recording; and Ron Padgett, interview by author, New York, 17 June 1990.

178 78. Berrigan, interview by Rosanne Erlich, Ron Kostar, and Zack Rogow in Ratcliffe and Scalapino, *Talking in Tranquility,* 93. Although he did not specify the time period to which he referred, there is ample evidence in his work of the mid-1960s, as in the examples discussed in this chapter, that it was the mid-1960s.

79. Berrigan, "Letter to Joe Brainard" (22 October 1969), in Waldman, *Nice to See You,* 43.

80. *George Bernard Shaw: The Problem of How to Live* (Master's Thesis, University of Tulsa, 1962). Berrigan began his thesis in Tulsa and completed it in New York; see Waldman, *Nice to See You,* v. I am grateful to Ron Padgett for his observations on Berrigan's study of Shaw; interview by author, New York, 17 June 1990.

81. Berrigan, Diaries, undated entry, July or August 1963. Berrigan Collection. Reprinted by permission of the Estate of Ted Berrigan, Alice Notley, executor.

82. On the photograph used for Warhol's self-portrait, see Patrick S. Smith, interview with Gerard Malanga, 1 November 1978, in Smith, *Andy Warhol's Art and Films* (Ann Arbor: UMI Research Press, 1986), 397.

83. Ted Berrigan Diaries, Berrigan Collection. Berrigan owned a few Warhol works as well. Warhol had given him (and Padgett) one of his Brillo boxes (1964), which, according to Padgett, Berrigan used as a coffee table. Padgett also remembers that Berrigan had hanging on the wall in his apartment a Flower print (1964) and either a print (1964) or poster of the Liz portrait; Padgett, interview by author, New York, 17 June 1990.

84. For an excellent discussion of the verbal and visual puns in Duchamp's piece, see Richard Brilliant, *Portraiture* (Cambridge: Harvard University Press, 1991), 171–73.

85. On the photobooth portraits, see *Andy Warhol Photobooth Pictures,* with an essay by Gary Indiana (New York: Robert Miller Gallery, 1989).

86. Ron Padgett is fairly sure that Berrigan made this piece and then attributed it to Brainard; telephone interview by author, 11 October 1989.

87. Berrigan, Diaries (see n. 81 above), Berrigan Collection.

88. The review appeared in *Kulchur* 4 (autumn 1964): 95–96.

89. Berrigan, review of *Saturday Night Poems,* by Bill Berkson, *Kulchur* 5 (autumn 1965): 93. Ron Padgett has recalled that, aside from their numerous collaborations, he and Berrigan sometimes published their writings under each other's name. Padgett, telephone interview by author, 11 October 1989.

90. Malanga, "The Pleasure Seekers," *Chic Death* (see n. 32 above), 26.

91. Malanga, "A First World," *Chic Death* (see n. 32 above), 38.

92. Malanga, "Windshield," *Chic Death* (see n. 32 above), 62.

93. Ashbery, "A Blessing in Disguise," *Rivers and Mountains,* 26. For Ashbery's view of his use of personal pronouns, see Bloom and Losada, "Craft Interview with John Ashbery," *The Craft of Poetry,* 123.

94. Malanga's use here of first names has its source in the work of O'Hara. On O'Hara's "name-dropping," and the emulation of this and other O'Hara techniques by Ted Berrigan, see Marjorie Perloff, *Frank O'Hara: Poet among Painters* (1977; reprint, Austin: University of Texas Press, 1979), 127–29, 179. Malanga had picked this technique up, like many others, from Berrigan. Berkson's name appears in several O'Hara poems of the early 1960s, when, as noted in chapter 1, he and O'Hara developed a close relationship.

95. Malanga, *Chic Death* (see n. 32 above), 26.

96. For a more extended analysis of the *Screen Tests / A Diary* collaboration, see my essay "Collaboration as Social Exchange: *Screen Tests / A Diary* by Gerard Malanga and Andy Warhol," *Art Journal* 52 (winter 1993): 59–66.

97. Ashbery, "The Tennis Court Oath," *Tennis Court Oath,* 11.

98. Malanga, interview by author, New York, 15 August 1989, tape recording.

99. Ron Padgett kindly pointed out the identity of "A. Malgmo" in a telephone interview by the author, 11 October 1989. Some of the photographic reproductions in Berrigan's and Padgett's collaborative book *Bean Spasms* were also attributed to A. Malgmo; see Berrigan and Padgett, *Bean Spasms,* 140.

100. I wish to thank Joanna E. Fink for having called to my attention the likely pun in "A. Malgmo."

101. Berrigan, Art Chronicle, *Kulchur* 5 (autumn 1965): 22. The Cordier & Ekstrom ex-

hibition was *Not Seen and / or Less Seen of / by Marcel Duchamp / Rrose Sélavy 1904–1964: Mary Sisler Collection* (14 January–13 February 1965).

102. Berrigan, Art Chronicle, 24. The Warhol Flowers opened at Galerie Ileana Sonnabend in May 1965, and Ashbery interviewed Warhol at this time in Paris for a review of the exhibit that appeared in the *New York Herald Tribune* (International Edition), 17 May 1965 (reprinted in Ashbery, *Reported Sightings,* 120–22).

103. Berrigan, Art Chronicle, 24.

104. Ibid., 25. The Ashbery essay to which Berrigan here referred was published in *Joe Brainard: Assemblages and Collages* (New York: Alan Gallery, 1965); the exhibition was held from 4 to 23 January 1965.

105. The date of this screen test can be established because a published interview with Warhol that took place when the filming of it occurred is dated 3 March 1965; David Ehrenstein, "An Interview with Andy Warhol," *Film Culture* 40 (spring 1966): 41.

106. Ibid.

107. *Film Culture* 32 (1964): 14; reprinted in Berrigan, *So Going Around Cities: New and Selected Poems 1958–1979* (Berkeley: Blue Wind Press, 1980), 34.

108. Ibid. Reprinted by permission of the Estate of Ted Berrigan, Alice Notley, executor.

109. Other associations of Warhol with Native Americans seem to have been part of the artistic interactions between Berrigan and Joe Brainard. Notably, a drawing by Brainard of a Native American directly precedes the *Wanted: $2,000 Reward* collage and the photograph of Warhol in the fall 1965 issue of *Kulchur,* and a collage portrait by him of Berrigan's wife, *Portrait of Sandy* (1963), juxtaposes a headdress of feathers with a Campbell's Soup Can medallion and a ribbon on which "Andy Warhol" is written. This collage is reproduced in Waldman, *Nice to See You,* 4, ill. 7.

110. Berrigan, *So Going Around Cities* (see n. 108 above), 34.

111. Ashbery, "The Recent Past," *Poetry* 102 (June 1963): 144. This poem was later included in Ashbery's volume *Rivers and Mountains* (see n. 26 above), 23.

112. For example, in "Sonnet XXXVII" and "Sonnet LXXIV," in Berrigan's book *The Sonnets,* 37, 48. The title of Berrigan's book is in itself a kind of homage to Ashbery's *The Poems. The Poems* was published three times between 1959 and 1960, in *Evergreen Review* 2 (spring 1959), 97–101; *A New Folder,* ed. Daisy Aldan (New York: Folder Editions, 1959), 1–3 (see fig. 25); and as a book, with prints by Joan Mitchell (New York: Tiber Press, 1960). Berrigan first learned of *The Poems* upon viewing this latter edition; on 20 December 1962 (3:00 A.M.), he wrote that he "went to the Tiber press to see the 4 bk series by Ashberry [*sic*] Koch O'Hara, Schuyler, Mitchell, Leslie, Goldberg, Hartigan. Discovered exciting new poems by Ashberry [*sic*]." Ted Berrigan Diaries (see n. 81 above), Berrigan Collection.

113. Padgett, telephone interview by author, 11 October 1989. Along the same lines, Berrigan commented in an interview with Barry Alpert, concerning his bogus interview with John Cage, " 'Who owns words,' as Bob Creeley said that Tom Clark said. Which is right," in Ratcliffe and Scalapino, *Talking in Tranquility,* 32. For a general discussion of appropriation as "stealing" in the 1960s and 1970s, see Ed Friedman, "Stealing: The Context of My Criminal Record," in *The Poetry Project Newsletter* 139 (December 1990–January 1991): 9.

114. Susan Stewart, *Crimes of Writing: Problems in the Containment of Representation* (New York: Oxford University Press, 1991), 3. Stewart also here (pp. 7–9) traces the relationship between the history of ideas about plagiarism and that of individual identity.

115. Berrigan, Diaries (see n. 81 above), undated entry (July or August 1963), 15 October 1963, and 19 October 1963. Berrigan Collection.

116. Ron Padgett, interview by author, New York, 17 June 1990. Padgett has also commented on Berrigan's practice of stealing books in "On *The Sonnets,*" 9.

117. Berrigan, review of *Lines about Hills above Lakes,* by Jonathan Williams, *Kulchur* 4 (winter 1964–65): 96.

118. Berrigan, Diaries (see n. 81 above), 18 July 1963. Berrigan Collection.

119. Interview by Tom Savage in Ratcliffe and Scalapino, *Talking in Tranquility,* 167 (first published in *Transfer,* 1–2 [1987]).

120. The poem is entitled "Look Fred, You're a Doctor, My Problem Is Something Like This," and is quoted in full in the interview by Tom Savage in Ratcliffe and Scalapino, *Talking in Tranquility,* 170. Reprinted by permission of the Estate of Ted Berrigan, Alice Notley, executor.

121. Interview by Tom Savage in Ratcliffe and Scalapino, *Talking in Tranquility,* 168.

122. *Deathwatch* was performed in 1958, *The Balcony* from 1960 to 1962, and *The Blacks* from 1961 to 1964; each was highly successful. On these productions and their reception, see Edmund White, *Genet: A Biography* (New York: Alfred A. Knopf, 1993), 361, 422, 438–40.

123. On the influence of Genet in the United States during the 1960s, see Robert Sandarg, "Jean Genet in America," *French-American Review* 1 (1976): 47–53. On the contribution of this influence to an interest in the "promiscuous" homosexual man, see Michael Moon, "Outlaw Sex and the 'Search for America': Representing Male Prostitution and Perverse Desire in Sixties Film (*My Hustler* and *Midnight Cowboy*)," *Quarterly Review of Film and Video* 15 (1993): 27.

124. "Playboy Interview: Jean Genet," *Playboy* 11 (April 1964): 45–55.

125. Swenson, "What Is Pop Art?" 61.

126. Jean Genet, *Our Lady of the Flowers,* trans. Bernard Frechtman (New York: Grove Press, 1963).

127. As Kenneth E. Silver has pointed out in "Déjà-vu: Warhols Kunst des Industriell-Naiven," trans. Doris Janhsen, in *Andy Warhol: Retrospektiv* (N.p.: Gerd Hatje, 1993), 28, 31 n. 6, on a copy probably owned by Warhol of the 1961 Olympia Press catalog, the title *Our Lady of the Flowers* is circled in pen (along with a few other titles), and it is likely that Warhol himself marked it; this copy of the catalog is now in the Archives Study Center of the Andy Warhol Museum. This Olympia Press catalog listed a 1957 translation by Frechtman and not, as Silver stated, the later Grove Press edition. On the 1957 translation, see White, *Genet,* 351.

128. The fragment of *Our Lady* in *View* is entitled "It's Your Funeral," trans. Lincoln Kirstein and S. P. Bovie, *View: Parade of the Avant-Garde 1940–47,* ed. Charles Henri Ford, comp. Catrina Neiman and Paul Nathan (New York: Thunder's Mouth Press, 1991), 214–21 (first published in *View Paris* [special issue] 6 [March–April 1946]). Ford had planned to publish an English edition of *Our Lady of the Flowers* but was unable to realize it because his publisher decided against the project. On Ford's interactions with Genet, see White, *Genet,* 295–97. A translation of the novel by Bernard Frechtman was published in 1949 in a luxury edition with a drawing by Jean Cocteau; some copies of this edition made their way to the Gotham Book Mart in New York, and several others were given by the publisher to the art dealer Alexandre Iolas, who sold them in New York. Iolas ran the Hugo Gallery, where in June 1952 Warhol had his first one-person exhibition—drawings based on the writings of Truman Capote. Thus, it is possible that Warhol learned of Genet's book prior to his acquisition of the 1963 Frechtman translation. On the acquisition of the luxury edition by the Gotham Book Mart and Iolas, see White, *Genet,* 347, and on Iolas and Warhol, see David Bourdon, *Warhol* (New York: Harry N. Abrams, 1989), 32.

129. These issues of *View* are now in the Archives Study Center of the Andy Warhol Museum. Warhol's commercial art assistant of the mid-1950s to around 1965, Nathan Gluck, recalled in 1978 that he sold most of his several issues of *View* to Warhol; Smith, *Andy Warhol's Art and Films,* 322. Smith has pointed out that Warhol's friend Charles Lisanby showed Warhol his copy of Genet's book *Querelle,* with homoerotic illustrations by Cocteau (1947), and that Warhol had admired it; Smith, *Andy Warhol's Art and Films,* 67.

181

130. For distinct assessments of the circumstances that led to the censorship of the *Most Wanted* murals, see Bourdon, *Warhol,* 181–82; Rainer Crone, *Andy Warhol* (New York: Praeger, 1970), 30; and Charles F. Stuckey, "Warhol in Context," in *The Work of Andy Warhol,* ed.

Gary Garrels, Dia Art Foundation Discussions in Contemporary Culture Number 3 (Seattle: Bay Press, 1989), 16. Before the censorship occurred, a photograph of the installed *Most Wanted Men* appeared in the *New York Times,* and Ted Berrigan pasted this news item into one of his diaries of 1964 (Berrigan Collection). The *New York Times* clipping consists of a view of the Warhol works accompanied by a caption that reads: "POP AT THE FAIR: Faces of the criminals 'most wanted' by Federal Bureau of Investigation decorate exterior of New York State Pavilion, Andrew Warhol is artist."

131. For an analysis of the kinds of falsifications presented at this World's Fair, and their connections to commerce, see Maurice Berger, "World Fairness," in Berger, *How Art Becomes History: Essays on Art, Society, and Culture in Post–New Deal America* (New York: HarperCollins, Icon Editions, 1992), 46–62 (first published in *Artforum* 28 [October 1989]).

132. On this photograph, see White, *Genet,* 255, 319. The photograph is reproduced in the picture insert section between pages 144 and 145 of White's book.

133. Genet, *Our Lady of the Flowers,* 51–57. Reprinted by permission of Grove Atlantic Press.

134. On this aspect of Warhol's most wanted series, see Kenneth E. Silver, "Modes of Disclosure: The Construction of Gay Identity and the Rise of Pop Art," in *Hand-Painted Pop: American Art in Transition, 1955–62,* ed. Russell Ferguson (Los Angeles: Museum of Contemporary Art; New York: Rizzoli, 1992), 194; and Richard Meyer, "Warhol's Clones," *Yale Journal of Criticism* 7 (spring 1994): 83.

135. Genet, *Our Lady of the Flowers* (see n. 133 above), 54.

136. Andrew Kagan, "Most Wanted Men: Andy Warhol and the Anti-Culture of Punk," *Arts Magazine* 53 (September 1978): 119–20. Sartre observed in *Saint Genet: Actor and Martyr,* trans. Bernard Frechtman (New York: George Braziller, 1963), 485, that "the great criminals are more famous than honorable writers who are their contemporaries."

137. Genet, *Our Lady of the Flowers,* 56.

138. Jean-Paul Sartre, introduction, Genet, *Our Lady of the Flowers,* 1.

139. Many of the Flower paintings were made in June and July of 1964, according to Bourdon, *Warhol,* 193.

140. Genet, *Our Lady of the Flowers,* 52.

141. Silver, "Déjà-vu: Warhols Kunst des Industriell-Naiven," 28.

142. Jean Genet, *The Thief's Journal,* trans. Bernard Frechtman and foreword by Jean-Paul Sartre (New York: Grove Press, 1964), 9–11. Reprinted by permission of Grove Atlantic Press. (This passage is quoted as an introduction to Meyer, "Warhol's Clones," 79, but Meyer discusses neither Genet nor the writer's significance for Warhol in his essay.)

143. The film was shown by Jonas Mekas at the Writers' Stage Theater at 83 East 4th Street. After the screening, the police confiscated it, closed up the theater, and arrested Mekas. See Mekas, "Report from Jail," in Mekas, *Movie Journal: The Rise of a New American Cinema, 1959–1971* (New York: Collier Books, 1972), 129–30 (first published in *Village Voice,* 19 March 1964); and "Showcases I Ran in the Sixties," in *To Free the Cinema: Jonas Mekas and the New York Underground,* ed. David E. James (Princeton: Princeton University Press, 1992), 323. Warhol referred to this screening in *POPism,* 79, and his friend Charles Lisanby remembered having attended it with Warhol; Smith, interview with Lisanby, 11 November 1978, in *Andy Warhol's Art and Films,* 376. On the Warhol film that was confiscated on this occasion, see Bourdon, *Warhol,* 175.

144. On *A Song of Love,* see Jane Giles, *The Cinema of Jean Genet: Un Chant d'Amour* (London: British Film Institute, 1991) and White, *Genet,* 362–67.

145. For a different kind of discussion of the connections between Warhol's films and Genet's ideas, which focuses on the relationship of Warhol to his subjects, see Smith, *Andy Warhol's Art and Films,* 147, 157–58, 163.

146. Jack Kroll, "Saint Andrew," *Newsweek,* 7 December 1964, 100–103A.

147. The following partial list of reviews of and notices about *Saint Genet* that appeared

in high-profile publications during 1963 and 1964 are an index of its currency at the time: "The Case of Jean Genet," *Time,* 11 October 1963, 114, 116; Lionel Abel, "The Genius of Jean Genet," *New York Review of Books* 17 October 1963, 7–8; Renata Adler, "All Saints," *New Yorker,* 9 November 1963, 234–43; L. S. Roudiez, "The Evil and the Ecstasy," *Saturday Review,* 26 October 1963, 38–39; Norman Podhoretz, "Sartre's Genet," *Show* 4 (January 1964): 37–39; Christopher Ricks, "Dejecta," *New Statesman,* 10 January 1964, 46–47.

148. Kroll, "Saint Andrew," 103A.

149. Sartre, *Saint Genet,* 4.

150. Ibid., 79.

151. Ibid., 281–82.

152. Ibid., 12.

153. Ibid., 293–94.

154. Ibid., 512.

155. On Warhol's use of the strobe-cut in *Bufferin,* see Callie Angell, *The Films of Andy Warhol: Part II* (New York: Whitney Museum of American Art, 1994), 28; Yann Beauvais, "Fixer des images en mouvement," *Andy Warhol, Cinema,* 105–6; and Miles McKane and Catia Riccaboni, "Filmographie," *Andy Warhol, Cinema,* 259. I discussed the personal component of his use of the technique in this movie, as well as the movie's references to stolen paintings, in a program at the Harvard Film Archive, 7 March 1991.

156. The antipathy that Warhol felt for Ricard was reciprocated and remained in force over the years, as is evident in a few remarks made by Warhol to Frederick Castle in an interview published as "Occurrences: Cab Ride with Andy Warhol," *ARTnews* 66 (February 1968): 46, and in *The Andy Warhol Diaries,* ed. Pat Hackett (New York: Warner Books, 1989), 199 (25 January 1979), 484 (3 February 1983).

157. Diary entry of 24 September 1966, in "From *The Secret Diaries,*" in *Out of this World: An Anthology of the St. Mark's Poetry Project, 1966–1991,* ed. Anne Waldman (New York: Crown Publishers, 1991), 287–88.

158. Malanga, telephone interview by author, 13 August 1990, tape recording. The first line of Malanga's *Screen Tests* poem to Ricard, "A field of flowers is not invisible," would seem to be a play on the title of a poem that was written by Ricard in 1965 (and in which Malanga is named) entitled "An Idea Is Something We Can't See." The poem is published in Rene Ricard, *Rene Ricard, 1979–1980* (New York: Dia, 1979), 56.

159. On Susan Bottomly, see Bourdon, *Warhol,* 238, 240.

160. Malanga, *Prelude to International Velvet Debutante* (Milwaukee: Great Lakes Books, 1967), 7.

161. Jean Stein, *Edie: An American Biography* (New York: Alfred A. Knopf, 1982), 285–87. The description of *The Andy Warhol Story* in *Edie* is from an interview with Ricard; the film is not listed in any of the existing Warhol filmographies.

162. Malanga stated that Ricard had made some dollar bill drawings and signed Warhol's name to them in a telephone interview by the author, 13 August 1990, tape recording.

163. Swenson, "What Is Pop Art?" 26.

164. John Wilcock, *The Autobiography and Sex Life of Andy Warhol* (New York: Other Scenes, 1971), no pagination. For a discussion of how such activities raised problems for the authentification of Warhol's work, see Benjamin H. D. Buchloh, "Andy Warhol's One-Dimensional Art: 1956–1966," in *Andy Warhol: A Retrospective,* ed. Kynaston McShine (New York: Museum of Modern Art, 1989), 56, 61 n. 58.

165. *Andy Warhol Diaries,* 132 (6 May 1978).

166. Ibid., 142 (11 June 1978). Warhol also accused Malanga of making fake electric chair paintings; ibid., 631–32 (12 March 1985). There is one documented instance of Malanga having made silkscreen paintings that he claimed were by Warhol, but these paintings, based on a photograph of the slain Ché Guevara, were not from Warhol's existing repertoire of images; see Bourdon, *Warhol,* 291 n. 2.

1. Early on in his career as a critic, Mekas used the term "film poem" to describe experimental film in, for example, "The Experimental Film in America," in *Film Culture Reader*, ed. and intro. P. Adams Sitney (New York: Praeger, 1970), 21–26 (first published in *Film Culture* 3 [May–June 1955]). This article contained a somewhat homophobic sentiment, which Mekas soon outgrew, as is often noted.

2. An excellent study of the significance of the term "film poem" during the 1950s and early 1960s is found in David E. James, *Allegories of Cinema: American Film in the Sixties* (Princeton: Princeton University Press, 1989), 29–32.

3. It is also worth noting here the plethora of American poetry that either made film its subject or alluded in more subtle ways to film. For a general study of this phenomenon, see Laurence Goldstein, *The American Poet at the Movies: A Critical History* (Ann Arbor: University of Michigan Press, 1994).

4. Jerry Tallmer, introduction, *Pull My Daisy*, text by Jack Kerouac, film by Robert Frank and Alfred Leslie (New York: Grove Press; London: Evergreen Books, 1961), 17.

5. On this influence, see also J. Hoberman, "The Forest and *The Trees*," in *To Free the Cinema: Jonas Mekas and the New York Underground*, ed. David E. James (Princeton: Princeton University Press, 1992), 116.

6. The one critic who has noted the connections between the idea of the "film poem" and Warhol's early films is Stephen Koch, who observed that these films, "speaking very roughly, . . . belong in the stream of nonnarrative 'poetic' avant-garde cinema. . . ." *Stargazer: The Life, World and Films of Andy Warhol*, rev. ed. (New York: Marion Boyars, 1991), 19.

7. Mekas, "Notes on the New American Cinema," *Film Culture* 24 (spring 1962), in Sitney, *Film Culture Reader*, 101.

8. Mekas, "On Film Troubadours," in Mekas, *Movie Journal: The Rise of a New American Cinema, 1959–1971* (New York: Collier Books, 1972), 20 (first published in *Village Voice*, 6 October 1960).

9. Parker Tyler, "A Preface to the Problems of the Experimental Film," *Film Culture* 17 (February 1958), in Sitney, *Film Culture Reader*, 42.

10. Tyler, in "Poetry and the Film: A Symposium," *Film Culture* 29 (summer 1963), in Sitney, *Film Culture Reader*, 172.

11. Cinema 16 was founded in 1947 by Amos and Marcia Vogel and operated until 1963. On this establishment and its influence on Mekas, see James, *To Free the Cinema*, 6–7.

12. Willard Maas, "Poetry and the Film: A Symposium," in Sitney, *Film Culture Reader*, 176, 184. The other participants in the symposium were Maya Deren, Arthur Miller, and Dylan Thomas; the latter two objected strongly to the idea of film poetry. Another filmmaker involved with the Cinema 16 group, Hans Richter, asserted that all experimental film should be called "film poetry," in "Hans Richter on the Nature of Film Poetry," *Film Culture* 11 (1957): 5–7. For an analysis of Richter's essay within the context of the concept of the "film poem," see James, *Allegories of Cinema*, 29.

13. Archives Study Center, the Andy Warhol Museum. In this same issue of *Film Culture*, Mekas published his poem "Press Release," which begins with a list of filmmakers whom he characterized as "the film poets of America today" and draws attention to the lack of receptiveness to these "poets" by the public at large, asserting that it is, nevertheless, their work that will remain; *Film Culture* 29 (summer 1963): 7–8.

14. The film of Maas and Menken, and Warhol's dissatisfaction with it, were reported in John Wilcock, "The Detached Cool of Andy Warhol," *Village Voice*, 6 May 1965, 24. Maas also appeared, along with Menken, Malanga, and Edie Sedgwick, in a film called *Bitch* (1965); on this film, see Miles McKane and Catia Riccaboni, "Filmographie," *Andy Warhol, Cinema* (Paris: Éditions CARRÉ and Centre Georges Pompidou, 1990), 256.

15. On Jack Smith's influence on Warhol, see, for example, Vivienne Dick, "Warhol: Won't Wrinkle Ever, a Film-maker's View," in *Andy Warhol: Film Factory*, ed. Michael O'Pray

(London: British Film Institute, 1989), 154. Warhol's divergence from the use of myth and symbol found in the films of Smith is pointed out in O'Pray, "Warhol's Early Films: Realism and Psychoanalysis," in *Andy Warhol: Film Factory*, 177.

16. Mekas, "Notes on the New American Cinema," *Film Culture* 24 (spring 1962), in Sitney, *Film Culture Reader*, 102.

17. Mekas, "On Cinéma Vérité, Ricky Leacock, and Warhol," *Village Voice*, 13 August 1964, in *Movie Journal*, 154.

18. Mekas, "Andy Warhol: 'The Chelsea Girls,'" *Village Voice*, 24 November 1966, 29 (first published in "Movie Journal," *Village Voice*, 29 September 1966). On the importance of the concept of "realism" in Mekas's criticism, see John Pruitt, "Jonas Mekas: A European Critic in America," in James, *To Free the Cinema*, 52–56.

19. On the divergence of Mekas's aesthetic from that of the European "film poems" and likewise from that of the critic Parker Tyler, see J. Hoberman's 1995 introduction to Parker Tyler's book *Underground Film: A Critical History* (1969; reprint, New York: Da Capo Press, 1995), vii–x.

20. Mekas, "*Pull My Daisy* and the Truth of Cinema," *Village Voice*, 18 November 1959, in *Movie Journal*, 6. This review was occasioned by the premiere of *Pull My Daisy* at Cinema 16.

21. Mekas, "Sixth Independent Film Award" (1964), in Sitney, *Film Culture Reader*, 427.

22. The significance of *Pull My Daisy* for the work of Mekas and Warhol is noted in passing in Barry Miles, *Ginsberg: A Biography* (New York: Simon and Schuster, 1989), 258, while Rainer Crone has placed Warhol, in general terms, within the generation of the beats in *Andy Warhol: The Early Work 1942–1962*, trans. Martin Scutt (New York: Rizzoli, 1987), 15.

23. On Warhol's familiarity with *The Flower Thief*, see Andy Warhol and Pat Hackett, *POPism: The Warhol '60s* (New York: Harcourt Brace Jovanovich, 1980), 35. The success of the film during its showing at the Charles Theater is discussed in Hoberman, "The Forest and *The Trees*," 117. Mekas wrote a favorable review of it, "Taylor Mead and *The Flower Thief*," *Village Voice*, 19 July 1962, in *Movie Journal*, 63–64. Mekas used the Charles Theater to show experimental film from 1961 to 1963; see Mekas, "Showcases I Ran in the Sixties," in James, *To Free the Cinema*, 323. Warhol stated that he often attended these screenings in *POPism*, 30.

24. According to Mead, "he had read my books before I met him and he asked to have them autographed. I was flattered by that because I really admired him." Taylor Mead and David Bourdon, "The Factory Decades: An Interview," *Boss* 5 (1979): 35. Warhol would also have known Mead's work through its publication in *Fuck You / A Magazine of the Arts*. Issue number 5, volume 3 (May 1963), containing Mead's work, is in the Archives Study Center of the Andy Warhol Museum.

25. Ford, interview with John Wilcock, in Wilcock, *The Autobiography and Sex Life of Andy Warhol* (New York: Other Scenes, 1971), no pagination.

26. For a summary of Levine's activities as an actress and filmmaker, see Sheldon Renan, *An Introduction to the American Underground Film* (New York: E. P. Dutton, 1967), 203.

27. Taylor Mead, *Excerpts from the Anonymous Diary of a New York Youth* (1961; reprint, New York: n.p., 1962), 33, 41.

28. Ibid., 2.

29. Regarding the casting for the Tarzan and Jane movie, Mead himself later observed, "I was a logical Tarzan, being opposite to the type," in his essay "Acting: 1958–1965," in Walker Art Center, *The American New Wave, 1958–1967* (Minneapolis: Walker Art Center, 1982), 17.

30. Mead, telephone interview by author, 11 November 1991, tape recording.

31. Warhol and Hackett, *POPism*, 39.

32. Jack Kerouac, *On the Road* (1957; reprint, New York: Penguin Books, 1976), iv.

33. Robert M. Coates, "The Art Galleries: The 'Beat' Beat in Art" [review of "Sixteen Americans"], *New Yorker*, 2 January 1960, 60. A discussion of this review in relation to the

work of Rauschenberg is found in Lana Davis, "Robert Rauschenberg and the Epiphany of the Everyday," in *Poets of the Cities: New York and San Francisco 1950–1965* (Dallas: Dallas Museum of Art and Southern Methodist University; New York: E. P. Dutton, 1974), 40.

34. Jack Kerouac, *On the Road*, 156, 182. Allen Ginsberg has aptly remarked that the pop material in books such as *On the Road* contributed to the emergence of pop art, in Peter Kadzis, "Interview: With Pen and Lens," *Boston Phoenix Literary Section* 38 (June 1991): 7. Taylor Mead himself has stated that he thinks the beat writers had an impact on Warhol; Mead and Bourdon, "The Factory Decades," 35.

35. Warhol recalled that he took this trip in order to see the United States and not because, as some people thought, he was afraid to fly; Warhol and Hackett, *POPism*, 35. The car trip is attributed to a fear of flying by Mead in Mead and Bourdon, "The Factory Decades," 23, and by Victor Bockris (who also recognized the link to *On the Road*), *The Life and Death of Andy Warhol* (New York: Bantam Books, 1989), 135. It is amusing to consider here the fact that Jack Kerouac *was* afraid of airplanes; see Gerald Nicosia, *Memory Babe: A Critical Biography of Jack Kerouac* (1983; reprint, Berkeley and Los Angeles: University of California Press, 1994), 603.

36. Warhol and Hackett, *POPism*, 35.

37. Ibid., 38–39.

38. Mead, interview by author, 11 November 1991, tape recording.

39. Bockris, *Life and Death*, 137.

40. Mead, *Excerpts from the Anonymous Diary*, 1, 2. For the passage in "Howl" that Mead here emulated, see Ginsberg, *Howl and Other Poems* (San Francisco: City Lights, 1956), 12.

41. *Fuck You / A Magazine of the Arts* 4 (August 1962): no pagination.

42. "Fuck You: The Talk of the Town," *Fuck You* 5 (December 1962): no pagination.

43. The other movies by Warhol in which Mead plays significant roles are: *Taylor Mead's Ass* (1964), *Imitation of Christ* (a segment of the twenty-five-hour film ****) (1967), *Nude Restaurant* (1967), and *Lonesome Cowboys* (1968).

44. Emile de Antonio's involvement with the distribution of *Pull My Daisy* is discussed in J. Hoberman, "Pull My Daisy / The Queen of Sheba Meets Atom Man," in Walker Art Center, *The American New Wave, 1958–1967*, 37.

45. This screening is described in Warhol and Hackett, *POPism*, 31.

46. See this chapter, note 4.

47. This description is of the print I have seen of *Couch*, which belongs to Gerard Malanga and is the version discussed in Yann Beauvais, "Fixer des images en mouvement," *Andy Warhol, Cinema*, 98–100. Other versions of the film may have been screened. Richard Dyer describes the film as consisting of eight reels in *Now You See It: Studies on Lesbian and Gay Film* (London: Routledge, 1990), 155. In addition, a twenty-four-hour version of *Couch* was reportedly screened at the Factory; see McKane and Riccaboni, "Filmographie," 255.

48. Reel-to-reel audio recording, 1964, collection Gerard Malanga.

49. One of the reels shot on this day, of Corso, Ginsberg, Kerouac, and Mead, was lost, according to Warhol's account in *POPism*, 240–41.

50. Kerouac, *Pull My Daisy*, 22.

51. The allusions in *Couch* to both Hollywood and psychoanalysis are noted in Bockris, *Life and Death*, 154. While the couch in this film refers to Hollywood, the kinds of sex that occur on it—between men, or a menage-à-trois of two men and one woman—show what Hollywood did not, as is noted in Beauvais, "Fixer des images en mouvement," in *Andy Warhol, Cinema*, 98.

52. On Warhol's interest in the film *Scorpio Rising*, and echoes of it in his 1965 movie *Vinyl*, see Paul Arthur, "Flesh of Absence: Resighting the Warhol Catechism," in O'Pray, *Andy Warhol: Film Factory*, 151, and Gretchen Berg, "Nothing to Lose: An Interview with Andy Warhol," in *Andy Warhol: Film Factory*, 58 (first published in *Cahiers du Cinéma in English* 10 [1967]).

53. On the *apparent* spontaneity of *Pull My Daisy,* see James, *Allegories of Cinema,* 92. An extensive account of the making of this film is found in Nicosia, *Memory Babe,* 582–85.

54. Tallmer, introduction to Kerouac, *Pull My Daisy,* 14.

55. Ibid., 15.

56. The incident on the set of "Pull My Daisy" and Kerouac's increasingly shocking behavior (fueled by alcohol) are described in Nicosia, *Memory Babe,* 584 and 571, respectively.

57. A few minutes prior to this exchange, Kerouac similarly instructs Ginsberg to "get up, move in, get up, move in; then we go faster and faster."

58. At this point in the dialogue someone, perhaps Warhol, suggested making a "piss" movie, to which Kerouac replied, "You can get that. But you need a light on it, right? Let's go. . . . But you have to do it fast."

59. See, for example, Kerouac, *On the Road,* 40 (on W. C. Fields) and 154 (on Groucho Marx). Kerouac included the Three Stooges, W. C. Fields, and the Marx Brothers among the figures to whom the roots of the beats can be traced in his paper "Is There a Beat Generation?" which he read at a forum of the same title, sponsored by Brandeis University and held at Hunter College Playhouse on 6 November 1958; *Jack Kerouac: "The Last Word"* (Rhino Records R4 70939-D, 1990).

60. The influential film critic and historian P. Adams Sitney contributed greatly to this incorrect assumption in his book *Visionary Film: The American Avant-Garde* (New York: Oxford University Press, 1974), 409–10, in which he wrote that "Warhol made the profligacy of footage the central fact of all of his early films, and he advertised his indifference to direction, photography, and lighting. He simply turned the camera on and walked away." This viewpoint prevailed despite the fact that Jonas Mekas had attested, in an essay published four years prior to the publication of Sitney's book, that, through his own observations of Warhol working, he knew that Warhol was hardly an indifferent, passive filmmaker; "Notes After Reseeing the Movies of Andy Warhol," in O'Pray, *Andy Warhol: Film Factory,* 31 (first published in *Andy Warhol,* ed. John Coplans [New York: New York Graphic Society, 1970]).

61. See, for example, Miles, *Ginsberg,* 335.

62. See Warhol and Hackett, *POPism,* 240.

63. Taylor Mead, telephone interview by author, 11 November 1991, tape recording.

64. Ginsberg showed up at the Factory for a party to celebrate the opening of Warhol's Flower paintings exhibit at Castelli Gallery in 1964, for the "Fifty Most Beautiful People" party in 1965, and during Bob Dylan's notorious visit there in 1966; see Warhol and Hackett, *POPism,* 87, 103, 150. On Ginsberg's performance with the Velvet Underground at the Dom, see Miles, *Ginsberg,* 387. Ginsberg's presence at one of the Velvet Underground's multimedia programs at the Dom was recorded by Jerry Tallmer in "Rebellion in the Arts: 5. Mixed Media," 1966 news clipping, Andy Warhol file, New York Public Library Theater Collection.

65. Allen Ginsberg, telephone interview by author, 13 December 1991, tape recording.

66. Mekas, "On Cinéma Vérité, Ricky Leacock, and Warhol," *Movie Journal,* 154–55.

67. A photograph by Nat Finkelstein of Malanga and Warhol at this reading is in the Archives Malanga.

68. I am grateful to Thomas Frick for calling my attention to Warhol's *Paris Review* literary "portrait gallery."

69. Kent E. Carroll, "More Structured, Less Scandalized Warhol Aiming for a Wider Playoff," *New York Times,* 7 May 1969; reproduced in Margia Kramer, *Andy Warhol Et Al.: The FBI File on Andy Warhol* (New York: Unsub Press, 1988), 54.

70. The relevance to Ginsberg of Whitman's poetry and celebration of love between men has often been pointed out. See, for example, John Tytell, *Naked Angels: Kerouac, Ginsberg, Burroughs* (1976; reprint, New York: Grove Weidenfeld, 1991), 223–26, 241–44.

71. Ginsberg, *Howl and Other Poems,* 23. "A Supermarket in California" remains one of Ginsberg's most often reprinted poems. It has appeared in collections ranging from *The New*

187

American Poetry: 1945–1960, ed. Donald Allen (New York: Grove Press; London: Evergreen Books, 1960), 181, to *The Portable Beat Reader,* ed. Ann Charters (New York: Viking, 1992), 71–72.

72. See *The Portable Walt Whitman,* ed. Mark Van Doren, revised by Malcolm Cowley, with a chronology and bibliographical check list by Gay Wilson Allen (New York: Penguin Books, 1973), 216–94, 385, 411–84.

73. See, for example, "The Wound-Dresser," *Drum-Taps,* and "Boys in the Army," *Specimen Days,* in Van Doren, *The Portable Walt Whitman,* 226–29, 456–57.

74. In the poet Jim Carroll's slightly fictionalized diaries of actual events, he recorded that in 1971 Morrissey asked Ginsberg

> "to play the part of Walt Whitman, issuing aid and comfort, in every sense of the word, to the Union wounded (and any Rebels, for that matter, if they're cute enough)."
> "A lot of good-looking boys?" inquires Allen.
> "That's the way we work . . . that's our signature, Allen," Paul replies.
> "Sounds like fun," Allen is bubbling. "Any script written yet?"
> "Umm, not yet . . . but we'll send it to you soon . . . an outline at least. By the way, Jim, maybe there's some work for you . . . like writing dialogue, when we get to that stage. . . . maybe we can even use you as a soldier."

Carroll, *Forced Entries, The Downtown Diaries: 1971–1973* (New York: Penguin Books, 1987), 26. Ginsberg himself commented to his biographer Barry Miles, regarding his attraction to Warhol's Factory: "I was interested in the films, civil liberties, and the beautiful boys he had. . . . But they were unobtainable or in another realm of some sort." Miles, *Ginsberg,* 336.

75. Bob Colacello, *Holy Terror: Andy Warhol Close Up* (New York: HarperCollins, 1990), 61. According to Colacello, Paul Morrissey had proposed the Whitman film, which was to be a comedy, in spring 1971, and the attractive Joe Dallesandro, who was in several Warhol-Morrissey films of the late 1960s and early 1970s, was to play the wounded soldier whom Whitman, acted by Ginsberg, "nurses back to health."

76. Ginsberg, telephone interview by author, 13 December 1991, tape recording. Ginsberg also stated in this interview that Morrissey had called him to ask if he would play the role of Whitman, and that he was unsure whether the idea for the film was Morrissey's or Warhol's.

77. On the taping of *a: a novel,* see Warhol, *The Philosophy of Andy Warhol (From A to B and Back Again)* (San Diego: Harcourt Brace Jovanovich, 1975), 95.

78. *Excerpts from Visions of Cody* (New York: New Directions, 1959). For the other excerpts from this novel that were published during the late 1950s and early 1960s, see *A Bibliography of Works by Jack Kerouac (Jean Louis Lebris De Kerouac): 1939–1975,* comp. Ann Charters, rev. ed. (New York: Phoenix Bookshop, 1975), 33, and Nicosia, *Memory Babe,* 593.

79. Four of the dust jacket designs that Warhol made for New Directions books are listed in *"Success is a job in New York . . .": The Early Art and Business of Andy Warhol,* ed. Donna M. De Salvo (New York: Grey Art Gallery and Study Center; Pittsburgh: Carnegie Museum of Art, 1989), 81, and a number of them are reproduced in Andreas Brown, *Andy Warhol: His Early Works 1947–1959* (New York: Gotham Book Mart Gallery, 1971), no pagination.

80. Nicosia, *Memory Babe,* 610.

81. See Ted Berrigan with Aram Saroyan and Duncan McNaughton, "The Art of Fiction XLI: Jack Kerouac," *Paris Review* 11 (summer 1968): 63.

82. Warhol, *Philosophy of Andy Warhol,* 94–95.

83. On Burroughs's use of audio tapes, see Robin Lydenberg, "Sound Identity Fading Out: William Burroughs' Tape Experiments," in *Wireless Imagination: Sound, Radio, and the Avant-Garde,* ed. Douglas Kahn and Gregory Whitehead (Cambridge: MIT Press, 1992), 409–37.

84. See, for example, Mekas, "On *Blonde Cobra* and *Flaming Creatures* (From My Tape Recorded Diaries)," *Village Voice,* 24 October 1963; in *Movie Journal,* 101–3. On Mekas's

"film diaries," see especially David E. James, "Film Diary / Diary Film: Practice and Product in *Walden*," in *To Free the Cinema*, 145–79. On the relationship between Mekas's notion of the "film diary" and the work of Malanga and Warhol, see my essay "Collaboration as Social Exchange: *Screen Tests / A Diary* by Gerard Malanga and Andy Warhol," *Art Journal* 52 (winter 1993): 62.

85. Tytell wrote that the events on the tape in *Visions of Cody* "are told in a manner anticipating Pop realism, with the graphic and relentlessly obsessive concentration on the ordinary that is seen in Warhol's movies. The catalyzing principle is Rimbaud's "*dérèglement des tous les sens*"; *Naked Angels*, 183.

86. Koch, *Stargazer*, 30.

87. Kerouac, *Visions of Cody*, with "The Visions of the Great Rememberer," by Allen Ginsberg (1972; reprint, New York: Penguin Books, 1993), ix.

88. See, for example, Kerouac, *Visions*, 155, 208.

89. Some examples are Andy Warhol, *a: a novel* (New York: Grove Press, 1968), 87, 198, 208–9.

90. On the idea that taking Benzedrine would produce an openness and honesty in communication, see Kerouac, *On the Road*, 42.

91. Critics have pointed out the connections of the individual novels to the work of Joyce. On the relationships between Joyce's writings and *a: a novel*, see, for instance, Sally Beauman, review of *a: a novel*, *New York Times Book Review*, 12 January 1969, 32. On *Visions of Cody* and the work of Joyce, see Nicosia, *Memory Babe*, 376.

92. There are even similarities in the details of the telephone conversations; compare, for example, Kerouac, *Visions*, 130, to Warhol, *a*, 36. For instances of music being played, see *Visions*, 135–36, and *a*, 57–58.

93. "Goofing" is defined by Kerouac in *Pull My Daisy*, 27.

94. Kerouac, *Visions*, 170. © 1972 by the Estate of Jack Kerouac. Reprinted by permission of Sterling Lord Literistic, Inc.

95. Warhol, *a*, 126–27. Ginsberg is also brought up by Ondine in another passage of the novel; see *a*, 96. Ondine frequented the same Bleecker Street bar as Ginsberg, the San Remo, and it is possible that he met Ginsberg there or through one of his San Remo friends. On the San Remo, see Miles, *Ginsberg*, 127, and Warhol and Hackett, *POPism*, 54–55.

96. Kerouac, *Visions* (see n. 94 above), 220.

97. Warhol, *a*, 53, 264.

98. On this aspect of the tape recorded segment of *Visions of Cody*, see Michael Davidson, *The San Francisco Renaissance: Poetics and Community at Mid-century* (Cambridge: Cambridge University Press, 1989), 74. Regarding his use of the tape recorder, Warhol wrote, "You couldn't tell which problems were real and which problems were exaggerated for the tape. Better yet, the people telling you the problems couldn't decide any more if they were really having the problems or if they were just performing"; *Philosophy of Andy Warhol*, 26–27.

99. On this dimension of *Visions of Cody*, see Davidson, *San Francisco Renaissance*, 74. The process by which the tapes of *a: a novel* were transcribed is described in Warhol, *Philosophy of Andy Warhol*, 95, and Warhol and Hackett, *POPism*, 149, 287.

100. On the criticisms Kerouac received for using tape transcriptions in the novel, see Nicosia, *Memory Babe*, 387, 414.

101. The negative reviews of *a* included that of Sally Beauman (see this chapter, n. 91), Robert Mazzocco, "aaaaaa . . . ," *New York Review of Books*, 24 April 1969, 34–37, and "ZZZZZZZZ," *Time*, 27 December 1968, 63. On the reception of *a*, see also Bockris, *Life and Death*, 243–44.

102. Warhol and Hackett, *POPism*, 287.

103. For example, there was a great deal of mostly negative writing about *On the Road* (but, as already noted, it was a great publishing success); on the criticism of Kerouac's novel, see Nicosia, *Memory Babe*, 556–57, 559.

104. I have considered this point in an abbreviated form in "Collaboration as Social

Exchange: *Screen Tests / A Diary* by Gerard Malanga and Andy Warhol," 64. Ronald Sukenick has associated the "commodity component" of the beat movement with the "art publicity genius" of Warhol in *Down and In: Life in the Underground* (New York: William Morrow, Beech Tree Books, 1987), 112.

105. Paul O'Neil, "The Only Rebellion Around," in *A Casebook on the Beat,* ed. Thomas Parkinson (New York: Thomas Y. Crowell, 1961), 234 (first published in *Life,* 30 November 1959).

106. Norman Podhoretz, "The Know-Nothing Bohemians," in Parkinson, *A Casebook on the Beat,* 201–2 (first published in *Partisan Review* 25 [spring 1958]).

107. John Leonard, "The Return of Andy Warhol," *New York Times Magazine,* 10 November 1968, 32.

108. See Joseph Morgenstern, "Beatniks for Rent," in *Kerouac and Friends: A Beat Generation Album,* ed. Fred W. McDarrah (New York: William Morrow, 1985), 243–51 (first published in the *New York Herald Tribune,* 1 May 1960). The Rent-a-Beatnik advertisement that was run in the *Village Voice* and a *Mad* magazine parody of it are reproduced in *Kerouac and Friends,* 247, 284.

109. Ronald Sukenick noted that McDarrah's business foreshadowed a trend that would soon develop, in *Down and In,* 118.

110. Ginsberg has noted that the tape transcriptions in *Visions of Cody* presage Warhol's interest in commonplace objects, in "The Visions of the Great Rememberer," *Visions,* 409–10.

111. This statement was quoted, among other places, in Herbert Gold, "The Beat Mystique," in Parkinson, *A Casebook on the Beat,* 248 (first published in *Playboy,* February 1958), and by Bill Randle in the notes he composed to accompany the record he produced, *Readings by Jack Kerouac on the Beat Generation* (Verve LP #15005, 1960).

112. Gene R. Swenson, "What Is Pop Art?" *ARTnews* 62 (November 1963): 26.

113. Kerouac, *On the Road,* 126.

114. Mekas, quoted in Jack Kroll, "Saint Andrew," *Newsweek,* 7 December 1964, 103.

115. K. S. Lynn, review of *Dr. Sax,* by Jack Kerouac, *New York Herald Tribune Book Review,* 31 May 1959, as cited in Nicosia, *Memory Babe,* 588, and Gold, "The Beat Mystique," in Parkinson, *A Casebook on the Beat,* 247, 252, 254.

116. Joseph Gelmis, "On Movies: He Has Trouble Communicating Whether On or Off the Screen," *Newsday,* 8 December 1966. Probably in response to this article, Warhol brought up the question of boredom in his work in an interview that Gelmis later conducted with him; see Gelmis, *The Film Director as Superstar* (Garden City, N.Y.: Doubleday, 1970), 70.

117. See, for example, John Bernard Myers, "A Letter to Gregory Battcock," in *The New American Cinema: A Critical Anthology,* ed. Battcock (New York: E. P. Dutton, 1967), 139, and James Stoller, "Beyond Cinema: Notes on Some Films by Andy Warhol," *Film Quarterly* 20 (fall 1966): 38.

Conclusion

1. See Warhol, *The Andy Warhol Diaries,* ed. Pat Hackett (New York: Warner Books, 1989), 344, 488–89.

2. On Gould's illness and the demise of his relationship with Warhol, see ibid., 552, 639, 698, 708, 757.

3. Charles Stuckey, "Heaven and Hell Are Just One Breath Away!" in *Andy Warhol: Heaven and Hell Are Just One Breath Away! Late Paintings and Related Works, 1984–1986,* foreword by Vincent Fremont, afterword by John Richardson (New York: Rizzoli International in association with Gagosian Gallery, 1992), 24.

190

Special Collections

Andy Warhol Museum, Pittsburgh, Penn. Archives Study Center.

Fales Library, New York University, New York. Ed Sanders Collection.

Harry Ransom Humanities Research Center, University of Texas at Austin. Malanga Collection.

Houghton Library, Harvard University, Cambridge, Mass. John Ashbery Papers.

Northwestern University Library, Evanston, Ill., Special Collections.

Rare Book and Manuscript Library, Columbia University, New York. Berrigan Collection.

Theater Collection, New York Public Library, New York. Andy Warhol clipping files.

Publications

Abrahams, Roger D. "A Performance-Centred Approach to Gossip." *Man: The Journal of the Royal Anthropological Institute* 5 (1970): 290–301.

Aldan, Daisy, ed. *A New Folder—Americans: Poems and Drawings*. 1959. Reprint. New York: Kraus Reprint Co., 1970.

Allen, Donald, ed. *The New American Poetry: 1945–1960*. New York: Grove Press; London: Evergreen Books, 1960.

Altieri, Charles. "John Ashbery and the Challenge of Post-modernism in the Visual Arts." *Critical Inquiry* 14 (summer 1988): 805–30.

———. *Self and Sensibility in Contemporary American Poetry*. Cambridge: Cambridge University Press, 1984.

"Andy Warhol 1928–87: A Collage of Appreciations from the Artist's Colleagues, Critics and Friends." *Art in America* 75 (May 1987): 137–43.

Andy Warhol, Cinema. Paris: Éditions CARRÉ and Centre Georges Pompidou, 1990.

Andy Warhol: Death and Disasters. Essays by Neil Printz and Remo Guidieri. Houston: The Menil Collection and Houston Fine Art Press, 1988.

Andy Warhol Museum. *The Andy Warhol Museum: The Inaugural Publication*. Pittsburgh: Andy Warhol Museum, 1994.

Angell, Callie. *The Films of Andy Warhol: Part II*. New York: Whitney Museum of American Art, 1994.

Ashbery, John. "Interview with John Murphy." *Poetry Review* 75 (August 1985): 20–25.

———. "Paris Notes." *Art International* 7 (25 June 1963): 76–78.

———. Preface to *New Realists*. New York: Sidney Janis Gallery, 1962.

———. *Reported Sightings: Art Chronicles, 1957–1987*. Edited by David Bergman. New York: Alfred A. Knopf, 1989.

———. *Rivers and Mountains*. 1966. Reprint. New York: Ecco Press, 1977.

———. *Some Trees*. 1956. Reprint. New York: Ecco Press, 1978.

———. *The Tennis Court Oath*. Middletown, Conn.: Wesleyan University Press, 1962.

Banes, Sally. *Democracy's Body: Judson Dance Theater 1962–1964*. Ann Arbor: UMI Research Press, 1983.

———. *Greenwich Village 1963: Avant-Garde Performance and the Effervescent Body*. Durham: Duke University Press, 1993.

Barnouw, Erik. *The Image Empire: A History of Broadcasting in the United States*. Vol. 3. New York: Oxford University Press, 1970.

Barthes, Roland. *Image—Music—Text*. Translated by Stephen Heath. 1977. Reprint. New York: Noonday Press, 1988.

———. *A Lover's Discourse: Fragments*. Translated by Richard Howard. New York: Noonday Press, 1978.

Battcock, Gregory, ed. *The New American Cinema: A Critical Anthology*. New York: E. P. Dutton, 1967.

Beauman, Sally. Review of *a: a novel*, by Andy Warhol. *New York Times Book Review*, 12 January 1969, 32.

Benjamin, Walter. *Illuminations*. Edited by Hannah Arendt and translated by Harry Zohn. New York: Schocken Books, 1969.

Berger, Maurice. *How Art Becomes History: Essays on Art, Society, and Culture in Post–New Deal America*. New York: HarperCollins, Icon Editions, 1992.

Bergman, David. *Gaiety Transfigured: Gay Self-Representation in American Literature*. Madison: The University of Wisconsin Press, 1991.

Berkson, Bill, and Joe LeSueur, eds. *Homage to Frank O'Hara*. 3d ed. Bolinas, Calif.: Big Sky, 1988.

Berrigan, Ted. Art Chronicle. *Kulchur* 5 (autumn 1965): 22–31.

———. *Many Happy Returns*. New York: Corinth Books, 1969.

———. Review of *In Advance of the Broken Arm*, by Ron Padgett. *Kulchur* 5 (spring 1965): 100–102.

———. Review of *Lines about Hills above Lakes*, by Jonathan Williams. *Kulchur* 4 (winter 1964–65): 96.

———. Review of *Saturday Night Poems*, by Bill Berkson. *Kulchur* 5 (autumn 1965): 93.

———. *So Going Around Cities: New and Selected Poems 1958–1979*. Berkeley: Blue Wind Press, 1980.

———. *The Sonnets*. Rev. ed. New York: United Artists Books, 1982.

———, and Ron Padgett. *Bean Spasms*. Illustrated and with drawings by Joe Brainard. New York: Kulchur Press, 1967.

———, Ron Padgett, and Joe Brainard. *Some Things: Drawings / Poems*. N.p., 1966.

———, with Aram Saroyan and Duncan McNaughton. "The Art of Fiction XLI: Jack Kerouac." *Paris Review* 11 (summer 1968): 60–105.

Blauner, Peter. "Rock Noir." *New York,* 27 November 1989, 44–49.

Bloom, Harold. *Figures of Capable Imagination.* New York: Seabury, 1976.

Bloom, Janet, and Robert Losada, "Craft Interview with John Ashbery." In *The Craft of Poetry: Interviews from the New York Quarterly,* edited by William Packard. Garden City, N.Y.: Doubleday, 1974. First published in *New York Quarterly* 9 (winter 1972).

Blumenthal, Albert. "The Nature of Gossip." *Sociology and Social Research* 22 (1937): 31–37.

Bockris, Victor. *The Life and Death of Andy Warhol.* New York: Bantam Books, 1989.

———. *Transformer: The Lou Reed Story.* New York: Simon and Schuster, 1994.

———, and Gerard Malanga. *Up-Tight: The Velvet Underground Story.* New York: Quill, 1983.

Boone, Bruce. "Gay Language as Political Praxis: The Poetry of Frank O'Hara." *Social Text: Theory / Culture / Ideology* 1 (winter 1979): 59–92.

Bourdon, David. "Andy Warhol." *Village Voice,* 3 December 1964, 11.

———. Introduction to "The New York Correspondence School." *Artforum* 6 (October 1967): 50–55.

———. *Warhol.* New York: Harry N. Abrams, 1989.

Bourel, Michel. "Andy Warhol à Paris dans les années 60." *Artstudio* 8 (spring 1988): 94–105.

Brainard, Joe. "Andy Warhol: Andy Do It." *C: A Journal of Poetry* 1 (December 1963–January 1964): no pagination.

———. *Selected Writings: 1962–1971.* New York: The Kulchur Foundation, 1971.

Breslin, James E. B. *From Modern to Contemporary: American Poetry, 1945–1965.* Chicago: University of Chicago Press, 1984.

Brilliant, Richard. *Portraiture.* Cambridge: Harvard University Press, 1991.

Brown, Andreas. *Andy Warhol: His Early Works 1947–1959.* New York: Gotham Book Mart Gallery, 1971.

Burroughs, William S., and Brion Gysin. *The Third Mind.* New York: Viking Press, 1978.

C: A Journal of Poetry (1962–65).

Campbell, Jill. "Politics and Sexuality in Portraits of John, Lord Hervey." *Word & Image* 6 (October–December 1990): 281–97.

Carroll, Jim. *Forced Entries, The Downtown Diaries: 1971–1973.* New York: Penguin Books, 1987.

Carroll, Paul. *The Poem In Its Skin.* Chicago: Follett, A Big Table Book, 1968.

Castle, Frederick. "Occurrences: Cab Ride with Andy Warhol." *ARTnews* 66 (February 1968): 46–47, 52.

Charters, Ann. *A Bibliography of Works by Jack Kerouac (Jean Louis Lebris De Kerouac): 1939–1975.* Rev. ed. New York: Phoenix Bookshop, 1975.

———, ed. *The Portable Beat Reader.* New York: Viking, 1992.

Chassman, Neil. "Poets of the Cities: Levelling of a Meaning." In *Poets of the Cit-*

ies: New York and San Francisco 1950–1965, 8–31. Dallas: Dallas Museum of
Art and Southern Methodist University; New York: E. P. Dutton, 1974.

Coates, Robert M. "The Art Galleries: The 'Beat' Beat in Art." *New Yorker*, 2 January 1960, 60–61.

Colacello, Bob. *Holy Terror: Andy Warhol Close Up*. New York: HarperCollins, 1990.

Collins, Bradford R. "*Life* Magazine and the Abstract Expressionists, 1948–51: A Historiographic Study of a Late Bohemian Enterprise." *Art Bulletin* 73 (June 1991): 283–308.

Coplans, John. "The Early Work of Andy Warhol." *Artforum* 8 (March 1970): 52–59.

Crone, Rainer. *Andy Warhol*. New York: Praeger, 1970.

———. *Andy Warhol: The Early Work 1942–1962*. Translated by Martin Scutt. New York: Rizzoli, 1987.

Davidson, Michael. *The San Francisco Renaissance: Poetics and Community at Mid-century*. Cambridge: Cambridge University Press, 1989.

Davis, Lana. "Robert Rauschenberg and the Epiphany of the Everyday." In *Poets of the Cities: New York and San Francisco 1950–1965*. Dallas: Dallas Museum of Art and Southern Methodist University; New York: E. P. Dutton, 1974.

Demers, Claire. "An Interview with Andy Warhol." *Christopher Street* (September 1977): 37–40.

Denby, Edwin. *The Complete Poems*. Edited and with an introduction by Ron Padgett. New York: Randon House, 1986.

De Salvo, Donna M., Trevor Fairbrother, Ellen Lupton, and J. Abbott Miller. *"Success is a job in New York . . .": The Early Art and Business of Andy Warhol*. Edited by Donna M. De Salvo. New York: Grey Art Gallery and Study Center; Pittsburgh: Carnegie Museum of Art, 1989.

Di Prima, Diane. *Poets' Vaudeville*. New York: Feed Folly Press, 1964.

———, and LeRoi Jones, eds. *The Floating Bear: A Newsletter 1961–1969*. Reprint. Introduction by Diane di Prima. La Jolla, Calif.: Laurence McGilvery, 1973.

Drabble, Margaret. "Novelists as Inspired Gossips." *Ms.* 11 (April 1983): 32–34.

Drozdowski, Ted. "Lou Reads." Review of *Between Thought and Expression*, by Lou Reed. *Boston Phoenix*, 1 November 1991, sec. 3, 12–13.

Du Plessix, Francine. Introduction to "Painters and Poets." *Art in America* 53 (October–November 1965): 24.

Dyer, Richard. *Now You See It: Studies on Lesbian and Gay Film*. London: Routledge, 1990.

Ehrenstein, David. "The Filmmaker as Homosexual Hipster: Andy Warhol Contextualized." *Arts Magazine* 63 (summer 1989): 61–64.

———. "An Interview with Andy Warhol." *Film Culture* 40 (spring 1966): 41.

Elledge, Jim, ed. *Frank O'Hara: To Be True to a City*. Ann Arbor: University of Michigan Press, 1990.

Fairbrother, Trevor. "Tomorrow's Man." In *"Success is a job in New York . . .": The Early Art and Business of Andy Warhol*. Edited by Donna M. De Salvo, 55–74.

194

New York: Grey Art Gallery and Study Center; Pittsburgh: Carnegie Museum of Art, 1989.

Feldman, Alan. *Frank O'Hara*. Boston: Twayne, 1979.

Ford, Charles Henri, ed. *View: Parade of the Avant-Garde 1940–47*. Compiled by Catrina Neiman and Paul Nathan. New York: Thunder's Mouth Press, 1991.

Foucault, Michel. *Language, Counter-Memory, Practice: Selected Essays and Inter-views*. Edited and with an introduction by Donald F. Bouchard, translated by Donald F. Bouchard and Sherry Simon. Ithaca: Cornell University Press, 1977.

Freedberg, David. *The Power of Images: Studies in the History and Theory of Response*. Chicago: University of Chicago Press, 1989.

Fremont, Vincent. Introduction to *Andy Warhol Polaroids 1971–1986*. New York: Pace MacGill Gallery, 1992.

Fuck You / A Magazine of the Arts (1962–65).

Garrels, Gary, ed. *The Work of Andy Warhol*. Dia Art Foundation Discussions in Contemporary Culture Number 3. Seattle: Bay Press, 1989.

Gates, Henry Louis, Jr. "Sudden Def." *New Yorker,* 19 June 1995, 34–42.

Gelmis, Joseph. *The Film Director as Superstar*. Garden City, N.Y.: Doubleday, 1970.

———. "On Movies: He Has Trouble Communicating Whether On or Off the Screen." *Newsday,* 8 December 1966.

Genet, Jean. *Our Lady of the Flowers*. Translated by Bernard Frechtman and intro-duction by Jean-Paul Sartre. New York: Grove Press, 1963.

———. *The Thief's Journal*. Translated by Bernard Frechtman and foreword by Jean-Paul Sartre. New York: Grove Press, 1964.

Giles, Jane. *The Cinema of Jean Genet: Un Chant d'Amour*. London: British Film In-stitute, 1991.

Ginsberg, Allen. *Howl and Other Poems*. San Francisco: City Lights, 1956.

Giorno, John. Interview by Winston Leyland. In *Gay Sunshine Interviews*. Edited by Winston Leyland. Vol. 1. San Francisco: Gay Sunshine Press, 1978. First published in *Gay Sunshine* 24 (spring 1975).

Glendinning, Victoria. *Edith Sitwell: A Unicorn Among Lions*. New York: Alfred A. Knopf, 1981.

Gluckman, Max. "Gossip and Scandal." *Current Anthropology* 4 (1963): 307–16.

Goldberg, Vicki. *The Power of Photography: How Photographs Changed Our Lives*. New York: Abbeville Press, 1991.

Goldstein, Laurence. *The American Poet at the Movies: A Critical History*. Ann Ar-bor: University of Michigan Press, 1994.

Gooch, Brad. *City Poet: The Life and Times of Frank O'Hara*. New York: Alfred A. Knopf, 1993.

Gruen, John. *The New Bohemia*. With photographs by Fred W. McDarrah. 1966. Reprint. Pennington, N.J.: a capella books, 1990.

———. *The Party's Over Now: Reminiscences of the Fifties—New York's Artists, Writ-*

ers, Musicians, and Their Friends. 1972. Reprint. Wainscott, N.Y.: Pushcart Press, 1989.

Guiles, Fred Lawrence. *Loner at the Ball: The Life of Andy Warhol.* London: Bantam Press, 1989.

Harari, Josué V., ed. and trans. *Textual Strategies: Perspectives in Post-Structuralist Criticism.* Ithaca: Cornell University Press, 1979.

Harris, Mary Emma. *The Arts at Black Mountain College.* Cambridge: MIT Press, 1987.

Harte, Barbara, and Carolyn Riley, eds. *Contemporary Authors.* Rev. ed. Vols. 5–8. Detroit: Gale, 1969.

Haskell, Barbara. *Blam!: The Explosion of Pop, Minimalism, and Performance, 1958–1964.* New York: Whitney Museum of American Art in association with W. W. Norton, 1984.

Heffernan, James A. W. *Museum of Words: The Poetics of Ekphrasis from Homer to Ashbery.* Chicago: University of Chicago Press, 1993.

Hering, Doris. "James Waring and Dance Company: Judson Memorial Church, August 25, 1963." *Dance Magazine* 37 (October 1963): 28, 60.

Hess, Thomas B. "Andy Warhol." *ARTnews* 63 (January 1965): 11.

Heylin, Clinton. *Bob Dylan, Behind the Shades: A Biography.* New York: Summit Books, 1991.

———. *From the Velvets to the Voidoids: A Pre-Punk History for a Post-Punk World.* Middlesex, England: Penguin Books, 1993.

Hornick, Lita. *The Green Fuse: A Memoir.* New York: Giorno Poetry Systems, 1989.

Indiana, Gary. "History." In *Andy Warhol Photobooth Pictures.* New York: Robert Miller Gallery, 1989.

James, David E. *Allegories of Cinema: American Film in the Sixties.* Princeton: Princeton University Press, 1989.

———, ed. *To Free the Cinema: Jonas Mekas and the New York Underground.* Princeton: Princeton University Press, 1992.

Junker, Howard. "Andy Warhol, Movie Maker." *The Nation,* 22 February 1965, 206–8.

Kadzis, Peter. "Interview: With Pen and Lens." *Boston Phoenix Literary Section* 38 (June 1991): 7.

Kagan, Andrew. "Most Wanted Men: Andy Warhol and the Anti-Culture of Punk." *Arts Magazine* 53 (September 1978): 119–21.

Kaplan, Allan. Review of *C: A Journal of Poetry. Kulchur* 4 (winter 1964–65): 93–96.

Kenner, Hugh. *Historical Fictions: Essays.* San Francisco: North Point Press, 1990.

Kermani, David. *John Ashbery: A Comprehensive Bibliography, Including His Art Criticism, and with Selected Notes from Unpublished Materials.* New York: Garland Publishing, 1976.

196

Kerouac, Jack. "Is There a Beat Generation?" (1958). In *Jack Kerouac: "The Last Word."* Rhino Records R4 70939-D, 1990.

———. *On the Road.* 1957. Reprint. New York: Penguin Books, 1976.

———. *Readings by Jack Kerouac on the Beat Generation.* Notes by Bill Randle. Verve LP #15005, 1960.

———. *Visions of Cody.* With "The Visions of the Great Rememberer," by Allen Ginsberg. 1972. Reprint. New York: Penguin Books, 1993.

———, Robert Frank, and Alfred Leslie. *Pull My Daisy.* Introduction by Jerry Tallmer. New York: Grove Press; London: Evergreen Books, 1961.

Koch, Stephen. *Stargazer: The Life, World and Films of Andy Warhol.* Rev. ed. New York: Marion Boyars, 1991.

Kornbluth, Jesse. *Pre-Pop Warhol.* New York: Random House, Panache Press, 1988.

Kostelanetz, Richard, ed. *American Writing Today.* Vol. 1. Washington, D.C.: USICA, 1982.

Kramer, Margia. *Andy Warhol Et Al.: The FBI File on Andy Warhol.* New York: Unsub Press, 1988.

Kris, Ernst, and Otto Kurz. *Legend, Myth and Magic in the Image of the Artist.* Edited and translated by E. H. Gombrich. New Haven: Yale University Press, 1979.

Kroll, Jack. "Saint Andrew." *Newsweek,* 7 December 1964, 100–103A.

Kuspit, Donald. *The Cult of the Avant-Garde Artist.* Cambridge: Cambridge University Press, 1993.

Lanz, Henry. "Metaphysics of Gossip." *Ethics: An International Journal of Social, Political and Legal Philosophy* 46 (1936): 492–99.

Léger, Fernand. "A New Realism—The Object." *The Little Review* (Paris) 11 (winter 1926): 7–8.

Lehman, David. "The Whole School." Review essay. *Poetry* 119 (January 1972): 224–33.

———, ed. *Beyond Amazement: New Essays on John Ashbery.* Ithaca: Cornell University Press, 1980.

Leonard, John. "The Return of Andy Warhol." *New York Times Magazine,* 10 November 1968, 32–33, 142, 144 ff.

Levin, Jack, and Arnold Arluke, *Gossip: The Inside Scoop.* New York: Plenum Press, 1987.

Livingstone, Marco, ed. *Pop Art: An International Perspective.* London: Royal Academy of Arts, 1991.

Loewinsohn, Ron. "Reviews: After the (Mimeograph) Revolution." *Triquarterly* 18 (spring 1970): 221–36.

Lowney, John. "The 'Post–Anti-Esthetic' Poetics of Frank O'Hara," *Contemporary Literature* 32 (summer 1991): 244–64.

Lydenberg, Robin. "Sound Identity Fading Out: William Burroughs' Tape Experiments." In *Wireless Imagination: Sound, Radio, and the Avant-Garde,* ed. Douglas Kahn and Gregory Whitehead, 409–37. Cambridge: MIT Press, 1992.

Malanga, Gerard. *Chic Death.* Cambridge, Mass.: Pym-Randall Press, 1971.

———. *Prelude to International Velvet Debutante.* Milwaukee: Great Lakes Books, 1967.

———, and Andy Warhol. *Screen Tests / A Diary.* New York: Kulchur Press, 1967.

Mazzocco, Robert. "aaaaaa. . . ." Review of *a: a novel*. *New York Review of Books*, 24 April 1969, 34–37.

McCabe, Cynthia Jaffee, ed. *Artistic Collaboration in the Twentieth Century*. Washington, D.C.: Smithsonian Institution Press, 1984.

McClure, Michael. *The Beard & VKTMS*. New York: Grove Press, 1985.

McDarrah, Fred W., ed. *Kerouac and Friends: A Beat Generation Album*. New York: William Morrow, 1985.

McDonagh, Donald. "The Incandescent Innocent." *Film Culture* 45 (summer 1968): 55–60.

McGregor, Craig, ed. *Bob Dylan, The Early Years: A Retrospective*. 1972. Reprint. New York: Da Capo Press, 1990.

McShine, Kynaston, ed. *Andy Warhol: A Retrospective*. New York: Museum of Modern Art, 1989.

Mead, Taylor. *Excerpts from the Anonymous Diary of a New York Youth*. 1961. Reprint. New York: n.p., 1962.

———, and David Bourdon. "The Factory Decades: An Interview." *Boss* 5 (1979): 19–43.

Mekas, Jonas. *Movie Journal: The Rise of a New American Cinema, 1959–1971*. New York: Collier Books, 1972.

———. "Press Release." *Film Culture* 29 (summer 1963): 7–8.

———, Jack Kroll, Richard Goldstein, and Richard Preston. "Andy Warhol: 'The Chelsea Girls.'" *Village Voice,* 24 November 1966, 29.

Meltzer, David, ed. *The San Francisco Poets*. New York: Ballantine Books, 1971.

Meyer, Richard. "Warhol's Clones." *Yale Journal of Criticism* 7 (spring 1994): 79–109.

Miles, Barry. *Ginsberg: A Biography*. New York: Simon and Schuster, 1989.

Miller, Debra. *Billy Name: Stills from the Warhol Films*. Munich: Prestel, 1994.

Mitchell, W. J. T. *Iconology: Image, Text, Ideology*. Chicago: University of Chicago Press, 1986.

———. *Picture Theory*. Chicago: University of Chicago Press, 1994.

Moon, Michael. "Outlaw Sex and the 'Search for America': Representing Male Prostitution and Perverse Desire in Sixties Film (*My Hustler* and *Midnight Cowboy*)." *Quarterly Review of Film and Video* 15 (1993): 27–40.

Moramarco, Fred. "John Ashbery and Frank O'Hara: The Painterly Poets." *Journal of Modern Literature* 5 (September 1976): 436–62.

Morrissey, Paul, and Derek Hill. "Andy Warhol as a Film-maker: A Discussion between Paul Morrissey and Derek Hill." *Studio International* 181 (February 1971): 57–61.

Motherwell, Robert, ed. *The Dada Painters and Poets: An Anthology*. 2d ed., 1981. Reprint. Cambridge: Harvard University Press, Belknap Press, 1989.

Myers, John Bernard. *Tracking the Marvelous: A Life in the New York Art World*. New York: Random House, 1983.

Nicosia, Gerald. *Memory Babe: A Critical Biography of Jack Kerouac*. 1983. Reprint. Berkeley and Los Angeles: University of California Press, 1994.

O'Hara, Frank. *Art Chronicles 1954–1966.* Rev. ed. New York: George Braziller, 1990.

———. *The Collected Poems of Frank O'Hara.* Edited by Donald Allen. 1971. Reprint. New York: Alfred A. Knopf, 1979.

———. *Standing Still and Walking in New York.* Edited by Donald Allen. San Francisco: Grey Fox Press, 1983.

O'Pray, Michael, ed. *Andy Warhol: Film Factory.* London: British Film Institute, 1989.

Pacquement, Alfred. "The Nouveaux Réalistes: The Renewal of Art in Paris around 1960." In *Pop Art: An International Perspective,* ed. Marco Livingstone, 214–18. London: Royal Academy of Arts, 1991.

Padgett, Ron. *Great Balls of Fire.* Rev. ed. Minneapolis: Coffee House Press, 1990.

———. *Quelques Poèmes / Some Translations / Some Bombs.* New York: n.p., 1963.

———. "Poets and Painters in Paris, 1919–39." *The Avant Garde: ARTnews Annual* 34 (1968): 88–95.

———. "Sound and Poetry: A New Approach." *Kulchur* 5 (spring 1965): 72–78.

———. *Two Stories for Andy Warhol.* New York: C, 1965.

Parker, Alice C. *The Exploration of the Secret Smile: The Language of Art and Homosexuality in Frank O'Hara's Poetry.* New York: Peter Lang, 1989.

Parkinson, Thomas, ed. *A Casebook on the Beat.* New York: Thomas Y. Crowell, 1961.

Perloff, Marjorie. *Frank O'Hara: Poet among Painters.* 1977. Reprint. Austin: University of Texas Press, 1979.

———. *The Poetics of Indeterminacy: Rimbaud to Cage.* Princeton: Princeton University Press, 1981.

Phillpot, Clive. "The Mailed Art of Ray Johnson." In *More Works by Ray Johnson, 1951–1991.* Philadelphia: Goldie Paley Gallery, Moore College of Art and Design, 1991.

Pliny the Elder. *Natural History.* Loeb Classical Library, 1952.

Plunkett, Ed, et al. "Send Letters, Postcards, Drawings, and Objects . . . : The New York Correspondence School." *Art Journal* 36 (spring 1977): 233–41.

The Poetry Project Newsletter 139 (December 1990–January 1991). Special issue on appropriation.

Pomeroy, Ralph. *Stills and Movies.* San Francisco: Gesture, 1961.

Ratcliff, Carter. *Warhol.* New York: Abbeville, 1983.

Ratcliffe, Stephen, and Leslie Scalapino, eds. *Talking in Tranquility: Interviews with Ted Berrigan.* Bolinas, Calif.: Avenue B; Oakland, Calif.: O Books, 1991.

Reed, Lou. *Between Thought and Expression: Selected Lyrics of Lou Reed.* New York: Hyperion, 1991.

———. "The Murder Mystery." *Paris Review* 53 (winter 1972): 20–27.

Renan, Sheldon. *An Introduction to the American Underground Film.* New York: E. P. Dutton, 1967.

Ricard, Rene. *Rene Ricard, 1979–1980.* New York: Dia, 1979.

Rivers, Larry. "Life Among the Stones." *Location* 1 (spring 1963): 90–98.

Rose, Phyllis. "Literary Warhol." *Yale Review* 79 (autumn 1989): 21–33.

Ross, Andrew. *The Failure of Modernism: Symptoms of American Poetry.* New York: Columbia University Press, 1986.

Sabini, John, and Maury Silver. *Moralities of Everyday Life.* Oxford: Oxford University Press, 1982.

Sandarg, Robert. "Jean Genet in America." *French-American Review* 1 (1976): 47–53.

Sanders, Ed. *Ed Sanders' Catalogue #1* (June–July 1964).

——. *Peace Eye.* Buffalo, N.Y.: Frontier Press, 1965.

——. *Tales of Beatnik Glory.* New York: Citadel Press, 1990.

Sandler, Irving. *American Art of the 1960s.* New York: Harper and Row, Icon Editions, 1988.

Sartre, Jean-Paul. *Saint Genet: Actor and Martyr.* Translated by Bernard Frechtman. New York: George Braziller, 1963.

Schultz, Susan M., ed. *The Tribe of John: Ashbery and Contemporary Poetry.* Tuscaloosa: University of Alabama Press, 1995.

Shapiro, David. *John Ashbery: An Introduction to the Poetry.* New York: Columbia University Press, 1979.

——. "Poets & Painters: Lines of Color." In *Poets and Painters,* 7–27. Denver: Denver Art Museum, 1979.

——. "Polvere di diamanti." In *PopArt: evoluzione di una generazione,* 131–48. Milan: Electa, 1980.

Sheppard, Eugenia. "Pop Art, Poetry and Fashion." *New York, Herald Tribune,* 3 January 1965, 10–12.

Shibutani, Tamotsu. *Improvised News: A Sociological Study of Rumor.* Indianapolis: Bobbs-Merrill, 1966.

Shoptaw, John. *On the Outside Looking Out: John Ashbery's Poetry.* Cambridge: Harvard University Press, 1994.

Silver, Kenneth E. "Déjà-vu: Warhols Kunst des Industriell-Naiven," translated by Doris Janhsen. In *Andy Warhol: Retrospektiv,* edited by Zdenek Felix, 15–31. N.p.: Gerd Hatje, 1993.

——. "Modes of Disclosure: The Construction of Gay Identity and the Rise of Pop Art." In *Hand-Painted Pop: American Art in Transition, 1955–62,* edited by Russell Ferguson, 179–203. Los Angeles: Museum of Contemporary Art; New York: Rizzoli, 1992.

The Sinking Bear 1–9 (1963–64).

Sitney, P. Adams. *Visionary Film: The American Avant-Garde.* New York: Oxford University Press, 1974.

——, ed. *Film Culture Reader.* New York: Praeger, 1970.

Smith, Alexander, Jr. *Frank O'Hara: A Comprehensive Bibliography.* New York: Garland Publishing, 1980.

Smith, Dinitia. "The Poetry Kings and the Versifying Rabble." *New York Times Magazine,* 19 February 1995, 36–43.

Smith, Patrick S. *Andy Warhol's Art and Films.* Ann Arbor: UMI Research Press, 1986.

200

Sotheby's. *The Andy Warhol Collection.* 6 vols. New York: Sotheby's, 1988.

Spacks, Patricia Meyer. *Boredom: The Literary History of a State of Mind.* Chicago: University of Chicago Press, 1995.

———. *Gossip.* New York: Alfred A. Knopf, 1985.

Stein, Gertrude. *Lectures in America.* 1935. Reprint. Boston: Beacon Press, 1985.

Stein, Jean. *Edie: An American Biography.* Edited with George Plimpton. New York: Alfred A. Knopf, 1982.

Steiner, Wendy. *The Colors of Rhetoric: Problems in Relations between Modern Literature and Painting.* Chicago: University of Chicago Press, 1982.

Stewart, Susan. *Crimes of Writing: Problems in the Containment of Representation.* Oxford: Oxford University Press, 1991.

Stirling, Rebecca Birch. "Some Psychological Mechanisms Operative in Gossip." *Social Forces* 34 (1955–56): 262–67.

Stoller, James. "Beyond Cinema: Notes on Some Films by Andy Warhol." *Film Quarterly* 20 (fall 1996): 35–38.

Stuckey, Charles F. "Heaven and Hell Are Just One Breath Away!" In *Andy Warhol: Heaven and Hell Are Just One Breath Away! Late Paintings and Related Works, 1984–1986,* foreword by Vincent Fremont; afterword by John Richardson, 9–33. New York: Rizzoli International in association with Gagosian Gallery, 1992.

———. "Warhol in Context." In *The Work of Andy Warhol,* edited by Gary Garrels, 3–33. Dia Art Foundation Discussions in Contemporary Culture Number 3. Seattle: Bay Press, 1989.

Sukenick, Ronald. *Down and In: Life in the Underground.* New York: William Morrow, Beech Tree Books, 1987.

Swenson, Gene R. "What Is Pop Art?" *ARTnews* 62 (November 1963): 26, 60–61.

Tallmer, Jerry. "Rebellion in the Arts: 5. Mixed Media." News clipping, 1966. Andy Warhol clipping file, New York Public Library Theater Collection.

Trotter, David. *The Making of the Reader: Language and Subjectivity in Modern American, English and Irish Poetry.* Basingstoke: Macmillan, 1984.

Tyler, Parker. *Underground Film: A Critical History.* 1969. Reprint. New York: Da Capo, 1995.

Tytell, John. *Naked Angels: Kerouac, Ginsberg, Burroughs.* 1976. Reprint. New York: Grove Weidenfeld, 1991.

Van Doren, Mark, ed. *The Portable Walt Whitman.* Revised by Malcolm Cowley, with a chronology and bibliographical check list by Gay Wilson Allen. New York: Penguin Books, 1973.

Vincent, Stephen, and Ellen Zweig, eds. *The Poetry Reading: A Contemporary Compendium on Language and Performance.* San Francisco: Momo's Press, 1981.

Von Hallberg, Robert. *American Poetry and Culture: 1945–1980.* Cambridge: Harvard University Press, 1985.

Waldman, Anne, ed. *Nice to See You: Homage to Ted Berrigan.* Minneapolis: Coffee House Press, 1991.

———, ed. *Out of This World: An Anthology of the St. Mark's Poetry Project, 1966–1991.* New York: Crown Publishers, 1991.

201

———, and Marilyn Webb, eds. *Talking Poetics at the Naropa Institute*. 2 vols. Boulder: Shambhala Publications, 1978–79.

Walker Art Center. *The American New Wave, 1958–1967*. Minneapolis: Walker Art Center, 1982.

———. *In the Spirit of Fluxus*. Minneapolis: Walker Art Center, 1993.

Ward, Geoff. *Statutes of Liberty: The New York School of Poets*. New York: St. Martin's Press, 1993.

Warhol, Andy. *a: a novel*. New York: Grove Press, 1968.

———. *The Andy Warhol Diaries*. Edited by Pat Hackett. New York: Warner Books, 1989.

———. *The Philosophy of Andy Warhol (From A to B and Back Again)*. San Diego: Harcourt Brace Jovanovich, 1975.

———. "A Warhol Portrait Gallery: Literary Section." Edited by Robert Becker. *Paris Review* 26 (winter 1984): 100–11.

———, and Pat Hackett. *POPism: The Warhol '60s*. New York: Harcourt Brace Jovanovich, 1980.

———, and Gerard Malanga, eds. *Intransit: The Andy Warhol-Gerard Malanga Monster Issue*. Eugene, Ore.: Toad Press, 1968.

Warhol. Paris: Galerie Ileana Sonnabend, 1964.

Warhol Verso De Chirico. 1982. Reprint. Milan: Electa, 1985.

Watari Museum of Contemporary Art. *I Love Art: Andy Warhol, Joseph Beuys, Nam June Paik, Jonathan Borofsky, Keith Haring, Robert Mapplethorpe*. Tokyo: Watari Museum of Contemporary Art, 1991.

Webb, Richard C., with the assistance of Suzanne A. Webb. *Jean Genet and His Critics: An Annotated Bibliography, 1943–1980*. Scarecrow Author Bibliographies, No. 58. Metuchen, N.J.: Scarecrow Press, 1982.

White, Edmund. *Genet: A Biography*. New York: Alfred A. Knopf, 1993.

Wilcock, John. *The Autobiography and Sex Life of Andy Warhol*. New York: Other Scenes, 1971.

———. "The Detached Cool of Andy Warhol." *Village Voice*, 6 May 1965, 24.

Wilentz, Elias, ed. *The Beat Scene*. New York: Corinth Books, 1960.

Wilson, William. Introduction to *Correspondence: An Exhibition of the Letters of Ray Johnson*. Raleigh: North Carolina Museum of Art, 1976.

Wolf, Reva. "Collaboration as Social Exchange: *Screen Tests / A Diary* by Gerard Malanga and Andy Warhol." *Art Journal* 52 (winter 1993): 59–66.

———. "Portraiture as Gossip: Andy Warhol's 1963 Cover Design for *C: A Journal of Poetry*," *Harvard Library Bulletin* 5 (summer 1994): 31–50.

Woodmansee, Martha, and Peter Jaszi, eds. *The Construction of Authorship: Textual Appropriation in Law and Literature*. Durham: Duke University Press, 1994.

Woods, Gregory. *Articulate Flesh: Male Homo-Eroticism and Modern Poetry*. New Haven: Yale University Press, 1987.

"ZZZZZZZZ." Review of *a: a novel*, by Andy Warhol. *Time*, 27 December 1968, 63.

References to illustrations are printed in italic type.

205

209

210